THE
OMEGA
WORKSHOPS

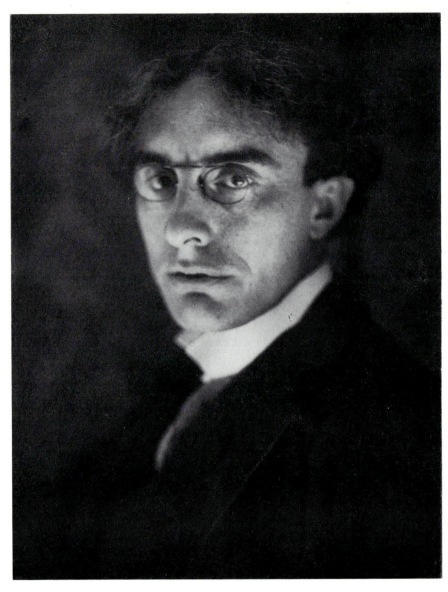

Roger Fry

THE OMEGA WORKSHOPS

JUDITH COLLINS

THE UNIVERSITY OF CHICAGO PRESS

To Janet Baker
' . . . a member of that family of wondrous beings . . . '

The University of Chicago Press, Chicago 60637
Secker & Warburg Limited, London W1V 3DF

Phototypeset by Wyvern Typesetting Ltd, Bristol
Printed in Great Britain by
BAS Printers Limited, Over Wallop, Hampshire

91 90 89 88 87 86 85 84 1 2 3 4 5

Library of Congress Cataloging in Publication Data

Collins, Judith.
The Omega Workshops.

Bibliography: p.
Includes index.
1. Omega Workshops. 2 Decorative arts—Great
Britain—History—20th century. I. Title.
NK942.O45C6 1984 745'.0942 83-18285
ISBN 0-226-11374-4
ISBN 0-226-11375-2 (pbk.)

CONTENTS

FOREWORD

I was sick in the Omega. It must have happened sometime in January 1919. A few months later the business went into voluntary liquidation. There is no reason to connect these two *contretemps* and indeed the former is of so little interest that, even if she had been aware of it, Dr Collins would hardly have mentioned the matter – and if I allude to it now it is only because it is, as far as I can tell, the only thing about the Omega that she does not know.

Until I read this book I had supposed that I knew as much as anyone of the Omega's history, and a good deal more than most; when it has been published and read by a large public, as it assuredly will be, I shall be deprived of both these distinctions. In writing a foreword, therefore, I can no longer rely upon my ability to supply information. Looking for something to say I find myself turning from the minutiae of history (and as will have been observed, I have been compelled to gather crumbs so minute as hardly to satisfy the appetite of a wren) and looking rather to those broad commonplaces of art history which are so generally known as to be taken for granted, and which have only that novelty which derives from a general disinclination to dwell upon the obvious.

'There are two kinds of painting,' said Duncan Grant, 'the Northern and the Southern.' I believe that he committed this rash statement to paper, he having been asked to write a preface for someone's exhibition, and the generalisation, as he admitted with a smile, got him into 'a great deal of trouble'. It was indeed a bold thing to say, but there is a rough and ready truth about it and it encourages me to go further and to say that, for Duncan and his friends, the great events of the year 1910 and above all the revelation to the British public of the importance of Cézanne – events which resulted, one might almost say which culminated, in the creation of the Omega Workshops – signalled a new interest in this country in what he would have called 'Southern' art. That is not quite how we see it today,

but at that time and for those people – indeed for the great mass of the British public – the Northern element in the revolutionary movements of the new century was either unknown or felt to be merely ancillary to the great convulsions of French Art. They knew nothing of Teutonic expressionism and saw all innovations as coming from Paris and relating to a tradition which went back through Cézanne and Poussin, the High Renaissance, Piero della Francesca, Masaccio and Giotto to the walls of Byzantium.

It is indeed the walls that should engage our attention; the mosaicists of Ravenna, and their Italian heirs, express themselves naturally upon walls. The character of their work is largely determined by the needs of the church or the palace where they find employment, and when, in later centuries, the artist yields to the demands of a new market which in its turn requires the frame and the easel, much of the old architectonic discipline endures. Poussin, working on quite small pictures, still retains those qualities of monumental order which we find in the *Stanze*; and those who have seen Cézanne airborne like a bewildered astronaut in the helical corridors of the Guggenheim Museum will realise to what extent he assumed the existence of and still needs a cubic and rectilinear environment with vertical walls and horizontal floors – things which, in that museum, are strikingly absent. What I call 'Southern' art is, then, closely tied to architecture, whereas 'Northern' art, which grew up amidst coloured windows and darkened interiors, might find a congenial home within the pages of a book – that is to say within a framework which could easily be transported from place to place and which invited the spectator not to look around him, as he would in a painted room, but to bury his head in it – in a volume with its own space and, it may be, its own world. Consider for an instant two masterpieces of these opposing genres: Leonardo's representation of the Last Supper is in effect a remodelling, a drastic alteration of the architecture of the refectory of Sta Maria delle Grazie; if it is to have its full effect upon us it must be seen *in situ*. Compare with that the strange and moving description of what is after all a fairly banal incident of Dutch life which we call the *Night Watch*. It is a scene observed from without; we are spies peering through a glass wall. It has the private quality of a great novel.

Now this private and portable device – a painter's vision of the world and/or his imagination, separated from his environment by a band of gold (the one colour that would never find its way into the picture itself) – was the chosen vehicle of the realists and the Impressionists. They were not decorators, and hardly looked beyond the picture frame. No doubt there were at that time great decorative projects, but they did not engage the

attention of the kind of painters who interested the *avant garde* at the beginning of the twentieth century. But whereas the *avant garde* in Continental Europe seemed hardly aware of the applied arts, in England it was different. The first generation of Pre-Raphaelites was already interested in the idea of adventuring into the applied arts; the second generation went boldly beyond the picture frame and tried its hand at fabrics, furniture, books and stained glass. At the same time, and again largely through British initiatives, the century found a style of its own which was not historicist and which, appropriately enough, was called *art nouveau.*

Roger Fry, who didn't care for *art nouveau* or for the Pre-Raphaelites of the Brotherhood, did always have a qualified but genuine affection for the work of Burne-Jones. His sentiment might be tiresome but his sense of design was impressive and he was, in the sense used here, very much a Southern artist looking always to Italy for inspiration. In the same way Fry was never quite happy with Impressionism; as he said when he first saw Impressionist pictures: 'I don't like having facts thrown in my face.'

I once asked Gropius whether he had had Ruskin in mind when he started the Bauhaus. He replied, with positively Irish exactitude, that 'he had him very much not in mind'. I think that the relationship between Fry and the Morris workshops was rather of that kind. Morris was trying to say something important about art and everyday life. Fry's 'message', if you can call it that, was not dissimilar, but he had no use for the language which Morris had used. He found what he needed in the pictorial idiom of Cézanne and, even more, in that of the Fauves. The use of bold and brutal colour, the acceptance of pictorial conventions so rude and rapid that they made questions of verisimilitude almost irrelevant, gave the decorator a vocabulary which could be taken without adaptation from the easel picture to furniture, pottery, textiles, lampshades and hats. The Impressionists (to apply the words of another revolutionary) had merely 'explained the world, the point was to change it'.

I think that I am right in finding the genesis of this remarkable attempt to transform the man-made world by means of unrestrained colour and bold design in what I have called Southern art. It is a fact that Fry and his friends did at about this time go to Ravenna and to Constantinople, and that some of them, at all events, were deeply influenced by the mural paintings of St. Savin. But it is also true that a very different kind of art – the art of primitive peoples and in particular of the Africans – was at the same time discovered and admired. And in the creation of the Omega Workshops also there were motives of a very different kind at work. Fry wanted to establish a place where a young artist might earn ten shillings a

week, and for this purpose the painting of chairs was more to the point than the painting of pictures – and there may have been other forces at work. It is an unfortunate fact, but one that has to be faced, that artists do not always feel and behave exactly as art historians think they should feel and behave. The appropriate and inevitable processes of history do not always appear to them as compelling as we may suppose. Indeed we may on occasion be moved by the most trifling and seemingly incongruous circumstances. Perhaps – it is just possible – some importance should be attached to the fact that, in January 1919, a child was sick in the Omega Workshops.

Quentin Bell
1983

1
BOYCOTTED BY SOCIETY:
1910 & 1911

'THE British public has dozed off again since the last show and needs another electric shock. I hope I shall be able to provide it. Just imagine, the Royal Academy still goes on.'[1] These sentences, in a letter from Roger Fry to his mother written in the summer of 1912, reveal the intensity of his desire personally to attack the philistinism of the British public. They give some idea of his dislike for the most important artistic institution in the country, the Royal Academy, ensconced in the ample galleries of Burlington House in Piccadilly. The 'last show' to which Fry referred was the first Post-Impressionist exhibition, entitled 'Manet and the Post-Impressionists', which he offered to the British public at the Grafton Galleries, London, in the winter of 1910. Fry had coined the neologism 'Post-Impressionist' to describe the paintings by the contemporary French artists in his exhibition; a few sentences from the catalogue provide a working definition of the aims of a Post-Impressionist painter:

There comes a point when the accumulations of an increasing skill in mere representation begin to destroy the expressiveness of the design, and then . . . the artist grows uneasy. He begins to try to unload, to simplify the drawing and painting . . . He aims at synthesis in design; that is to say, he is prepared to subordinate consciously his power of representing the parts of his picture as plausibly as possible, to the expressiveness of his whole design.

'Manet and the Post-Impressionists' completely overturned the 'Custard Islanders' preconceptions of what to expect from an art exhibition. (Fry was in the habit of calling the British 'Custard Islanders' or 'the inhabitants of Bird's Custard Isle', and this pejorative assessment – likening them to a glutinous yellow mass – no doubt reflected what he felt to be their lack of enthusiasm for questions of aesthetic import.) Up until 'Manet and the Post-Impressionists', the British public had required that a painting should portray the objects, occurrences and emotions of life in a

realistic manner, and thus contain a very high proportion of human and moral interest. Any concern for compositional qualities, use of colour and line or painterly techniques was not in evidence. Wilfrid Blunt, the poet, who visited 'Manet and the Post-Impressionists', reacted in exactly the manner Fry had expected when confronted with canvases by Gauguin, Cézanne, Van Gogh, Vlaminck, Derain, Rouault, Matisse and Picasso:

To the Grafton Gallery to look at what are called the Post-Impressionist pictures sent over from Paris . . . The drawing is on the level of that of an untaught child of seven or eight years old, the sense of colour that of a tea tray painter, the method that of a schoolboy who wipes his fingers on a slate after spitting on them . . . Apart from the frames, the whole collection should not be worth £5, and then only for the pleasure of making a bonfire of them.[2]

Not only were the canvases of the French Post-Impressionist painters under attack and considered to be worthy of a conflagration, but Fry himself was a candidate for similar abuse. After he had dared to mount a second Post-Impressionist exhibition at the same venue, in the winter of 1912 – the exhibition which he hoped would disturb the dozing of the British public – a colleague, Lytton Strachey, reflected: 'Nobody could be surprised if a stake were set up tomorrow for Mr. Roger Fry in the courtyard of Burlington House.'[3] Fry and the Royal Academy had been waging a battle since his first Post-Impressionist exhibition in 1910, when some eminent Royal Academicians thought fit to attack him in the columns of several newspapers and periodicals such as *The Nation*, and expressed their disgust with his support of modern French art – not that they were prepared to recognise it as art and thus on a par with their own aesthetic activities. Fry retaliated, reminding his readers that his exhibition gave the first 'opportunity to the British public to judge of a great movement of which it had hitherto remained in almost total ignorance, and it has given Sir W. B. Richmond R.A. the opportunity to express publicly his shame at bearing the designation of artist. That is perhaps even more than one had ventured to hope.'[4]

Fry's support for modern French art was of recent origin. As he himself later confessed, he came late to its appreciation, only discovering Cézanne, for example, in 1906, the year of that artist's death. Since his conversion to modern art came about only four years before the mounting of his first Post-Impressionist exhibition, it gave his critics cause to accuse him of immoderate haste in his espousal of the new movement and perhaps to think that he might abandon it equally swiftly. Following his conversion to the work of painters like Cézanne, Gauguin, Van Gogh (who although a Dutchman was counted amongst the French) and

Matisse, he became an enthusiastic and vocal campaigner on behalf of the movement. Fry's crusade in the name of modern art found its first expression in print in 1908. He was closely connected with the *Burlington Magazine* – founded in 1903 primarily for the study and appreciation of the art of the past – and a letter from Fry to the editor, Sir Charles Holmes, was published in the March issue: 'I should like to enter a protest against the tendency, which I have noticed, to treat modern art in a less serious and sympathetic spirit than that which you adopt towards the work of the older masters.' This was in response to an editorial in February on Impressionism, whose tone Fry declared to savour of 'Pharisaism'.

Fry's aesthetic theories had been founded on a deep and thorough knowledge and love of Italian art of the thirteenth to sixteenth centuries. His first book, in 1899, was devoted to the art of Giovanni Bellini; and in 1901 he had contributed a chapter on the development of Italian art to a new *Guide to Italy*. He was thus listed, by the British public, with those art historians concerned with Italian Renaissance painting. Fry now began to look at contemporary French art in terms of the Old Masters and vice versa, and urged others to do the same: 'If only our art historians would look at the old masters as though they were contemporaries, we should probably get some very instructive criticisms and some very frank admissions of a kind to horrify the conventionally cultured.'[5] He defended his first Post-Impressionist exhibition on these grounds:

I have been accused of a strange inconsistency in admiring, at one and the same time, the accredited masterpieces of ancient art and the works here collected together, which are supposed to typify the latest and most violent of all the many violent reactions against tradition which modern art has seen. Without being much interested in the question of my own consistency, I believe that it is not difficult to show that the group of painters whose work is on view at the Grafton Gallery are in reality the most traditional of any recent group of artists . . . they are in revolt against the photographic vision of the nineteenth century, and even against the tempered realism of the last four hundred years.[6]

He also came to the conclusion that the French Post-Impressionists were the heirs of those Italian artists whom he had so admired. In particular he singled out Cézanne: 'He renewed as it were all the great principles of design of the great Italians of the Renaissance, and gave them a modern significance.'[7]

Fry's knowledge of the art of the Italian Renaissance was based not only on frescoes and panel paintings, but also on the applied or decorative arts executed by the same artists. The artists of Florence, Siena and Rome throughout the thirteenth to sixteenth centuries were equally prepared to

turn their hand to an altar-piece, a cassone panel, a banner or a small wooden box; and the artistic merit of each object was potentially the same, since the hand of a professional artist was responsible for each of them. Nor was there any sense then that the applied or decorative arts were lower in standing than the fine arts. This social prejudice was a later accretion which Fry refused to recognise, regarding it as divisive and unjust. He was thus concerned to expose or eradicate this false distinction, which he felt certainly existed in his own day.

In 1910 Fry wrote an article for the *Burlington Magazine* on a modern designer, the jeweller Mrs. Koehler, attacking any attempt to distinguish between fine art and applied art which might result in a pejorative assessment of applied art:

Whatever be the effect of this insidious and fundamentally snobbish distinction upon the despised 'applied' artist, we are at last beginning to see that its effect upon the 'Fine' artist is deplorable, and that in proportion as he has cut himself loose from the fundamental limitations and conditions of design he has lost his science and craftsmanship, has become clever, conceited and unworkmanlike. For the sake of sound views on aesthetics too, the distinction had better be forgotten, since it is as necessary to explain the satisfaction we derive from the simplest specimen of the potter's craft as, let us say, from a Rembrandt etching, and indeed the more we analyse the beauty of the most complex and freest examples of the Fine Arts, the more we are driven back upon certain fundamental properties of form and colour which hold to some extent in every real work of art, however unpretentious.[8]

Exposing what he saw as the erroneous distinction between fine art and applied, decorative art, Fry was again seen to be attacking well-rehearsed social and aesthetic value judgements. He was only too aware of the effect his attack would have upon entrenched positions if he continued to promote the elevation of the applied arts as worthy of the same consideration as the fine arts – witness a further sentence from the same article: 'There is a certain social class-feeling, a vague idea that a man can still remain a gentleman if he paints bad pictures, but must forfeit the conventional right to his Esquire, if he makes good pots or serviceable furniture.' Royal Academicians were no doubt the gentlemen who painted the bad pictures; the latter part of the sentence had a most prophetic ring in that Fry himself, under the aegis of his Omega Workshops (not founded until 1913), later made exceptionally good pots and designed original, uncluttered furniture. He was anyway deemed to have forfeited his right to the term of Esquire with his exhibition 'Manet and the Post-Impressionists', since the typical response by press, public and academic artists alike was that he should be boycotted by decent society. Fry's

knowledge of the multifarious artistic activities of the *botteghe* of Renaissance Italy would have reinforced his zeal to expand the range of activities of the artists of his own time. Such a development could only follow from a much greater breadth of vision in the training of art students.

The idea of artistic workshops for the education of art students modelled on Renaissance *botteghe* had been mooted in the last two decades of the nineteenth century, notably by Fry's own art teacher, Francis Bate. And, in the very year of Fry's first Post-Impressionist exhibition, his close and valued colleague, C. R. Ashbee, was preparing a book called *Should We Stop Teaching Art?* in which, on a discussion on 'the Problem of the Art School', he wrote:

Much of the public money now spent in futile teaching might be better spent in the endowment of artistic workshops, where this teaching would be more efficient than it is at present, while in so doing we should not only teach, but we should endow skill, invention and imagination, instead of as at present stimulating it artificially in schools, and then checking it unnaturally in life.[9]

The education of art students was an issue which Fry seemed to sidestep. He was certainly interested in the possibilities of fostering art in primary schools. But as far as professional artists were concerned he preferred to gather together people who had already had an art education; he would then give them support and freedom to expand in his Omega Workshops.

At the same time as the education of art students was being reassessed by Francis Bate and others, professional artists were also gathering into various groups which were taking a new look at the function and definition of the artist in society. Each group had its own subtle idea of what this definition should be, and tried in its own way to bring about an interaction between art and handicraft. In 1882 Arthur Mackmurdo had founded the Century Guild, a group of artists and craftsmen under the rule of anonymity whose aim was 'to render all branches of art the sphere no longer of the tradesman but of the artist'. In 1884 the Art-Workers' Guild was founded by a group of Norman Shaw's pupils and assistants to bring together 'craftsmen in architecture, painting, sculpture and the kindred arts',[10] in the hope of uniting these arts into an influential body. And in 1888 Fry's friend, C. R. Ashbee, founded his Guild and School of Handicraft for the training of craftsmen, at Toynbee Hall in the East End of London. He brought a new concept into the idea of the guild – that of spiritual comradeship between the members.

One thing which these three institutions had in common was the word 'Guild'. When Fry founded his Omega Workshops for the employment of

'artist-decorators', he eschewed this connotation of medieval and Renaissance societies. Even though his knowledge of Renaissance workshops helped in the formation of his ideas, he did not want to give the impression that his artists were looking back to the past for inspiration; the styles he encouraged them to explore both in fine and applied arts were based on a distillation of Post-Impressionist painting executed in France in very recent years, *c.* 1905–10. This regard for the present instead of nostalgia for the past was perhaps the crucial difference between Fry's group and others from the time of William Morris. Fry's artists were so radical that they used the latest style in French painting for decorative purposes even before the French themselves cared to do so.

In 1907 Walter Crane wrote *An Artist's Reminiscences*, encapsulating many ideas of the late-nineteenth-century Arts and Crafts revival through the formation of the various guilds. Crane had been influential in promoting a mission to 'turn our artists into craftsmen and our craftsmen into artists'. Fry himself supported Ashbee, to the extent of subscribing to his Guild of Handicraft funds. He was also a member of the Art-Workers' Guild from 1900 until his resignation in 1910 – a significant move which, considered with hindsight, marked the beginning of his isolated stance.

Fry's own attitude to the role of the artist and the craftsman differed from those of his contemporaries. In founding his Omega Workshops, Fry did not encourage artists and craftsmen to work together; nor did he try to make craftsmen into artists. But he did believe that artists should not limit themselves to the creative act as a cerebral and emotional experience; it should be a physical one also. He encouraged his artists literally to 'apply' their art, to all manner of surfaces. However, he did see their function as one of creativity rather than technical expertise: 'In many branches of design it would be wasteful to employ the designer in the actual execution, but in the case of wall painting and decorative sculpture the execution is the craft of the artist.'[11] His artists designed fabric patterns for house furnishings, but they did not weave or print the material. They designed furniture, but they did not learn to be cabinet-makers. All these techniques, which could be learnt and needed skill but could be performed without inspiration, Fry delegated. In one case, metalwork, the technique involved was so complex that no amount of inspiration alone would allow an artist to work in that field. Nonetheless, Fry believed that even in metalwork 'such work must be done by the designer'. But as all metalworkers were naturally involved in the war effort during the Omega years, the want of a craftsman to teach the designer meant that metalwork could not be attempted at all. Some Omega products are full of new decorative ideas but poor in execution; but Omega designs handed to

craftsmen for execution always resulted in high quality both in creative ideas and finish – for example, the dining-chairs, the furnishing fabrics and the rugs.

Fry's idea of a workshop which would employ young professional artists part-time and afford them moral and financial support was very much in keeping with his views on patronage. Another reason for his antagonism towards the Royal Academy was what he considered to be their maladministration of the Chantrey Bequest. Sir Francis Chantrey, a famous nineteenth-century sculptor and Royal Academician, left £108,000 invested in a trust fund for the purchase of 'works of art of the Highest Merit', with two provisos. One was that the purchases should be chosen by the president and council of the Royal Academy. The other was that the works should have been executed in Britain. Although his bequest was intended for the purchase of works by young living artists, it did not actually insist on it, and the council of the Royal Academy used the money to buy an embarrassingly large number of works by middle-aged Royal Academicians. Fry was not alone in his criticism: the House of Lords held a debate in 1904 which condemned this state of affairs. But for Fry, who gave evidence to this debate, consideration of the patronage of young living artists was not a matter to be debated and reported on and then left in the air; it was something which demanded a positive, practical gesture of support.

In April 1910 he was one of seven people who grouped themselves into a provisional committee under the title 'Modern Art Association'. By May the group had increased to ten and the name had changed to the Contemporary Art Society.[12] This group was formed in opposition to the Royal Academy council responsible for the spending of the Chantrey Bequest, and it aimed to support the cause of modern art by charging a subscription to members which would be used to purchase examples of modern British art. It was also the intention of the Contemporary Art Society to exhibit its purchases often and widely, throughout the length and breadth of Britain.

By the end of 1910, Fry was becoming more closely acquainted with the artist Vanessa Bell, whom he had first met in 1902 or 1903. She had initially regarded herself as a 'terrible low creature, a female painter' while Fry had appeared to her as one of the 'dreadful members of the upper world', for she first knew him as a lecturer and great authority on Italian art and 'the newest and most learned of young critics'.[13] Her sister, Virginia Woolf, was later moved to claim that 'in, or about December 1910, human character changed',[14] and although the context in which this claim

occurred was an essay on the current state of the novel, actually written in 1924, she could well have formulated this assertion from a knowledge of the activities of her friend Roger Fry and his attempt to alter radically the insular Edwardian consciousness: activities which included his first Post-Impressionist exhibition, his part in the formation of the Contemporary Art Society, and last but not least the galvanising effect he had upon his colleagues. Vanessa Bell, with hindsight, also recorded the same shift in her awareness at that period: 'That autumn of 1910 is to me a time when everything seemed springing to new life – a time when all was a sizzle of excitement, new relationships, new ideas, different and intense emotions all seemed crowding into one's life. Perhaps I did not realise then how much Roger was at the centre of it all.'[15]

In 1907 Clive and Vanessa Bell had befriended a young painter, Duncan Grant, and in the autumn months of 1910 Vanessa Bell was probably responsible for introducing him to Fry. From that moment on, Fry, Vanessa Bell and Duncan Grant formed a triumvirate concerned with modern art, advising and encouraging each other. Fry now had two friends with whom to share his practical experiences of painting, and Vanessa Bell and Grant now had access to an established critic with a fund of knowledge on many periods of art history and on exhibition organisation. In February 1911 Fry, Bell and Grant all exhibited together for the first time, under the auspices of Vanessa Bell's own exhibiting society, the Friday Club, at the Alpine Club Gallery, Mill Street, London. All three were listed in the catalogue as painter members of the club, and exhibited two paintings each, only one of the six – Fry's *Flooded Valley* – being identifiable at this distance in time. When reviewing the year's art for 1911 the critic Lewis Hind recalled that the paintings in this Friday Club show were 'saturated with Post-Impressionism'.[16] Thus in just under a year from Fry's exhibition 'Manet and the Post-Impressionists' critics were applying the term to Fry's own work and that of his colleagues. In December 1910 Virginia Woolf (still then Miss Stephen) took a cottage at Firle in Sussex, which she christened Little Talland House. The following March it was being furnished with odds and ends of furniture and splendid bright new appliquéd curtains designed and made by her sister Vanessa Bell. Virginia Woolf described the house in April 1911 as 'done up in patches of post-impressionist colour',[17] in what was probably one of the first references to the new art movement as applied to a domestic setting.

Just after the Friday Club show closed at the end of February, Fry was busy trying to organise an exhibition of the best non-academic talents in British art, to be held at the Grafton Galleries in the winter of 1911. The proprietors of the Grafton Galleries, undaunted by the public outrage

which accompanied 'Manet and the Post-Impressionists', were prepared to offer him their gallery for the winter months of 1911, with a free hand as to his choice of exhibition. No doubt this decision was affected by the large amount of money collected from the shilling entry fee paid by not less than four hundred visitors daily to Fry's first Post-Impressionist exhibition. In planning his new exhibition, Fry – recognising that his provisional list of new young artists would not provide enough canvases to fill the extensive space of the Grafton Galleries – was obliged to approach 'the conservatives, Steer, Tonks and Co'.[18] Writing to William Rothenstein he told him that the chance to organise another exhibition at the Grafton Galleries, this time showing the work of British artists, seemed 'a real acquisition of power for the younger and more vigorous artists . . . I don't like exhibitions any more than you do, but until we have got back to a more perfect way of life altogether, they remain the only possible medium of communication.'[19] His professed dislike of exhibitions, however, is not borne out by the evidence. He seemed actively to seek out chances for organising, visiting, lecturing on, and writing about them. And his purpose was strongly didactic: the spread of knowledge about art to an ever-widening public.

The winter exhibition of 1910 at the Grafton Galleries was mounted by Fry in order to introduce into Britain a knowledge of recent French art. But his proposed winter exhibition for 1911 was more than just a means of introduction to current British art. It was, as he stated, 'a medium of communication'. He wanted people to look and enjoy, and then preferably to buy. Fry believed in the talent of the young band of British painters like Vanessa Bell and Duncan Grant. A number of such people, aged between twenty-five and thirty-five, had gathered around him after the experience of 'Manet and the Post-Impressionists', and they now looked to him as a leader; he in turn wanted to help them by giving their latest work exposure. But he was aware that the public response to their painting could well be one of suspicion and attack, since many of them adopted the most blatant qualities of French Post-Impressionism, such as crudeness of execution, rejection of draughtsmanship, and a very bright palette. As he wrote in the following year: 'The history of art in the nineteenth century is the history of a band of heroic Ishmaelites, with no secure place in the social system, with nothing to support them in the unequal struggle but a dim sense of a new idea, the idea of freedom of art from all trammels and tyrannies.'[20]

Fry's plans for the new exhibition began to founder, however. The cause was antagonism from certain of his painter colleagues, such as William

Rothenstein and Augustus John, who he had believed would support him. In April 1911 he went to Turkey for a much needed holiday with Clive and Vanessa Bell and another friend, H. J. T. Norton. The holiday must have been some consolation since it was intended to satisfy Fry's long-felt desire for first-hand experience of Byzantine art. The party stayed for some days in Constantinople, and then journeyed on to Brusa, where a two-day stop was planned. The choice of Brusa may have been due to Grant, who had gone there in 1910 and had been impressed by what he saw. In fact, Grant's visit to Turkey in 1910 had been inspirational – he wrote of it to Lytton Strachey: 'As regards colour and form they are absolutely unbridled, every available surface of any possible kind must be covered with patterns. The horses' tails are died [*sic*] red, blue and green, the hard boiled eggs every colour of the rainbow. No two things are ever made or done alike.'[21] At Brusa, though, Vanessa Bell fell seriously ill as the result of a miscarriage, and their sightseeing plans had to be abandoned.

Although forced to call a halt to his programme of discovery of Byzantine art, especially the accomplishments of the mosaic artists, Fry would already have had the chance to absorb several good examples in Constantinople, possibly also taking in an impressive mosaic scheme at Nicaea, on the way to Brusa. Meanwhile, even at such a distance from London, he was still prepared to attempt the salvage of his 1911 winter exhibition. He wrote again to William Rothenstein from Constantinople; two sentences indicate his feeling: 'Unless those who care for what is vital in art agree to co-operate loyally, commercialism will always trample us underfoot. Just now there seems to me an occasion for a real effort at such co-operation.'[22] In Turkey Fry was surrounded by the superb results which teamwork could achieve: large areas of decorative fresco and mosaic, publicly available and attributable to the encouragement of powerful patronage and the willing cooperation of groups of artists. The significant statement from his 1912 essay 'Art and Socialism' – 'what the history of art definitely elucidates is that the greatest art has always been communal, the expression of common aspirations and ideals' – could well have been conceived standing in front of some of these fresco and mosaic decorations. Permanent schemes of mural decoration also abolished any need for the temporary exhibition of artists' work, and offered evidence of the existence of a wealthy, knowledgeable and interested state patron.

Fry was drawn to study the aesthetics and styles of Byzantine art because he felt that the modern French art he had shown at the Grafton Galleries represented a serious effort 'at a more expressive art than we have had for several centuries' and corresponded to 'the beginning of the return to Byzantine and Early Christian Art'.[23] He saw the same elements of style in

both Byzantine and modern French art, and believed both to share a predilection for 'significant' and emotional design. One later-twentieth-century scholar has described Byzantine art as seeking 'to express a significant idea rather than to please; it was forceful and assertive, expressive in conception, and favoured vivid impressive colouring; figures were represented frontally; there was no attempt at illusion or true perspective'.[24] Taken out of context this description could easily apply to a French Post-Impressionist painting. Even before organising the first Post-Impressionist exhibition, Fry had created a link between Byzantine art and modern French art by pinpointing the importance of El Greco: 'Was it not El Greco's earliest training in the lingering Byzantine tradition that suggested to him his mode of escape into an art of direct decorative expression? and is not Cézanne after all these centuries the first to take up the hint El Greco threw out?'[25] Fry saw no problem in offering Cézanne as both an heir to the artists of the Italian Renaissance and a descendant of Byzantine artists; his idea of art-historical progress would have readily conceded that the Italian Renaissance artists learnt much from the Byzantines.

When Fry returned to England on 6 May, he began encouraging a hand-picked group of young British artists to produce designs for a new commission which he had secured before his Turkish holiday. The commission had been obtained from an old Cambridge friend, Basil Williams, who was in 1911 chairman of the house committee at the Borough Polytechnic at the Elephant and Castle, London. The Polytechnic boasted an art department, led by a Mr. Patric. However, no contact seems to have been established between this gentleman and Fry, and in fact the murals were painted on site during the summer vacation. Fry turned to Duncan Grant, Frederick Etchells and Bernard Adeney to produce designs, which had to be shown for approval to the Polytechnic house committee on 30 June. His choice of Grant, whose art he already greatly admired, would have been influenced by Grant's recent mural decorative scheme for Maynard Keynes' room in Webbs Court, King's College, Cambridge. Grant had begun four panels, depicting male and female fruit harvesters and dancers, in the winter of 1910–11. Although unfinished, these panels offered good evidence of his ability to design and execute large-scale figure compositions. In the four Webbs Court panels (still extant under later panels by Duncan Grant and Vanessa Bell) a formula emerged which Grant was to exploit significantly over the next eighteen months. He arranged his figures so that at least one in each panel showed its back to the spectator.[26]

The project at the Borough Polytechnic involved decorating a large room, the students' dining-room, and also the walls of the passage and stairs leading to it, and required the work of several artists. Fry was unable to offer Vanessa Bell a place in this communal commission, as she was still recovering from her illness. No source relates how, where or when Fry first met Adeney or Etchells. Adeney was thirty-three in 1911, the eldest of the artists Fry chose, and had trained as a painter in the Royal Academy Schools and at the Académie Julian in Paris. He had first exhibited in the Royal Academy Summer Exhibition of 1900, where he showed a large painting of St. Francis which eventually found a home in Brede Church in Sussex. Then there was a gap in his exhibiting career until 1912, while he established himself as an art teacher. By his own admission, he was 'deeply moved by the first Post-Impressionist Exhibition' and: 'At that time there was considerable excitement in the art world because of the Post-Impressionist Exhibition and quite a number of murals were going up. I and Etchells and others had done several halls.'[27] If Adeney's 'at that time' can be taken to mean 1911, then this could imply an experience of mural painting before Fry called on his help for the Borough Polytechnic.

In contrast to Adeney, Etchells was the youngest member of the decorative team and was just at the end of his art school training. He had yet to exhibit in public, but must have been able to convince Fry of his talent for large-scale work, since he was awarded the largest space. The scheme began with Grant, Adeney, Etchells and Fry: the preliminary sketches were approved by the Polytechnic's house committee on 30 June, and the actual work then promised for August. Fry soon found he needed more artists to help, and he enlisted MacDonald Gill, the brother of Eric Gill, and Albert Rothenstein, the brother of William. (Albert and another brother, Charles, changed their names to Rutherston during the war, but William retained Rothenstein.) Fry's knowledge of both MacDonald Gill and Albert Rothenstein would have stemmed from his prior acquaintance with their brothers. It is significant that Fry passed over artists possibly more suited in style, such as Spencer Gore and Wyndham Lewis, whose work he must have known, and who may well have been on his projected list for the 1911 exhibition of young British artists.

Gill and Rothenstein seem unlikely choices beside these two more talented painters. Indeed, after the Polytechnic venture Fry was to drop Gill and Rothenstein from his circle, retain Adeney, Etchells and Grant, and offer an invitation to Gore and Lewis. Adeney, Etchells, Grant and Lewis were all to be asked to participate in the Omega Workshops, and Adeney was the only one not to take up this opportunity. In 1941 Adeney recalled the situation at the Omega in 1913: 'Roger Fry wanted me to be a

sort of foreman of works at one time but I knew the recalcitrant nature of that spirited group of artists . . . They were incensed that their names did not appear, as they were the actual workers and designers and Fry took all the credit.'[28] Adeney was referring to Wyndham Lewis and Etchells rather than Grant, who seemed happy for his work to remain anonymous – one of the precepts of the Omega Workshops.

Fry's original theme for the decorations was 'Getting the Food' – an eminently suitable subject for a dining-room – but this was abandoned in favour of 'London on Holiday'. Mural decorations in public buildings in Britain in the late nineteenth and early twentieth century usually took as subject material historical patriotism or high moral instruction. Walter Crane, a supporter of public mural schemes, spoke in 1912 of his desire to promote mural decorations in schools, stating how he 'was greatly in favour of symbolical or allegorical subjects, as they were most likely to impress the young mind'.[29] The art critic of the *Athenaeum* wrote of the Polytechnic murals: 'The decorators of the Borough Polytechnic must prepare to be howled at as anarchists and charlatans because, instead of setting themselves to copy the works of dead masters, they have dared to attempt what the masters achieved – the expression, that is, of the significance of contemporary life.'[30] Fry's choice of a theme portraying contemporary Londoners bent upon enjoyment expressed a sense of *joie de vivre* which reviewers picked up, finding it especially in Grant's canvas of *Bathing*: 'They seem, rather than Cockney bathers in the Serpentine, to be primitive Mediterraneans in the morning of the world.'[31] Each artist was apparently allowed to choose his own subject within the framework of contemporary London life: Fry chose 'the Zoo', Grant 'bathing' and 'football', Rothenstein 'paddling', Adeney 'the Round Pond', Gill 'Punch and Judy', and Etchells 'the fair'. The walls of the passage and stairs leading to the dining-room were painted in sky-blue, orange, white and primrose blocks of colour; presumably these areas were not suitable for more complex treatment. The rectangular dining-room was large enough to accommodate two six-foot murals and one ten feet wide on each long wall, and one twenty-foot-wide mural – Etchells' *The Fair* – on the short wall. The other short wall was intended to have a mural which featured a bear, but this was never executed, possibly because of shortage of time.[32] Since the murals were painted in the summer vacation, they presumably had to be up by the start of the new term.

The murals started halfway up the walls and continued to the ceiling. At Fry's suggestion they were painted in an oil medium on canvases prepared with a waxy base, which were then placed on the wall, and thus could be removed if necessary. (Wax was an odd ingredient, but Fry had

used it when in 1893 he painted a fresco in wax and spirit on the chimney breast of the drawing-room at the *Magpie and Stump*, Ashbee's house in Cheyne Walk.)[33] The areas of canvas required for the Borough Polytechnic murals were so large that they had to consist of pieces stuck together. Each artist had also to paint a complex geometric design around the edges of his canvas, which must have required painstaking effort but was presumably intended to give overall unity to a scheme made up of very different compositions and styles. This aggressive patterned border, at times nearly two feet wide, threatened to overwhelm the figurative scenes within. It was most probably designed by Fry, and was composed of concentric squares graded in tone, with diagonally stepped smaller squares at their corners. Fry was to repeat this motif of concentric squares, again in a decorative context, on several Omega Workshops products.[34]

Diagonally stepped squares can also be found in a wide patterned border framing the biblical narrative scenes of the decorative mosaic cycle in the church of the Kariye Camii in Constantinople, which Fry had viewed only weeks before the planning of the Borough Polytechnic scheme. Fry's aesthetic theory, conjuring a line from sixth-century Byzantine mosaics through El Greco to Cézanne and his followers, and which could be taken to include a small band of English painters aware of such a line, could certainly support a link between Byzantine mosaics in Constantinople and murals in a Polytechnic at the Elephant and Castle. Indeed, a couple of critics, possibly unaware of how perceptive they were, singled out for attention the treatment of the water in Grant's canvas *Bathing*, describing this as 'wavy streaks of paint . . . such as you see in Christian fifth-century mosaics'.[35] In fact no extant fifth- or sixth-century Byzantine mosaics treat water in such wavy streaks, since this device is more suited to a painting technique rather than to the implanting of thousands of tesserae; but the point remains that critics were groping towards a description of Fry's young artists as 'Byzantine'.

When the project was completed in September 1911, a fee of £100 was paid to Fry to distribute amongst the six artists, and their expenses – probably materials and travelling costs – were reimbursed to the sum of £55 8s 0d. An evening discussion on the murals and the general theme of public decoration using the Post-Impressionist style was organised at the Polytechnic, and if we take Fry's words as evidence, he gave a rousing talk. 'It was a very amusing occasion with much freedom of speech, but on the whole they seemed inclined to be converted to my view.'[36] He must have begun to feel well on the way to bringing this new style into public approval.

In contrast to the kindling spirit of his oratory in praise of this

communal decorative scheme, a single-handed attempt to produce a
ceiling decoration was not altogether successful. This was in the home of
the Noble family at Ardkinglas in Argyll, where it still survives. The site
was private and obscure, and the reactionary ceiling painting – it was
actually a shaped canvas stuck to the ceiling – of Apollo and his fiery
chariot received no publicity. A preparatory panel sketch for this ceiling,
exhibited in London in the winter of 1910, was offered for public comment
and received adverse reviews. In its defence, Fry retorted: 'The step from
critical and intellectual assent to practice obviously takes time.'[37] The
painting had been commissioned in May 1910 and was not actually fitted
into place until the summer of 1911; Fry had worked on it for nearly a year,
during which his theory and practice were constantly being rethought. In
contrast to the two or three weeks which he took to paint his Borough
Polytechnic canvas, this long period of gestation was not very fruitful –
perhaps because Fry needed the catalysing effect of other painter
colleagues.

The first Post-Impressionist exhibition had featured a photographic
sales section where the public could buy black and white illustrations of
modern French paintings. In the *Art News* for 9 March 1912 an
advertisement for Hanfstaengl, a photographic agency, offered not only
continuing sales of French art but also photographs of the 'New Borough
Polytechnic Decorations' at 2s 6d each, while the French paintings in
photographic form cost from 3d. Obviously Fry wanted to attract as much
attention as possible for the scheme.

The *Athenaeum* review of the Borough Polytechnic murals had warned
the painters that they might well be labelled 'anarchists'. This was a charge
which echoed around them at regular intervals and which Fry recalled in
April 1913 in an interview that he gave to the press on the announcement
of the formation of the Omega Workshops. This venture was a logical step
after the heady experience of organising and taking part in the work of the
Polytechnic murals. Fry announced:

I hope to get a group of young artists to work together, freely criticising one
another and using one another's ideas without stint. I think it very important
that they should work together in this way, and that we should cease to insist
on the extreme individuality of artists. This was borne in upon me very much
when I got a group of young artists to decorate the Borough Polytechnic.
They all worked together, taking their ideas from one another, developing
them along their own lines, and feeling so thoroughly all the time that the
work was a common effort that they refused to sign the pictures, saying, 'No,
these we did together; let there be no individual signature.'[38]

It is significant that two artists, Rothenstein and Grant, did in fact sign

their works. Rothenstein's signature appears in the bottom right-hand corner of his canvas, whereas Grant's merges with the brush-strokes which make up the stripes representing water. The existence of Grant's signature was only revealed, at Grant's suggestion, when the Tate Gallery exhibited his Polytechnic canvas *Bathing* on the occasion of his ninetieth birthday in 1975.[39]

In August, while Fry was in the throes of painting his canvas at the Polytechnic, Vanessa Bell wrote to him from a convalescent holiday:

What wouldn't I give to be helping you to decorate the room and no doubt your ideas would do quite as much for me as they do for Adeney. I believe you do have an extraordinary effect on other people's work – I always feel it when I'm with you – I wonder what will happen if we get together this group of people in the autumn. You will stir them all up to something quite new.[40]

The group mentioned by Vanessa Bell must have been drawn from the cast at the Polytechnic and the provisional list of young artists for the failed Grafton Galleries exhibition. From further evidence, Fry apparently intended to work with other artists on communal decorative schemes organised by himself. Vanessa Bell wrote again to him on 2 September: 'How splendid that Duncan and Etchells should have got some more decoration to do,' and Fry wrote to Grant in an undated letter of the same period: 'I am cultivating her [Lady Cunard] while the fit of art patronage lasts. She's promised our group a room at her house, and says she'll make Lord Curzon do likewise. All which may not amount to anything but it's worth the shot.'[41]

Fry spent a good deal of energy then, persuading suitable patrons to offer up their walls to his group, which probably by late autumn had settled on a membership of Grant, Etchells, Adeney and Fry himself. The intention was obviously to include Vanessa Bell when she had recovered, because Fry wrote to her on 12 October, planning all the painting they were to do together: 'You will come and do my wall won't you? . . . And the London Hospital and all the other jobs.'[42] It seems none of these schemes came to fruition, even though Fry was in his element as impresario and organiser, trying to wheedle commissions out of society people. This adumbrates the role he was to play within his Omega Workshops.

When Fry wrote 'his' wall, he could well have referred to a wall in his own house, Durbins. A design exists, by Vanessa Bell, of two standing nudes placed above a fireplace, and the grey wall surround and plain rectangular fireplace are to be found at Durbins. The nudes are solid, simple in outline, and imposing – and make one regret that she was unable to contribute to the Borough Polytechnic scheme. However, although this

design was never executed, Bell did paint a nude figure on a wall of Fry's house in the spring of 1914, when she, Fry and Grant worked together on murals in his entrance hall.

At the same time as attempting further schemes for murals in the autumn of 1911, Fry was also urging Bell, and probably Grant, to produce designs for domestic articles. In September Bell told him of her progress: 'I made a feeble attempt yesterday to draw another design for your chair but it wasn't successful. Would it do to have the figures, rather like the one I did – holding up something, mackerel perhaps – and meeting between them, all on a flat ground?'[43] Since she then offered to work it, this most probably referred to an embroidered chair-cover, one of the categories of object to be offered for sale at the Omega Workshops.

In December 1911 the first exhibition organised by the Contemporary Art Society – a touring loan exhibition – opened at Manchester City Art Gallery. The catalogue contained two essays, one by D. S. MacColl on the origins and aims of the Society, and the other by Fry, not surprisingly, on the work of the younger artists. Fry mentioned Augustus John, Henry Lamb, Maxwell Lightfoot, Sickert, Spencer Gore and Charles Ginner, and then gave a fuller treatment to the work of two members of his group, Grant and Etchells. It is worth quoting some of his phrases on Grant and Etchells, particularly since he was not to write of Etchells again: 'Both realise more clearly than any other modern English artists the value of the bare statement of structural planes and lines of movements and the importance of scale and interval in design . . . Duncan Grant . . . shows . . . a spontaneous lyrical feeling of singular purity and intensity, while Etchells has a more dramatic sense of character and . . . real gifts . . . as a designer and colourist.' Fry was readily able to use this essay to promote the colleagues he admired, and by the end of 1911 he must have been forming clearer ideas of the potential of his coterie.

2
A GROUP IS ESTABLISHED:
1912

IN January 1912 Fry held his third one-man show of paintings, at the Alpine Club Gallery, London. (The other two had been at the Carfax Gallery, London, in 1903 and 1909.) Besides the corpus of fifty-two recent oil paintings, this event's most noteworthy aspect was Fry's attempted transformation of the gallery. His object was to make the whole environment count, so that correspondences were offered between the spirit of the paintings, their frames and the gallery seating. If he had been given the chance to paint the walls of the gallery, he probably would have taken it. The reviews remarked on his titivation of the gallery: 'This is a particularly interesting exhibition, and has been most carefully arranged; the picture frames specially painted to agree with their contents, and the so respectable plush settees in the centre of the room most happily clothed in a more wanton suit of red and white cotton.'[1] After this experiment with decorated frames, the other members of Fry's group followed his example and throughout 1912 painted several of their own. Fry's use of geometric patterns painted on the wooden frame of an oil painting was an extension of the device which he first introduced in the Borough Polytechnic murals. Like Fry, Etchells favoured severe geometrical patterns of coloured squares and chevrons, while Grant and Bell chose patterns of random blobs.[2] In his attempt at brightening the gallery in which his pictures were being shown, Fry harked back to Whistler's decorative schemes for his own exhibitions in the 1880s. Fry, however, did not choose pale and delicate harmonies for wall and furnishings, but rather very bright ones.

Having christened Fry 'the prophet of Post-Impressionism', critics naturally looked for Post-Impressionist qualities in his paintings. The pictures in the exhibition did not disappoint them: 'Post-Impressionism, it is perhaps needless to add, requires a thick green, blue, or red line round every contour in order to mark the departure from old-fashioned

Impressionism, where no outline was recognised at all. Pictorial illusion must be dispelled by ignoring planes. This Mr. Fry has loyally carried out.'³

Many of Fry's paintings were on a large scale, and it was recognised that in these works he was 'aiming at breadth and the necessary limitations of wall painting'. He appears to have achieved this breadth under limiting conditions by using Grant's 'leopard manner' technique, so named by Vanessa Bell, which employed large dabs of paint arranged over the whole area of the picture, in a manner somewhat reminiscent of Seurat; but since the brush-strokes were much larger and squarer than Seurat's tiny dots of paint, they more closely resembled mosaic tesserae. The art critic Robert Ross aptly commented: 'Alone, probably of all the Post-Impressionists, French or English, Mr. Fry has actually been to Constantinople in order to obtain a new Mosaic dispensation for Art.'⁴ Fry seems to have believed that the 'leopard manner' or 'mosaic' technique was a foolproof way of executing large decorations such as wall paintings, because it was 'at once fully expressive and easily executed'.⁵ Whether any Omega Workshops wall decorations were executed in this way it is difficult to say; certainly, from the visual records of those which are known, only the murals for Lalla Vandervelde's flat, of 1916, bear any relationship with this formula.

An entry in Fry's diary for 28 November 1911 records a meeting with Charles Aitken, the Director of the National Gallery of British Art (now the Tate Gallery). At the end of that month a committee was formed, with D. S. MacColl as chairman and Aitken as honorary secretary, 'to promote the practice of mural painting in schools, churches, hospitals, and other public institutions, more especially by young artists and students, a scheme long ago propounded by Mr. Watts'.⁶ These aims were announced in *The Times* of 5 February 1912. The committee used the opportunity to call for subscriptions to a fund for paying painters, whose work was to be selected from an exhibition of designs at Crosby Hall, Chelsea, in May or June. It is surprising, given Fry's fresh and successful experience at the Borough Polytechnic, that he was not invited onto this new committee, since it was completely consistent with his own declared aims. It must surely have been a topic of conversation when Fry met Aitken at the end of November.

He did, however, have his group. By February 1912 this included a new member, Wyndham Lewis. How Fry first met Lewis, history does not record; but possibly Fry saw his three paintings at the second exhibition of the Camden Town Group in December 1911, and liked what he saw.⁷ He wrote to Lewis on 21 February asking him if he would like 'to come to a meeting to settle the nature of the group of artists which Duncan Grant, Etchells and I propose to start? We shall meet at Mrs. Bell's house,

46 Gordon Square, at 5.0 on Tuesday, 27th. We propose to make it a very small group to begin with.'[8] The letter did not indicate the nature of the group; it could have been the formation of a new exhibiting body (although there was no urgent need to form such a body, since Vanessa Bell's Friday Club served in that respect), or maybe a gathering of forces for further large-scale decorative work. By the date of the letter, Grant, Etchells and Fry had all had some experience of large-scale decorative work, but Lewis and Vanessa Bell probably had not.

Ten days after Fry's one-man exhibition had closed at the Alpine Club Gallery, a Friday Club exhibition opened there, containing the works of Fry, Grant, Frederick Etchells and his sister Jessie, Vanessa Bell and Edward Wadsworth, though not Wyndham Lewis. Wadsworth showed five paintings – more than anybody else – one of which was *Plage au Havre.* It was a broadly executed painting, relying for its effect on large areas of flat patterning. Fry, Vanessa Bell and Grant were on the hanging committee for this exhibition, and were thus able to see a large range of Wadsworth's recent work. As yet, however, Fry did not include him in his new group.

The same exhibition included two works by Grant. One, *The Red Sea*, was given the description 'decoration' in the catalogue – as was a painting by Etchells entitled *Seated Figure of a Woman* two months earlier, at the Contemporary Art Society's exhibition at Manchester. *The Red Sea*, still extant, is a large work (48 x 59¼ in.), and was at the time the largest easel painting Grant had done. No doubt the experience of painting the huge canvases of *Bathing* and *Footballers* for the Borough Polytechnic and those for Maynard Keynes' room in Cambridge had inclined him to increase the size of his oil paintings. The subject matter of *The Red Sea* is linked with *Bathing*, nude figures against stylised waves being common to both. As the right-hand nude male is cut off by the edge of the canvas in *Bathing*, so is the left-hand nude female in *The Red Sea*, thus contributing to the sense of scale by implying that the work spreads into the surrounding space. The inclusion of the word 'decoration' along with the title suggests that this painting may have been begun with a decorative scheme in mind. Alternatively it could indicate the category to which Grant felt the painting belonged, because of its size, its 'leopard manner' technique, and possibly its depiction of ample female nudes. The name of *The Red Sea* denotes no biblical reference; it refers to the actual colour of the sea against which the large green nudes are set. After this one showing, Grant's dislike of the painting grew. It was never exhibited again, and the other side of the canvas was used for *The Ass.*[9]

Frederick Etchells showed four works in the exhibition. Only one can be positively identified – *The Hip Bath*. Etchells' bare statement of form, admired by Fry, was well expressed in this composition of a female nude seen from the back and set against the curve of the bath. Something Etchells never did again was to paint the title of the work on the front of the canvas, in capital letters, in the top left-hand corner. Certainly this would ensure that it retained its original title, with no confusion over the subject-matter. However, given Etchells' knowledge of painting in Paris – he rented a studio there from 1911 to 1914 – it could relate to the fact that Robert Delaunay and Marcel Duchamp were also writing the titles on the fronts of their canvases.[10] Fry bought *The Hip Bath* at the time of the exhibition for his own collection. He also contemplated purchasing *The Red Sea*; it was probably Grant's dislike of the work that made him reject it.

Vanessa Bell's four works for the Friday Club cannot now be identified with certainty, but it can be assumed from the titles that three were straight-forward oil paintings. The fourth, on the other hand, was entitled *Design for a Screen*, and this is the first indication that Fry's colleagues were giving thought to the painting of furniture, probably at his direction. Bell showed this work again in May; but during 1912 no actual painted screen seems to have followed the design.

A few weeks after the Friday Club exhibition, the group of artists referred to in Fry's letter to Lewis had received a name – the Mill Street Club. Fry used this name on a postcard to Duncan Grant dated 18 March, and notified Grant of another meeting, again at 46 Gordon Square.[11] The name of Mill Street links the group to the Alpine Club Gallery, then situated on the corner of Mill Street and Conduit Street. With this obvious connection, it could indicate the intention to form an exhibiting group. Ironically, when the group next exhibited at the Alpine Club Gallery, in March 1913, their name was not the Mill Street Club but the Grafton Group, after the street that included the Grafton Galleries, home of Fry's two Post-Impressionist exhibitions. The meeting at 46 Gordon Square was held on 5 April, and as well as probably making plans for future exhibitions the members decided to compete as a group in a mural painting competition recently announced in *The Times*. Several theoretical public sites were suggested; the competitor had to choose one of them and tailor his designs to suit the space available. The Mill Street Club decided to choose the Middlesex Hospital site, and to submit a communal decorative plan which included panels by each of the members.[12]

The name Mill Street Club was not to be used, meanwhile, for the exhibition Fry was planning for that May in Paris. The group of Roger Fry, Vanessa Bell, Wyndham Lewis, Frederick Etchells and Duncan Grant had

to be enlarged, to swell the number of canvases to about forty. For this reason Fry had to invite other English artists to exhibit and then choose a mild blanket title. He settled on 'Quelques Indépendants Anglais'. The decision to send an exhibition of recent English painting to Paris was perhaps intended to show French painters how art was faring across the Channel, in the belief that there would be a sympathetic audience. Fry's plans for the group show were linked with plans for an intended one-man show of his own work – probably the paintings he had recently shown at the Alpine Club Gallery. The group show was to be held at the Galerie Barbazanges; Fry's show – which did not materialise – was to have been at the Galerie Vildrac.

The Galerie Barbazanges was situated on the ground floor of Paul Poiret's mansion at 109 faubourg St-Honoré. It was run by a dealer named Barbazanges, under some sort of supervision from Poiret, the dress designer. Poiret had lived at that address from 1909, and in April 1911 had founded the Ecole Martine (named after his daughter, born in that year) in an attempt to start a new movement in French applied arts. This was intended to bring a new sense of freedom and gaiety to interior decoration and furnishing, and to be run in tandem with his dress-design business. Poiret also employed Mme. Sérusier, the wife of the painter, to run a school for twelve- to thirteen-year-old girls from working-class families who showed artistic talent. They were paid a daily wage for producing designs. In 1912 Mme. Sérusier left and Poiret let the girls work on their own. Their designs for murals, rugs and furnishing fabrics received praise and attention. Two rooms of Martine products were shown at the 1912 Salon d'Automne, and again at an exhibition devoted to the Ecole Martine at the Galerie Barbazanges. The Ecole Martine was a very successful and lucrative venture in which other countries showed much interest. In 1921 Poiret set up a branch of Martine at 34 Baker Street, London, advertising their wares as art fabrics for dress and house decoration.

Since the Ecole Martine was next door to the Galerie Barbazanges, when Fry was in Paris he would have had a good chance to look at the workshops and their products. The bright, naïve results produced by these girls are likely to have impressed him, although his Omega Workshops would encourage designs more nearly related to contemporary trends in painting and based on theories and principles rather than on the unconscious innocence of the art of adolescent girls. In December 1912, however, when Fry sent out a circular letter to enlist support for his Workshops, he referred to the similar possibilities inherent in the Ecole Martine.

The show held at the Galerie Barbazanges in May 1912 comprised the work of ten artists: Vanessa Bell, Frederick and Jessie Etchells, Fry, Charles Ginner, Spencer Gore, Grant, Charles Holmes, Lewis and Helen Saunders. Fry wrote of this group to his friend Charles Vildrac in April: 'Duncan Grant will exhibit and certainly he has genius, perhaps Etchells also; the others like myself have but a little talent and at least goodwill.'[13] Thus by the spring of 1912 Fry placed Grant above all others in his group, with Etchells a close second, and singled out no one else by name.

Grant showed six works, of which the whereabouts of four are known: *The Queen of Sheba, Dancers, View of Corfe* and *Preparations for the Whippet-race*.[14] *The Queen of Sheba* is of particular interest as it was supposedly a sketch for part of a decorative scheme for the cloister at Newnham College, Cambridge. This fact emerged in the entry for this painting in Duncan Grant's retrospective exhibition at the Tate Gallery in 1959. But the source of the information has never been satisfactorily verified – apart from which there is no cloister at Newnham College. The Tate catalogue names Fry's friend Miss Jane Harrison as the organiser of this scheme, which was to include other artists. Whatever the circumstances of the work's initiation, *The Queen of Sheba* is materially different from Grant's other three paintings. It is in oil on plywood, a hard support like a wall, in contrast with the yielding springy surface of a canvas; it is a perfect square; and it is painted in the loose *pointilliste* style, the 'leopard manner'.

Etchells showed seven works, two of them known today: *The Entry into Jerusalem* and *The Dead Mole*.[15] The latter canvas measures 65¾ x 41¾ in., and shows his confidence in choosing to work on a large scale. Both canvases also indicate Etchell's very eccentric choice of subject. Lewis showed six works, two of which were designs for letterheads. None of his four paintings shown here are known to be extant, and the title of one, *Creation*, poses a few problems. If it was the same work as that shown by Lewis at the Allied Artists' Association exhibition at the Royal Albert Hall in July 1912, then to judge by reviews it was a large decorative painting; Clive Bell described it as 'pure formal composition'. But if the Galerie Barbazanges *Creation* was sent on to Cardiff with other works from the show in July, they cannot be the same work. The only other decorative work exhibited was Vanessa Bell's *Design for a Screen*, which she had shown at the Friday Club.

On 4 June *The Times* carried a review of the mural painting competitive exhibition (organised by MacColl and Aitken's committee) held at Crosby Hall, Chelsea. The reviewer commented on the difficulty experienced by young artists in selling their pictures and went on to say:

'If it were common practice for public bodies and private persons, having a wall space to be decorated, to call in a painter to decorate it, painters would have both a business and a definite problem.' The reviewer then expressed the opinion that very few of the designs exhibited showed any real talent; and this judgement might have been different if the work of Fry's group had not been excluded. In a letter to Wyndham Lewis written in early June, Vanessa Bell wrote: 'I suppose you have heard that all our decorations have been not even hung at Crosby Hall which is rather amusing as Mr. Aitken got up the whole scheme in order to get work for Duncan Grant and Etchells.'[16] Certainly, Fry's Borough Polytechnic scheme had paid dividends, by making the work of Grant and Etchells known to the director of the National Gallery of British Art; but Aitken's scheme to bring them further decorative work failed. Vanessa Bell also wrote to Fry about this sorry state of affairs: 'Duncan seems to have taken them [the mural designs of the Mill Street Club] in charge. He didn't get them framed and I have my suspicions as to whether he ever got them to the right place.'[17] Grant was notoriously absent-minded – it seems strange that he should have been entrusted with the practical arrangements for submitting the designs to the competition. The fact that Fry was out of the country at the time seems the only explanation. Walter Sickert too reported on the bulk of poor exhibits and the show's failure to achieve its ends. He also reported: 'The Keeper of the Tate Gallery has publicly admitted that unless arrangements can be made for galleries to buy pictures, artists will be hard put to live.'[18]

Grant and Etchells had meanwhile procured themselves some work, although probably unpaid, seizing an opportunity in the spring of 1912 to paint a huge mural in a private house. The house, 38 Brunswick Square, was taken by Virginia Stephen at the end of November 1911 for herself and her brother Adrian. Maynard Keynes rented the ground-floor rooms from them, and the main ground-floor room, which was large with a curved wall at one end, was the site of the mural. It was a massive area; from contemporary photographs (neither the mural nor the house is extant) one can guess the dimensions were about nine feet high and thirty feet long. There is no record that Fry was responsible for the initiation of this mural; he was away on a painting holiday in France with a French painter friend, Henri Doucet, for part of May and June.

The mural must have proved a daunting task. On 2 May, in reply to a letter from Robert Ross asking to see Grant's recent work with a view to making a purchase for the Contemporary Art Society, Grant wrote: 'I'm very sorry that I have nothing finished at present to show you. I have been

working lately on a fresco on a wall – which I wish I could get rid of.'[19] On 6 June Vanessa Bell wrote to Fry in France: 'I saw D's [Duncan's] and Etchells' decoration which I think very good – no one else does – it's not finished and wants a good deal doing in places but bits are very good. It's extraordinary how indistinguishable they become. I suppose their general colour schemes have a great deal in common.'[20] The subject, as in the Borough Polytechnic scheme, was a scene of London contemporary life, a street accident with horses and two hansom cabs. But although, unlike the Polytechnic paintings, which were on stretched canvas, the Brunswick Square mural was described by Duncan Grant as 'a fresco', it would not have been executed in the true fresco manner, where the pigments are painted into a coat of wet plaster, to be permanently sealed on drying. Nonetheless it would still have been created by the application of water-based paints directly on to the plaster of the wall. It is significant that, unlike the Polytechnic murals, where the individual style of each artist was quite apparent, Grant and Etchells were now willing and able to blend their styles. Grant's 'leopard manner' was used; so Etchells must also have been prepared to adopt this method of working – indeed he produced several easel paintings in this style during the latter half of 1912.[21]

Despite Grant's frustration because the large mural at 38 Brunswick Square had taken up a great deal of his time and energy, he was nonetheless prepared to embark on a further mural in the same house a short while later. Adrian Stephen had rooms there on the first floor, and Grant painted a wall of his drawing-room with a scene of tennis players engaged in a doubles match. Again the subject related to local everyday life, a tennis court being a feature of the central garden in Brunswick Square, which all the houses overlooked. This mural, painted directly on to the wall like the one on the ground floor, was also on an expansive scale, perhaps twenty feet long or more.

Grant did not work with Etchells on this wall. The reason would probably not have been disharmony between the two men, only that Grant, having by then taken lodgings at 38 Brunswick Square, had the advantage of being on site, while Etchells lived at West Horsley in Surrey. Grant did enlist the assistance of Adrian Stephen, though, having discovered him to possess 'a certain talent for painting'.[22] From the evidence of an old photograph it appears that Grant did not use his leopard style for this mural, preferring instead a starker approach. The tennis players are merely bold flat shapes, which rely for expression on the quality of their contours. Grant must have been pleased with this style, for he employed it again in a further decorative venture at 38 Brunswick Square. Another contemporary photograph shows a window bay, with all the

panelled wooden areas around the window and the wall underneath covered by a number of nude figures adopting various balletic poses; some even defied gravity and appeared to float or swim effortlessly in the space allotted to them. Two designs for these decorative nudes and an oil painting, *Sunhat on a Chair*, which depicts part of this window bay, are all still extant. By the autumn of 1912 the practice which Grant had gained through painting several murals had given him more confidence, and he became very enthusiastic about the possibilities of decorating a home environment.

It appears that some or all of the canvases shown at the Galerie Barbazanges were subsequently sent on to Cardiff for exhibition in July (the exhibition and its venue were organised by Spencer Gore). When the paintings were returned to the artists, Vanessa Bell took a long look at Grant's work (he was away on holiday) and changed her opinion. Up to that point she had admired his work unwaveringly, but she wrote to Fry in August that she felt *The Queen of Sheba* was spoilt by being 'too sweet, too pretty and small' and that the 'usual English sweetness was coming in and spoiling all'.[23] In this same letter she spoke of her concern for the applied arts in Britain. She talked of a recent visit to Ethel Sands' and Nan Hudson's house at Newington in Oxfordshire, feeling apprehensive in case Fry wanted to introduce them into his group:

I was a little alarmed at their excessive elegance and eighteenth-century stamp. It isn't what we want even for the minor arts, is it? Won't they import too much of that? Of course I know they're useful, but I do think we shall have to be careful especially in England where it seems to me one can never get away from all this fatal prettiness. Can't we paint stuffs etc. which *won't* be gay and pretty? I see how easy it would be to turn out yards of very fanciful and bright and piquant things and I don't see what else that couple can do. I daresay you're right in using them, but although I don't go to Clive's lengths I must say that seeing them in their own chosen surroundings did give me rather the creeps – at least when I thought of bringing that into anything to do with art.[24]

Fry had also visited Newington in August and commemorated his visit by painting the terrace of Miss Sands' house, showing Miss Sands, Nan Hudson and a fellow-guest, Anne Douglas Sedgwick. Fry must have offered Sands and Hudson an invitation of some kind to join his group, probably to design fabrics.

Perhaps Vanessa Bell's letter prevented this idea from becoming reality; when she wrote it, Fry was probably in Paris, choosing pictures for his second Post-Impressionist exhibition, which was to open in October 1912

at the Grafton Galleries and run until December. The poster for 'Manet and the Post-Impressionists' had consisted of a reproduction of a Gauguin painting – a woman with bare breasts – together with hand-drawn lettering by Fry, which provided the factual information. When the poster for the second Post-Impressionist exhibition was being planned, Fry was able to turn to the members of his group for advice; in fact, Fry, Grant, Bell and Etchells all played a part in its design. Bell and Fry were responsible for the idea of the head of the woman and her upraised hand (perhaps enticing the spectator to come and share the experience which they knew lay in store). Fry then passed the design over to Grant and Etchells for its final forms. Grant drew the female figure as it is on the finished poster – she bears a strong resemblance to Vanessa Bell – and Etchells added the lettering. With its aggressive black and white patterning, the poster becomes more than just a means of providing information: it attains the status of a work of decorative art in its own right. The poster also came in a collectors' edition, printed in colour, either green or orange. C. R. Ashbee recalled a visit to the second Post-Impressionist exhibition with H. A. Roberts, who seemed unmoved by the poster's aesthetic qualities: '"Which would you rather have?" asked Roger handing him an alternative poster, hideous in green and orange. "I think *orange* would suit me best," Roberts replied, folding it with fine precision in about 4to ply to put it with his card case.'[25] The poster design was also used as the cover of the exhibition catalogue. The method of producing this poster, with four artists working together, criticising and utilising each other's ideas, would have delighted Fry and proved to him that such communal artistic activity could be made to bear fruit.

The second Post-Impressionist exhibition was to include English and Russian as well as French works of art. Fry was only responsible for the French, or so he said in the catalogue introduction. In fact he played a large part in deciding which English works were to be included too, though in theory Clive Bell chose them. And Boris Anrep chose the Russian. Clive Bell's group of eleven English artists was drawn substantially from Fry's coterie, although Fry would never have included Stanley Spencer, whom he thought of as a present-day Pre-Raphaelite. The eleven were Bernard Adeney, Vanessa Bell, Frederick and Jessie Etchells, Fry, Eric Gill, Spencer Gore, Grant, Henry Lamb, Wyndham Lewis and Stanley Spencer. After undergoing a re-hang, the second Post-Impressionist exhibition reopened for the month of January 1913, this time including Cuthbert Hamilton and Edward Wadsworth.

In the introduction to the exhibition Fry explained the change in scope compared with the first in 1910: 'Then the main idea was to show the work

of the "Old Masters" of the new movement . . . Now the idea has been to show it in its contemporary development not only in France, its native place, but in England where it is of very recent growth.' The preface to the catalogue for the English group was written by Clive Bell, and he felt no need to stress their recent conversion to Post-Impressionism: 'Happily there is no need to be defensive. The battle is won.' The debt of the English artists to the French had to be acknowledged, though, and Bell believed 'it could be computed and stated with some precision. For instance, it could be shown that each owes something, directly or indirectly, to Cézanne.' If Fry had written the English group preface, he might also have pointed out the debt the English artists owed to Gauguin. In 1908 he could write of Gauguin: 'Here is an artist of striking talent who . . . has seriously set himself to rediscover some of the essential elements of design.'[26] And with hindsight, from the early 1920s he set Cézanne and Gauguin together as the prime influence which helped English artists to find their feet: 'With the appearance of the new Cézannian art in England, most of all with the first sight of Gauguin's intensely decorative silhouettes, the younger English artists began at once to practice [sic] design in a way that made them again fit to take a hand in the applied arts.'[27]

The word 'again' is revealing, implying an earlier era when English artists had taken to the applied arts with success. This other era seems to be the decades around 1700, if we take as evidence a statement in *Reflections on British Painting*, published in the year of Fry's death, 1934. There Fry remarked that the painting of that time was not worthy 'to be put beside that culminating expression of English taste and feeling in design which marks the end of the seventeenth century and the early decades of the eighteenth century', when 'nearly all our architecture and applied art showed supreme distinction and a quite specifically English tact and delicacy of taste'.[28] Since Fry believed that the state of the fine arts bore directly upon the state of the applied arts, and since the artists of that period were Lely, Kneller and Hogarth – the first two portraitists who did not attempt the principles of plastic pictorial design, and the third a painter who 'turned almost entirely to illustration' – the flourishing of the applied arts at this time was especially remarkable because they could draw only on tact and delicacy of taste rather than on the grandeur and simplicity seen in the art of the French Post-Impressionists. Now, with mentors of such quality, English art was once again predisposed to encourage the applied arts, and was quite possibly entering its most propitious era.

Nonetheless, given the state of British philistinism and the Director of

the National Gallery of British Art's recent statement concerning the precarious livelihood of artists from sales of their paintings after the failure of the mural design competition, some new forum of patronage and income had to be devised. The press and the public had damned Fry's second Post-Impressionist exhibition as eagerly as they had the first, which caused him to comment: 'It shows that British Philistinism is as strong and self-confident and as unwilling to learn by past experience as ever it was, and doubtless these are among the characteristics which have made us so proudly and satisfactorily what we are.'[29] The hope of a revival in public patronage was a vain one, but what about a revival in state patronage? This was the theme of an essay which Fry contributed to a compilation of texts edited by H. G. Wells and published in 1912 under the title *The Great State*. Fry's essay was called 'Art and Socialism'.

In 'Art and Socialism' Fry postulated his theory that the greatest art was communal. He based this claim on his knowledge of anonymous large-scale fresco and mosaic decorations, mostly in sacred settings, and on early Italian artists' workshops. But the organisation of communal art should not be too strongly controlled by the state, since he believed too much organisation of this kind led to an art of the Egyptian or Roman type, with a prolonged and arid continuity of style inculcated by precept, training and rules. Fry believed it was essential for an artist to have a sense of freedom, because he saw the artist as 'an intolerant individualist claiming a kind of divine right to the convictions of his peculiar sensibility'.[30] His concept of the artist would have been reinforced by his deepening knowledge of his friends Vanessa Bell and, particularly, Duncan Grant, for he wrote in 1917: 'The artist's manners are sometimes charming, but usually uncertain – his hours are short and subject to sudden change – he has opinions of his own as to what will be best, not necessarily for his client but for the good of Art in the abstract.'[31] But if times were hard for art and artists to flourish in and it was found:

impossible . . . to stimulate and organise the abstract creative power of the pure artist, the balance might . . . be in favour of the new order if the whole practice of applied art could once more become rational and purposeful . . . All our pictures would be made by amateurs . . . [and] the painter's means of livelihood would probably be some craft in which his artistic powers would be constantly occupied, though at a lower tension and in a humbler way.

But even though Fry, in 'Art and Socialism', imagined a situation where amateurs painted the pictures and artists worked as craftsmen, this was not what he envisaged would happen in his Omega Workshops. These were to be a form of patronage for painters so that they could continue first and

foremost as painters, professional artists who supplemented their modest incomes by turning to the applied arts for part of the time.

Fry thought that an improvement in the applied arts would greatly help to alleviate the conditions of life: 'In a world where the objects of daily use and ornament were made with practical common sense, the aesthetic sense would need far less to seek consolation and repose in works of pure art.' According to his vision, 'Ultimately, when art had been purified of its present unreality by a prolonged contact with the crafts, society would gain a new confidence in its collective artistic judgement, and might even boldly assume the responsibility which at present it knows it is unable to face.'

By 1912 it had become evident to Fry, in considering the plight of the applied arts, that one course was to follow William Morris and his attempt to rectify 'the lamentable condition of the applied arts'. Morris felt he had to rescue the applied arts from 'their state of complete degradation', and he started a firm in 1861 for the production of decorative household articles. Fry considered himself to be in a similar position to Morris in that 'any attempt to bring art and industry together must depend to some extent on the aims and predilections current among the artists of the day . . . William Morris's attempt was fortunate in that the movement among the artists of his day was toward decorative design.' But between the era of Morris and his own of 1912, any attempt at reconciliation would have been futile because, in Fry's view, the aims of the former time were directed in art towards natural appearances, and not to the study and practice of pure design. 'But the most recent movement in art, which may be described under the inclusive title of Post-Impressionism, has brought the artist back to the problems of design so that he is once more in a position to grasp sympathetically the conditions of applied art.'

Fry believed in Morris's idea of art 'by the people and for the people', but he knew that Morris's position was untenable. He stated that the artists of the Omega Workshops would be 'less ambitious than William Morris, they do not hope to solve the social problems of production at the same time as the artistic'. Fry deliberately wrote the later paragraphs of his essay 'Art and Socialism' in an environment which afforded a view of the 'fatuous and grotesque' in the ordinary objects of daily life – a railway refreshment room. He detailed the 'painful catalogue' of patterns applied unthinkingly and aggressively to chairs, tables and curtains:

. . . patterns taken from at least four centuries and as many countries . . . Now consider the case of those men whose life-work it is to stimulate this eczematous eruption of pattern on the surface of modern manufactures. They are by far the most numerous 'artists' in the country . . . Probably each of

them has somewhere within him something of that creative impulse which is the inspiration and delight of every savage and primitive craftsman; but in these manufacturers' designers the pressure of commercial life has crushed and atrophied that creative impulse completely. Their business is to produce, not expressive design, but dead patterns. They are compelled, therefore, to spend their lives behaving in an entirely idiotic and senseless manner, and that with the certainty that no one will ever get positive pleasure from the result.

Fry's rage at this waste of artistic energy knew no bounds; he was roused to a pitch where some courageous step had to be taken. Somehow the idea of organising a workshop, previously perhaps only a daydream, became vividly real to him, and his first practical consideration was, of course, finance. He wrote to Wyndham Lewis on 7 December: 'I'm horribly busy. The fact is I'm working very hard trying to raise capital for our decorative scheme. So far the only help promised comes from Bernard Shaw.'[32] Shaw's offer of help probably stemmed from a meeting with Fry, whose 'immense charm' and 'incredible persuasiveness'[33] must have had their effect. The method Fry chose for informing other sympathetic colleagues of the formation of his Omega Workshops was a formal one. He composed a long and carefully worded circular letter which was sent out on 11 December. This did not evoke the same response from Claude Phillips and Logan Pearsall Smith as from Shaw, who had also received a letter. Phillips did not wish to participate until he was able to judge the workshop in action, and Pearsall Smith criticised the name of Omega, with 'its suggestion of Eureka and other horrors'.[34] He obviously objected to omega being a Greek word (the last letter in the Greek alphabet), and to it having strong Christian connotations (Revelation i, 8 and 11: 'I am Alpha and Omega, the first and the last'); this objection was also upheld by Fry's Quaker family.

By the late nineteenth century the word omega was in use as meaning the last word on a subject. Many of Fry's friends believed he chose it so that his workshops would thus reflect the last word in decorative art, and C. R. Ashbee and his wife 'chaffed him for the impertinence of suggesting that "Omega" stood for the "last word" in art. He denied the imputation.'[35] Some critics, rather perceptively, saw Cézanne as the alpha to the omega. Winifred Gill, a young artist who lived in Guildford and was known to Fry's family, recalled Fry's search for a name for his workshops: 'He was looking for something, some trademark that had a name of its own that everybody knew. I think it was very effective because everyone could say Omega and remember it.'[36] It was a useful and anonymous symbol because it was both a word and a sign, which could be used as a trademark. As Fry explained in his circular letter: 'All the products of the workshops will be

signed by a registered trademark. This will ensure the exclusiveness of our designs, an important point in view of the inevitable commercial imitation which follows upon the success of any new ideas.' Later on in his letter Fry went into the details of the financial arrangements of the workshops:

The business will be established on the following lines – The first charge will be the payment of the workers and expenses of management; the next charge will be interest at 5% on the capital . . . I shall hope to arrange later for a co-operative or profit-sharing scheme for the workers. I shall myself contribute a fair share of the capital and shall devote myself very largely to the direction and artistic management of the workshops. In the business details I have the promise of assistance from Mr. Leonard Woolf.[37]

Leonard Woolf was the secretary to Fry's second Post-Impressionist exhibition, and performed his job well. Early in 1913 Woolf studied the administration of the Women's Cooperative Guild in the Midlands, but although he would have been well qualified to advise Fry on such matters he does not actually seem to have done so.

Fry had to make practical arrangements for the Omega Workshops to function smoothly. The premises were to be open to the public five days a week, from 10.30 a.m. to 5.30 p.m. A business manager and a showroom manager were to be employed, and a caretaker and his wife would live on the premises. Fry would offer a fee of thirty shillings per week to the artists, for which they were expected to work for three half-days. They were not allowed to do more than that; the rest of their time was expected to be devoted to the practice of fine art. One room was to be set aside as a studio solely for the production of designs. If there was to be no set commission upon which Fry would direct the artists to work, then each artist (who could attend at a time of his own choice) was free to produce a decorative design, which did not need to have any particular application in view. The completed and unsigned design would then be placed in a portfolio in the studio and would become common property. Any design could be selected for any purpose, and sometimes the same design was used to adorn quite different objects – for example, a silk evening cloak and a firescreen.

At the very end of 1912 Fry was in a ferment of activity. Not only was he drumming up financial and moral support for his Omega Workshops, but he was also presiding over his second Post-Impressionist exhibition at the Grafton Galleries. As if it were not enough to organise and show these paintings and sculptures to the British public, he arranged concerts and lectures in the evenings to complement the exhibition, inviting young French literary figures to speak, and himself lecturing on both painting and

poetry. 'When the galleries were shut to the public he would open them again to bring people together – people from many different worlds, ladies of fashion, painters, poets, musicians, businessmen. The new movement was not to be restricted to the art of painting only.'[38]

3

'HIS HAIR FLEW. HIS EYES GLOWED':

1913

On Boxing Day 1912 Virginia Woolf wrote in a letter to Lytton Strachey: 'I suppose you have heard of various disasters in London – Nessa [Bell] more or less broken down – Roger [Fry] rampant, but at one point forced to sit with his head in his hands, giddy if he so much as saw a picture. They're starting on furniture now – have you heard? All good reasons for living in the country.'[1] Her flippant conclusion – that life was better out of London where it could avoid the latest manifestations of Fry's schemes – was designed mainly to amuse Strachey, since she had correctly imagined that that would be his response. In fact, Virginia Woolf was to be a noble supporter of Roger Fry's latest scheme, the Omega Workshops, ordering unusual clothes and bright furnishing materials, and attending several of the entertainments and art exhibitions. She was also one of the first to offer positive support by subscribing to a loan scheme for paintings by Omega artists.

Woolf's remarks to Strachey are confirmed in more sober fashion by Duncan Grant's diary entry for 8 January 1913: 'Etchells worked at a table, and I painted a screen.'[2] The impulse for such activity would have been Fry's belief that his decorative arts workshop looked as though it had the promise of enough money for an initial trial period. Up to the day that Virginia Woolf had written to Lytton Strachey, Fry had collected £850. Bernard Shaw contributed £250, Hugh Lane £50 and George Davison another £50;[3] the donors of the remaining £500 have not been discovered. Fry's target sum for setting up his workshop was £1500, so throughout the month of January he had to continue persuading people to offer financial support. Frederick Etchells was evidently becoming rather excited at the prospect of working for the Omega Workshops and was making plans a little prematurely. Vanessa Bell wrote to Fry:

Clive says that he [Etchells] is coming to London on the understanding that you are going to begin using the money you have got for decoration at once, and that there will therefore be paid work for him to do immediately. I suppose this is not the case and that it's even possible you might return the money if no more were forthcoming.[4]

Although Etchells had begun to flex his muscles by decorating a table the previous week in Grant's rooms in Brunswick Square, he had to be restrained from rushing to London from his home in Surrey and renting a house there; paid employment was not yet a feasible proposition. As the month of January passed, however, it became increasingly obvious that although money came in slowly, haphazardly, and in smaller rather than larger sums, the amount required was going to be raised and the project would go ahead. Fry's typewritten circular soliciting support for the workshops, sent out in December, had indicated that all money donated was to be regarded only as a loan to his scheme for, as he wrote: 'A fixed proportion of the profits . . . will be devoted to forming a sinking fund for the repayment of capital.'[5] Even with this assurance, a close and sympathetic colleague took his time to decide upon his donation, as his wife Vanessa Bell informed Fry: 'Clive has decided today that we are to give you £100. I'm not sure but I think he really wants to give it – and also to make a slight grievance of it! Well, he may as well – Anyhow you're to have the £100. How much have you got now? It must be well over the £1000.'[6] Clive Bell continued to bear a slight grievance over this money, raising the matter with his wife in August 1913; his letter is lost but her reply remains: 'As for your remarks about the money we lent to the O.[Omega] . . . I think they're a little uncalled for. As I drew the cheques that were actually given to the company, of course the receipt and share certificates were given to me.'[7] By August the workshops were established as a limited company, with £501 worth of £1 shares allocated to five people, of whom Vanessa Bell was one (her letter refers to this transaction).

Whatever caused this mood of dissension between Clive Bell and Fry in the first half of 1913, it could not be said to arise from their aesthetic standpoints. Bell might have had doubts about supporting Fry's decorative workshop financially, but he cannot have entertained any critical doubts about supporting its proposed foray into the applied arts. In January 1913 Clive Bell's article entitled 'Post-Impressionism and Aesthetics' appeared in the *Burlington Magazine*, now co-edited by Fry. In it Bell stated:

Sensitive people seem to agree that there is a peculiar emotion provoked by successful works of art . . . What quality is common to S. Sophia and the windows at Chartres, Mexican sculpture, a Persian bowl, Chinese carpets,

Giotto's frescoes at Padua, the masterpieces of Poussin, of Cézanne, and of Henri Matisse? Only one answer seems possible – significant form. In each, forms and the relations of forms stir our aesthetic emotions.[8]

It is noteworthy that Bell's list of successful works of art – works held in the same respect by Fry – contained not only easel paintings but also frescoes, mosaics, stained-glass windows, bowls and carpets, all of which were to become part of the Omega Workshops' sphere of activity.

By the middle of February money problems were behind Fry and administrative ones lay ahead. On the 18th he wrote to G. L. Dickinson, an old friend who had possibly given financial aid: 'I'm horribly busy with . . . my scheme. I've got £1500 and am going ahead. Already one architect has given me an order, and today a big firm of cotton printers has written to ask me if I can supply designs; and so far I haven't published a word so it looks as though I had hit on the psychological moment.'[9] Fry had not yet, as he said, published a word about his scheme for a decorative arts workshop. But in several lectures he gave at this time – in Leicester in the second week in February, Liverpool in the third week and Leeds at the very beginning of March – the same talk, entitled 'Principles of Post-Impressionist Design', would certainly have revealed something of his current state of mind on the subject. None of the notes for these lectures survive, and it is impossible to reconstruct their content. But it is unlikely that he missed the chance of informing the public how very suitable the Post-Impressionist style would be for adaptation to the applied arts. His lecture in Leicester was organised by the City Art Gallery to accompany a loan exhibition of Post-Impressionist paintings organised by Sydney Gimson with the help of the Contemporary Art Society;[10] and the one in Liverpool coincided with a selection of paintings chosen by Fry and sent from his second Post-Impressionist exhibition, which had just closed at the Grafton Galleries.

This smaller Post-Impressionist exhibition was held at the Sandon Studios in Liverpool, and contained the work of French and British artists.[11] The original show had to be greatly reduced because of the size of the galleries and the transport costs, so several artists were excluded, most notably Wyndham Lewis. In the complete second Post-Impressionist exhibition in London, Lewis had ten entries, more than any other British artist;[12] and it is remarkable that Fry did not include any of these works in the Liverpool exhibition, particularly as by this time Lewis was an important member of Fry's own group. All the other members of the group – Frederick and Jessie Etchells, Bernard Adeney, Cuthbert Hamilton, Grant, Vanessa Bell, Edward Wadsworth – had their work chosen for

Liverpool. An extant letter of Lewis's indicates some correspondence between him and Fry on the subject of Lewis's omission. In it, Lewis replied to a letter from Fry which is now lost:

Your answer yesterday I confess puzzled me. – 'I forgot to ask if you have anything to send' – whereas all other contributors to Grafton were asked merely if their paintings or drawings then in Gallery should be sent on to Liverpool. The implication is obvious. I am animated by most cordial sentiments as regards yourself and your activities. But to continue in an atmosphere of special criticism and ill-will, if such exist, would have manifest disadvantages, as well as being distasteful, to me.[13]

This misunderstanding followed on the heels of one concerning the commission on sales at the second Post-Impressionist exhibition, when without explanation to the painters Fry altered the rate. As the secretary to the exhibition, Leonard Woolf, recalled: 'Most of them meekly accepted what they were given, but Wyndham Lewis, at best of times a bilious and cantankerous man, protested violently. Roger was adamant in ignoring him and his demands; Lewis never forgave Roger.'[14] These two misunderstandings marked the beginning of the parting of the ways for Fry and Lewis. Whether Fry took up his position by accident or design is hard to say. Certainly Lewis was always quick to feel any slight, real or imagined, and Fry's behaviour seems inexplicable given the apparently close working relationship between the two men and their shared concern for the new scheme.

The very first press announcement about the Omega Workshops came almost in throw-away fashion in the last paragraph of a letter written to *The Nation* by Bernard Shaw and published in the issue for 1 March. The letter was concerned with the differences in opinion in matters of art criticism between the writer and Fry, differences which did not run deep, as the last paragraph disclosed. Shaw thanked Fry for his serious responsibility to his chosen field, admitted a sympathy with his views on Matisse, Picasso and Alma-Tadema, and hoped 'that his appeal for the means of establishing a workshop in London to keep this country in the forefront of European art, and incidentally to gain for his brave band of English Post-Impressionist painters and craftsmen something more succulent to eat than the abuse of Sir William and Sir Philip'[15] would be successful. Shaw had, of course, actively aided this appeal with a generous donation a couple of months earlier.

When Fry had sent out his circular soliciting support, he announced that he had 'selected a suitable house in Fitzroy Square with admirable

workshops and storage cellars and good ground floor show-rooms. By letting off a flat at the top, I can secure the whole of this for about £120 a year.'[16] But although it was December 1912 when Fry found what he considered an ideal base, negotiations for possession of the property took him until March 1913. 'My decorating scheme goes along well. I've got orders already for stuffs and painted furniture, but as yet cannot get a house to start in.'[17] This (in a letter written on 5 March from Fry to Gertrude Stein) implies a hitch in the establishing of the Omega Workshops in Fitzroy Square. Vanessa Bell, writing to Fry the following day from her home at 46 Gordon Square, Bloomsbury, also indicated a lack of a definite base for the Omega: 'It is true that the centre of this blessed business has got to be outside this house but it won't get on without me, and I shall poke my nose into all the details . . . wherever you establish yourself.'[18]

But the problem was to be resolved by the weekend of 22 and 23 March, if not a day or two earlier. In the *Daily Chronicle* on Monday 24 March the resident art critic, C. Lewis Hind, informed his readers of the imminent metamorphosis of the Grafton Group of painters into a group of artist decorators, with a base for work in a house in Fitzroy Square:

There Mr. Fry and his flock propose to persuade the world once more (it needs doing periodically) that the mere painting of pictures is but a small part of the realm of art. In this house in Fitzroy Square, redecorated à la Post [-Impressionist], the Group is going to make and paint furniture, to design cheerful patterns in fabrics, and other pleasing things in the crafts.[19]

Since the house, number 33, had been leased for the past seven years to the Territorial Force, 1st Battalion of the Royal Fusiliers, it was obviously in need of some such transformation. Lewis Hind's announcement was part of a larger article which reviewed a Grafton Group exhibition at the Alpine Club Gallery, and which made a connection between the paintings of the Grafton Group and their decorative capabilities.

The first Grafton Group exhibition opened at the Alpine Club Gallery, Mill Street, London on Saturday 15 March. The cover of the catalogue listed the group members – Vanessa Bell, Frederick Etchells, Roger Fry, Duncan Grant and Wyndham Lewis, the latter included during a period of truce with Fry. Twelve other artists were invited to exhibit, and the number of paintings totalled sixty-one. The catalogue, with a small preface unsigned but undoubtedly by Fry, gives only the titles of the paintings, deliberately omitting the names of the artists: 'It has been thought interesting to try the experiment of exhibiting the pictures anonymously in order to invite the spectator to gain at least a first

impression of the several works without the slight and almost unconscious predilection which a name generally arouses.'[20] The concept of anonymity referred to in this preface differed slightly from that which was to prevail at the Omega Workshops. The preface implies that the spectator, after some consideration, would attempt to put a name to a painting, and adds that 'Information as to the authorship . . . can be obtained from the Secretary.' But no such information would be divulged at the Omega Workshops, where everything produced was to be anonymous and signed only with the trademark of the omega symbol Ω. Purchasers of applied art at the Workshops were to be encouraged to buy because of the aesthetic quality of the object, and not because of the name of the artist-decorator.

Fry's attempt to make the spectator use his eyes without recourse to information such as authorship was whole-heartedly supported by Clive Bell, who wrote in his book, Art, possibly at this very time: 'The habit of recognising the label and overlooking the thing, of seeing intellectually instead of seeing emotionally, accounts for the amazing blindness, or rather visual shallowness, of most civilised adults.'[21] The first Grafton Group exhibition was noteworthy in the context of the development of the Omega Workshops because examples of applied art were shown alongside the paintings. It was widely reviewed and gave several journalists a chance to display their visual shallowness. Nevertheless their comments are vital in building up a picture of this exhibition, because the information in the catalogue itself is scanty.

The scant information in the catalogue means that it is not possible to say with certainty how many works Vanessa Bell exhibited; it may have been three – Room with a Figure, a portrait and a painted screen entitled Daffodils.[22] The critic of the Westminster Gazette, perhaps armed with information from the secretary of the exhibition, confidently ascribes the screen Daffodils to Vanessa Bell, and considers it 'has good points, and anyhow, this departure offers a new and legitimate field for the decorative painter, which is well worth developing'. The critic of the Daily News and Leader saw the screen in a different light: 'The daffodils are really melted wax candles mixed with dragon's blood,'[23] a description which seems to indicate a somewhat scrappy painterly execution. That their work was unfinished, unresolved and shoddy in execution was a charge often levelled at the work of Vanessa Bell and Duncan Grant; the same criticisms were aimed at many of the products of the Omega Workshops. By contrast this was never said of the work of Roger Fry, since he was much more prepared to labour on, sometimes long after a work was apparently finished.

Frederick Etchells showed three paintings – The Chinese Student,

Composition, and *Joseph and Potiphar's Wife*[24] – all of which excited a good share of critical comment. Despite his enthusiasm at the beginning of 1913 for the Workshops, Etchells does not appear to have exhibited any piece of applied art in this show. Up until the Grafton Group exhibition the Omega personnel had been mainly occupied with small-scale decoration, such as painting cushion-covers and boxes or producing designs for embroidered seat-covers. Etchells' preference for large-scale work would not have lent itself easily to such items, although it is surprising that he did not adapt one of his figure compositions for a larger Omega article such as a screen. The newspapers remarked on his penchant for ugliness and for cutting up his figures into distorted facets, and his love of harsh, strident colours. His *Composition* showed 'a purple nude figure gazing intently at the green knee of another nude figure',[25] and the fact that these two colours were the chosen livery of the Women's Social and Political Union did not go unnoticed.

Cuthbert Hamilton, invited for only the second time into Fry's artistic coterie – the first occasion being the re-hang of the second Post-Impressionist exhibition during January 1913 – showed some works which displayed similar qualities to those of Etchells, figures whose bodies and faces were composed of facets.[26] The actual timing of Cuthbert Hamilton's acceptance into the Workshops is not recorded. He was not one of the five members of the Grafton Group, and was probably not encouraged to try his hand at the applied arts in time for the Grafton Group exhibition in March. He was, however, one of the four artists – the other three being Grant, Lewis and Fry – to be singled out by name in *The Times* review of the Omega Workshops' private view in July 1913.

Several papers noticed a stylistic bond not only between Etchells and Hamilton but also between these two and Wyndham Lewis. The critic of the *Daily Telegraph* declared Lewis to be the best of the trio: 'Among the Cubists Mr. Wyndham Lewis is supreme. If his composition of life-size figures, *Three Women*, is not a picture, hardly, indeed a work of art at all, it is a very powerful design of its kind'. The salient features of *Three Women* can be built up from several newspaper reviews; terms such as 'life-size', 'cartoon', 'design' and 'wilful drawing' appear to describe a work about five to six feet in height, possibly executed in bodycolour rather than oil on canvas.[27] On the evidence of his work in the Grafton Group show it seems that Lewis, like Etchells, preferred to concentrate on large-scale figure compositions, and probably did not turn his hand to the applied arts with the same conviction as Vanessa Bell, Fry, and Grant.

Of the five members of the Grafton Group, Duncan Grant just edged ahead of Wyndham Lewis in column inches. Grant showed *Matting*, a

screen entitled *Sheep*, and *Construction*, the last two of which were given the most notice. Grant's painted screen received much praise. *The Times* said of it: 'The Screen, which is ornamented with blue sheep, is really a brilliant piece of decoration, for the sheep, though blue, are full of character and yet perfectly subordinated to the rhythm of the whole design;' the *Daily Telegraph* called it 'beautiful and expressive', and the *Westminster Gazette* even suggested it could be improved upon – by the addition of a gold background and the extension of the design across six panels instead of three.[28]

Even with Lewis's life-size *Three Women*, Grant's *Construction* appears to have been the largest painting in the exhibition. Its subject was a huge naked man building brick by brick a church which was much smaller than himself. *The Times* wrote:

It does give the impression of great strength and absorbed energy; and, if you forget that the man himself is very unlike the Apollo Belvedere, you will see that the whole picture in colour and in spacing is far from ugly, indeed that it might be beautiful if it were one of a series placed in some large building where it could be seen at a distance and in a light that would suit it.[29]

Charles Marriott, in the *Evening Standard*, took up this theme of vigour and boldness:

We are at the beginning of a genuine revival in folk-art . . . it is only necessary to look at the big conversation piece . . . and the green Brobdingnagian adding the last bricks to a blue building over the fireplace, to recognise that the painters responsible know their trade, and address themselves to the communal mind . . . But beyond all question of merit is the impression that painting is once more becoming a man's job; as when the Italian – or Early English, for the matter of that – fresco painters said: 'Hullo! What larks! There's a wall. Chuck us a bit of ochre and let's make a picture on it.'[30]

Astute critics ascribed to these paintings a decorative function more appropriate to the items of applied art displayed in the show.

The only painting to be positively identified as a work by Fry was entitled *Frosty Morning*, which was generally admired. '"Frosty Morning" shows not the slightest sign of frost anywhere save in the title,' remarked the *Daily Citizen* critic; but the *Daily Telegraph* was more sympathetic: 'Mr. Roger Fry, revolutionary in theory, but relatively moderate and dignified in realisation, has a well-balanced and . . . surprisingly coherent composition, "Frosty Morning".'[31] The same qualities of moderation, dignity and balance could have been attributed to an embroidered chair-back designed by Fry and worked by Winifred Gill, which was also

on show. It was the *Sketch* magazine that printed the first visual record of the Grafton Group's applied art, choosing that genre rather than the paintings on display. Its photographs showed Fry's chair-back adorning a chair, and two other embroidered chair panels, one showing a vase of flowers, probably by Fry, and the other showing what was described as a 'cat on the cabbage' design, probably by Grant.[32]

Along with the titles of the paintings in this exhibition the catalogue lists only two works of applied art. However, not only did the *Sketch* illustrate three works, but the *Daily Express* described 'pictures . . . firescreens, bed-screens, woolwork chaircovers and tablecovers, all in the most approved of modernist designs'. The critic of the *Pall Mall Gazette* did not, however, tender his approval for the latest efforts of Fry's coterie: 'Worst of all, the Grafton Group have begun to devote their attention to applied art – to furniture. All that can be said of it is, that it is "gay". The upholstery of a chair exhibited at the Alpine Club is as gay and as subtle in colouring and design as an Early Victorian beadwork bag.'[33] Doubtless the *Pall Mall* critic intended his remarks to be deprecatory, but in fact he picked on exactly the historical period from which Fry drew inspiration. In two separate interviews on the aims of his new decorative arts workshop, Fry said of its embroidery: 'We have revived the old-fashioned Victorian cross-stitch,' and 'I like Berlin wool-work. It is so durable and strong, and is a particularly good medium for us.'[34]

Although Grant and Lewis were the most discussed British artists in the Grafton Group exhibition, both were eclipsed by the two foreign artists in the show, Max Weber and Kandinsky. Kandinsky showed only two works, both entitled *Composition* and both executed in watercolour. Fry did not make contact with Kandinsky direct, but borrowed the two items from the collection of Michael Sadler. Kandinsky had shown in London since the summer of 1909; but Max Weber's work had not been exhibited before in Britain, so one is led to ask how Fry gained a knowledge of his work.[35] Weber was by far the best-represented artist in the whole show, with a total of eleven works.

In 1911 Alvin Langdon Coburn, a friend and admirer of Weber, had begun to purchase several paintings and take photographs of his work. Late in 1912 Coburn left New York and settled in London. At the beginning of 1913 he decided to attempt to make Weber's work known in London and even to secure for him a British art-dealer. He sought out Fry, showing him two paintings and a book of photographs of the artist's work. As Coburn reported back to Weber, Fry 'was delighted with your work, he said it was the most interesting new stuff that he had seen in some time'.[36] At a further meeting, this time accompanied by Grant and Vanessa Bell,

Fry was shown photographs and examples of Weber's work by the indefatigable Coburn. Again Coburn reported back to New York, saying how keen all three were for Weber to exhibit with them in the forthcoming Grafton Group exhibition. Inspired by this enthusiasm, Weber decided to send eleven works for Fry to choose from. Coburn wrote back: 'I believe Fry has some other scheme to use your things in some other way, so there will be no harm in having them over here.'[37] Unfortunately Coburn does not expand upon this notion of Fry's. In any event, Fry hung all eleven works which Weber sent, placing his three largest canvases each in central positions on the walls.[38] If the evidence of Weber's Grafton Group showing is any kind of indicator and if he could have been persuaded to leave New York for London, as Coburn had done, he could well have found himself a prominent position in Fry's new decorative workshop.

The applied art shown at the Grafton Group exhibition gave only a glimpse of an activity which had begun for Vanessa Bell and Duncan Grant in the winter of 1911 as a spontaneous diversion from the serious business of painting pictures. Vanessa Bell's and Duncan Grant's friendship and their admiration for each other's talents was the catalyst for a number of experiments in decoration. At the end of November 1911 Vanessa Bell wrote to Fry about what had happened when Grant had taken tea with her the previous day: 'We invented a new art, the art of covering boxes with a most beautiful lacquer of different colours and painted with figures.' But although a very close friend of Fry's, Vanessa Bell was not prepared to share with him the process by which this decoration was effected.[39] No boxes decorated in this way by Grant or Bell seem to have survived; the painted boxes which stem from the Omega Workshops were decorated by a different technique – that of a water-based bodycolour painted over a thin layer of size or gesso. Also there was a difference in approach, as the decoration of boxes with lacquer would have been considered too meticulous and time-consuming for the Omega Workshops. Small objects like boxes were to be decorated swiftly, without too much preparation and forethought. A few sentences extracted from letters by Vanessa Bell support this attitude; in December 1912 she wrote to her husband: 'I am doing a rather nice box now I think, very simple, squares and circles.'[40] A few weeks later she wrote to Fry: 'I did a little to my blue and green box yesterday but am disgusted with it. I think I shall paint it all over again with something quite different.'[41]

In December 1912 Vanessa Bell sent her father-in-law a Christmas present of one of her painted boxes – it arrived together with a copy of Fry's

circular asking for support. Mr. Bell senior confessed that he would have been better disposed towards this venture if he had not actually seen a product similar to that which his money would have been intended to promote.[42] Perhaps this experience with Mr. Bell senior, of philistine taste, engendered hesitation when it came to showing boxes in the Grafton Group exhibition; otherwise the dearth of boxes amongst the applied art items in the show is hard to explain.

Immediately after the closure of the Grafton Group exhibition on 31 March, attention appears to have focused on designing patterns for printed linens, with a view to producing examples and offering them for sale at the projected opening of the Omega Workshops, at 33 Fitzroy Square, at the beginning of July. Experimentation with patterns for fabrics took place at Vanessa Bell's studio at 46 Gordon Square (the house in Fitzroy Square was not yet functioning as a studio workshop), with Grant, Bell and Fry all trying their hand. The discipline obviously taxed their designing abilities, since Bell afterwards remarked how pleasant it was to be 'painting again after doing all these patterns. Duncan has been trying to do a pattern but gets even more muddled than I do, in fact I don't think he'll ever master repeats.'[43] Somehow such difficulties were overcome, perhaps by communal effort, and six splendid designs for printed linens resulted. By 31 May Fry was able to tell his old friend Lowes Dickinson: 'Our stuffs are being printed and the French firm that's doing them are full of enthusiasm and are altering all their processes to get rid of the mechanical and return to the older, simpler methods.'[44]

Fry was careful never to announce the name of the French firm responsible for the printing of the Omega Workshops' linens. In the Omega sales catalogue published a year later which offered descriptive notes on the categories of articles, Fry again deliberately chose to withhold its name, no doubt out of concern about exploitation and plagiarism from competitors. All he admitted was that 'a French firm of printers . . . have employed a number of special technical processes in order to preserve as far as possible the freedom and spontaneity of the original drawing'.[45] It seems probable from the look of the linens that the special technical processes involved printing from wooden blocks covered with felt. Winifred Gill, who wrote her reminiscences of her time as an employee of the Omega Workshops in the form of thirteen letters during 1966 and 1967, confirmed this: 'The patterns were printed in France. The first lot were printed with wooden blocks but then the factory in which they were made was over-run by the Germans during the war and we had to find somebody else further South who could do it for us.'[46] It is interesting that both Winifred Gill and Charles Robinson, the business manager of the Omega

Workshops from 1913 to 1916, were unable when later questioned to recall the name of the French firm of printers; Fry's request for secrecy was upheld. [47]

It is instructive to examine one of the printed linens in detail, since the process from original design to finished artefact offers an insight into the workings of the Omega, especially in the case of 'Amenophis', which was by Fry himself. Of the six printed linens, entitled 'Amenophis', 'Margery', 'Maud', 'Mechtilde', 'Pamela' and 'White', the central four bear female names which relate to friends or relations within Fry's circle.

The designer of 'Amenophis' is known because the work is known from which the design evolved. At the fiftieth anniversary exhibition to mark the founding of the Omega Workshops held at the Victoria and Albert Museum in the winter of 1963–4, the source of 'Amenophis' was revealed to be an oil painting by Fry. This was *Still Life, Jug and Eggs*, which he painted in the first half of 1912. [48] The composition of this still life must have been deliberately set up as a model, since both Fry and Vanessa Bell painted a version of it. It thus becomes one of the many examples of a shared motif painted simultaneously by both Fry and Bell, and more usually Grant as well. [49] But when the still life was painted, Fry obviously had no idea that it would serve as the basis for a textile design; that process was initiated about a year later in the spring of 1913. In the printed linen, the outlines of the foreground book, the jug and the two eggs nearest to it are still recognizable.

Although abstracting outlines from a realistic oil painting and re-using them to form a non-representational textile design is most unusual, it must have appeared quite logical to Fry. In an interview with a journalist from the *Pall Mall Gazette* at the time when he was designing linens, he announced: 'One of the essences of Post-Impressionism is the return to a more architectural and structural basis of design, and is therefore peculiarly adapted to the applied arts.' [50] His *Still Life, Jug and Eggs* was, in his terms, a Post-Impressionist painting, distinguishable by its insistence upon significant contour and the ordered arrangement of masses. It was therefore, in his terms, most logical to adapt its structural essence for a piece of applied art. No equivalent sources have been discovered for the other five Omega printed linens, and because of this it is impossible to say whether they also evolved by the same process. But on at least two other occasions oil paintings by Vanessa Bell and Duncan Grant were taken as a starting point and abstracted in order to achieve new status as Omega designs. [51]

The same *Pall Mall Gazette* article was the very first to devote itself to the activities of the Workshops. Fry, seated beside Grant's *Sheep* – the painted

screen which had been recently shown in the Grafton Group exhibition – was asked about the aims of his new scheme. The article began by explaining to its readers Fry's basic premise, which was to infiltrate Post-Impressionism into the public's life by:

. . . extending it to the applied arts, and thus introducing it more fully into our homes in the shape of mural decorations, upholstery, and decorative furniture of all kinds. Incidentally, too, the studios and workshops that he has taken at 33, Fitzroy Square, may serve to offer profitable employment to artists who, by their paintings alone, may be quite unable to make a livelihood.[52]

So the basic premise was twofold: to encourage the spread of a new artistic movement and its appreciation, and to offer a form of patronage to those young artists who wanted to work to this end. The article then reported Fry's attempt to put his aims into a historical context:

We are accused of being anarchic and anti-traditional, whereas we are really trying to bring back art into what we believe to be the sounder and also the older traditions . . . painting confined to easel painting tends to lose its virility, and . . . monumental paintings – that is to say, paintings on walls – are the true school for design.[53]

Theories about wall paintings may have been in Fry's thoughts particularly at this time because he was anticipating a holiday in Italy the following week, with Vanessa and Clive Bell and Duncan Grant. Their itinerary included Venice, Viterbo, Toscanella, Florence, Arezzo, Borgo Sansepolcro, Padua and Ravenna. The intention was to study frescoes and mosaics, conscious that these embodied techniques which they themselves (excluding Clive Bell) would be using in the near future as members of the Workshops. As we have seen, Fry thought of his Omega Workshops as having affinity with those earlier communal ventures, in a way that rooted the project in history but gave the Omega artists freedom to challenge stale ideas, as those earlier Italians had done. On his return to England, he wrote to Lowes Dickinson:

In the sixth century . . . they were in a hopeless muddle; the old stupid Roman attitude (dully materialistic and fatuous like that of modern popular art) still persisting, and yet this new ferment working – and the new thing wasn't a religious thing: the Ravenna mosaics are still quite formal courtly things, a part of Protocol; it was just a new excitement, about what? . . . Anyhow, it's life, and Roman art was dead. We're so like that now: somehow all the people in this new movement are alive and whatever they do has life and that's new.[54]

During their time in Italy three incidents heralded the advent of the

Omega Workshops. In the last week of April the *Sketch* and the *Art Chronicle* announced the formation of the Omega Workshops as a limited company 'for applying Post-Impressionism to domestic decorations and furniture'.[55] Then on 13 May Thomas Withers, Fry's solicitor, presented the Articles of Association of the Omega Workshops Limited; on 14 May it was registered as a limited company with its registered office at 33 Fitzroy Square, and a capital of £1000 in £1 shares. In the Articles of Association two subscribers (Roger Fry and Duncan Grant) were listed, each with one share apiece, and their signatures are witnessed by Clive and Vanessa Bell.[56]

Shortly after Fry's return from Italy the Omega Workshops held an inaugural dinner to encourage further support and patronage, on 12 June 1913. The idea had been first mooted by Vanessa Bell in February of that year:

We [Vanessa and Clive Bell] propose to get up a Bohemian dinner to you [Fry] given by all the grateful young artists about the middle of July at the Italian restaurant in Great Portland Street[57] (I think) where the Butler Erewhon dinners are given. We should get all your disreputable and some of your aristocratic friends to come and after dinner we should repair to Fitzroy Sq. where would be seen decorated furniture, painted walls etc. There we should all get drunk and dance and kiss. Orders would flow in and the aristocrats would feel sure they were really in the thick of things. If properly done it seems to me it might be a great send off for the business.[58]

The venue and the financial arrangements for the dinner are not known – but at least one copy of the menu is still extant. The watercolour decoration around the four sides is divided equally between abstract and figurative designs, the left-hand panel and base having a lady and a dog on a lead, while the top band and right-hand panel have a pattern based on loose zigzags. The lady is smartly dressed and could refer to the aristocratic patrons it was the intention to attract. This juxtaposition of abstract and figurative styles would become typical of works produced by the Omega Workshops. One can only speculate as to the guest list; presumably Duncan Grant, Vanessa and Clive Bell, Fry, Frederick and Jessie Etchells and Winifred Gill were in attendance, plus as many patrons as could advantageously be invited. It is not certain whether the guests included Edward Wadsworth, Cuthbert Hamilton or indeed Wyndham Lewis, who may well have been on holiday in Spain at this time.[59]

On Monday 7 July the sixth London Salon of the Allied Artists' Association opened at the Royal Albert Hall. Three catalogue numbers in the applied arts section refer to products of the Omega Workshops: '1282: Curtains – hand-dyed, 1283: Bedspread – hand-dyed £5 5s, 1284: Boxes

and candle shades (priced)'. These items are not mentioned in contemporary reviews of the London Salon, which all concentrated on the fine art works on show, especially as the contributors included Brancusi, Zadkine and Kandinsky. It was not the first time Omega Workshops products had been put into a public exhibition of fine art – witness the screens and embroidered chair-backs in the first Grafton Group exhibition in March – but it was the first time they were shown under the official title of Omega. Although the items were not mentioned in reviews, the *Art Chronicle*, in a somewhat laconic fashion, told its readers: 'The Omega Workshops showed bedspreads, boxes, etc. They sold some work.'[60]

If this information was correct, it must have constituted the earliest sale and been most welcome to Fry. None of his letters or personal papers, however, supports this statement, and it is impossible to ascertain the particular character of the products. The hand-dyed curtains could have been painted with an abstract design, or have been figurative like the 'Adam and Eve' curtains being hung in the showrooms of 33 Fitzroy Square at that very time. The same is true of the handpainted bedspreads. But a marked copy of the Allied Artists' Association exhibition catalogue[61] does reveal clues concerning the boxes and candle shades. Its pencil annotations are: 'Chip Box Flowers + Birds 10/6', '8 Lampshades @ 1/6 = 12/-'. This seems to imply a series of eight shades with associated designs. Wyndham Lewis is known to have designed nine shades, one of which is slightly different from the others. Perhaps the remaining eight were those on show at the Allied Artists' Association. To judge by the look of the printed card shades, reproduced by process engraving, Lewis's original drawings must have been in pen and ink. Four shades have designs of bowler-hatted men meeting blonde- and dark-haired women; three have designs of female figures, sometimes accompanied by small animals; and the remaining two have circus scenes. Lewis very rarely drew animals; apart from these lampshades, only three other examples are known, all executed between 1912 and 1914.[62] It may be significant that an exhibition of drawings by Pablo Picasso was held at the Stafford Gallery, London, in April–May 1912, consisting only of works dating from c. 1904–5, and that the subjects of some of these were circus performers and animals. If Lewis was influenced by this subject-matter, he seems to have limited his experiments to work produced for the Omega Workshops.

The following day, Tuesday 8 July, was the private view of the Omega Workshops. A particular stratum of London society was well represented, but there was not perhaps such a large number of journalists. *The Times* was alone in carrying a review. This started with a mention of a small

exhibition of watercolours by Fry also on show at 33 Fitzroy Square (as if Fry were not busy enough). It then continued, in a sympathetically enthusiastic way, singling out four names in the association of artists at work there: Fry himself, Grant, Lewis and Hamilton. It described certain works on show, but on the whole kept to the general principles behind the organisation. Readers were informed that the Omega Workshops were a society of artists who were trying to do away with the middleman and were designing for themselves, the resulting articles having 'a gaiety and simplicity not often found in English work that is supposed to be artistic'. *The Times* critic wisely recognised the link between Post-Impressionist painting, of the sort recently shown in London, and the designing done at the Omega. He may have been nudged in this direction by Fry himself, although a knowledge of the second Post-Impressionist exhibition catalogue essays could have prompted him to this opinion. He felt that the Omega artists all followed

Post-Impressionist principles that the representation of real objects, whenever practised, is used as a motive of design, and not to remind us of the realities represented. This is, of course, the principle of all good design, but in these works it is carried much further than usual and in most cases with good results. Only an artist of very great ability can combine the amount of representation common in most patterns with a fine abstract design, and in most patterns the design is sacrificed ruthlessly in the representation. These artists have realised this simple fact, and they have hit upon a method of design which needs ability and skill, but which is not hopelessly beyond their powers . . . the best of them are controlled by a clear and certain purpose, which is the source of the pleasure they give.[63]

The Times article is a perceptive and sensitive piece, written not after a long period of consideration but at speed, after the shock of the first encounter with the products. The attention given to the spirit of gaiety and enjoyment which emanated from the Workshops and their output would have pleased Fry greatly. When interviewed a month later at the Omega, Fry is reported to have said: 'It is time that the spirit of fun was introduced into furniture and into fabrics. We have suffered too long from the dull and the stupidly serious.'[64]

According to Winifred Gill, on the day that the Omega opened to the press in July the French artist Henri Doucet could have been discovered hastily decorating the walls of one of the showrooms with a template of artichoke leaves and a pot of deep-red paint. He was in Britain probably at Fry's request, to coincide with the opening of the Omega. It is not known how often Doucet came over to England, leaving a wife and small child in Paris, to join the other employees in producing designs. No applied art

items can confidently be attributed to him except perhaps a handpainted silk dress showing a moonlit pastoral scene, and five sheets of designs for pottery vessels, with comments written in French. His style of oil painting is known, however, through a handful of canvases still in the collection of Fry's family, and the illustration of a large canvas in the second Post-Impressionist exhibition catalogue.[65]

The private view went well; Fry wrote to his mother: 'We had a great success. The German ambassadress was very keen and ordered a lot of our stuffs and gave names to the various designs. And various other great ladies came and were very enthusiastic.'[66] The German ambassadress was Princess Mechtilde Lichnowsky ('Mechtilde' was the name of one of the linens). 'Margery' and 'Pamela' were named after the sister closest to Fry and his daughter, respectively. 'Maud' probably refers to Lady Cunard. 'White' seems too general a name to be associated in this way with a person.

After opening day with its promise of patronage, the business of running the Omega Workshops Company Limited had to be attended to. A Return of Allotments paper was drawn up on 11 July and presented by Fry's solicitors. The number of shares allotted totalled £501, for which five people were responsible – Fry for £300, Sir Alexander Kay Muir for £100, Vanessa Bell for £50, Lady Ian Hamilton for £50, and Duncan Grant for £1. The three names of Fry, Bell and Grant are not surprising, but it is interesting to speculate on Fry's powers of persuasion in introducing the other two. Lady Hamilton was a prominent member of London society, but her brother Sir Alexander Kay Muir was not even resident in London and had an estate in Perthshire. Three days later, on 14 July, a document listing the names of the directors of the Omega was signed, again by Fry, Vanessa Bell and Duncan Grant, all three giving their occupation as 'artist'.

The Times review of the private view at the Omega, although offering a sympathetic appraisal, fell short on visual evidence of the objects it described. But this was redeemed when the *Daily News and Leader*, a newspaper without a regular art column and not known to be concerned with avant-garde developments in the art world, sent a reporter and a photographer round to Fitzroy Square early in August, to interview Fry and to see what was going on. On Thursday 7 August the first illustrated article on the Omega appeared in this newspaper, filling just over half a page with text and a large black and white photograph. Again the tone of the review was enthusiastic. The photograph showed the interior of 33 Fitzroy Square: the two showrooms on the ground floor, divided by wooden folding doors which were always kept fastened back, and which in summer 1913 were divided by a pair of handpainted curtains. The caption

to the photograph drew attention to these curtains, the mural on the wall seen in the far room, and two painted screens. It could not have done much more since there was not a great variety of goods in evidence. The journalist described the curtains thus: 'The pattern at first seems little more than a confused medley of lines – purple, green, blue, crimson, and yellow – but as one regards it one finds that there is method in the madness. It is a pictorial presentment of Adam and Eve in the Garden of Eden.'[67]

The figure of Eve seen kneeling before the trunk of a tree on the left-hand curtain is complemented by the figure of Adam on the other curtain. He is more difficult to perceive since the curtain is less open and obscured by a screen and a chair. Adam is lying on his front on the ground, the upper half of his body supported on his elbows, and he is looking across towards Eve. The wilful distortion of Adam's pose is characteristic of Grant, as are the large eyes of Eve, the line that continues from the eyebrow down to the nose, and the Cupid's bow mouth. Similarly characteristic are the small internal facets which make up her body.[68] The foliage seen in the upper half of the curtains, with its realistic flowerheads arranged amongst simple geometric shapes, is perhaps the work of Grant and another artist. The very dense filling of the space above Adam's body does not look like Grant's work.

The writer of the article in the *Daily News and Leader* continued:

The walls of the Post-Impressionist home will not be as the walls of ordinary homes. I saw an example in which the walls were covered with a wonderful landscape in aesthetic tones, pale purple skies, and shining moon, and blue mountains. 'If people get tired of one landscape,' said Mr. Fry, 'they can easily have another. It can be done in a very short time.'[69]

Fry's final sentence was an important one. When the Omega Workshops prospectus was published about a month after this interview, the same words reappeared: 'The artists of the Omega Workshops, having practiced [sic] decorative design, are able to work together upon a roughly indicated plan with much greater freedom and certainty and are therefore able to carry out the painted decoration of a room, or a whole house, in a very short time.'

Spontaneity and enterprise were part of Fry's ideology at the Omega; works were not to be long labours, meticulous and polished – but free, bright and summary. A great deal of preliminary sketching and forward planning was not regarded as necessary, decisions were to be made during the act of creation, and serendipity ruled. The screen in the right foreground of the photograph also received attention. The journalist commented:

Rodin accentuated the lines which best expressed the spiritual state he interpreted; and the artist, who created the four circus figures which adorned a screen in a corner of the room, may possibly have been actuated by the same motive. The features were awry, the necks bulging, the waists abnormally long, and the legs abnormally short. 'But how much wit there is in these figures,' said Mr. Fry. 'Art is significant deformity.'

Fry would rather have substituted the name of Matisse for Rodin, but he would have appreciated the concept of lines expressing emotion. Clive Bell's *Art* was not to be published until March 1914, and the cult status of the term 'significant form' was thus still eight months away; but Fry showed himself conversant with it – even able to distort its meaning.

In this first illustrated article on the Omega, Wyndham Lewis received good coverage, with a prominent photograph of the circus screen and attendant comments, albeit under cover of anonymity. Apart from this screen, whose design, at least, can be attributed to his hand, it is difficult to ascribe much to Lewis during his period of employment at the Omega. His association as a designer with the Workshops was not a long one, probably starting in the spring and ending certainly in October of 1913. The painted screen is not truly indicative of the general drift of his work in the spring and early summer of 1913, but it is closer to the type of work he was producing in 1912. The scrubby, patchy method of applying the pigment to the surface was not a hallmark of Lewis's technique, either; but then he may not have been responsible for the actual painting of the screen.

The *Daily News and Leader* article mentioned the Omega re-opening, formally, in the autumn 'when three rooms (including a nursery), furnished in Post-Impressionist fashion, will be exhibited'. It would seem therefore that 8 July was an exceptional day, set aside for the press view and for a private viewing for patrons. Only in the autumn was the Omega open daily for business. In the meantime one probable visitor was Ethel Sands, a wealthy American painter and friend of Sickert, and certainly not much activity or goods were apparent to her. She described the scene in a letter: 'Duncan Grant, who looked unshaven and bewildered and a group of men and maidens who looked exactly like the chorus in "Patience" round two chairs and a few boxes.'[70] For the moment several employees were on holiday – Wyndham Lewis and Frederick Etchells in Dieppe, and Vanessa Bell, Fry and Grant sharing their time between a camp at Brandon, near Thetford in Norfolk, and Asheham in Sussex. Nevertheless, preparations must have been under way for the sitting-room for the forthcoming *Daily Mail* Ideal Home Exhibition. The commissioning of this project was a source of dissension, for the reason that Fry (acting

on behalf of the Omega) and Lewis each thought he had been appointed by the *Daily Mail* to decorate a Post-Impressionist room: Lewis had had a message, brought to the Omega by Spencer Gore, and Fry a letter from the *Daily Mail*. In a taped conversation made in 1962, Winifred Gill recalled:

Fry had a letter from the *Daily Mail* suggesting he do a room at the Ideal Home Exhibition. He talked it over with his co-directors because he knew it would mean raising a good deal of money, but then the stuff made for it could afterwards be sold, and so he agreed to do it and then he allocated the work that he wanted done.

As far as can be ascertained, the very first advertisement for the Omega Workshops appeared in August in the *Burlington Magazine*, of which Fry was the current co-editor and one of the founders. Placement in a magazine 'for connoisseurs' indicates the level of patronage Fry hoped to attract. The advertisement may have been intended to coincide with the article in the *Daily News and Leader*, or to announce the Workshops prior to their showing at the Ideal Home Exhibition. Whatever the reason, it only appeared for the month of August. It was small, and not specially prepared to appear in the magazine; it was actually the letterhead from the Omega Workshops business notepaper. The heads of the figures, their arm positions and the treatment of drapery all suggest that it was designed by Lewis.[71] It is perhaps surprising that Fry gave Lewis this task, when Grant and Etchells had recently proved themselves with their joint design for the second Post-Impressionist exhibition poster and catalogue cover. However, Lewis had also proved his worth in this field, although not at Fry's behest. He had designed the prospectus cover, programme, menu and stationery letterhead for the *avant-garde* nightclub in Heddon Street, London, of the Cabaret Theatre Club – the Cave of the Golden Calf – in the autumn of 1912. When in May 1912 Fry had organised at the Galerie Barbazanges, Paris, the exhibition of his little group of English artists which included Lewis, the latter contributed two items, numbers 5 and 6, jointly listed as *Des En-Têtes (Dessins)* – designs for letterheads.

At about the same time, *c.* September 1913, an Omega Workshops prospectus was printed and circulated. It took the form of a four-page essay, with no illustrations. The text is anonymous but assuredly springs from the pen of Fry, and stands almost as a manifesto rather than as an advertisement. Possibly it was published to coincide with the showing of the Omega sitting-room in the Ideal Home Exhibition; certainly it was not ready for the private view in July. Fry's pamphlet was an exposition of the ideology of the Omega, and very didactic in tone; it probably did not expand the market for Omega products. Vanessa Bell remarked: 'I can't

make any criticisms on your prospectus, only that I thought you ought to ask people to come to the showrooms more plainly.'[72]

The discord arising from the Ideal Home commission has received much attention from the partial and impartial alike, and has been christened the 'Ideal Home Rumpus'.[73] It may be thought by the casual reader to be the most notable event in the life of the Omega Workshops, but this would seem to exaggerate its significance. From the argument between Lewis and the Omega that ensued from this incident grew a secession group, the Vorticists, and for a short period a rival decorative workshop, the Rebel Art Centre. There had always been the likelihood of a disagreement, whatever the cause, between Fry and Lewis, with the initiative coming from Lewis. Augustus John, who had known Lewis in Paris in the early years of the century, wrote of him: 'He conceived the world as an arena, where various insurrectionary forces struggled to outwit each other in the game of artistic power politics.'[74] In this field of artistic power politics Fry was no innocent, and thus a strong match for Lewis. The general consensus of opinion about the outcome of the Ideal Home Rumpus is that Fry triumphed, in his stance of feigned unconcern, and Lewis suffered. But Fry suffered too, in the sudden disappearance of five Omega employees[75] – well over half his workforce.

The centre, or rather, vortex, of the dispute concerned the mantelpiece for the sitting-room. A letter written later by Lewis, which he referred to as the Round Robin, states:

When it was announced in the Workshops that the Ideal Home Exhibition room had been secured by the Omega and it came to apportioning the work, Mr. Lewis was told by Mr. Fry that no decorations of any sort were to be placed on the walls, and was asked if he would carve a mantelpiece. Shortly after this Mr. Lewis went away on his holidays, and on his return in September, found large mural decorations, destined for the Olympia exhibition, around the walls of the workroom.[76]

It seems strange that Fry decided there would be no wall decorations in a room which could have done a great deal to advertise the Omega – thousands more people would find their way to Olympia than would ever venture to ring the front door bell of 33 Fitzroy Square. Equally, all Fry's early pronouncements on his decorative ventures stressed the importance of allowing artists to decorate walls, and here was a chance of doing so for a public exhibition. But the Omega entry, written by Fry in the Ideal Home Exhibition catalogue, stated: 'The Omega Workshops Ltd. is a society of artists who devote themselves to applied design, their most important work lies in the application of pictorial designs to the decoration of

walls.'[77] It is possible – discounting a change of mind while Lewis was on holiday in France – that Fry may have wished deliberately to exclude Lewis from any Omega mural scheme. He had not, after all, included him in any of the mural schemes which his 'group' had so far undertaken, and indeed he did not even apportion a mural decoration to Etchells, who had been favoured in that respect thus far.

The mural decorations which confronted Lewis on his return from holiday might well have annoyed him for two distinct reasons: first, that they were there at all, and second, that their theme was dancing figures, conspicuously close to his own dancing figures painted as wall decorations in the Cabaret Theatre Club. A contemporary colour photograph of part of the Omega sitting-room shows what is probably the back wall of the exhibition stand, divided into sections by painted pilasters. Between these pilasters are three painted panels of dancing figures, executed in the same colours, but even in the small photograph showing signs of different hands. This is borne out by a letter from Vanessa Bell to her husband Clive:

I have been working quite hard at my panel at the Omega. I think the whole wall ought to be rather fine in colour. There are three panels 6 ft by 4 ft 9, each of two dancing figures in reddish pink and green yellow ochre round them and red pilasters between and blue below. Duncan and I and Roger are each doing a panel. It's great fun working on a large scale.[78]

These exhibition panels were painted on the Omega premises at 33 Fitzroy Square in the five days 18–22 August, just after Grant, Bell and Fry had returned from their Norfolk holiday. The subject-matter of the panels, with their nude figures dancing in wild abandon, do indeed display a strong family relationship to Lewis's designs for the Cabaret Theatre Club murals. But the Omega catalogue entry attributes their derivation to the action of dance itself: 'The walls are decorated . . . by various artists working together on the general theme of designs based on the movements of the dance.'[79]

Unfortunately the contemporary photograph shows no sign of any mantelpiece. In her taped interview, some fifty years later, Winifred Gill remembered Fry allotting the work on this perplexing item to Lewis:

He asked Wyndham Lewis to carve some uprights to go either side of the hearth. Well, I don't think Wyndham Lewis was very keen on doing this. He was working on these blocks of wood downstairs in the basement. He didn't like this and he didn't come in and do it and just about a week or two before the exhibition, he just blew up and said that he wasn't going to do it at all. He was jolly well walking out and the others walked out with him and I remember the dispute on the stairs, and then Roger coming in and saying it

was a bit thick they had walked out and left us with this half-finished, and then Wyndham Lewis's blocks of wood remained in the basement until the place closed up.

However, in a letter to Gore only four days after Lewis walked out, Fry told a different story about the mantelpiece:

As a matter of fact, Lewis wanted to do carving for it. It was his own suggestion and I considered it the most interesting and important job in the whole work. However he never carried it out in spite of constantly repeated assurances that he would, and finally left me to substitute somebody else on the last day.[80]

Since the Ideal Home Exhibition opened on Thursday 9 October the last day would have been Wednesday 8th, or even a day or two earlier, allowing for the installation of the room at Olympia. Winifred Gill remembered that the dispute on the stairs took place on 5 October. This was a Sunday, and Fry must have had the power to ask most of his employees to work on that day, since there was a deadline. Etchells, Hamilton and Wadsworth must have been helping, along with Lewis, to get the room and its furniture ready on time – since Winifred Gill remembered that when Lewis walked out he was able to take the other three men with him. The person to whom Fry turned to finish the mantelpiece is a mystery, if indeed it was finished; it was included in the sitting-room if one believes the evidence of the catalogue entry, although this would have been written a couple of weeks before the opening and thus before the dispute. The catalogue states: 'The woodwork of the mantelpiece is both designed and executed by one of the artists.' Winifred Gill, again at a distance of fifty years, offers evidence which seems to deny any carved mantelpiece in the sitting-room: 'For the Ideal Home Exhibition Wyndham Lewis carved a mantelpiece, but this was not finished. Instead we painted two uprights in indian red, black and white, which, mixed, made the favourite Omega colour, mulberry.'[81] Certainly, painted uprights in a deep red would have matched the painted pilasters between the three painted panels. It remains a little puzzling that Lewis should have accepted the job of carving the mantelpiece in the first place. He had no previous experience of woodcarving, as far as is known, but then neither did any other artists at the Omega at that time.

Shortly after the publication of volume two of John Rothenstein's *Modern English Painters*, which discussed several of the artists who had been employed at the Omega, William Roberts – who became a member of the Omega in the winter of 1913 – felt moved to publish privately his own version of his artistic career to date, being displeased with Rothenstein's

account. On the subject of Lewis's activities, Roberts reminisced: 'When I joined the Omega, and before that event, I had never heard of Lewis or his work. Nor were the remnants he left behind at the Omega, some small paper lampshades and two bits of partly carved wood (which I later discovered to be his), at all likely to impress.'[82]

The Omega Workshops entry in the Ideal Home Exhibition catalogue reminded visitors that 'with trifling exceptions . . . everything in the room is either wholly the work of the artists of the Omega Workshops, or has been executed from their designs and under their supervision'. The only category of decorative furnishings singled out as specially designed for the room were the rugs. From the contemporary photograph only two rugs are visible, although the dark patch on the extreme left of the room could well be a third. The identity of the artist responsible for the rug placed underneath the painted table can be deduced from stylistic clues. A design for the rug, very close in colour and shape to the actual article, exists, and, closely studied, it is a revealing document.[83] The design is made up of seven long, narrow rectangles relieved by bands of short parallel hatchings at two different angles. It contains many changes of mind about the angle of these lines, which could imply that the artist was experimenting with this device for the first time.

Fry was impressed by this rug and praised its qualities of sensual irregularity and surface sensibility in his lecture, 'Sensibility', given as Slade Professor at Cambridge in the winter of 1933–4: 'It was designed by a modern English artist . . . [who] has taken a theme of almost daring geometrical simplicity, but, not relying only on the broken quality of the knotted surface of the rug, he has deliberately broken his rectilinears by small steps up and down; he has also made his shading sometimes perpendicular and sometimes diagonal.'[84] In the lecture Fry compared a slide of this rug with a slide of a primitive Negro textile, but was careful to note that the primitive craftsman tended 'inevitably to produce irregularities and variations in the design'. The irregularities in the English rug were not inevitable or accidental but rather deliberate and calculated. This was of course the essential difference between the traditional and unquestioning use of pattern and a conscious exploitation of that approach. A further difference was that the primitive Negro textile would have been executed by the designer and the English Omega Workshops rug was subcontracted out to specialist craftsmen.

Although Fry did not divulge the name of the English artist responsible for the Omega rug, the use of hatched strokes is a hallmark of Duncan Grant's work in the second half of 1913. It is more than likely, then, that

he was the designer. The painting which is crucial to an understanding of the development of hatching in Grant's work during the latter half of 1913 is Picasso's *Nude with Drapery* of summer 1907, now in the Hermitage Museum, Leningrad.[85] Grant became acquainted with this painting and several attendant sketches for it when it was in the collection of Leo and Gertrude Stein, and he later acknowledged its importance to his work. In the *Nude with Drapery*, both the volume of the figure and the flatter background are given a hatched treatment.

Grant could have become acquainted with the *Nude* and its satellites from the autumn of 1907 when it entered the Steins' collection. However, its effect upon him does not appear to have been immediate, since he did not experiment with the method of hatching until 1913, possibly starting with the curtains and floor covering in his painting *The Tub*, now in the Tate Gallery.[86] The straight vertical line with its short hatched strokes down the right-hand side of this canvas is seen again in a very similar format and identical place in a still life of a vase of flowers, which belonged to Lady Ottoline Morrell.[87] In both *The Tub* and the still life the hatching acts as a two-dimensional decorative device, exactly as it does in the rug. In other paintings executed in these same months Grant is also able to use the hatching as a form of stylised shading to enhance a volume, for example in his *The Head of Eve*, *Tents*, and *The Ass*.[88] Since every one of these works was probably executed within Grant's first six months at the Omega, it would seem that the effect upon him there of freedom to experiment released this latent Picasso influence. The long vertical line accompanied by short hatching strokes can be seen as vir- tually a trademark of Grant's work in several items of applied art;[89] it is even used as a surrounding motif to the three panels of dancing figures on the back wall of the Ideal Home Exhibition stand.

The second rug, partly visible in the photograph of the Ideal Home room, is thought to have been designed by Frederick Etchells. It can be attributed to him on the basis of its arrangement of shapes, particularly the almost unbalanced central mass and the zigzagged bottom border, all underpinned by a secure and regular grid of squares. The use of stripes, diamonds, triangles and squares, often in conjunction with each other, can be found in most of Etchells' paintings – from his mural, *The Fair*, for the Borough Polytechnic in the summer of 1911 to his *Woman at a Mirror*, painted in the summer or autumn of 1913.[90]

The Omega sitting-room showed three chairs arranged along the back wall, one below each of the three decorative wall panels. Fry designed a basic dining-chair for the Omega, an example of which can be dimly seen in the corner of the room, in front of the curtain of 'Maud' linen. Fry wrote

of the Omega furniture: 'In designing for furniture we have considered comfort and practical needs first, and have tried to embody these in designs of extreme simplicity and architectural fitness.'[91] His basic dining-chair, a combination of four-square wooden members framing a cane seat and back – the wooden parts being painted or lacquered in a dark red or a pale grey and the cane parts gilded – was indeed extremely simple and fit for its purpose, as all owners of these chairs would testify. They were made for the Omega Workshops by the Dryad Company of Leicester, and it could well be that Fry discovered the potential of this fledgling firm[92] when he went to that city in the middle of February 1913, to give a lecture on Post-Impressionist design. The three chairs in the Ideal Home room, each with an extra circular headpiece (forming an Ω shape), are the only ones of this kind known to have existed. It is feasible that they were expressly designed to display the Omega symbol as a crowning feature, for in fact the middle chair, probably the focal point of the whole room, has such a symbol painted in bright red on to the headpiece.

To the extreme left of the Ideal Home room a desk can be seen in the photograph. This piece of furniture is now lost,[93] but it is well known from an Omega Workshops publicity photograph. Winifred Gill recalled that marquetried furniture was made for the Omega by a 'Pole called Kallenborn, who worked for Ambrose Heal, and who lived in a back street nearby'.[94] From 1905 John Joseph Kallenborn had a cabinet-making business at $65\frac{1}{2}$ Stanhope Street, just across the Euston Road from Fitzroy Square. As Virginia Woolf related in her biography of Fry: 'He had to hunt out carpenters and upholsterers, little men in back streets who could be trusted to carry out designs and to make serviceable objects.'[95] Fry was lucky in having a good cabinet-maker on his door-step, and the marquetried furniture made by Kallenborn constitutes some of the best of the Omega products.

The commission for the Ideal Home room was only received by the Omega in mid-July, and this desk was on show by 9 October. Its design and execution therefore fell between those dates. Since Lewis, Etchells, Wadsworth and Hamilton did not leave the Omega for good until 5 October, any of them could have been responsible for the design of this desk. A close scrutiny of the marquetry panel at the back of the desk reveals a design which appears to be three abstracted human figures in contorted poses. The two outer figures have their squarish heads pointing downwards to the left, while the central figure is facing in the opposite direction. By their unsupported sprawling positions, seemingly unaffected by gravity, one could posit that they are abstracted swimming figures; and

if so, then it follows that the design could be by Grant. Iconographically, Grant was fascinated by the subject of swimmers. There are many examples by him in various media, from the Borough Polytechnic mural of 1911 through the Omega years.[96] Technically, it is not far-fetched to see a papier collé design as the blueprint for this marquetry panel, and Winifred Gill remembered that Grant produced other papier collé designs for translation into marquetry. Grant, beginning to use papier collé from the spring of 1913,[97] liked the technique because it enabled him to emphasise a profile. Of course, it is in the nature of marquetry, with its veneers applied to a flat support, to echo the technical methods of papier collé, but the shapes in this panel do seem to owe their origin to a cut rather than to a gesturally drawn line. Another consideration is that for some paintings in 1913 Grant had begun to choose a long narrow format; this then became exaggerated into his *Abstract Kinetic Collage Painting with Sound* of 1914 with its dimensions of 11 in. by 14 ft.[98] With his predilection for such proportions, the long rectangle of the desk panel would thus have presented no problems for Grant.

The Omega room at the Ideal Home Exhibition was not well received. It drew unfavourable comments from the press and public, and from Their Majesties, who on visiting the exhibition deemed it the perfect example of how not to decorate a sitting-room. Neither was attendance at the show especially pleasant for the Omega personnel, since on the adjacent stand, the Moonlight Sonata Room, this piano piece by Beethoven was played continuously for the three-week duration of the exhibition: this indeed is the only memory of the whole affair retained by Fry's daughter, then aged eleven.

Just after the Ideal Home Exhibition opened, Fry set off for a painting holiday in France. He felt a great need for a change from the effort of getting the room ready and administering personnel, and from the complaints of Lewis. After Fry had left for France, Lewis, possibly with help from Etchells, Wadsworth and Hamilton, composed a letter containing accusations against the Omega. This was then sent to shareholders and patrons of the Workshops, including Sickert, G. B. Shaw, E. M. Forster and Maynard Keynes. It was this letter, which Lewis called the Round Robin, rather than the row within 33 Fitzroy Square itself on 5 October, which brought the dispute between Lewis and Fry to the attention of a wider audience. And from the evidence of the letter, it was obvious that the dispute over the Ideal Home room was only one of several wider issues. Lewis accused Fry of trying to prevent Etchells and himself from showing their work in an exhibition organised by the art

critic Frank Rutter, and went on to ridicule the ideology of the Omega and generally show contempt for the standard of its work:

As to its tendencies in Art, they alone would be sufficient to make it very difficult for any vigorous art-instinct to long remain under that roof. The Idol is still Prettiness, with its mid-Victorian languish of the neck, and its skin is 'greenery-yallery', despite the Post-What-Not fashionableness of its draperies. This party of strayed and Dissenting Aesthetes, however, were compelled to call in as much modern talent as they could find, to do the rough and masculine work without which they know their efforts would not rise above the level of a pleasant tea-party, or command more attention.[99]

Lewis did admittedly applaud the enterprise's attempt to eliminate 'the middleman-shark' from the process of putting the artist in touch with industry. However, he implied that something rather sinister was taking its place, and this he described as 'a Pecksniff-shark'.[100] In the letter the Pecksniff-shark was Fry. Lewis used this term again, in 1914, in his polemical magazine *Blast*, no. 1, in an article entitled 'Futurism, Magic and Life'. This time the term 'Pecksniff-shark' was applied to a generic group – to all such creatures who feed off artists when they get their noses 'nearer and nearer the surface of life'.[101] Fry is thus the model, in Lewis's categories, for the enemy of the artist. *Blast* also included the manifesto of the Vorticists and a remarkable list of people and institutions 'Blessed' or 'Blasted' by them. It is somewhat surprising not to read Fry's name (and Bell's, for that matter) in the company of the Blasted. When, in the early summer of 1914, the lists of Blasted and Blessed were compiled, Fry's name would not have been left out inadvertently, for by that time Lewis's own Rebel Art Centre was in direct competition with the Omega. Lewis could not bring himself to vilify Fry by name, but the cutting phrase, 'Blast the Amateur Sciolast Art-Pimp Journalist Self Man No-Organ Man' – possibly including Clive Bell – seems pointed enough.

Rutter's exhibition, mentioned in the circular letter, opened in London on 12 October. Although there might have been strife over his requests for their paintings, Lewis, Hamilton, Wadsworth and Etchells were all well represented, with seven, three, five and six works respectively. Vanessa Bell, Fry and Grant were not invited to exhibit. They had obviously not produced, in Rutter's opinion, significant examples in one of the 'various schools of painting which have made some noise in the world during the last quarter of a century'.[102] Rutter's aesthetic views were similar to Fry's in many respects, though maybe he had a greater respect for Fry's criticism than for his painting.

It is likely that Bell, Grant and especially Fry felt slighted by their omission from this exhibition. However, the departure of half the

workforce of the Omega meant that they were plunged into a frenzy of activity in order to keep abreast of all the decorative work needed to meet two imminent deadlines – one was a show at the Omega and the other a display of products at the Army and Navy Stores in London. Fry told G. B. Shaw: 'As you've been so much interested in the Omega, you may like to hear that the defection is really fortunate as only one of these four artists has been of any real use.'[103] From correspondence between Fry and Grant,[104] it can be deduced that the artist they missed most was Frederick Etchells. Fry seemed relatively unperturbed by the departure of the other three, who had probably not yet had time to prove their worth.

On the way back to England from his fortnight-long painting holiday, Fry stopped for a day or two in Paris, possibly meeting Clive and Vanessa Bell there, and purchased a Picasso from Kahnweiler, the *Head of a Man*, painted in the spring or summer of 1913.[105] In one of his articles in *The Nation* in November 1912, defending his choice of works for the second Post-Impressionist exhibition, Fry did admit to some bewilderment over Picasso's latest works: 'As to . . . those in which Picasso frankly abandons all direct reference to natural appearance, I confess that I take them to some extent on trust, a trust which is surely justified by his previous work.'[106] It was thus a brave choice to purchase such a recent conceptual yet decorative work. By this date, Fry's collection of modern foreign works of art included oils by Lhôte, Marchand, Thiesson and Vlaminck, and a head – *Mlle Pogany* – by Brancusi. This new purchase was of a different spirit. At first glance it looks like a collage, whereas it is really oil, charcoal, ink and crayon on sized paper. Perhaps it was the mixing of media and the support of prepared paper that drew Fry's attention; perhaps too he chose it because it seemed closer to work being produced at the Omega than to his own current painterly practice. Certainly the rectangular panels of colour with their stripes and dots, decorative in effect, have an affinity with abstract designs for rugs being produced at 33 Fitzroy Square.

Fry was back in London by the beginning of November, and the echoes of Lewis's thunderbolt were still rumbling around. New employees at the Omega were required, since with Fry's absence abroad the work had fallen entirely on Grant and Vanessa Bell. He wrote to his friend Rose Vildrac on 4 November: 'Another quite gifted young artist has already come to the Omega; it is going all right, I am sure . . . Mrs. Bell and Duncan Grant have really worked heroically to make up for the absence of the defectors.'[107] Writing to Rose Vildrac in French, he referred to the young artist in the masculine gender, thus meaning either Gaudier-Brzeska or

William Roberts, both of whom had recently joined his Workshops. More probably it would have been Roberts, since Fry might have described Gaudier-Brzeska as a sculptor.

In the face of the defection of Lewis, Wadsworth, Hamilton and Etchells from the Omega in October, Clive Bell's purchases for the Contemporary Art Society (he was the buyer of works from 1 July to 31 December 1913), intended to reflect the work of the Omega group, must have seemed a little ironic when he presented them for inspection by the committee on 12 December. In those six months he had bought *Adam and Eve* by Grant, *Laughing Woman* by Lewis, *The Natives* by Hamilton, *Woman at a Mirror* by Frederick Etchells, and *Still Life* by Jessie Etchells (but no example by Wadsworth, and, delicately, none by Vanessa Bell). The canvases, of which only the two by Frederick and Jessie Etchells are still extant – the Contemporary Art Society having lost the other three over the intervening years – are worth consideration, since they reveal the work of these artists at the point at which they, with the exception of Grant, quitted the Omega. Lewis's *Laughing Woman* was a large canvas that related to a cartoon of the same subject shown at the Grafton Group exhibition in March. Stylistically *Laughing Woman* and its preparatory works are tangential to items produced by Lewis at the Omega, and it adumbrates much more clearly than his *Circus* screen design and lampshades the direction he was to take. *The Natives* by Hamilton was an oil painting measuring $32 \times 23\frac{1}{2}$ in. It was described in a newspaper review as showing: '. . . women who appear to have undergone the process meted out to the freshly caught lobster',[108] from which one may conclude that Hamilton used the harsh red tonalities soon to be so beloved of Lewis. It is impossible to draw any conclusion about Hamilton's work for the Omega. Only one painting of his is visually recorded from the 1913–19 period, and even that is only known from a 1914 illustration.[109]

Etchells' *Woman at a Mirror*, an oil painting on very thin canvas measuring $45\frac{1}{2} \times 30\frac{1}{8}$ in., was given to Manchester City Art Gallery by the Contemporary Art Society in 1964. It carries on the theme of his three works at the first Grafton Group exhibition, where the chosen subject-matter was a single or double figure composition, the figures being severely distorted. The colours of purple and green were used in a work, *Composition*, at the Grafton Group; and with *Woman at a Mirror* Etchells again used green, with a range of pink, plum, purple and lilac. The two vertical stripes down the right-hand side of the canvas were not characteristic of Etchells, though from 1913 this device assumed importance in the work of Vanessa Bell and Grant. Fry, Bell and Grant all admired Etchells as an artist, and the Omega gave him the opportunity to

produce some splendidly bold rug designs, and probably other items. The brilliant geometric style which he displayed at the Omega was to stand him in good stead in the London *avant-garde* art world during the next couple of years.

Still Life by Jessie Etchells, presented by the Contemporary Art Society to Rochdale Art Gallery by 1924, is one of three known oil paintings by this artist. Nothing can be deduced about her qualities as a designer from these three paintings, only about her admiration for artists such as Van Gogh and Derain. [110] As a female employee of the Omega, she, like Winifred Gill, Nina Hamnett and Gladys Hynes, would have been more occupied with the translation of designs on to artefacts such as fabrics, lampshades, tables and chairs, rather than with creative design. The obvious exception to this was Vanessa Bell because of her status as one of the directors, but even she came in for her share of needlework.

In early November a second illustrated newspaper article was devoted to the activities of the Omega. The paper was the *Daily Mirror*, which on 8 November carried three photographs with captions. Two were of the showrooms at no. 33, while the third was of Fry himself with the caption: 'Would you like your house fitted with Post-Impressionist furniture, carpets and hangings? If you would, go to the Omega Workshops, Fitzroy Square, and Mr. Roger Fry will do the rest.' Photograph 1 bore the caption: 'The kind of cushions you would have on the armchairs', and showed a female figure – possibly Winifred Gill – embroidering a canvas cushion cover. She was seated on a wooden garden bench and surrounded by several large down-filled hand-painted cushions. Of the four most prominent visible examples, three are painted with abstract designs made up of multi-directional strokes, but the fourth bears a simplified and reduced version of Grant's contemporary painting, *The Ass*. [111] This is another unmistakable instance of an original oil painting's translation into the surface decoration of a household object, the limbs of the animal being altered in this case to suit its new use.

Dominating the *Daily Mirror* photograph, above the female embroiderer and the handpainted cushions, were four framed and glazed reproductions from Byzantine mosaics, possibly printed in colour. The largest showed the head of St. Agnes from the procession of the Virgins on the north wall of San Apollinare Nuovo, Ravenna. It was probably a life-size reproduction, since the original detail would be about 3 feet by 2. The head of St. Agnes is the most recognisable detail for the reason that as a portrait head it is a conventional choice. The other three reproductions are most bizarre in their choice of area, the one to the left being the pelvis and leg, in heavily decorated garments, of Caspar, the first Magus, from

the scene of the three Magi, again on the same wall in San Apollinare Nuovo. The remaining two are hands isolated from bodies, one gesturing, the other covered, and holding a jewelled crown. The choice of such unconventional details obscures their original descriptive part in the scene from which they are taken and, particularly in the choice of the area of Caspar's jewelled clothing, enables them to function as abstract pattern.

This visual evidence of an interest in Byzantine art, and especially the Ravenna mosaics, which first emerged in April/May, was reinforced in December by a signboard for the outside of the Omega premises, painted by Grant. The critic P. G. Konody, describing a visit to the Omega in December, referred in his column in the *Observer* to this signboard and its subject of 'an emaciated Byzantine youth'.[112] Grant is known to be the artist responsible for this lost signboard because of a letter from Fry to Grant which urged him to return to London and told him: 'We must have the sign up.'[113] Whether Fry left Grant free to choose the subject-matter for the signboard is unknown, but most probably Fry, with his creed of freedom for the sensibility of the artist, was prepared to accept whatever Grant chose to produce. In a similar way he had left the final design for the poster of the second Post-Impressionist exhibition to Grant, although he approved the subject-matter, and was to do the same with the other Omega signboard which Grant painted, in 1915. The Byzantine youth signboard was probably more eccentric and hermetic than the simple boldness of the second signboard of 1915. Konody used the term 'Byzantine' again in his review of his visit to the Omega, describing the Workshops' decorations as 'Primeval, Byzantine or Barbaric', all adjectives which would have pleased Fry. But what he had meant by a Byzantine youth remains unclear.

Byzantinism of a superficial sort had already reared its head amongst the Fry circle of artists in 1912: superficial in that it was a form of window-dressing. Vanessa Bell and Duncan Grant painted simultaneously the portrait of a woman dressed to look like Theodora from the mosaic panels of the Empress in San Vitale, Ravenna. The circumstances of this portrait are not clear; it could well be that Bell and Grant suggested the costume of the sitter. Again, in May 1912, Grant, designing costumes for a production of *Macbeth* by Granville-Barker, dressed the characters in Byzantine garments and slippers. (Lewis did a drawing in 1912 that he entitled Russian Scene – is there a Byzantine connection here?)

Photograph 2 in the *Daily Mirror* showed the main showroom at the Omega, with the caption, 'The kind of room in which you would live, that is if your nerves could stand it'. Although the view of the showroom is similar to that shown in the photo in the *Daily News and Leader* on 7

August, the room has in the intervening period been filled with a large range of goods. There is a painted table, a painted rush-seated chair, seven painted boxes, two embroidered cushions, a firescreen, an upholstered armchair, painted lampstands, some odd overpainted commercial pottery and a painted chest of drawers. What strikes one most forcibly here is the great variety of styles present: each class of object seems to have evoked a different response from the artists.

On 28 November Fry wrote to Grant, who was staying in Cambridge with Maynard Keynes, begging him to return: 'We are opening early next week . . . There's a 100,001 things to be finished.'[114] Fry was referring to an exhibition at the Omega Workshops which opened in the first week of December. It was to show three rooms, specially arranged and decorated: a sitting-room, which was also the showroom, on the ground floor, and a bedroom and a nursery on the second floor. A printed card was issued as an advertisement. Although an ephemeral item, much care was lavished on it, with a design drawn by Grant and carefully executed lettering by Fry; the card was lithographed. From the ones that remain it can be deduced that each was handpainted in different colours, to make it more individual and less commercial in effect. The first objects confronting guests as they approached 33 Fitzroy Square were the signboard, and two painted panels fixed to recesses in the façade.

As one paces the stately equilateral of Fitzroy-Square there is to be observed a strange stir among the errand boys and loafers who stop to gape at a house in the south-west corner. It is No. 33, the home of 'Omega Workshops, Limited', one of the instruments to the hand of Mr. Roger Fry; and the butcher boy is arrested by the stains of a diluted Post-Impressionism that has filtered through the wall into vacant spaces on the second [sic] floor. These flirting decorations – gay, giddy and slight – might hold their places on some sun-baked wall within the equatorial belt, but . . . they affront the grave decorum of Fitzroy-Square.[115]

At first-floor level on the exterior façade of no. 33, on either side of a large central rectangular window, are shallow niches approximately 6ft 6in. high and 2ft 9in. wide. It was obviously decided when the house was leased that these areas were ideal for decoration, and it seems that Fry asked Duncan Grant to produce a panel. Indeed a design for such a panel, in the Victoria and Albert Museum, bears an inscription (added in 1963 by a member of the staff) stating that Grant thought it was the work either of himself or of Lewis, as he believed they were the two artists who painted the panels.[116] It is possible that Grant and Lewis were originally chosen, but by mid-September the commission had definitely passed to Grant and

Vanessa Bell, who were then staying together at Virginia Woolf's country house, Asheham, in Sussex.

Vanessa's correspondence with Fry, who was still in London organising the Ideal Home Exhibition room, related their progress. They nailed the canvas for the panels to the outside of the house in order to get the right effects, and worked at them outdoors. They chose as subject-matter two pairs of dancing figures dressed in modern clothes. In one letter Vanessa included a sketch of the composition of her panel which reveals the design in the Victoria and Albert Museum to be hers. She explained to Fry that as well as using yellow, green and Venetian red, she and Grant were applying a lot of black and white, in order to create a striking and eye-catching effect. Her considerations were only aesthetic ones and that is why she wrote: 'Marjorie Strachey thinks them hideous and that we shall be stopped by the police but I can't see what she means.'[117] The canvases were painted in the week 17–24 September 1913, and they were in position, to judge by a newspaper review, at the beginning of December.

Of the three rooms on display in December, only the nursery was visually recorded through two contemporary black and white photographs; the other rooms, without new mural decorations, received only verbal descriptions. The most thorough account of the colour scheme of the nursery is given by P. G. Konody in his *Observer* article entitled 'Post-Impressionism in the Home':

Here, long before evil habits have been formed, the prattling infant is to be led, all unconsciously, into the gay groves of Post-Impressionism . . . The floor is laid with brilliant yellow felt . . . The curtains are yellow also, and a long space of wall is decorated by a master-mind, in which one rather suspects the dominating influence of Mr. Roger Fry. It is – well, a landscape, expressed with some freedom. A blue, uneasy ribbon of colour is a range of mountains; a paler blue blob is a pond, and, unmistakably, on the stretch of yellow that may be sand, is the black silhouette of a huge mammoth elephant . . . Above on the roof a terrific sky is in progress, and what one takes to be a sunset is stuck on to the cornice. The whole room is gaudy with an effect like a piano-organ.[118]

The photograph offers signs that this mural decoration was painted on cut paper shapes which were then stuck to the walls. The evidence for this is what look like seams of overlapping paper just below the line where wall meets ceiling, and again an edge of paper wrapping round the dark angle of wall at the very left of the photo. Certainly it might have seemed more expedient to produce removable exhibition murals rather than actually painting the walls.

The style of the mural is not directly related to either the *Blue Lagoons* in

another room at the Omega or the panels of dancing figures included in the Ideal Home sitting-room. This inconsistency is characteristic of Omega schemes, since different hands were responsible for different commissions, employees changing over the six years of the Workshops' existence. On stylistic grounds the nursery murals have been attributed to Vanessa Bell. They would indeed fit the general development of her work from 1910 onwards, in which there is a gradual simplification of elements in the composition, an insistence on contour and silhouette, and an increasing use of thin vertical strips of colour.[119] Also, in August 1913 she had painted the walls of her sons' nursery at 46 Gordon Square with 'lions stalking zebras and jaguars pouncing on deer'.[120] It seems probable that Fry commissioned her to paint a nursery for the Omega Workshops after seeing her talents thus displayed in her own home.

The effect of the two other rooms seems to have been discordant, if we again take the word of P. G. Konody:

One seeks in vain for any dominating idea or central motive in the decoration or furnishing of these rooms. The impression derived from all of them is merely surface decoration – often superfluous – and not substance or structure. Things are not decorated, but disguised; they are to be looked at, not to be used. Pink chairs are there to be pink and not to be sat upon; tables are heavily laden with formless wriggles of paint which disturb the eye and serve no useful purpose; carpets and rugs cry out from the floor to rebuke the foot that would tread upon them; and restless screens seem to topple under the weight of cramped Post-Impressionist landscapes that offer neither beauty nor illusion.

But, *pace* Konody, by the end of 1913 the Workshops had been established. After a hesitant start and difficulty over personalities the group had begun to produce a good body of work and had staged several exhibitions.

4
SALONS AND CAFÉS:
1914

In the last few days of 1913, Fry sent a note to Gaudier-Brzeska to remind him of arrangements concerning his participation in the second Grafton Group exhibition: 'We shall be hanging at the Alpine Club on Thursday evening. Would you bring your things there then. I hope you have some more besides these.'[1] The brief note gives no indication of what Fry meant by 'these', but it can be taken to imply the existence of some works by Gaudier at the Omega Workshops. The Thursday of the note was 1 January 1914, and for the rest of the month, from Friday 2nd, the Grafton Group held their second exhibition at the Alpine Club Gallery.

The first Grafton Group exhibition had taken place at the same venue in March 1913, but between then and January 1914 the group's membership had changed. Only the triumvirate of Fry, Bell and Grant remained from the original five artists, Lewis and Etchells having left the group, as we have seen. Fry had given Lewis the chance to participate in the second Grafton Group exhibition, sending him a typed circular on 13 November reminding him that members must contribute £8 each toward the rental of the Alpine Club Gallery.[2] If no contribution was received by a certain date, then the artist forfeited his membership of the group. Quite possibly Fry sent a similar notice to Frederick Etchells, but his personal papers have not been preserved. Fry's offer to Lewis, and probably to Etchells, of an opportunity to exhibit again with the Grafton Group may indicate that, to Fry, the break between them was not irreparable. However, Lewis and Etchells were not of the same opinion, since they did not take up the opportunity thus offered.

In 1913 nine sympathetic British artists had been invited to exhibit along with the five Grafton Group members; in 1914, for his supporting cast of exhibitors, Fry turned to a different set – this time eight young French artists. He also decided to include sculpture. This decision was no

doubt motivated by the recent addition of Gaudier-Brzeska as an employee of the Omega Workshops.

Gaudier-Brzeska was introduced to Fry by Nina Hamnett sometime around October 1913, as an artist in need of financial support, and Fry decided to help him. Gaudier's talents as a sculptor and draughtsman did not fit too easily into the design activities of the Omega, and Fry's offer must have been more in the nature of a subsidy, or contract, in order that he could continue to work as a sculptor. 'He never actually worked there [33 Fitzroy Square] but we sold drawings of his and small pieces of sculpture on commission and he looked in fairly often, probably to see if we owed him anything and to bring in fresh stuff. He never stayed for long.'³ Whether Winifred Gill here meant to refer to odd visits or to his length of contract with the Omega is unclear. Be that as it may, in general terms she was correct, since his association with the Omega only lasted for about nine months, until June or July 1914. He then decided to affiliate himself with the developing Vorticist movement and play a part in the life of the Omega's rival decorative venture, the Rebel Art Centre.

The five sculptures by Gaudier exhibited at the second Grafton Group exhibition were *Vase* in marble, *Boy* in alabaster, *Fawn* in stone, *Cat* in marble, and *Dancer* in red stone. All of these were being exhibited for the first time. All comprised either naked figures or animals, for even the vase is in fact a naked figure. Both categories were typical of Gaudier, and fitted in well with the subject-matter preferred by the Omega. Of these five sculptures four were accredited as belonging to Fry and the Omega, in a list which Gaudier compiled on 9 July 1914 which contained all the works he had produced up to that date. It is unclear whether Gaudier implied that Fry, through the Omega, commissioned the works, or just provided the means whereby they could come into being. The fifth work, the red stone *Dancer*, was not linked with the Omega by Gaudier; also his list dated the work as 1914, which seems unlikely as it was already being exhibited by 2 January of that year. Only one of Gaudier's works was sold at the second Grafton Group exhibition: the *Fawn* was bought by Mrs. Mayor of Campden Hill for £15, of which the Omega took 25 per cent commission. The other works were still unsold at his death; *Boy*, *Cat*, and *Vase* remained the property of the Omega, while *Dancer* passed to Sophie Brzeska.

After Gaudier's death on 5 June 1915 fighting at the front at Neuville St Vaast, Ezra Pound attempted to promote his friend's work to the American collector John Quinn. (At that time Pound was writing Gaudier's biography.) He wrote to Quinn in July to inform him of

Gaudier's death, and probably urged him to purchase the unsold works. Quinn wrote back the same month asking Pound to buy for him everything of Gaudier's he could lay his hands on, and sent drafts of £10 and £30 to be used as deposits. Pound visited the Omega Workshops in the first week of September and deposited £30 to 'hold down their little lot'. An official Omega receipt recorded this £30 deposit for the two sculptures '*Water Carrier – vase*' and '*Cat*' as being paid on 7 September 1915, and a further £12 10s completing and paid invoice on 7 February 1916. By August 1916 Quinn was in possession of the '*Water Carrier – vase*' and the *Cat*.[4]

A further sculpture which Gaudier catalogued in his 9 July list as belonging to the Omega was the marble group, *Maternity*. Its probable date is late 1913 or early 1914. A date of *c*. February 1914 would fit: whereas Gaudier did not include it in the second Grafton Group exhibition, it was shown in the first London Group exhibition in March 1914. As with the sale of *Fawn*, Gaudier's 9 July list stated that *Maternity* was 'to be sold by the Omega Workshops for £20, ¼ of which was commission'. Twenty pounds was not reckoned to be a high price. Gaudier's five entries in the second Grafton Group exhibition ranged from *Fawn* at £15 to '*Dancer – red stone*' at £50. The Omega must have taken over the responsibility for *Maternity* between 20 June (the last day of the exhibition 'Twentieth-Century Art', held at the Whitechapel Art Gallery, London, in which *Maternity* was on show described as lent by the artist) and 9 July, when Gaudier compiled his list. The first time that *Maternity* was reproduced was in August 1916, when Fry wrote an article on Gaudier, published in that month's issue of the *Burlington Magazine*, in response to Ezra Pound's newly published biography of the artist. Fry's *Burlington* article was accompanied by five illustrations, two of *Maternity* and three of works which Gaudier executed for the Omega Workshops: the earthenware *Cat*, a plaster design for a woodwork newel, and a marquetry tray – *The Wrestlers*.

Two of these three works are still extant. The earthenware *Cat* exists in more than one version, reflecting its status as a mould-made piece which could be turned out in quantity. Gaudier did not include this *Cat* in his list of 9 July, probably because by this time it did not satisfy his demanding conditions for a sculpture. Pound, in his biography, included a partial catalogue of the sculpture, where as number 26 he listed: 'Model of cat for porcelain. (Omega shops)'. Pound did not mention the medium of this work, but an examination of the pottery cat indicates hardened clay as the model's most probable original material. Plaster or alabaster are not suitable materials from which to take a mould, and the pottery *Cat* has the dragged smooth surface typical of hardened clay. Gaudier owned a cat,

given to him by Spencer Gore, and he made numerous pen and pencil
sketches of it. A sheet of paper on one side of which he wrote his review of
the Allied Artists' Association exhibition at Holland Park Hall (published
in *The Egoist* on 15 June 1914) bears on the other side four sketchy pencil
drawings of a cat seated in a hunched position, the pose of the pottery cat,
one of which shows it on a small pedestal. A more assured drawing exists of
a cat adopting the pose of the pottery cat with its forelegs crossed, but
without any indication of a pedestal.[5] It thus seems that the three-
dimensional version of the cat was well worked out first in two dimensions.

Critical comment on the pottery cat has made references to an affinity
with small Chinese sculptures of animals. Gaudier himself alluded to
Chinese animal figures when referring in his review to his own sculpture
on show at the Allied Artists' Association exhibition at Holland Park
Hall. Earlier Pound, in *The Egoist*, had described Gaudier's *Boy with a
Rabbit* as Chinese Chou; Gaudier replied: 'Boy with a Rabbit . . . has
been referred to . . . as an echo of the bronze animals of the Chow
dynasty. It is better than they. They had, it is true, a maturity brought by
continuous rotundities – my statuette has more monumental concentra-
tion – the result of the use of flat and round surfaces.'[6] Perhaps, if he could
have included the pottery *Cat* in his definition of sculpture, Gaudier would
have praised that similarly. None of the three works, *Cat*, 'newel' or 'tray',
which Fry illustrated as Omega works in the *Burlington Magazine* article,
would have been considered by Gaudier as major works. Their decorative
or functional values would not have condemned them, but their
translation from one medium into another would. The cat was modelled in
clay in order for a mould to be made from it; the plaster design for a
woodwork newel again implies a change of material, and the marquetry
tray was executed by hands other than Gaudier's. He thought of sculpture
as a virile, direct art: 'The sculpture I admire is the work of master
craftsmen. Every inch of the surface is won at the point of the chisel –
every stroke of the hammer is a physical and a mental effort. No more
arbitrary translations of a design in any material.'[7] His work for the Omega
could not be that of producing pieces directly out of a hard material like
wood, stone or brass; rather it was preparation in a softer material: clay,
plaster, a finished drawing. The only time he received the chance to carve
was to produce two large stone vases for the home of Lady Hamilton. Even
then two plaster maquettes had to be made first; and when Gaudier began
to work directly on the stone, its hardness and the shortness of time left to
work it combined to defeat him.

The plaster design for a woodwork newel is known only through the
illustration in the *Burlington* article. No size was given, but it is unlikely to

have exceeded his figurative sculptures' average height of about 18 inches. The compact figure displayed 'peculiar bluntness and yet sweetness of form', the qualities by which Fry believed Gaudier's sculpture could be distinguished. Although this plaster figure, a seated male nude, was made so that a copy could be executed in wood, Gaudier did not let slip the chance to work direct. Instead of modelling the figure first in clay and then casting it in plaster, the illustration shows that the plaster itself has been carved into shape with a claw chisel. Drawn chalk lines marking the edge of a plane are still visible on the figure, and a vertical mark on the base possibly indicates the reduction of the base to make it fit on to the newel-post for which it was designed, possibly for Lady Hamilton's hall. Gaudier cannot have been too displeased with this figure or he would not have cut his monogram into the base, a detail just visible in the illustration. It did not receive an entry in his list of 9 July; but with the outbreak of war he added an appendix on 5 August, and probably the entry 'With Roger Fry . . . one design in plaster' referred to it. Pound, in his catalogue of Gaudier's sculpture, described it as 'Boy, in plaster. Omega shops, unimportant'.

Gaudier's third work initiated through the Omega, and illustrated in the *Burlington* article, was his marquetry tray. Not surprisingly, it was not included in either Gaudier's or Pound's list of his sculptures. The caption in the *Burlington Magazine* gave it the title *The Wrestlers*, perhaps bestowed by Fry. The drawing on which its design was based belonged to the series of works – drawings, a plaster relief and a lino-cut – which stemmed from Gaudier's visits to the London Wrestling Club, off Fleet Street, where he was taken by Major Charles Wheeler.

H. S. Ede in his book *Savage Messiah* related how Fry was pleased with the work that Gaudier showed him at their first meeting at the Omega Workshops; and as a result Fry 'ordered a special poster, and also a tray, for which Pik [Gaudier] might expect a few pounds'.[8] Such a commission, for a guaranteed fee, lay outside the usual arrangements at the Omega Workshops, where artists were paid for their hours of attendance and not for particular pieces. Nina Hamnett offered a different interpretation which is perhaps nearer the truth: 'I brought Henri [Gaudier-Brzeska] round one day and he did a design for a tray which was eventually carried out in inlaid woods.'[9] Gaudier's design for a marquetry tray may have been one of his first activities at the Omega in the winter of 1913; certainly at that very time Grant and Bell were also producing designs for marquetry trays.

Another project which was probably undertaken in the winter of 1913 was Gaudier's maquette for a bird-bath. This commission was for Fry's

home, Durbins, and would have served as a companion piece to the nude commissioned from Eric Gill in 1910–11, already situated in the garden. An inscription cut into the plaster base of the maquette indicated that the scale was to be increased sixfold, which would have resulted in a work nearly 4½ feet in height. If executed, this work would have constituted Gaudier's largest sculpture.

Another commission from Fry for some comparable ornaments, this time under the umbrella of the Omega Workshops, was offered to Gaudier in the spring of 1914. The Omega Workshops had received a commission from Lady Ian Hamilton to transform the entrance hall of her London home at 1 Hyde Park Gardens. The floor, walls and ceiling were treated in the following months to a bright metamorphosis, the floor being covered with mosaic and the walls and ceiling with a patterned striped textile. It was intended to include within this colourful scheme two unusual stone flower-vases, carved by Gaudier. Two plaster maquettes remain,[10] but which in no way make up a pair. Possibly they represent two separate solutions to the problem of how the stone flower-vases were to look. Neither maquette found its way into Gaudier's list of 9 July or into the appendix to it of 5 August; but then he was not in the habit of including maquettes, only finished works. One of the plaster maquettes is constructed from elements of two human figures, who possibly kneel, and who bear the weight of a large, tall and narrow bowl on upraised arms. The second maquette – about half the height, 13¾ in. as opposed to 25 in. – is more abstract. It comprises three pairs of vestigial arm-like forms, with crude human faces inscribed into the outside plane of each of the six arms, and a wide shallow bowl at the top. The photograph of the entrance hall at 1 Hyde Park Gardens appeared on page 5 of the *Omega Workshops Descriptive Catalogue*, published in the autumn of 1914. It showed two stone vases on turned stone shafts, but these were obviously commercial replacements for the two stone vases which Gaudier failed to execute before he left to join the French army in August 1914. His friend Horace Brodzky offered further details of this commission:

The open space in front of the arch was the scene of his last – and his largest – carving. It was never finished. The work was unsuited to him, and absolutely beyond his powers, but this time his vanity had got the better of him. This job was a commission secured not very long before his departure for the Front. Two huge blocks of rough stone had been dumped into the yard one afternoon when I arrived . . . leaving Brzeska, looking like an ant beside them, to get on as best he could. He was expected to convert these masses of greyish stone into two vast garden vases, and the job came, if I remember rightly, through the Omega Workshops.[11]

Brodzky related how the stone proved too hard for Gaudier's chisels, breaking them repeatedly. After working on them for several days Gaudier had only managed to carve a shallow groove in the top surface of one of them. In October 1914 Brodzky visited Gaudier's studio: 'The stones lay there in the yard, the grass sprouting about them, now firmly embedded by their weight in the ground.' He visited the studio again on 29 June 1915 – whether in response to news of Gaudier's death we do not know – and made two drawings of the exterior and interior, the interior view showing one of the stones which had been intended as Lady Hamilton's vase.[12]

With Gaudier's departure for the front in August 1914 his association with the Omega was severed. From the autumn of the previous year he had enjoyed a useful partnership with Fry's workshops, which had provided him with materials and a means of subsistence. It had drawn out that side of him which had attempted before to work in design but had always failed.[13]

The list of exhibitors at the first Grafton Group exhibition in March 1913 had reflected the circle of artists around Fry at that moment. Similarly, the exhibitors at the second Grafton Group exhibition, after the secession of Lewis, Etchells, Hamilton and Wadsworth in October 1913, included artists currently engaged by the Omega Workshops. It also included a group of French artists whose mentor, Charles Vildrac, had run his own gallery in the rue de Seine, Paris, from 1909. Vildrac sent about fifteen canvases by French artists – Chabaud, Doucet, Friesz, Lhôte, Marchand and Vilette – and Fry hung them alongside his own works and those of Vanessa Bell, Duncan Grant, Winifred Gill, Nina Hamnett and William Roberts, as well as a Derain and a Picasso owned by himself.

Hamnett and Roberts had only been affiliated to the Omega for a couple of months, and this was their first chance to exhibit their paintings as members of Fry's select group. Hamnett was in fact chosen to be the secretary of the exhibition.[14] Her exhibiting debut had been at the sixth London Salon of the Allied Artists' Association in July 1913. She had shown three portraits, a genre which was to dominate all others in her work; her one exhibit in the second Grafton Group exhibition, *Head of a Girl*, kept to this theme. Her address given in the catalogue of the Allied Artists' Association exhibition was 41 Grafton Street, off Fitzroy Square; and it was possibly her proximity to the premises of the Omega Workshops that led her to seek membership. She described how she was encouraged to make that approach, but gave no indication of the source of the advice:

One day somebody said 'You might get a job to paint furniture and do decorative work at the Omega Workshops . . .' Feeling brave one morning I

went to Fitzroy Square, and asked to see Mr. Fry. He was a charming man with grey hair, and said that I could come round the next day and start work. I went round and was shown how to do Batiks. I was paid by the hour. I made 2 or 3 pounds a week and felt like a millionaire.[15]

Although Nina Hamnett's reminiscences were often far from accurate, this one is instructive. She did not imply that she took round any work for Fry to see, and if we accept her words it would seem that Fry took her on without judging her artistic capabilities. Whereas Gaudier had arrived with some drawings and Roberts with a letter of introduction, Fry did not seem to expect so much previous experience from his women artists. Nina Hamnett recorded that she was immediately assigned to working with textiles, an area almost exclusively reserved for the female employees. Like her, several other artists had walked into 33 Fitzroy Square in search of employment and patronage, but it was rare for that approach to be successful. Winifred Gill remembered what usually ensued:

Sometimes Roger would politely refuse them, always a difficult thing to do. The phrase he hit upon as being likely to be the least hurtful, was that their work did not 'interest' him. It was, I think, colour that was the deciding factor. I remember a young German who was given a parasol to paint. He didn't qualify. Roger said of him that although his line was not so bad, his colour was 'absolutely bloody' which might be fairly translated as 'muddy'.[16]

Fry's preferred method of seeking out employees was to visit exhibitions and art schools and choose the talent that he liked. Paul Nash and Alvaro Guevara were certainly chosen in this way.

As with Hamnett, the second Grafton Group exhibition in January 1914 was William Roberts' second public exhibition. His entry was entitled *Figure Composition*, and given such a general title it is not possible to identify the work from what remains extant. It is not even possible to say whether it was still in the abstracted figurative vein of his first exhibit, *Ulysses*, shown a month before, or whether he had moved further along the road of abstraction. Charles Marriott in the *Evening Standard* described Roberts' *Figure Composition* as a good exercise in abstract design. In his later writings Roberts implied that his work at the Omega had affected his experiments with abstraction. It is also evident from his writings that, although he did not stay at the Omega long enough to produce many designs, he held the venture in great respect and continued to do so for many years. Writing in 1957, he recalled: 'Whilst at the Omega, I was interested; after leaving the Omega I was interested; and today I am still interested in the originality and quality of the designs and decorations for textiles, fabrics and furniture that the Omega produced.'[17]

By early 1914 the Omega was having an effect on the London art world. Artists who had not been chosen by Fry were jealous, and those who had left the Omega stirred up antagonism. Fry wrote to friends: 'I find I get more and more hated for trying to do something. The Omega especially has stirred up all the worst feelings. It's odd, and I should be so popular if I did nothing,' and 'The Lewis gang do nothing else even now but abuse me. Brzeska, who sees them, says he's never seen such a display of vindictive jealousy among artists.'[18] It seems also, according to a letter from Vanessa Bell to Roger Fry, that a few artists attempted to infiltrate the organisation and then alter its structure to suit their own purposes, with David Bomberg as ringleader:

I think Bomberg and Co. are intolerable. You must simply treat them in a perfectly cold business-like way. After all it is purely a business matter and you haven't really any choice. You are bound to use the money as economically as you can and to get the best value possible and none of these people are indispensable. Roberts is very good but I believe you will be able to get hold of all sorts of quite good people now and it's absurd they should give themselves these airs.[19]

Although his working period was short, Roberts was obviously valued by Fry and Bell. Roberts' happy ability to fit in with the work at the Omega was regarded by outsiders as an attempt to ingratiate himself into Fry's circle. John Currie wrote to Edward Marsh: 'Bobby [Roberts] is mixed up with the Omega Workshops and has very little but things he's been doing specially to please Fry so that he could get work.'[20] In his autobiographical writings Roberts gave no indication as to why or when he left the Omega, and there is no Omega work by Roberts still extant. He probably left in the spring of 1914 to pursue an independent path, but by June of that year he was affiliated closely enough with the Vorticists to be one of the signatories to their manifesto, which was published in the first issue of their magazine, *Blast.*

After hanging the second Grafton Group exhibition at the Alpine Club Gallery Fry wrote to his friend Vildrac:

The French pictures do not stand out from ours . . . I believe our mutual understanding has been so greatly to our advantage that now we are beginning to construct real pictures . . . But we must always be strengthening the bonds between us to help the true aesthetic to emerge here where they really only like the romantic and the sentimental.[21]

If, as Fry wrote, the English contingent were beginning to construct 'real' pictures, what in his terms was a real picture like? The three English works in the exhibition which received the fullest critical attention from

reviewers were Grant's *Adam and Eve* and *The Ass*, and Vanessa Bell's *Women and Baby*. Only *The Ass* is still extant; the other two works are known only by contemporary photographs. Fry bought both *The Ass* and *Women and Baby* at this time, and Clive Bell bought *Adam and Eve* for the Contemporary Art Society a couple of months earlier. On that evidence alone the three works must have appeared as successful and, most probably, 'real' pictures. Fry's oft-quoted phrases from his second Post-Impressionist exhibition catalogue – 'The French Post-Impressionists' – reveal the qualities of a real picture: '. . . these artists do not seek to give what can, after all, be but a pale reflex of actual appearance, but to arouse the conviction of a new and definite reality. They do not seek to imitate form, but to create form.' At the end of January 1914, giving a lecture at Bournemouth to coincide with an exhibition of works belonging to the Contemporary Art Society – and taking the opportunity to attempt to explain to his audience the aims and achievements of the English Post-Impressionists – Fry said:

> There was no expression in art without distortion. The moment the artist became conscious of any feeling for his subject distortion was inevitable. Distortion was necessary if the artist was to convey to other people what he felt about a thing. They, the English Post-Impressionists, were trying to emphasise that. They wanted people to look at a picture and not through it at some other reality of which it reminded them. They wanted the picture to be the reality and not the echo of the reality.[22]

Grant's *The Ass*, although being exhibited for the first time in the second Grafton Group exhibition, had been presaged in November, when a painted cushion copied from it was included in a newspaper photograph of Omega articles. Although Fry bought Grant's painting, he made no recorded comment on it until several years later: 'With The Ass, the decorative element is . . . marked. It has a rich pattern effect almost like a tapestry with however suggestions of plastic movements which give it a great force.'[23] He was also to say of his other purchase, *Women and Baby*, at a later date:

> It is of peculiar interest as a case where the point of departure was psychological, though the état d'âme translated itself at once into purely plastic and spatial terms. It is also clear that all the artist's conscious effort was concentrated on these and that the psychological nucleus of the whole design had rapidly faded from the conscious field.[24]

The key word to be found in both quotations is 'plastic', a quality to be experienced throughout both canvases and one of primary importance, counter to the English tendency towards narrative and illustration.

Unfortunately, reviewers concentrated on the content more than the formal aspects of these two works, commenting on the character and expression of *The Ass* and on the poignancy and pathos of the figures in *Women and Baby*. No single reviewer thought to point out the contrast effected by showing the applied art alongside the fine art, as they had with the first Grafton Group exhibition. The examples of applied art included in the second exhibition were two painted screens, one by Vanessa Bell and the other by Fry (although the catalogue entry lists it as by Grant), and two designs, one by Bell for a screen and one by Grant for needlework. Bell's extant painted screen, *Bathers in a Landscape*, could well have been the one in the exhibition. Surprisingly, though, no reviewer referred to it. The *Bathers in a Landscape* screen is fascinating because three other works by Bell relate to it, and together they offer good evidence of her method of working.

In the middle of August 1913 Bell and Grant, accompanied by Maynard Keynes and Fry for some of the time, went on a camping holiday at Brandon, near Thetford in Norfolk. The party also included other friends, the four Olivier sisters Daphne, Brynhild, Margery and Noel. The camp, from the evidence of paintings of it, consisted of three tents set up in a field surrounded by dense woodland. Bell's first attempt was a sketch of the three tents in the field, painted in oil on board. This was abandoned, and the board reversed, for an angular drawing of a female figure in front of the likewise angular lines of a single tent. Bell then returned to her original idea of the tents in the field. In an oil painting on canvas, *Summer Camp*, she produced a more complicated composition, with five people arranged in a symmetrical manner in front of the three tents. (Grant, taking a more distant viewpoint, painted a canvas showing the three tents and some background trees, but no figures.) Bell's canvas with the five figures then became a basis for the design of a four-leaved painted screen. The layout of the composition was retained, while the colour harmonies, tonal contrasts and figure details were all altered – but then the painted screen was over four times the area of the original canvas.

In the screen the emphasis was vertical, whereas the paintings had a horizontal basis. In the painting of five people in front of the tents, the horizontal direction was reinforced by a horizontal line, sketched about two thirds up the canvas. This division had previously been used in Bell's *Iceland Poppies* of 1909. In her screen she pencilled this horizon line lower down, at the halfway level. Later she rejected this division, so that the screen bears no horizontal break; nonetheless, it features in the pencil under-drawing in two other works by her. The first was the portrait of Frederick and Jessie Etchells, painted in the autumn of 1912. Here, a

careful examination of the laying in of the contours reveals that there was a strong horizontal division of the canvas, about halfway up, which was subsequently painted out. (An extra vertical window-jamb in the preliminary drawing also disappeared.) The same aggressive horizontal division was also eliminated from her finished sketch design for an Omega rug for the home of Lady Ian Hamilton, executed in the spring of 1914. The design is made up of three rectangles, each surrounded by a wide red border; and a similar border originally ran horizontally across the exact centre of the composition. Indeed, it would not be too fanciful to see Bell's Hamilton rug design as yet another work in the progressive abstraction from a naturalistic beginning of three tents in a field. The directional lines of the Hamilton rug bear a close relationship to the angles of canvas and tent-poles which appear in the painted screen.

If the *Bathers in a Landscape* screen was the one exhibited in the second Grafton Group exhibition, it, along with one by Fry, was highly priced at £20. This was not a great deal compared with the price on some of the paintings on show, but as a piece of applied art produced by the Omega Workshops it was expensive. In the *Omega Workshops Descriptive Catalogue*, produced in the autumn of 1914, the highest price was £12 12s 0d for a large velvet settee – articles of painted furniture all costing less. However, the entry for painted screens has no listed price; and every single screen had obviously to be priced according to criteria of size, medium, etc. Of the three works by Vanessa Bell in the second Grafton Group exhibition which, by virtue of their titles, can be linked to this painted screen, it is instructive to look at their prices. A painting, *Tents* – possibly the painting of five people in front of the tents – was offered at £10, an average price for a small oil painting by Bell. And as we have seen, the painted screen was offered at £20. But the highest price was reserved for *Design for a Screen*, at £25. This cannot conceivably have been as large as the painted screen, and must have been priced in relation to quality rather than quantity. From one tiny mention in a review, this design seems to have been abstract. As one cannot speculate whether Bell priced abstracts higher than figurative works, it may be that she assigned this high price because she particularly liked the work. By comparison Grant's design for needlework was only priced at £10; this would have been a smaller work, scaled for cushions and chair-backs.

The painted screen Fry showed at the second Grafton Group exhibition is probably the one extant. This is known as the *Provençal Landscape* screen, the only Omega painted screen with a purely landscape subject. Fry showed ten landscape paintings here, plus a still life. Most of the titles reveal the works' origin in the painting trip which Fry took with Henri

Doucet in October 1913 in Provence, around Aramon and Villeneuve-les-Avignon. In most reviews of the exhibition Fry's landscapes, and even the painted screen, received praise. For example: 'In each of them one feels there is something seen, and in each simplification is used only to bring the forms more closely into relations with each other and to emphasize weight and mass.'[25] The screen and the oil paintings were thus discussed in the same terms, because Fry's fine and applied art works were recognised as being in the same style.

Two reviews commented on the suitability of the current Grafton Group members for decorative work. Of these, one regretted that the Church's demise as the major patron of large-scale decorative schemes had left appropriate painters hard-pressed to find any replacement:

If Mr. Fry were to volunteer the entire redecoration and repewing of the City Temple . . . there is no saying how greatly he might advance the well-being of the profession of painting by restoring to it the great patron under whose protection it was first fostered. Mrs. Bell might undertake the Synagogues again, and Mr. Duncan Grant the Wesleyan Chapels, leaving the Church of England for the Academy.[26]

T. E. Hulme, in *The New Age*, was not prepared to consider such a wide scope for the Grafton Group. He thought their talents would only appeal to a tiny domestic minority, rather than to national public institutions. Describing Grant's *Adam and Eve* and *The Ass*, he called them jokey and amusing; he then continued on the exhibition as a whole:

It is all amusing enough in its way, a sort of aesthetic playing about. It can best be described in fact as a new disguise of aestheticism . . . At first appearance the pictures seem to have no resemblance to pre-Raphaelitism. But when the spectator has overcome his first mild shock and is familiarised with them, he will perceive the fundamental likeness. Their 'queerness', such as it is, is not the same serious queerness of the pre-Raphaelites, it is perhaps only quaint and playful; but essentially the same cultured reminiscent pleasure is given to the spectator. This being the basic constituent of both arts, just as the one ultimately declined into Liberty's, so there is no reason why the other should not find its grave in some emporium which will provide the wives of young and advanced dons with suitable house decoration.[27]

Hulme's acerbic comments contained a kernel of truth, since his view that the whole show had a 'typically Cambridge sort of atmosphere' was not far from a description of the circle of Fry's patrons.

At the end of the run of the Grafton Group exhibition, Fry wrote to his friend, Robert Trevelyan: 'I've seen P. Nash and arranged for him to come later on and try his hand at decorative work. We shall see how he turns out. It's a good test of where his real power lies. He has imagination of

some kind if he can only find the way in which to use it. Also he's very sympathetic and I should like to have him with us.'[28] Fry wrote to Trevelyan in this vein because Trevelyan had known Nash longer than him. Nash's biographer, Anthony Bertram, recalled how in November 1912, when Trevelyan mentioned 'Roger', Nash 'was still innocent enough to ask "Roger Who?"'.[29] In September 1913 Nash wrote to his future wife of his hopes for art: '. . . especially . . . my half-articulated scheme of things for establishing artists in a real status in the business of life . . . If we will all work at producing drawings, paintings, decorated furniture, etc, and make a real effort to produce new and beautiful things in these directions.'[30]

Nash's half-articulated scheme to help artists was based not on a friendship with Fry but with another sympathetic artist, William Rothenstein, who was willing to lend his house as a base for shows and activities. This scheme came to nothing, however. Meanwhile, even though the Omega existed by the time Nash wrote this letter, he seemed unaware that it went a long way to fulfilling his personal hopes for art and artists. These hopes, shared with his wife, were the early beginnings of a passion which was to be central to Nash's thought concerning the artist in society, and it was no wonder Fry spoke of Nash as being sympathetic.

In November 1913 Paul Nash and his brother John held a two-man exhibition of their work at the Dorien Leigh Gallery at South Kensington. Fry was as much impressed by Nash's work there as he had been by his entries to the New English Art Club's exhibition in the spring of 1913. As a result he offered an invitation to Nash in January 1914 to join the Omega Workshops. We know Nash began to work at the Omega from the third week in February, because he told his fiancée on 12 February: 'I start work at the Omega next week.' By the first week in March he wrote to Edward Marsh, a new friend, that he was 'making endless notes and sketches for designs destined for Omega' and 'now I must go and paint my next candlestick'.[31] By 10 March, however, his association with the Omega appears to have been terminated, with the decision to leave taken by Nash himself; he wrote again to his fiancée on that date: 'The Omega can go to the Devil. I shan't be there.'[32] His association lasted about three weeks, and he cannot have contributed much. It may be that, with no great decorative commission under way – even though Lady Hamilton's interior decorations at 1 Hyde Park Gardens were on the books – Nash was set to do very routine tasks. His reference to his 'next candlestick' implies he had already painted more than one, and this was usually a task which fell to the women artists like Winifred Gill or Nina Hamnett. Fry was

probably cautiously testing Nash's decorative abilities, but for Nash the process was too long-winded.

Although Nash's time at the Omega was very short and nothing can be attributed to his hand, he was moved enough by the printed textiles and the decoration of an antechamber room to include a description of them in an article – 'Modern English Textiles' – in 1926, and in a book – *Room and Book* – in 1932. In the article he said: 'I think it is fair to say that the modern movement in textile design began with the establishment of the Omega Workshops a year or two before the War.' In *Room and Book* his comments on the Omega linked Fry's efforts back to Morris and the nineteenth century, rather than placing them in a class of their own.

One illustration in *Room and Book* was a photograph of a room decorated by the Omega Workshops. In his preface Nash thanked those who had provided him with illustrations, and since Fry's name was included the photograph must have come from him. It had appeared in the *Omega Workshops Descriptive Catalogue* with the caption, 'Wall Decorations in Antechamber'. Nash's caption merely stated: 'Omega room (circa 1913)', possibly the result of relying in 1932 on Fry for such information. Grant always held the opinion that the photograph showed a room decorated by himself, Vanessa Bell and Fry on the first floor of 17 Bedford Square, the town house of Henry Harris, a colleague of Fry's. However, neither the Omega catalogue nor Nash's book gave the illustration a location. From an examination of the room in the photograph, it appears, from the level of the mantelpiece, that the walls were only about eight feet in height, with no windows apparent. No room on such a small scale with such features exists anywhere at 17 Bedford Square. The Omega catalogue is itself confusing, in that every other interior decorative scheme illustrated by a photograph gives the address in the caption. The antechamber photograph followed photographs of the entrance hall at 1 Hyde Park Gardens. Stylistically, however, the two interiors are unrelated. The only way to place the antechamber decorations is to date them by stylistic evidence. This suggests they were executed at the end of 1913 or the very beginning of 1914. It may even be that Nash illustrated this antechamber in his book because he had first-hand knowledge of it, possibly even attending its unveiling during his short affiliation with the Omega.

The objects in the room reflect a date in the winter of 1913. The fire-screen, or one remarkably similar (designed by Grant), appeared in a photograph of the Omega showroom in the *Daily Mirror* on 8 November 1913. A wooden *Group* by Fry on the mantelpiece is believed to have been first shown in the Omega sitting-room at the Ideal Home Exhibition in

October. The two painted vases show the beginnings of Fry's attempts at pottery-making and decorating, which only began in earnest in the late autumn of 1913. Nash's caption to the photograph gave the names of the artists involved. (Even without this evidence, though, it would be possible to detect the hands of Grant and Bell.) It described the decoration of the room as a 'scheme evolved by Duncan Grant and executed by him, Vanessa Bell and Roger Fry'. Nash also went on to say: 'The character of the decoration is very spontaneous and lively.' This is certainly true of the sinuous, meandering infilling of a wide strip at the bottom of the walls, which would be difficult to plan in sketch form. The large patterned pots filled with heavy-headed flowers and sharp leaves were possibly a less spontaneous motif; they bear a family relationship with pots of flowers in the mosaics on the walls of the mausoleum of Galla Placidia at Ravenna, which likewise feature a wide band of decorative marble facing below. Perhaps there is indeed a positive influence here, if one takes into account the illustrations of Ravenna mosaics on the walls in one room at 33 Fitzroy Square in November 1913.

The free sinuous coloured lines in the band at the bottom of the wall were to become one of Grant's favourite space-filling techniques at the Omega. They can be seen covering the sides, and even the bottom, of a painted wooden box – the 'Goldfish box' – painted by Grant in the autumn of 1913 and now in the Victoria and Albert Museum. This technique reached its widest public when Grant used it, in spring 1915, to cover the bottom half of the Omega Workshops signboard, which hung just above the front door of 33 Fitzroy Square, rather like an inn sign. The technique nearly always occurred as a band at the bottom of a decorative scheme. As such it could well have been inspired by the real and false marbled panels used as the lowest layer of decoration in many Italian and some French frescoed churches – a device which Grant greatly admired.

At the end of January, Fry, accompanied by Clive and Vanessa Bell, paid a short visit to Paris. There Gertrude Stein took them to see Picasso, and the party also visited Matisse. Grant was not with them, since he had gone to Paris earlier in the month and after a meeting with Picasso had travelled south to Tunis. For Fry, Bell and Grant these were their last leisured visits to Paris, and to the studios of artists working there, before the outbreak of war in August curtailed their direct contacts with contemporary French art. Also at the end of January 1914, Fry was able to look back at the first six months of the Omega Workshops and to see how his precarious venture was faring. It had survived; but it had already used up its initial capital of £1500. It is unfortunate that no record of the accounts remains; it would

have been fascinating to see how the money was spent – what percentage went on artists' salaries, how much on materials, paints, dyes, gesso powder, how much went to pay the business manager and caretaker, or how much was spent on mounting temporary exhibitions. With the capital spent – perhaps largely on the room for the Ideal Home Exhibition – Fry had to set about injecting more money into the Omega account. Before he turned to beg from the same friends, he himself took a further allotment of £1 shares to the value of £100 and persuaded his favourite sister, Margery, to put in £50.

With the second Grafton Group exhibition only just over at the Alpine Club Gallery, a Friday Club exhibition followed in quick succession at the same venue. As with the Friday Club exhibition in January 1913, the February 1914 show opened without contributions from Fry, Bell or Grant. They had shown between them twenty-five works at the second Grafton Group exhibition, and it is obvious that the Grafton Group, rather than the Friday Club, was now their chosen exhibiting milieu. This may be because Fry decided that the Grafton Group should always include members of the Omega Workshops, thus more clearly defining his own coterie, whereas the Friday Club welcomed a good many artists who were not part of Fry's circle.

Although by the end of 1913 Lewis, Etchells, Hamilton and Wadsworth were definitely not members of Fry's circle, a touring exhibition organised by the Contemporary Art Society, which visited Manchester, Leeds, Bradford, Aberdeen and Liverpool between November 1913 and February 1914, gave a contrary impression. Because of the arrangement of a section of this exhibition Fry and the four seceded artists were made to look like a united group. In addition to the usual categories of Oil Paintings and Watercolours and Drawings, there was another called Decorative Cartoons. This choice of title must have come from someone inside the Society; whatever they meant by it was not reflected by the works shown, which were oil paintings. Three works in the Decorative Cartoon section had been bought for the Contemporary Art Society by Clive Bell – Hamilton's *The Natives*, Lewis's *Laughing Woman* and Etchells' *Woman at the Mirror*. Several others did not appear to be Society purchases but were more likely loans by the artists themselves – for example, William Roberts' *The Carpenter's Shop*, Wadsworth's *Canal de Condekerque*, and Fry's *Still Life. Laughing Woman* and *Woman at the Mirror* were both large, about six foot and four foot high respectively – perhaps size played a part in the inclusion of work in the Decorative Cartoon category. However, one cannot imagine that a still life by Fry would have been expansive in scale. Reviewers tended to lump together all the

above artists under the title of 'cubists'. Nonetheless, many singled out Fry for special comment, possibly because his works seemed all the more shocking given his status as an older, establishment figure. Although the review in question has not been traced, it is probable that Wadsworth discovered in a Yorkshire paper in December 1913 a paragraph describing Lewis and himself as 'disciples of Fry' and members of the 'Omega group', which related to this odd category of works in the Contemporary Art Society's exhibition.

By February, far from being members of the Omega group and disciples of Fry, the four seceded artists were on the point of founding their own rival group, as we have seen. On the 26th of the month Lewis even beat Fry in the race to secure and complete a decorative scheme for a member of London society, when his decorations for the dining-room in the Countess of Drogheda's house in Wilton Crescent were unveiled at a private view and party. The guest list was impressive in its choice of social and artistic illuminati – Augustus John, Jacob Epstein and Wadsworth, for example; but it did not include the name of Roger Fry. One wonders how long it was before Fry gained the opportunity to see this room, or if he never saw it, relying instead on press coverage and word of mouth. Lewis had obtained the commission in November 1913, having been approached by the Countess. Although the decorations are no longer extant, photographic and press coverage allow a reconstruction of the scheme. The walls and ceiling were black, with a brightly coloured abstract frieze under the cornice. Lewis also designed a decorative glass overmantel. Ezra Pound, in *The Egoist* for 16 March, wrote of Lewis's interior decorations, reminding his readers that 'one can only pause to compliment the Countess of Drogheda that she has set a good example to London'. It is not known whether the Countess's friend, Lady Ian Hamilton, attended the unveiling party on 26 February, but it seems the challenge of commissioning modern artists to decorate domestic rooms did not pass unheeded. Lady Ian Hamilton had, of course, pre-empted the Countess, taking shares in the Omega Workshops as far back as July 1913. Now she was about to convert her financial support into a practical offer of employment.

On 6 March Fry wrote to Grant, who was still in France working on decorations for Jacques Copeau's production of *Twelfth Night* at the Vieux Colombier Theatre in Paris. His letter gave news of the Omega: 'Lady Ian Hamilton sticks to us and has given me a stained-glass window and Vanessa a mosaic floor to do.'[33] Lady Ian Hamilton had been unable to offer a decorative commission any earlier because in the winter of 1913 she was occupied with moving house. The moment she was settled in her new home, 1 Hyde Park Gardens, sometime in February, the Omega were

allowed to begin their planned transformations. If a letter of Christmas Day 1913 from Vanessa Bell to Fry refers to plans for Lady Ian Hamilton's decorations, then Fry's letter of 6 March was out of date; the Christmas Day letter contained the sentence, 'You'll also have to dash about and see to stained glass etc.' Possibly, by Christmas 1913, Lady Ian Hamilton had already decided, in detail, what she wanted for her new home. Her niece, Marjorie Hamilton, was working for the Diaghilev Ballet; as a result Lady Hamilton was much influenced by Diaghilev's designers and wished to transfer this influence to her own home, to the extent of transforming it to an approximation of a stage set for a Diaghilev ballet. She alone was responsible for planning her interior decorations, only asking in the Omega Workshops to provide certain items. The scheme consisted of three decorated rooms on the first floor – a drawing-room, a ballroom and a small room over the porch known as the Chinese room – and the entrance hall on the ground floor. To make this hall more spacious, Lady Hamilton had some walls knocked down; she then asked the Omega Workshops to provide it with a mosaic floor and two stained-glass windows. A black and white photograph on page 5 of the *Omega Workshops Descriptive Catalogue* gives a partial idea of the decorations for this hall – partial because only the mosaic floor and steps are visible. The siting of the two stained-glass windows is not apparent, nor do the walls appear to be painted – though family sources reveal they were.

Having planned the overall scheme of the entrance hall, Lady Hamilton left the individual designs of the floor, windows and four rugs to the designers of the Omega. When the mosaic floor was in place she had the ceiling painted, and two long curtains covered the walls, all in stripes of the same colours – black, green, dark red and yellow. Like all the painted decorations at 1 Hyde Park Gardens, the ceiling was not executed by the artists of the Omega. Instead Lady Hamilton used an old man called Collins, the master painter in a firm of local builders which she had used on other occasions. [34]

The mosaic floor decorations, still extant, consist of a large central roundel depicting a bowl of flowers set against simple rectilinear shapes, and a striped border around the floor edge and the risers of the five hall steps. Fry told Grant in March that Lady Hamilton had assigned the mosaic floor to Vanessa Bell. This could indicate either that Lady Hamilton stipulated certain artists within the Omega for certain jobs, or that Fry himself had allocated the work after receiving the commission. Bell produced the designs for the mosaic floor, but neither she nor any other Omega employee was responsible for the actual execution. There were several art mosaic firms in London, all

suited to the job. Fry would have subcontracted one such firm, but its name is not recoverable.

Likewise, in making the two stained-glass windows for the hall, the designs were produced by the Omega and the execution was entrusted to an outside firm, Lowndes and Drury of Fulham. The circular window is still extant, in the possession of the Victoria and Albert Museum; but the other, a very large rectangular one, is known only by later descriptions. These mention a window about 8 feet high and over 4 feet wide, with a design based on a rhythm of opposing curves and a dark range of colours, mostly greys. Sir Ian Hamilton's secretary remembered the subject – it was a scene of a salmon fisher standing in a river. Lady Hamilton disliked it from the moment it was in place, for two reasons. First, it was rather dark and did not fit in with her blazing Russian ballet colour scheme; second, it bore no connection with family pursuits. The name of 'Jock' Turnbull[35] has been assigned by Winifred Gill as designer of the two stained-glass windows. Sir Ian Hamilton's secretary also provided his name but had no clear idea what he was responsible for in the entrance hall scheme.

Miss Gill remembered working with Jock Turnbull at the Omega Workshops during the later part of 1913 and the first six months of 1914. She thought he was then about twenty-five, came from Hawick in Scotland, and had had experience in designing stained glass. A tentative link could be posited between Turnbull's nationality and the odd subject-matter of the large stained-glass window at 1 Hyde Park Gardens. A scene of a salmon fisher is perhaps too defined a subject for Fry to have chosen. However, the style and subject-matter of the circular window point to Fry as its designer. The main components of its composition, a distant hill with a striking contour framed by two slim vertical tree trunks, resemble those in an oil painting by Cézanne – *Les Moissonneurs* – of 1876. Fry borrowed this picture from the Parisian dealer Bernheime-Jeune for his second Post-Impressionist exhibition, and illustrated it in the exhibition catalogue. *Les Moissonneurs* was probably owned for a short period by Gauguin, who used its subject-matter as the basis for a fan design (1884) and a ceramic design (1886–7). Fry could have known of such borrowings and may have thought a further use of its motif followed in a good artistic tradition. The use of strictly ordered geometrical shapes in the band which forms the edge of the window is found in several other Omega designs by Fry.

Two articles in the *Sketch* for April and June 1915 concerned themselves with the home of Sir Ian and Lady Hamilton. The June article, as well as offering six photographs of the interior of 1 Hyde Park Gardens, mentioned the original colour schemes of the green drawing-room and the

black ballroom with its 'Futurist frieze'. A niece of Lady Hamilton's remembered the ballroom as having a black ceiling as well as black walls; but unfortunately the photograph of the room does not reveal this, nor is the detail of the futurist frieze at all clear. Like the entrance hall ceiling, this frieze would have been actually painted by Collins. But the design probably originated either with Lady Hamilton or with the Omega. The *Sketch* did say that 'the mistress of the house has mostly been her own designer and decorator and 1 Hyde Park Gardens is unique'.

However, it was not unique in containing *avant-garde* decorations. The *Sketch* itself, in March 1914, had shown four photographs of the new interior decorations designed by Lewis for the Countess of Drogheda's London house. Comparisons of Omega interiors with Lewis's usually point to the contrast between Lewis's hard-edged stark scheme for the Countess of Drogheda and the softer, more whimsical decorations in the photograph of the Omega antechamber.[36] But a closer analogy can be drawn between the Countess of Drogheda's room and Lady Hamilton's ballroom, both with plain black ceiling and walls topped by a multicoloured patterned frieze. It is possible that Lady Ian Hamilton's interior decorations, although inspired by Russian ballet décor, also derived from the Drogheda room, unveiled a couple of months previously. In his scheme Lewis had included one of his contemporary near-abstract oil paintings – *The Dancing Ladies* – and by hanging it over a door at the level of the frieze he had made painting and painted walls work together. Fry, at the Omega, would not have chosen such an approach; any decorated wall, just like a section of an early Italian fresco or a Byzantine mosaic, would be regarded complete without the adjunct of another separate work, even though by the same artist. (In fact, according to the *Sketch*, the walls of Lady Hamilton's black ballroom were hung with canvases by Frank Brangwyn and Mrs. Douglas Wells.)

In the spring of 1914 Lady Hamilton was enabled deliberately or otherwise to score over the Countess of Drogheda, because unlike Lewis the Omega Workshops were able to provide her with more than just decorated walls. They could produce, besides mosaic floors and stained-glass windows, marquetried and painted furniture, sofas, painted cushions, and rugs. For the small Chinese room on the first floor, which was decorated in yellow and black, the Omega provided a curved writing desk with a marquetry design of two birds on the top – it was curved to fit into a particular shape in the wall – an inlaid stool to complement the desk, and a painted armchair. The ballroom and drawing-room were furnished with several black velvet sofas piled high with handpainted silk cushions. The entrance hall had four matching rugs by Vanessa Bell laid

on the parts of the floor without mosaic decoration, made in the same colours used elsewhere in the hall.

The most splendid piece of furniture was the unique curved writing desk. This was most probably made for the Omega by J. J. Kallenborn from a design supplied by Fry; sadly, it was destroyed in a fire in 1978. With its marquetry inlay of two opposed peacock-like birds, it is one of a small group of Omega designs attributable to Fry in which the composition relies on a pair of confronted animals. The earliest example of this may well be the embroidery design of pairs of opposed cats and birds shown at the first Grafton Group exhibition in March 1913. (Later examples are a marquetry cupboard with a pair of giraffes, and a set of marquetry tables which each bore a pair of dogs.) Also in 1913, Fry painted in dyes a design of two peacocks fighting at both ends of a long silk chiffon stole. Fry would have been aware that a peacock motif would be associated with the decorative arts in Britain in the 1870s and 1880s. Whistler, William Morris, William de Morgan, Arthur Mackmurdo and C. R. Ashbee had all used this bird in wall decorations, fabrics, pottery, jewellery and metalwork. But Fry did not turn for inspiration to the work of this period, since it was one which he regarded with 'disgust'.[37] Rather, he had in mind a hanging in his hall at Durbins, a 'wonderful fifteenth-century Korean screen representing a red Phoenix on a very faded gold background'.[38] When Fry was asked by Lady Ian Hamilton to design a marquetried desk for a room in her home known as the Chinese room, his reason for re-using the design from the silk stole could well have been a symbolic link between the Korean derivation of this motif and the Chinese setting of the desk.

On 8 May 1914 an important exhibition – 'Twentieth-Century Art – A Review of Modern Movements' – opened at the Whitechapel Art Gallery. By this time the Omega Workshops had greatly enlarged the range of their products. A publicity pamphlet was issued in advance of the exhibition, explaining its aims and the field it proposed to cover. The text is anonymous and might well have issued from Gilbert Ramsay, the director of the gallery; but there are traces of ideas held by Fry and it may be that, as with the preface for the 'Manet and the Post-Impressionists' catalogue written by Desmond MacCarthy, this catalogue was composed after notes provided by Fry. The text, with additions, was then reprinted as the introduction to the catalogue of the exhibition.

When the pamphlet was published, it must have been decided to include an entry from the Omega Workshops, because it announced that the exhibition would be divided into groups. These would comprise two differing styles in painting, a complementary style in sculpture, and a new

style in decoration. The Omega Workshops were not mentioned in this context by name; but the description of the new style bears a strong relationship to Fry's ideas:

In decoration a new style has come, and this shows the first forward move in this country since William Morris and the 'arts and crafts' movement, for the 'new art' movement of fifteen years ago, though promoted by some able artists on the Continent and in Scotland, accomplished nothing vital in England. In design this new style shows affinities with Byzantine Art and with much savage art of the present time. It avoids the heavy metallic crudity of the colour schemes of the mid-Victorian period and the sophisticated timidity of the 'art shades' that followed in the eighteen-eighties and nineties.

Amongst the 414 works in the Whitechapel exhibition, the Omega had a huge entry of eighty objects, taking up a large share of the space in the lower gallery. Numbers 36 to 115 in the catalogue included furniture, textiles, pottery, trays, toys, lamp-standards and light bowls, as well as a group of miscellaneous personal objects such as fans, paperknives, bead necklaces and painted handbags. Besides finished objects, catalogue number 110 included a cartoon for a mosaic. Catalogue numbers 111 to 115 were all left blank; perhaps these were also cartoons or sketches. Number 110 could well have been Vanessa Bell's cartoon for Lady Hamilton's mosaic floor, maybe even executed by the date of the exhibition. Gilbert Ramsay of the Whitechapel Gallery appears as the lender of an Omega object, a decorated cushion, and this small token of support may suggest why the Omega was permitted such a large entry.

By the time the publicity pamphlet was reprinted as the introduction to the catalogue, the two differing styles in painting had been enlarged to four. In addition to painters influenced by Puvis de Chavannes, Augustus John and Cézanne, there were now groups influenced by Sickert and Lucien Pissarro, and the new group whose members had recently established the Rebel Art Centre. Artists who subscribed to a particular style were hung together, including the Rebel Art Centre artists – Helen Saunders, Christopher Nevinson, Roberts, Wadsworth, Etchells and Lewis. However, the work of Bell and Grant was somewhat scattered, although there was a grouping of some of their works, along with Fry and Adeney, in the upper gallery. Vanessa Bell showed five items, three of which had been seen in the second Grafton Group exhibition and one of which was on loan from the Contemporary Art Society. Fry also showed five, of which three were likewise from the second Grafton Group exhibition. Grant showed seven, all of which had been seen before – in

both Grafton Group exhibitions, in the second Post-Impressionist exhibition and at the second Camden Town Group show.[39]

The showing by Bell, Fry and Grant of paintings already exhibited indicates the extent to which they were occupied by the running of the Omega Workshops, with less time than they would have liked in which to paint. Just before the opening of the Whitechapel exhibition, though, in a few days of holiday taken at Fry's house at Guildford, Bell and Grant, along with Fry, began to paint murals in bodycolour on to a wall in the entrance hall, and to make a mosaic for the walls of the summerhouse outside, merely for their own pleasure. When left in each other's company and without the pressure of an outside commission, these three artists seemed to have welcomed the chance to work together on large-scale decorative efforts. Both projects ran in conjunction, with a simple rule governing their execution: if it was cold they painted indoors, and if the weather was warm they worked on the mosaic out of doors. The mural, consisting of two male nudes – one yellow and one earth-red – and one red nude female with blue hair, could be considered a finished piece, although it shows evidence of substantial alteration. The wall on which it is painted (still extant) is directly opposite the front door, and Fry must have been aware that it would cause some consternation in a Quaker household, with his spinster sister Joan in residence. The mosaic, also extant, is a much gentler piece of decoration, depicting a doubles game of badminton. It is unfinished, doubtless because the tesserae were much harder to manipulate, in a limited amount of time, than brushes and paint. The siting of the mosaic – in the summerhouse at the end of a broad terrace in the garden – related to real life, the terrace being marked out as a badminton court. It was unusual for a decorative scheme by Omega artists to relate so closely to everyday life – though Fry had tried to do this with his Borough Polytechnic mural schemes, where the dining-room decorations were to have been on the theme of 'Getting the Food'.

The Whitechapel exhibition continued until 20 June. Meanwhile, on 12 June the seventh London Salon of the Allied Artists' Association opened at Holland Park Hall. Despite the overlap, the Omega was able to show a good range of products in both exhibitions. Holland Park Hall was a new venue for the Allied Artists' Association, and space in a small upper gallery was allocated for the display of applied art to both the Omega Workshops and the Rebel Art Centre. This was by contrast with the Association's usual applied art section at the Royal Albert Hall, where anyone could exhibit. One page of its catalogue carried two half-page advertisements (the top half of the page advertised 'The Omega Lounge',

and the lower half 'The Rebel Booth'), their placing surely engineered for the greatest effect: it would have been obvious, even before a visit to both displays, that the description of the respective entries reflected their actual physical size – the letters in Fry's advertisement being much bigger and bolder. Fry was determined to emphasise further the difference between the two displays, and used a large advertising banner for the Omega. The banner, which is still extant, is over four feet deep and over twenty-four feet long, and made of handpainted and collaged material on a cloth base. It bears the legend 'Lounge decorated by the Omega Workshops Limtd 33 Fitzroy Square'. Vanessa Bell would have been responsible for its design, and probably a good deal of the execution. A photograph of the Omega lounge is one of the illustrations on page 15 of the *Omega Workshops Descriptive Catalogue*. The banner probably hung on the other side of the 'Maud' curtains at the right of the photograph. No visual record remains of the Rebel Art Centre booth.

Gaudier-Brzeska, on the staff of the Allied Artists' Association for this exhibition, produced a review of the show. He wrote highly of his own work, and praised paintings by Lewis and Wadsworth, discounting any claims of partiality with: 'Many readers will accuse me of self-adulation and praising of a sect – for all these people I have the greatest contempt.' From painting and sculpture, he went on to describe the applied art:

The Rebel Art Centre has a stand. The Omega shops have the lounge. The Rebel stand is in unity. A desire to employ the most vigorous forms of decoration fills it with fans, scarves, boxes and a table, which are the finest of these objects I have seen. The spirit of the lounge is one of subtlety. I admire the black and white carpet – the inlaid tables and trays, the pottery. The chairs, the cushions and especially a screen with two natural swans and the hangings of patched work irritate me – there is too much prettiness. Happily the Rebel stand shows that the new painting is capable of great strength and manliness in decoration.[40]

Gaudier-Brzeska's sympathies, by the summer of 1914, lay more with the 'strength and manliness' of the Rebel Art Centre products than with the 'subtlety' of the Omega ones. Also, he made the point of linking the paintings of the Rebel Art Centre artists with their applied art works – something he was not prepared to do for paintings by members of the Omega Workshops. As we have seen, similar opinions had been voiced by T. E. Hulme at the beginning of that year, although Hulme did concede a certain decorative value in the landscape paintings of Fry: 'He . . . accomplishes the extraordinary feat of adapting the austere Cézanne into something quite fitted for chocolate boxes.'[41]

One of Gaudier-Brzeska's notes for his review which did not find its way

into the printed article was: 'The table going with the screen spoils the effect.'[42] However hastily jotted, it does contain the core of the criticism levelled at the Omega lounge. There was a good measure of admiration in many papers, but *The Times* was quite correct in its conclusions:

The lounge . . . is a very pleasant show. It contains, however, too many features, and would be better if it depended only on the charming harmony of the carpet, the furniture and the curtains. These are marred by a certain number of irrelevant explosions in the way of rugs and other decorations which might be well enough in their proper place, but are merely distracting here. We criticise the lounge as a whole, because it is meant to be taken as a whole. A little taken away would make it a complete success, and would prove that a room furnished in the Omega style can be very pleasant.[43]

Certainly, in the photograph of the lounge the great variety of patterns and textures gives a sense of fussiness; and some juxtapositions do not function well – for example, the screen painted with two swans behind the crisp marquetry table and stool. The very light which fell on this busy amalgam of objects was itself filtered through decorative stained-glass panels. In the reviews, the pattern of these panels – unlike the two contemporary ones for the entrance hall of 1 Hyde Park Gardens – was described as abstract. There must have been a commission in mind for these three large panels, for it is inconceivable that Fry had them especially designed and made for his temporary display. He may well have been sympathetic to the criticism of his display, but his anxiety to advertise a great range of Omega products obviously outweighed his judgement of which pieces were the most complementary to each other.

Gaudier-Brzeska, however, had written of a spirit of subtlety in the lounge, and other reviewers picked the same theme. In response to the dominant colour harmonies, the *New Statesman* said: 'There are no "parlour fireworks" . . . the whole is a cool, restful tone of grey, and the furniture is no longer painted in bright colours, but is mostly black and white.' The *Journal of the Royal Society of Arts* described the colour scheme as fresh: 'Black is, of course, introduced very freely, but the greys, greens, and pinks used with it are fresh and clear and bright and as far removed from crudity and heaviness as they are from sadness and sombreness.'[44] The whole being a cool tone of grey no doubt refers to the colour of the lounge walls, which is consistent with the wall colour chosen by Fry for his own house, Durbins, and the showrooms at 33 Fitzroy Square. This same review quoted from what must have been a small pamphlet produced by Fry and on offer at the exhibition, making reference to the printed textiles 'specially executed by a firm of French colour-printers'. Fry was especially pleased with the range of Omega printed linens, donating examples to the

Victoria and Albert Museum in the winter of 1913 and, in July 1914 when they were on show at Holland Park Hall, registering them for copyright protection – possibly from a sense of competition with Lewis's rival decorative scheme. Besides printed textiles on show in the Omega lounge, there were also the patchwork hangings mentioned by Gaudier-Brzeska in his review (unfortunately not visible in the photograph). Gaudier levelled the charge of too much prettiness against them – ironically so, since they were designed and probably made by Vanessa Bell, who thus fell into the very category she had railed so strongly against when plans for the Omega were being formulated.

In the summer of 1914 the Omega Workshops were on the crest of a wave: 'I plainly see that there will very soon be hardly a street in Askelon in which Omega vans will not be as thick as those of William Whiteley and the Army and Navy Stores . . . I give it as my deliberate opinion that the Omega lounge is a most enviable achievement in domestic decoration,' was the opinion of one critic.[45] Commercial success seemed assured, and a loyal band of patrons had emerged as supporters. Princess Lichnowsky, the wife of the German Ambassador, was one – but her association was to be hurriedly severed. Two days after war was declared on 4 August 1914, the Lichnowskys had to leave Britain. Miss Gill remembered her: 'She had been a good friend to the Omega, and on her last visit had asked us all to tea at the Embassy; alas, there was no time left for this.'[46]

Fry himself was feeling optimistic about the future of his decorative venture in the spring and early summer of 1914. He wrote to Bernard Shaw in March: 'I think more and more that this venture was needed in order to save young artists from being swamped in the flood of commercial painting, and also to make people abandon this ridiculous worship of mechanical finish. I think it is going to succeed.' And Virginia Woolf was to write of him at this period: 'He was working harder than he had ever worked before, and with more hope. Many of the things that he had worked for seemed to be coming within reach . . . And then of course the war came.'[47] Ten days after war was declared, in a letter to Rose Vildrac, Fry indicated his intention to carry on with his Workshops: 'There is always the Omega – I cannot dismiss all those who subsist by it just now (they would be destitute owing to the general crises). So I shall try to carry on for a few months in the hope of a rapid end to the war.'[48]

From the evidence of a letter written by Fry to Grant and Vanessa Bell, he must have secured a new commission for the Omega before the outbreak of war. This was to decorate the Cadena Café at 59 Westbourne Grove, London. By the third week of August, preparations were well

under way. On the 23rd, Fry wrote to Grant and Bell, who were both staying at Asheham in Sussex in order to do some of their own painting:

Just plugging away at the tables – I've done six and got Jessie Etchells, who's back, to do one. She's very nice and it's so pleasant to have a real artist in the place. She wants to come and work, but Mr. Robinson is quite firm that she must work out. I suppose he's right because she's very weak and would tell anything to anyone who was nice to her. Still I hate not welcoming her back.[49]

When Frederick Etchells left the Omega, prompted by Wyndham Lewis in October 1913, he must have advised his younger sister to sever her own working relationship also, and Fry too seems to have preferred her to leave. In Jessie Etchells' diary for 1914 several entries indicate that she was partly employed at the Rebel Art Centre from May to July, in a decorative capacity. Two dates in July are relevant for an understanding of Fry's letter to Grant and Bell – they are 25 July: 'Finished work at Great Ormond Street,' and 27 July: 'Wrote to Roger Fry.'[50] The probable content of her letter was to re-establish contact and to seek some kind of employment again at the Omega. Although no contemporary evidence actually states that she left the Omega when her brother did, her inclusion in the Cubist Room at the 'English Post-Impressionists, Cubists and Others' exhibition at Brighton in December 1913 reinforces her connection with the new grouping of painters around Lewis. As Lewis wrote in his foreword to the Cubist Room, those painters were 'not accidentally associated . . . but form a vertiginous, but not exotic, island in the placid and respectable archipelago of English art'.[51] Only three of Jessie Etchells' paintings remain from these immediate pre-war years, and although they make a tiny handful, they do offer indications about her style and iconography. Except for the largest oil painting, the *Still life*, which is quite thickly painted with some blurring of foreground and midground details, she preferred a smooth, matt finish and relied heavily on a strong external contour to the components of her compositions – qualities which could be turned quite easily to decorative ends. Her work was quite feminine in theme – shops, dancers and theatres predominating.

Vanessa Bell's reply to Fry's letter about Jessie Etchells has survived. It confirms that the persecutor of Miss Etchells was seen, at any rate by the business manager of the Omega, Mr Robinson, to be Wyndham Lewis. Bell wrote: 'I think Mr. R[obinson] is really rather absurd about Jessie now. What can she tell anyone that would matter? And I can't think that Lewis and Co. will still go on trying to hurt you. They'll have enough to do fending for themselves.'[52] This would indicate that the Lewis–Fry feud still

smouldered and might be ready to be fanned by the force of Lewis's invective. By August 1914 Lewis would have had to admit himself surpassed as an organiser of a decorative arts venture. Fry's Omega Workshops had lasted thirteen months and his own, the Rebel Art Centre, had closed after about three.

It seems that Jessie Etchells assisted Fry in the painting of the tables (seven were mentioned in his letter and seven are seen in the photograph of the café) included in the Omega's commission to decorate the interior of the Cadena Café. The completed interior is known from a photograph on page 15 of the *Omega Workshops Descriptive Catalogue*; and since an entry in Fry's diary for 13 October 1914 reads 'Party at Cadena', it is not unreasonable to assume the party was to celebrate the unveiling of the Omega decorations there. It is not known who worked on the café murals, which were executed in the late summer. Fry talked of the relief of having Jessie Etchells back at the Omega – 'a real artist in the place' – which leads one to wonder whom he had been employing in the meantime. Vanessa Bell and Grant spent most of August and September out of London on various painting holidays, and the task of decorating the Cadena Café could well have fallen heavily on to Fry's shoulders. Two preliminary sketches remain. They indicate that the interior scheme, in the details of its colour range and the subject-matter of the murals, went through various stages. The final form of the murals features overlapping planes and segments and large isolated flower-heads, sometimes partly obscured. In this they resemble the mosaic roundel in the floor at 1 Hyde Park Gardens, executed a few months before. But the café murals have a much greater sense of depth in space and of shifting transparent planes. They are the most Cubo-Futurist of all Omega manifestations, and quite rare in their dissolution of the wall surface.

Apart from painting the tables, the Omega was also responsible for supplying eight rugs exclusive to the Cadena, a stained-glass ceiling light, painted glass lampshades, painted vases for the tables and painted tiles around the fireplace, painted woodwork, and even, according to Miss Gill, the costumes of the waitresses. All the new designs and patterns contrast oddly with the Voysey-style chairs retained by the café. The built-in seating around the walls also kept a late-nineteenth-century type of fabric cover, again Voysey-like in its regularly spaced arrangement of stylised flowers.

The Cadena Café reopened in October. It was probably at the same time that Fry set about producing the *Omega Workshops Descriptive Catalogue*. The Omega prospectus had been printed and distributed in the autumn of 1913, but by now it was quite inadequate. With the production

of an illustrated and descriptive sales catalogue, it would be possible for would-be patrons to gain a full idea of the wide range of decorative items available for purchase. The 1913 prospectus had had four pages and no illustrations. Reflecting the increase in interest and demand, the 1914 descriptive catalogue contained sixteen pages, with eleven black and white photographs and five line drawings. The date of the descriptive catalogue's production has always been hazy – partly because Fry mentions it nowhere, either in letters or in other personal papers. But with the Cadena Café decorations only completed in October and an advertisement for the catalogue appearing in the *Burlington Magazine* for November, it would have been produced at the end of October or the beginning of November.

The catalogue comprised a 370-word preface by Fry outlining the ideology of the Omega, followed by sections on decorative painting and sculpture, mosaic, stained glass, dress, furniture, textiles, printed linens, pottery, carpets, doormats, toys and miscellaneous items. Most of these categories have a preliminary paragraph contrasting the otherwise lamentable state of design in that field with what the Omega was doing to rectify the situation. The preface contains some of Fry's most quoted sentences, such as: 'The Omega Workshops Limited is a group of artists who are working with the object of allowing free play to the delight in creation in the making of objects for common life,' and 'The artist is the man who creates not only for need but for joy, and in the long run mankind will not be content without sharing that joy through the possession of real works of art, however humble or unpretentious they may be.' It was indeed a distillation of Fry's lifelong philosophy.

As an editor of the *Burlington Magazine*, Fry was no doubt able to keep an eye on the range of monthly advertisements carried by that magazine. In August and September 1913 he had placed the Omega Workshops' letterhead in the pages which carried small horizontal notices. A year was to pass before he ventured forth on a larger scale. Perhaps his motivation to advertise his own private scheme was affected by the paste-ups of the monthly advertisements: when there was space on a page, he offered to fill it. Certainly in 1913 and 1914 there was no aggressive attempt to inform an interested public. Throughout the Omega's existence, a handful of advertisements in the *Burlington Magazine* were the only public announcements of its continuing presence. In November 1914 Fry inserted an illustrated half-page advertisement for the Omega. This step was well justified by the twin message carried: the new descriptive illustrated catalogue was announced, and readers were informed of a 'Special Exhibition of small objects suitable for Christmas Presents'. This

was, in some ways, a repeat of the exhibition held at 33 Fitzroy Square in December 1913, also containing lots of small, reasonably priced domestic items. But this time there was no ideal room, no nurseries or bedrooms. Again, a printed invitation card was sent to individuals on the mailing list. This time, too, the standard set in 1913 was modified – the 1914 invitation card consisted of a printed message only, without attendant figures and hand-colouring. No review has been discovered of the 1914 Christmas exhibition. It must have been a small affair, not considered important enough to merit column space in the fifth month of the war.

When Fry wrote to his mother in October, he was growing anxious for the future of the Omega: 'The Omega just struggles on. At present it doesn't anything like pay expenses, but I hope that before Xmas there will be some little enlivening.' By December his tone had lightened. In two letters of that month, again to his mother, he was, first, pleased that she liked some Omega pots she had just purchased, and second, on 15 December: 'My Omega is going on better than I'd feared, perhaps I shall be able to weather the storm, but all depends on how long this infernal chaos lasts.'[53] The Christmas exhibition obviously injected enthusiasm (Vanessa Bell wrote in a letter to Fry of a list of over 315 people being the basis of an Omega mailing list). It may have brought new clients: Lady Fry bought from her son's scheme, possibly for the first time, and he was surely glad to receive a sign of his parents' approval. From the letter, it appears that she purchased some pots, possibly with a turquoise glaze.

Fry had begun his career as a potter in the late autumn of 1913. When the *Daily News and Leader* paid a visit to the Omega on 7 August and took a photographic record of the showroom, the only piece of pottery in evidence was a Delft plate on the mantelpiece. This was no doubt chosen for the crudity and vitality of its decoration, which was probably felt to have an affinity with the decorative aims of the Workshops. Again, in September 1913 when the Omega Workshops prospectus was published, no mention was made of pottery being made or decorated by the Omega's artists. It may not have been Fry's original intention to include this in their activities. Winifred Gill did recall, however, that in the early months of the Omega's existence some commercially available glazed white plates were decorated by painting over the glaze. The disadvantages of such a process are obvious – the overpainting is not sealed under a glaze, and is thus in imminent danger of being worn off with use or cleaning. Such pieces were probably not offered for sale at the Omega. Rather, they were private experiments in decoration. Fry must have decided that if the Omega was to make decorated pottery, they should only undertake the

complete process, making and decorating it themselves. Virginia Woolf, in her biography of Fry, offered a few sentences on Fry's beginnings as a potter:

And when he had found out how things are made there was the excitement of trying to make them himself. It seemed a natural division of labour – while his brain spun theories his hands busied themselves with solid objects. He went down to Poole and took lessons in potting. Soon a row of hand-made pots stood on the studio floor. 'It is fearfully exciting . . . when the stuff begins to come up between your fingers,' he wrote.[54]

Although Virginia Woolf was most accurate in describing Fry's elation at learning a new skill, she was less so in her historical detail. Fry's lessons in Poole were only a part of his education in pottery. Indeed he did not make contact with the Poole Pottery until late 1914/early 1915. Winifred Gill and Fry's daughter Pamela both remember that his first experience of potting on a wheel was at Mitcham in Surrey. There, he went for advice to George Schenck,[55] whose workshop was at 1 Nursery Road, Mitcham and who was listed in the Post Office Trades Directory as an art pottery manufacturer. George Schenck showed three items in the applied arts section of the third Allied Artists' Association annual exhibition in July 1910, when he was seventy-eight. Fry was taking lessons from him towards the end of 1913; surprisingly, Schenck seems to have expanded his business at this time, being listed in the Trades Directory for 1914 with a London address – 56 High Street, Bloomsbury.

Winifred Gill also remembered that the Mitcham potter (she was unable to recall the name of Schenck) 'made flower pots and such ware, mostly unglazed. The great drawback was that the clay when baked was to some extent porous.'[56] Not only Fry but Duncan Grant and Vanessa Bell also tried their hand there at making pots. However Schenck himself, being an old man and used to working in his own way, was not very proficient at helping Fry to discover new shapes in pottery. Vanessa Bell recalled:

We went to the pottery. Adrian, Duncan and I as A. [Adrian Stephen] was very anxious to come too. It is a fascinating place and so beautiful itself. The old potter was late of course but we tried our hands at potting while waiting for him. I wished I could have gone on for hours. It's very difficult of course but I don't for a moment believe the seven years story. Seven months would be more like it. Of course that old gentleman might well take seven years but he's obviously quite stupid and would have no natural instinct to help him. I couldn't help thinking even now that one would do the finishing much better than he does. He stayed till five and did about ten or eleven pots, two or

three pretty good I think. Then we left him to copy some again, but I doubt if he'll have done it decently.'[57]

Although Fry was fascinated by the actual experience of designing and making pots himself, his time for such an activity was limited. In practice he had to rely on another hand actually turning out each design in quantity. After he had thrown a pot that satisfied him on a wheel, he would then have it copied by Schenck. Later, when Fry's potting had reached a respectable standard, he had moulds taken of his pots in order to facilitate their mass production. But though mass-produced, they still bore the directness and sensibility of their maker.

Although Schenck was a useful contact, he seems to have been unable to teach Fry all he wanted to learn about pottery. He provided Fry with clay and a wheel and a knowledge of how to produce certain basic shapes; but since Schenck's output was mostly unglazed, perhaps his experience of glazes was rudimentary. Fry is believed also to have gone to Camberwell School of Art, where he would probably have learnt about glazes. The principal at that time (1913–14) was W. D. Dalton, who was deeply interested in Chinese pottery and its glazes. As the shapes of the Omega ware show, Fry, too, was an admirer of Chinese pottery, along with Delftware and the peasant pottery of Spain and Italy.

Omega pottery established a more secure footing after Winifred Gill effected a meeting between Fry and Roger Carter of the Poole Pottery, at Poole in Dorset. Miss Gill knew the Carters through her own family, who like them were Quakers. The Poole Pottery was a large commercial business, well able – and willing – to invite an embryo artist-potter into its midst.

Even though 1914 saw the outbreak of war it was a successful year for the Omega Workshops. They continued with business as usual, making light of new problems of survival and managing to publish a descriptive catalogue which presented their work in a clearer and more positive way. Good press coverage, three major exhibitions and important commissions all helped to ensure that they thrived.

5

REFUGEES, DRESSES AND COLLAGES: *1915*

On 15 January 1915 an unusual entertainment was held at 33 Fitzroy Square. Masterminded by Roald Kristian (Nina Hamnett's husband), with Fry's blessing, it was one of a series of Friday concerts. These were organised by various people under the umbrella of the Omega Art Circle, which appears to have been partly a fund-raising scheme for Belgian immigrants driven out of their country by the war, and whom Fry, in philanthropic vein, was anxious to help. Various people remember that evening – David Garnett wrote: 'We went to the Omega Workshops to see a performance of marionettes made by a mysterious figure called de Bergen [Roald Kristian], the husband of Nina Hamnett, the painter.' Sickert too referred to this event in a letter to Ethel Sands, describing 'Omega parties with poetry recitations and marionette shows (the great success of one was the swinging appendage of a nigger figure . . .)'.[1] One of these marionettes is reproduced as an illustration in Nina Hamnett's autobiography *Laughing Torso*. It is captioned 'One of Edgar's marionettes', Edgar being the name by which Hamnett referred to Kristian. From the illustration it is impossible to be precise about the size of the marionette, but it was surely a couple of feet high at least.

Grant too had made three marionettes, eight feet tall, to enact the last scene of Racine's *Bérénice*. This had been performed at Clive and Vanessa Bell's New Year party at 46 Gordon Square a fortnight before the Omega evening. Unfortunately no visual records of it exist. Was Roald Kristian influenced by Grant's marionettes? Kristian's marionette depended for its effect upon the rhythms of its profiles, and this, besides being a characteristic of marionettes, was also a characteristic of the art of both Grant and Kristian.

Working for the theatre was not, in 1915, a new departure for Grant.

Kristian's theatrical experience, on the other hand, is unknown, as are any but the most rudimentary personal details. He was born Edgar de Bergen in 1893 in Norway. His father, Maximilian de Bergen, was an 'artiste' – his exact profession is unknown but a theatrical sphere seems implied. Edgar de Bergen met Nina Hamnett in Paris in the summer of 1914, and they drifted into marriage, on 12 October 1914. By this time Nina Hamnett had brought the penniless de Bergen to stay with her parents in London. Hamnett always referred to him as Edgar, but it has been suggested that he adopted his two middle names, Roald and Kristian (although these are not listed on his marriage certificate), in response to anti-German feeling in England. In October or November 1914 Hamnett introduced him to Fry: 'We took two attics in Camden Town. The rent was 7/6 a week. We had very little furniture. I took Edgar to the Omega Workshops and Mr. Fry gave us both some work.'[2] Though fluent in French and German, Kristian lacked English. But despite this, and penury, he seems to have quickly made useful contacts. *Colour Magazine* could say of him, only about four months after his arrival in England:

Roald Kristian, a drawing of whose appeared in our last number, is a Norwegian by birth, and possesses a remarkable talent for sculpture. Kristian is also interested in the art of woodcutting, in which medium he has done some fine work. He was also responsible for the marionette show recently given at the Omega Workshops, all the figures and scenery being designed and executed by him.[3]

Nothing can be discovered which throws light on his talent for sculpture. However, a dozen or so woodcuts survive as evidence of his work in the field of graphics.

Some idea can be had of what Kristian looked like, since he and Hamnett sat to Sickert in his studio at 8 Fitzroy Street. The painting must have been executed between August 1915, when Sickert first rented 8 Fitzroy Street, and November 1916, when it was shown at the Carfax Gallery, London, where it was entitled *Nina Hamnett and Roald Kristian*. It is now in the collection of the Tate Gallery and has the additional title, *The Little Tea Party*. Hamnett recalled the sitting: 'Edgar and I sat for him together, on an iron bedstead, with a teapot and a white basin and a table in front of us. We looked the picture of gloom.'[4] Hamnett, in remembrance of this painting and, indeed, her relationship with Kristian, often used words like gloom. The picture does suggest a lack of communication between husband and wife – perhaps this was symbolic of their marriage. However, others obviously enjoyed Kristian's company. He was invited to stay with Lady Ottoline Morrell at Garsington, and was

highly respected by Fry and the group who produced *The New Age*, for which he illustrated articles and even contributed an obituary note on Albert Aurier.[5] This, and another clue, hint at Kristian having a good knowledge of modern European art, literature and music, even though he was only twenty-two in 1915. His marionette show at the Omega was a performance of Debussy's *Boîte à Joujoux*, and the choice of piece was entirely his own. Hamnett recalled:

Edgar suggested to Mr. Fry that they should have a musical performance of Debussy's 'Boîte à Joujoux', and that he should make and work the marionettes for it. This he did. We all worked the marionettes. We lay on our stomachs and pulled the wires. He cut them out of cardboard with a knife. We had a fine orchestra of Belgians and a good audience and they made some money.[6]

This last sentence is most revealing – *Boîte à Joujoux* was only written in 1913, in a piano version, and is not believed to have been orchestrated until after Debussy's death in March 1918. Yet somehow a refugee Belgian orchestra played it at the Omega, so presumably orchestral parts of some description must have been available.

The only surviving oil painting by Kristian, *Tea Pot*, is tiny – 12 by 8 in. It depicts a teapot, a mug and a wineglass set out at measured intervals against a plain background. When Fry included Kristian's *Tea Pot* in his Birmingham exhibition, 'The New Movement in Art', in July 1917, the painting was lent by the artist. But by the London showing of this exhibition in October, *Tea Pot* belonged to Fry. Kristian's work, according to exhibition catalogues, falls into three categories which were also favoured by Fry: still lifes, animals and portrait heads.

Nina Hamnett, in her reminiscences in *Laughing Torso*, recalled how she and Kristian worked at the Omega and often had lunch with Fry in his studio in Fitzroy Street. However, in contrast to her description of much work and good pay to be earned at the Omega when she first joined in the winter of 1913, conditions seemed more difficult for the artists there in 1915. She talked of 'being so poor, as there was not always work at the Omega'. January and February of 1915 appear to have been quiet months at the Workshops, even though the *Burlington Magazine* for January carried a half-page advertisement of new work available suitable for New Year presents, and the Omega Art Circle ran their series of Friday concerts to raise funds for Belgian refugees.

With the death on 5 March of Henri Doucet, fighting at the front in the French army, Fry lost a close and valued working colleague: 'My dear Doucet is killed. It's a terrible loss to me. I have so few artist friends who

were like him. I worked better with him than anyone else.'[7] Perhaps Doucet's nationality prompted this assessment, for Fry may have felt best able to discuss the problems of painting with a compatriot of Cézanne. Doucet's contribution to the Omega Workshops could never have been large, as his home was in Paris. But right from his early plans for the Omega, Fry had envisaged French artists working alongside the English. As he wrote of the programme for his applied art workshop in December 1912: 'I have also the promise of assistance from several young French artists who have had experience of such work.' If he was referring to Doucet as one among several French artists already experienced in applied art, no evidence of such experience remains. After Doucet's death, Fry showed concern for his wife Camille and her baby son and attempted to obtain small dressmaking jobs for her in London, although she remained in Paris.

In March Fry placed the first of several advertisements for 'The Omega Pottery' in the *Burlington Magazine*. He had evidently decided to concentrate on only one aspect of Omega production, rather than continue with the advertisements which had listed all the categories covered by the Workshops. This decision no doubt reflected the deterioration of civilised life under war conditions and his concern to appeal on a more utilitarian level. For, as he had said in the spring of 1914:

Pottery is of all the arts the most intimately connected with life, and therefore the one in which some sort of connexion between the artist's mood and the life of his contemporaries may be most readily allowed. A poet or even a painter may live apart from his age, and may create for a hypothetical posterity; but the potter cannot, or certainly does not, go on indefinitely creating pots that no one will use. He must come to some sort of terms with his fellow-man.[8]

Fry's very practical attempt to come to terms with his fellow men took the form of committing himself to help with war victims in France. Too old to be conscripted, he travelled to France towards the end of April to join his sister Margery, who was head of a team organising the Friends' War Victims' Relief Committee. Life was not dull, for while driving ambulances Fry was arrested at the front line, and held for a short time, under suspicion of being a spy.

He had left London towards the end of April, leaving the Omega in the capable hands of several women artists, notably Winifred Gill and Vanessa Bell. Although the market for Omega products must have

become very depressed, he entertained no thought of closing it down. Before he left for France he wrote to Vanessa Bell on 11 April about a new scheme for introducing dressmaking into the Omega. From the very beginning the Workshops had sold hand-dyed fabrics, and one or two handpainted dresses and silk evening cloaks were listed in the autumn of 1914 in the *Omega Workshops Descriptive Catalogue*, under the heading, 'Dress'. By 1914 linen tunics were being made to measure from Omega printed linens. Photographs exist showing Nina Hamnett in one made from 'Maud' and Joy Brown in one made from 'Margery'; and Vanessa Bell wrote of one for herself, in a letter of August 1914.

Joy Brown lived at Durbins with Roger Fry and his sister Joan; she was governess to Fry's two children, who were left motherless after Helen Fry's admittance to an asylum in York in 1910. Brown was good at dressmaking and it was she who had proposed the scheme for such at the Omega. On the point of his departure for France, Fry decided to allow this scheme a trial run, and placed Vanessa Bell in charge. Bell too was a good needlewoman; as Virginia Woolf remembered, from an early age she often 'sat silent and did something mysterious with her needle or her scissors'.[9] Bell had the idea of making or superintending the making of dresses suitable for Omega clients like Lady Ottoline Morrell, Iris Tree, Marie Beerbohm and Marjorie Strachey. These dresses, if bought, could then be paraded at various social functions at the beginning of the London season. She believed 'one could make dresses that would use the fashions and yet not be like dressmakers' dresses'.[10]

At the same time as Vanessa Bell was organising the dressmaking department for the Omega, Fry and his sister Margery were working with women refugees from the villages in the Marne and Meuse region of France whose homes had been destroyed by the war. They encouraged the refugees to take up embroidery as a therapy. Several embroideries done by French refugees still exist, donated to the Victoria and Albert Museum in 1918 by the Friends' War Victims' Relief Committee. From their designs and colours it appears that Fry attempted to foster in their makers the same aesthetic experimentation he encouraged at the Omega. The colours were all bright and strong – blue, turquoise, orange, cerise, mauve, yellow, light green and black – and judging by its quality the woollen thread used must have been brought from England expressly for this purpose. It was therefore probably Fry who chose the range of colours. He was also no doubt responsible for the designs, since the acquisition note to an embroidered linen tray cloth in the collection of the Victoria and Albert Museum states that the design was inspired by the mosaic pavement outside St Mark's, Venice.

The embroideries are executed in satin-stitch, an East European technique. However, with their bands of bold patterning and strong black outlines, they do not look East European, but rather African. This is consistent with Fry's admiration of textiles made by 'negro savages of the Congo', as voiced in the preface of the *Omega Workshops Descriptive Catalogue*, where he extolled African textiles and pronounced them to be 'of greater value and significance than . . . Lyons velvet'. Of all the Omega textiles, or perhaps more correctly, all the textiles initiated by Fry, these embroideries produced in France are the most African and barbaric in looks. It is interesting that he did not press their continued production upon the women artists at the Omega when he returned to England, even though his interest in African textiles had shown itself from the beginning of the Omega. Through the agency of John Hope-Johnstone, a colleague of Fry's and an inveterate globe-trotter, the Omega was able to import hand-embroidered and printed scarves and handkerchiefs direct from North Africa. Fry's idea was to sell these goods alongside Omega textiles and thereby to show an affinity of style.[11]

By the end of April the Omega dressmaking scheme was well under way. Charles Robinson, the business manager, was at that point planning to send out private view cards for a double exhibition. This would be firstly a show of costumes designed by Vanessa Bell and made by various needlewomen including Joy Brown, Barbara Bagenal and Kate Lechmere, and secondly a show of Roald Kristian's woodcuts. Both were to be held, concurrently, at 33 Fitzroy Square. Since the dressmaking scheme was still in its infancy when the exhibition opened on 10 June, several waistcoats, painted evening cloaks and painted parasols produced in the previous two years were included, to fill out the number of exhibits. Fry was still in France when the exhibition opened, and Vanessa Bell wrote on 12 June to tell what had transpired: 'The exhibition was not much of a success the first day but I think more people have been since.'[12] She wrote of the high standard of dressmaking of Joy Brown, who showed two dresses, one of which was especially made for Iris Tree, and of the new terms of employment for Miss Brown, which Bell herself must have drawn up:

Mr. Douglas Pepler has offered her £100 a year to start with to work for him at dressmaking. He will let her spend her afternoons at the Omega ready to see people or fit them and doing his or our work there. We are paying him the same that he asks other people for every dress she makes for us, and her 5% of our profit in every dress. We should risk nothing as we only pay when we have an order. Mr. Robinson seems to be very much against the whole dressmaking scheme, but I don't see that he can object to this . . . Mr. R.

however distrusts everything Duncan and I do profoundly, perhaps with some reason from his point of view.

Bell's letter throws new light on Douglas Pepler and his working mens' club – the Hampshire House Social Club – which was started about 1906. Douglas Pepler, a Quaker, was employed by the London County Council as a social worker. He had worked at Toynbee Hall, a local education centre in the East End of London, a few years previously. Fry had given lectures there at about the same time, and perhaps that is how he met Pepler. Pepler's intention was to found a similar institution in the West End of London. In 1906 he took on the running of the Hampshire House Social Club in Hammersmith, which boasted such amenities as a billiard room, a library and reading room, a bar parlour and a classroom. Pepler gradually turned this working mens' club into a craft workshop and artistic centre, beginning with a free picture show in the same year.

The emergence of a craft workshop in Hampshire Hog Lane, Hammersmith, was not an isolated venture in that area of London: William Morris had lived in Hammersmith Mall, and from his home there that particular corner of Hammersmith came to be a centre for the Arts and Crafts movement. From the beginning of the Omega, Fry had turned to Douglas Pepler and his workshops to treat the handpainted silk cushion covers, scarves and lampshades: Pepler and his workers fixed the dyes in the silk and restored the texture, which suggests that a much higher level of technical knowledge was available at Hampshire House than at the Omega. Vanessa Bell's new agreement with Pepler concerning the dressmaking scheme and the joint employment of Joy Brown would have seemed a most practical step to Fry. Pepler was thus one of a group of Quakers – along with Roger Carter, William Rowntree and the directors of the Dryad Company – who, in their separate ways, all helped with the Omega venture. Carter let Fry use the facilities of the Poole Pottery; Rowntree, of Rowntree's of Scarborough, in 1913 or 1914 mounted a promotional display of Omega goods, particularly textiles; and Dryad's made the distinctive Omega cane dining-chairs.

An indication of Vanessa Bell's ideas on dress design, which 'would use the fashions and yet not be like dressmakers' dresses', is provided by two sources. These show them to be simple and attractive. A press photograph exists, showing Bell in a dress designed by herself, but with Joy Brown's head stuck over her own. Mr. Robinson seems to have been responsible for this alteration, probably preferring, for Omega publicity purposes, the conventional good looks of Miss Brown to the pensive, sad-eyed face of Vanessa Bell, who was left bewildered by the change: 'I had a telegram

from Robinson . . . asking for my dress for Miss Joy to be photographed in. I have sent it, but what is happening? Won't the one of me do?'[13] The style of Vanessa Bell's dress, with its full-length skirt falling from an empire-line bodice, is also seen in another version. It is worn by Nina Hamnett in a full-length portrait of her painted by Fry in 1916 or 1917, now in the collection of the University of Leeds.

No catalogue remains for the exhibition of woodcuts by Roald Kristian shown concurrently with Bell's 'costumes' – and indeed it seems unlikely that one was ever produced, since Fry's absence in France would have removed the Omega's principal source of aesthetic commentary. Thus, an essay by Fry on the art of Kristian was unfortunately never written. The lack of a catalogue and reviews also makes it impossible to guess at the nature of Kristian's show. Probably his work would have been on a small scale; of all the extant examples of his woodcuts, none measures more than eight inches in any direction.

The full complement of decorative work attributable to Kristian at the Omega adds up to three small lampshade designs, two small rug designs painted on the recto and verso of a single sheet of paper, and three sets of woodcut illustrations for Omega publications. The lampshade designs comprise a frieze of interlaced winged animals – dragons, hounds and lizards – and the rug (or cushion) designs show a stalking bear set against a faceted background on one side, with a semi-abstract design based on a seated animal (but composed basically of large facets) on the other. All Kristian's work displays a strong affinity with the art of the North in Celtic and Viking times. His lampshade designs show an insistence on the interplay of the legs and tails of the animals and the use of curved ends to tails and jaws – descendants of the interlaced animals of the Hiberno-Saxon Book of Durrow (from the second half of the seventh century) and the tangled animal bodies of the Urnes style of eleventh-century Norway.

Besides a love of the artistic heritage of his homeland, Kristian also shows a knowledge of contemporary European developments. His two rug designs and his woodcut of three horses gambolling in a field, reproduced in the 1918 Omega Workshops' book, *Original Woodcuts by Various Artists*, seem to indicate a knowledge of the work of Franz Marc, whose chief subjects were likewise animals. Nina Hamnett reported that Kristian spoke fluent German when she met him in Paris in 1914.

It is not inconceivable that he had spent some time in Germany – maybe even in Munich, the major artistic centre – where he could have easily become acquainted with the work of Marc. The closest Kristian's work approached to Marc's was in the semi-abstract rug design, which

appears to be based on a seated animal. This shows a broad arc of back and
shoulder, seen from the side and complemented by the turn of the animal's
head; the pose is strikingly similar to that of Marc's *Tiger* woodcut of
1912.[14]

Not only Kristian, but also Hamnett, seemed to show some awareness of
developments in Germany. In a still life executed about 1912–14, she
painted amongst the household utensils a copy of *Der Sturm*, Herwath
Walden's radical art magazine. Knowledge of this periodical could have
come through her husband, or even a possible meeting with Walden on his
visit to Paris to look at artists' work for inclusion for his Erster Deutscher
Herbstsalon in 1913. In any event, it is an isolated example in Hamnett's
work of an acquaintance with German Expressionism.

The double exhibition of Kristian's woodcuts and Vanessa Bell's costumes
appears to have been neglected by the press. This can be partly explained
in that the same opening date, 10 June, was shared by another exhibition,
and one which received plenty of newspaper coverage. This was the first –
and only – Vorticist Exhibition, held at the Doré Galleries, New Bond
Street, London. In view of the rift between Lewis and Fry, it is rather
surprising to learn of the invitation which Vanessa Bell mentioned to Fry
(still in France in late May):

The Vorticists are having a show and asked Duncan to send. They also
wanted you to but thought you wouldn't and anyhow you couldn't be got at
in time. Duncan was doubtful about it but they said all kinds of other
outsiders were sending . . . so in the end he has sent 2 abstract pictures and
a still life . . . he wants to sell if possible as he's rather hard up.[15]

In the preface to the Vorticist Exhibition catalogue, the leader of the
group, Wyndham Lewis, wrote: 'In addition to the Vorticist Group several
other artists similar in aim have been invited to exhibit, and the show
includes specimens of the work of every notable painter working at all in
one or other of the new directions.' The Vorticist Group consisted of
Jessica Dismorr, Frederick Etchells, Henri Gaudier-Brzeska, William
Roberts, Helen Saunders, Edward Wadsworth and Wyndham Lewis, and
the invited artists were Bernard Adeney, Lawrence Atkinson, David
Bomberg, Duncan Grant, Jacob Kramer and Christopher Nevinson. It
does not seem, from Vanessa Bell's letter, that she was also invited to
show. Possibly this was because the organisers had not seen any of her
recent work – the last time she had shown was at the Whitechapel
exhibition in May and June 1914, where she had exhibited works which

had been seen before and which were not her latest. But then, the same is true of Grant.

The invitation offered to Fry indicates that the antagonism towards him must have been set aside in order to make a concerted assault upon the London art scene and to create an exhibition which contained all the latest diverse efforts. It is interesting to speculate, if Fry had been in Britain, whether he would have sent any work. Certainly his work in 1915 was experimental. So too was Grant's, who has acknowledged how working at the Omega allowed him a unique chance to experiment; and in that liberating environment he took up, as did Fry, papier collé and collage. The two abstract paintings and one still life which Grant sent to the Vorticist Exhibition are not known. But of all the works in the exhibition, it was the two abstracts that were most singled out for comment. The *Glasgow Herald* described them thus: 'Is it intended that we shall take seriously Mr. Grant's two "paintings" composed of pieces of firewood stuck on to the canvas and left uncoloured together with smears of paint upright in shape, put on all haphazard so far as can be judged?'[16] P. G. Konody, the art critic of the *Observer*, led his observations on Grant's paintings to a wider conclusion: 'The admission of Mr. Duncan Grant's "paintings", consisting of bits of firewood glued on to a dirty canvas, with here and there a few vertical stripes of colour, carries with it the danger that the whole exhibition may be suspected of fumisterie.'[17] (The word 'fumisterie' [joking] in a pejorative sense was likewise used by Sickert when in November of that year he described some of Fry's abstract paintings on show at the Alpine Gallery.)

Grant's smeared canvases, with messy scraps of wood rather temporarily attached, sound in essence like some of Picasso's recent constructions. Photographs of these had been shown alongside the paintings at the second Grafton Group exhibition in January 1914, where again critics thought they were being fooled. Witness the anonymous critic in the *Athenaeum*, who believed Picasso to be 'ponderously making game of the public . . . The fact that this "sculpture" could not be trusted to cross the Channel without falling to pieces seems to point to a deficiency in technique.'[18] An accusation of the same weakness could certainly have been levelled at Grant's two paintings in the Vorticist Exhibition. As Vanessa reported to Clive Bell: 'His things are badly hung and a piece of wood came off one and had to be nailed on again.'[19] But then, Grant was never an artist who cared for careful preparation of ground or meticulous technique. Rather, he painted on anything available with anything else that came to hand. His *Seated Woman*, now in the Courtauld Institute Galleries and first shown in the second Post-Impressionist exhibition, was

painted on an old piece of used wood, possibly part of a door, with its screw holes and scars of use. In the Omega years he also painted for his own pleasure, as we have seen, on doors still *in situ*, old boxes, walls and even hens. Several of his canvases of 1914 and 1915 have pieces of paper applied to them in what seems a haphazard manner. So his abstract painted constructions in the Vorticist Exhibition follow a logical progression and are not especially indebted to or influenced by any single artist.

Although Grant's collaged canvases for this exhibition have not remained, a work executed in the same months, still extant, indicates the path he was taking in 1915. This is a second Omega Workshops signboard which Grant worked on in May (and which presumably replaced the first one, which he had painted in December 1913). The side which bears the spare and gentle still life of two flowers in a glass bowl has, as part of the composition, a single vertical stripe down the left-hand side of the panel. This characteristic, according to the critics, was the sole compositional element of his two Vorticist paintings, whereas in the signboard still life it functions almost as part of an architectural framework, like a window jamb. The other side of the signboard, which consists of abstract ornamentation with an omega symbol superimposed, shows some of Grant's non-figurative space-filling techniques. One is left wondering why he filled the other side with a still life of flowers, when at this moment in his career he was experimenting with total abstraction. All the signboard had to do was to advertise the Omega Workshops, and the still life did not make a measurable contribution to that end. Some of Grant's use of collage can be seen on the side of the signboard which bears the omega symbol, where he has added – hammered in perhaps – five rows of metal studs which cut across the top of the arc of the omega and then echo it in reverse a little lower down. The five rows of studs add nothing to the impact of the symbol – in fact they work in a rather perverse manner, drawing attention to themselves and their non-relationship with the main compositional shape. Maybe they were added to do just this, to draw a comparison between their identity and that of the painted symbol. A similar kind of motivation could lie behind the abstract canvases with added scraps of wood.

A work by Grant in which a piece of wood works as an integral part of the composition is his so-called Morpheus bedhead, also executed about 1915. The head of the god of dreams – Morpheus – occupies the central position on the headboard. It is seen frontally, with different markings on the cheeks meant to indicate light and shadow. A carefully shaped piece of wood is screwed over the face to cover the left side of the brow and the

ridge of the nose, adding an extra dimension; cleverly it adds to this effect by contributing its own real shadow. Thus a collaged element is used here for a realistic effect. Grant employed this technique on two other occasions, in which both examples fall within a figurative, portrait genre. In a portrait of Vanessa Bell of 1916, the dress in which she posed was then cut and applied to the canvas; in a portrait of Lady Ottoline Morrell of 1914, Grant temporarily pinned a string of Woolworth's pearls around her neck, overlaying a set of painted pearls.

Besides the Omega Workshops signboard, two further works offer conclusions about Grant's technique and composition in his second year as an Omega employee. These are *Homage to Rupert Brooke* (oil on panel, $21\frac{3}{4}$ x 12 in.), and *The White Jug* (oil on panel, 41 x $16\frac{1}{2}$ in.). Neither work can be securely dated. *Homage to Rupert Brooke* is supposed to have been executed after receiving the news of Brooke's death (he was a friend of Grant), which happened on 23 April 1915, and *The White Jug* has been dated from *c.* 1914 to *c.* 1918 or 1922, when it was reworked. Grant remembered that he modified *Homage to Rupert Brooke*: this was probably with the addition of the collage, but it could also be that he added the two undulating lines which run down either side of the panel and the four narrow, straight lines which together make up what looks like a cross-section through a steeply gabled house. The evidence for this is that all these lines overlay the basic structure of rectilinear areas of various colours. Thus, what may have been a totally abstract composition may well have become one offering symbolic and personal connotations.

The same process can be seen at work in *The White Jug*. This when first painted was a wholly abstract work in which all compositional elements were long, narrow rectangles. Some years later Grant reworked the bottom half of the panel, adding a still life of a jug, a lemon and a vague, tall unidentifiable shape behind the lemon, all of which sit on an L-shaped area of écriture. This area might relate to a shape already underlying it in the composition, since it was a shape Grant liked – it can be seen two thirds of the way down *Homage to Rupert Brooke*, and is a prominent feature of four Omega rug designs by him. These rug designs show how closely, by the middle of 1915, Grant's fine art and applied art works resembled each other. He acknowledged how the experience of working part-time at the Omega Workshops in no way reduced his painting activities: '. . . on the contrary, I probably painted more as a result; working at the Omega helped to generate ideas.'[20]

Omega rugs were made in sizes 5 x 3 and 6 x 3 feet. Bedheads came sized approximately 1 x 3 feet. These schemes of proportion, of long narrow rectangles, echo the chosen dimensions of Grant's work in 1914 and 1915,

his *Abstract Kinetic Collage Painting with Sound* being the extreme example. Both *Homage to Rupert Brooke* and *The White Jug* have long, narrow proportions, as do the contemporary rug designs. It was a temporary phase, though, which had passed by 1916, when Grant reverted to his more usual average size of about 30 x 25 inches for works of fine art. Besides the fertile influence of abstract Omega designs upon *Homage to Rupert Brooke* and *The White Jug*, there is a possible influence from František Kupka's *Vertical Planes III* of 1912–13 (oil on canvas, $78\frac{3}{4}$ x $46\frac{1}{2}$ in.). This large painting was shown in Paris at the Salon des Indépendants in 1913 from 19 March to 18 May. Grant, along with Vanessa and Clive Bell and Fry, could very well have seen it, since they were all abroad together within the duration of the exhibition. Kupka's painting, if seen at first hand, could well have impressed both Grant and Bell with its total abstraction constructed from a concentration on strong and severe rectilinear elements, with the proportions of the canvas echoing these elements.

Such an influence would have worked on each in different ways. By the spring of 1913 Vanessa Bell's paintings had tended over two or three years towards strong architectonically based compositions. They show a preference for narrow vertical rectangles, prominently placed. Such structures assume greater importance in her work over the years; the sequence includes *46 Gordon Square* (1909–10), *Italian Landscape* (1912), *The Bedroom, Gordon Square* (1912), *Self-Portrait* (1912–13), *Street Corner Conversation* (1913), and *Portrait of a Model* (1913).

So a sight of Kupka's *Vertical Planes III* would only have confirmed a direction in which Bell had already begun. Grant's paintings, by the same date, showed no such reliance on architectonic means. His concern during this period had been to create compositions which contained human, animal or landscape elements in a rhythmic, often curvilinear, whole. If he had a response to Kupka's painting it was delayed, since his rectangular compositions only began to emerge *c.* 1914–15, after a year or two's practice of applied art at the Omega.[21] An isolated example which predates this is his rug for the Ideal Home Exhibition in 1913, the design of which is a sequence of seven repeated narrow rectangular units. Similar effects in North African textiles may have been a more concrete influence here.

Grant's abstract oil paintings composed of rectangular elements did later have to be modified: witness his transformation of *The White Jug* into a still life, thus giving the work its title and relegating the abstract shapes to a sort of decorative background. The obvious unease he felt over such works, which he apparently exhibited only once – at the Vorticist Exhibition – did not beset his applied art work at the Omega. There he was

quite happy to produce abstract designs, secure in the knowledge that they were destined for decorative ends and in a category well able to embrace abstraction.

It is unclear whether Fry would have visited the Vorticist Exhibition, since his movements during June are unknown – he most probably was still in France working for the Friends' War Victims' Relief. He was, however, back in London in July. As a response to being back within some sort of comfortable and civilised existence, he began to make plans for the Omega Workshops to act as a publishing house. It is a good indication of the energy and scope of Fry's ideas that he started to produce books with an Omega imprint at a time of paper shortage. The first reference to this venture is in a letter of 28 July from Fry to an old Cambridge friend, Nathaniel Wedd: 'We've nearly finished producing Clutton-Brock's poem on Hell. It'll be the best thing I think done in the way of books for ages.'[22] Whether Fry meant, with his 'for ages', a reference right back to the fifteenth century or a few decades back to the end of the nineteenth century, is not clear. The production of books with original woodcuts, although very much an English tradition, had lapsed over many years, but it was somewhat revived in the last two decades of the nineteenth century by artists including Charles Ricketts, Charles Shannon and William Nicholson.[23] It was Fry's intention likewise to produce books illustrated with original woodcuts.

The exploitation of original woodcuts as illustrations to a text had otherwise lain fallow since the time of Blake and Bewick, who had both drawn and engraved their designs rather than passing them over to professional engravers. The revival of wood-engraving by artists in England partly originated at the Central School of Arts and Crafts. There, as early as 1904, Noel Rooke began to work out his designs directly on the woodblock itself, rather than using it solely as a means of transforming one image into another more permanent printable image. Rooke was a pupil of Edward Johnston, the calligrapher – as was Eric Gill, who also took up wood-engraving a year or two later, but for a slightly different end: 'When I started wood-engraving in 1906 or 1907, it was for the sake of lettering.'[24] This had extended by 1908 to producing a Christmas card for himself, and by 1909 to a commission for a bookplate by Isabella Hildebrand. Fry first became aware of the two-dimensional work of Gill in 1908, and on several occasions between 1908 and 1911 Gill visited Fry at his homes in Guildford – first at Chantrey Dene and then, from 1910, at Durbins. In 1910 Fry commissioned Gill to engrave him a Christmas card, and the result was a small composition of the Holy Family with a midwife. Inspired

by this work, Fry cut his own woodblocks for Christmas cards in 1911 and 1912, and it was surely this progression which enabled woodcut Christmas cards to become Omega objects.

By 1915, when Fry wished to begin publishing books illustrated with woodcuts, it may well be that he found more inspiration across the Channel than in his own backyard. For his second Post-Impressionist exhibition he had borrowed several paintings from Vollard; and he must have known of this dealer's activities in the field of book-production, commissioning artist friends to produce lithographs and woodcuts to illustrate texts chosen by himself. Vollard's impresario role could well have been one that Fry wished to emulate. Grant, in a conversation on the Omega Workshops, remembered that 'Fry had an idea at the back of his mind to make it into a publishers.'[25] Although Vollard encouraged his artists to create lithographs, etchings and woodcuts, Fry limited his venture to woodcuts. It is not known why he started up the publishing side of the Omega in the summer of 1915 rather than when the Workshops came into existence. It was not exactly a propitious time, and he was aware of this, as he told his friend Wedd. 'It seems an odd time to do this sort of thing, but I think it's as necessary as ever to keep certain things going.'

When Fry started something new, he set about it in a most businesslike manner. It was thus that he decided to call in John Henry Mason, superintendent of printing at the Central School of Arts and Crafts and co-editor of *Imprint Magazine* during 1913, to ask his advice. Mason remembered the occasion with interest:

He [Fry] asked me to go and see him about the printing . . . Fry choosing books and brochures, and directing artists, and printers in the back streets, in their production . . . His first choice was a satirical poem by Clutton Brock, and I proposed using an old black letter type, which would have harmonised with the heavy black of the full-page wood engravings, and would have had a strong ironical flavour in being used for such a context. Fry, I think, missed this, and only felt a reminiscence of sentimentalism in black letter. So I followed, alternatively, with Stephenson & Blake Old Style No. 5, a thoroughly commercial type, I said. He jumped at this with eagerness in which I seemed to detect a touch of inverted sentimentality. He went into the job with gusto, and it was printed in Whitfield Street, by a commercial printer, who also seemed to get some good fun out of the game. As soon as the copies were delivered, Fry wired his delight.[26]

This book comprising Clutton-Brock's poem, *Simpson's Choice*, was the only one of the four Omega books in which J. H. Mason played an advisory role; with the other three Fry was able to carry on without outside help. It

was typical of him to have sought expert advice when venturing into new territories – not that helping to design the layout of a limited edition book was really a new field for him. In 1901, and again in 1908, he had designed the title pages for books of poems by his close friend, Robert Trevelyan; and as far back as 1892 he had provided the illustrations for another friend's book, C. R. Ashbee's *From Whitechapel to Camelot.* But with the Omega publishing venture, if we take the illustrations of the books as evidence, it seems Fry saw himself more as an impresario than as an artist. He did, however, design the title page for Robert Trevelyan's translation of part of *Lucretius on Death*; he obviously felt he had a monopoly on title pages for Trevelyan.

His role of impresario did mean, though, that he was closely involved in the choice of text. With his penchant for interesting foreign-language texts, whether new or neglected, he was often called upon, as an art historian and critic, to provide a new translation to make the work accessible to an English audience. The first of these was his translation of Maurice Denis's article on Cézanne, which appeared in the *Burlington Magazine* for January and February 1910. In January 1913 he tried to arrange for the translation and publication in England of Charles Vildrac's periodical *L'Effort Libre*; and in June 1913 he attempted to arrange the rights for a translation of a book entitled *Sous d'Humbles Toits.* Neither plan materialised. But by 1915, with the Omega imprint, he enjoyed more success. The second Omega book was a translation of some of Pierre Jean Jouve's poems, *Vous Êtes Hommes*, which became *Men of Europe.*

Fry's search for unusual texts, meanwhile, led him to enthuse over some recent translations of Chinese poetry by his friend Arthur Waley. But for opposition from colleagues acting as advisers to the Omega, he would have brought out the first volume of Waley's translations of Chinese poems from the Han period as an Omega book. Waley remembered the incident:

A meeting of the Omega Workshops was called at which about a dozen people were present. Roger Fry asked each of them in turn how many copies of translations such as mine . . . it would be possible to sell. The highest estimate was twenty. Saxon Turner, of the Treasury, answered inaudibly. He was asked to repeat what he had said and removing his pipe from his mouth, he answered with great firmness and clarity, 'None'. Roger had been collecting estimates . . . It was clear that in order to cover costs he must sell at least two hundred copies, so as the result of the meeting he gave up the idea of printing my translations.[27]

Arthur Clutton-Brock (whose poem *Simpson's Choice* constituted the text of the first Omega book) had been the art critic of *The Times* since 1908, and a friend of Fry's for about the same period. He lived near Fry in

Guildford, and the two men often had Sunday lunch together. Fortunately for Fry, Clutton-Brock was in sympathy with his activities at the Omega, and reported favourably on them in his column. It is not known whether Fry persuaded Clutton-Brock to write a satirical poem for him, or whether the poem was already written and then found suitable for publication. *Simpson's Choice* is a prose poem about the choice between good and evil which has to be made by the eponymous hero. Fry wrote to his friend Wedd at the end of July telling him the book was almost ready – 'We've nearly finished producing Clutton-Brock's poem' – and although the book is dated MCMXV (1915), it eventually reached publication at the very beginning of 1916. What Fry meant when he wrote of its production in July must have been the production of the woodcuts and the acquisition of the text, and the beginning of marrying the two together. The woodcuts for the book comprise three full-page items, two small panels at the start and finish of the poem, decorated initials throughout the text, and a decorative cover. They were all the work of Roald Kristian. Fry must have been impressed by Kristian's graphic ability, for he allowed him exhibition space at the Omega to show such work. It is not apparent whether these influenced Fry towards the production of books similarly illustrated. However, he told Wedd of Kristian: 'You see the man we've got has a real talent by the specimen I send.' Kristian's woodcuts for *Simpson's Choice* – the full-page ones illustrating the characters in the text – rely for their effect upon great contrasts in surface texture and an odd sense of composition. They are both unusual and effective, and more accomplished than contemporary efforts by English artists.

At the time when Fry initiated his publishing venture, there was comparable work being undertaken elsewhere. Douglas Pepler at the Hampshire House Workshops produced his first pamphlet, a tiny publication entitled *The Devil's Devices*, with woodcuts by Eric Gill; the Poetry Bookshop brought out a slim volume called *Spring Morning* with woodcuts by Gwendolen Raverat; and Claude Lovat Fraser's Flying Fame Press, which brought out broadsides and tiny booklets with his own woodcut illustrations, had been established two years before. It is interesting that by comparison the Omega has subsequently suffered neglect. References to the first proper step in the history of twentieth-century English wood-engraving begin with a mention of either the Pepler, the Raverat or the Lovat Fraser publications; but never *Simpson's Choice*.

Fry's publishing venture was slightly different in its ideology from the rest of the Omega Workshops' productions. It was an attempt, in most difficult times, to satisfy civilised values with esoteric texts and a high

standard of technical competence. Perhaps the publications were aimed at a different audience from those who would choose to buy a painted table or a boldly patterned hand-knotted rug. A letter from Fry to Robert Trevelyan gives a glimpse of his ideas about a market for Omega books: he talks of doing 'some advertising in educational places – girls' colleges and such like. Margery [Fry] tells me of yearning intellectual appetites among the lower middle classes of Birmingham, tho' I don't know whether they'd rise to this.'[28] By 'this' he meant a proposed translation by Trevelyan of a further text from the works of Lucretius (an earlier translation of part of *Lucretius on Death* having been used for the third Omega book, as we have seen). Of the four Omega books, only one – *Original Woodcuts by Various Artists* – was without any text, being just woodcuts with captions giving authorship. The texts for the other three books – *Simpson's Choice* (a satirical poem about death); *Lucretius on Death*; and *Men of Europe*, concerned with the war – are sombre in mood. Perhaps they reflected Fry's own state of mind – but whom was he hoping to reach? Did he feel that everyone shared his own mood in this second year of the war, and that thus a market was assured?

Whatever his views on a potential readership, Fry was very pleased with the finished result of the first Omega book. In 1926, in an article on the book illustrations of McKnight Kauffer, he was to describe book illustration in general as 'a battle ground, a no-man's land raked by alternate fires from the artist and the writer, claimed by both, sometimes nearly conquered by one, but only to be half recaptured by the other'.[29] He presumably thought his Omega books were successful in their negotiation of such a battleground. The 'Monthly Chronicle' section of the *Burlington Magazine* for November 1915 carried an item on the new publishing venture, and quoted from a prospectus sent to them:

The idea will be to publish works of a special character and to give to the setting of the page and the illustrations as perfect a harmony with the literary idea as possible. We intend generally to employ original woodblocks cut by the artist for the illustration and decoration of the text. The editions will for this reason usually be limited.[30]

Simpson's Choice was produced in an edition of five hundred and fifty copies. This was not limited in terms of private press production; it was the work of a commercial printer, Richard Madley, of 151 Whitfield Street, London. It was printed on Van Gelder paper, measured $11\frac{1}{4}$ x $9\frac{1}{8}$ in. and consisted of twenty pages bound in hard covers. Its cost was 12s 6d, and although this was a relatively high price, it was defensible. An anonymous review of the book in the *Observer* noted: 'The apparently excessive price

of the book . . . is justified by its beauty of production. The woodcuts of Mr. R. K. – which derive from Beardsley through Mr. R. F. – are "amusing" . . . and the fine large page and handsome type are a great pleasure to the eye.'[31]

Men of Europe, the second book, which followed hard upon the first, gives no indication of its edition size. Pierre Jean Jouve, the author, was a young French poet of whom Fry probably learnt from his friend Charles Vildrac. Vildrac and Jouve had both been members of the group associated with L'Abbaye. This was an old house at Créteil near Paris, of which they and other young French writers and artists took the lease in order 'to live as a community, supporting themselves with the produce of their garden and by printing and selling books'.[32] The venture only lasted fourteen months.

Men of Europe was a smaller and less elaborate book than *Simpson's Choice*. It comprised sixteen pages bound only in soft covers, and costing two shillings. Its woodcut decorations were again by Roald Kristian; but they consisted only of rectangular abstract designs at the beginning and end of the poems, and decorated initial letters. The abstract designs were made up of aggressive jagged shapes, supporting the spirit of the text; full-page figurative illustrations were absent. Like *Simpson's Choice*, *Men of Europe* bears a date of 1915, but again its true publication date was early in 1916. On 17 February 1916 Fry wrote to Vildrac: 'I have just published a few poems by P. J. Jouve from *Vous Êtes Hommes*'; and on 12 February the poet Gordon Bottomley wrote to Fry thanking him for his copy of the Jouve poems.[33]

November 1915 brought another instance of Fry's tremendous energy and enthusiasm, even in this difficult year under war conditions. In the second week of the month a one-man exhibition of his paintings opened at the Alpine Club Gallery. He showed fifty-four new works never before exhibited, and all probably dating from 1915, as well as a range of Omega pottery, again new and attributable to him directly. 1915 must have been a year in which he gave priority to his practical abilities because, unusually for him, he published only one article on art during those twelve months, and that was just a one-page obituary notice on Sir William van Horne. The fifty-four paintings in the exhibition were mainly French and English landscapes; but three bore the same title – *Essay in Abstract Design*. It seems this was Fry's only exhibition of abstract oil paintings. In any case his excursion into the field of abstraction rests on a handful of works. Only one of these three is identifiable today – the *Essay in Abstract Design* in the Tate Gallery – and it implies in its dimensions a certain timidity, only measuring $14\frac{1}{4} \times 10\frac{1}{2}$ in. This notion is dispelled,

however, by the content – the constituent formal elements are dominated, almost overpowered, by the application of two real pink bus tickets. Fry would have chosen these for their mass and colour rather than for their effectiveness as scraps of reality.

It was this work which gave Sickert grounds for attack in his review of Fry's exhibition: 'It remains . . . surprising that a painter who has the double advantage of power and erudition should continue to treat seriously fumisteries à la Picasso (framed posies of tram tickets, etc.).'[34] Sickert was not the only reviewer to invoke the example of Picasso here, and there is an undoubted link between Fry's *Essay in Abstract Design* and Picasso's *Head of a Man*, which Fry purchased in the winter of 1913. By the spring of 1914, on a flying visit to Paris, he had also purchased, again from Kahnweiler, *Still Life with Coffee Cup* by Juan Gris, a work executed in January or February 1914. Like the Picasso, the Gris emphasised simple hard-edged shapes, reminiscent of Omega designs, which would have appealed to Fry; this work too played its part in the evolution of *Essay in Abstract Design*. The Picasso and the Fry share some compositional similarities: a strong vertical line rising from the bottom centre, and overlapping planes in the centre. The links between the Gris and the Fry are more subtle. The only recognisable element in the Fry is an area just right of centre which looks like a patch of curtain; likewise, surrounding the coffee cup, glass and newspaper on the table in the Gris are patches of what look like curtains. Also the Fry is rather thinly painted in parts, and this allows the graining of the wooden panel on which it is executed to show through. A large triangular shape at the top of the Gris is painted to simulate wood graining, and the area is also intended to make a pun on the use of papier collé. In fact, both the Picasso and the Gris look at first glance as though they contain papier collé, but neither actually does. There is no denying that the Fry contains papier collé or collage, through the use of which it enters a rare category in his oeuvre.

Five, or possibly six, works in his Alpine Club Gallery exhibition contained papier collé or collage. But, apart from a tiny contemporary collaged composition – *Shabti Figure* (6 × 4 in.) – produced for his daughter Pamela's amusement, Fry never again used these techniques in his paintings.[35] Why then did he use them in so few works, and only in the years 1914–15? The answer lies in his contemporary work at the Omega Workshops, which seems to have brought about an experimentation with papier collé and collage. Fry experimented with cut and painted pieces of paper at the Omega, when producing designs for cupboards and rugs, and also in certain fine art works. But his use of the papier collé technique was invariably quite different depending on whether the work in question was

pure or applied art. In a design for an Omega Workshops marquetry and lacquer cupboard, done in pencil, chalk, bodycolour and papier collé on tracing paper, all the large dark patches (of grey, brown and black) are papier collé. The pieces have been carefully cut out in simple geometric shapes and glued over the preliminary pencil and bodycolour sketch and, as pieces of paper stuck on to the design, they remain inviolate. Nowhere has Fry smudged by graphic methods any cut edge of the papier collé. The cupboard design dates to 1914–15. By spring 1916 he was still observing these rules, in a papier collé rug design. This, like the cupboard design, is on a larger scale than the extant *Essay in Abstract Design*. Again, the same method is followed – over a large black circle in ink, the other coloured shapes are cut paper stuck in a carefully overlapped sequence.

With the *Essay in Abstract Design* and other paintings with papier collé also exhibited at the Alpine Club Gallery, a different process is used. In the *Essay* two small pieces of cut paper have been stuck along the bottom edge of the largest bus ticket, which, unlike the other two bus tickets, is illusionistically painted. The pieces of cut paper have been given a mottled finish. Neither piece is cut carefully, and they partly obscure the painted ticket; both shapes are erratic, but one is disciplined by a straight edge painted over it. Another work shown in the same exhibition – *German General Staff*, now known only from a photograph – shows the same disregard for the integrity of its cut paper shapes. This work was described in reviews as being unduly large – the officers were nearly lifesize – and painted in flat tones over cut and torn pieces of newspaper. It was very unusual to see Fry working on such a large scale in a fine art work – it must by all accounts have been about 6 × 5 feet – but the motivation was probably other than aesthetic. *Queen Victoria* and *Bulldog* were two further works in this exhibition which used papier collé. When one combines their titles with that of *German General Staff* and remembers that the First World War had been raging for fifteen months, a mood of humorous propaganda seems implied.[36]

Another exhibit, *Still Life with Coffee Pot* (now in the Fry Collection, Courtauld Institute Galleries), showed Fry's more usual choice of a banal, domestic content. Papier collé is used here too, with the same disregard for the cut shapes, which are scattered liberally all over the composition. This hardly helps to emphasise form, and in many cases seems totally unnecessary. (The influence of Gris's *Still Life with Coffee Cup* is very apparent here, especially in the way the long handle of the spoon projects from the cup in the Gris. This Fry has changed, in a rather absurd manner, into a banana, in order to keep the same compositional rhythms.) Like the

two real bus tickets in *Essay in Abstract Design*, the commercially marbled paper of the kind used in bookbinding for endpapers tends to dominate the composition.

The use of marbling as a space-filler was a popular Omega device. Here Duncan Grant led the way, in 1913 and 1914, with a dado for the wall decorations in an antechamber and tables and screens with a lilypond design.[37] Similarly, in his Omega Workshops signboard, the red Omega symbol is riding on top of highly coloured false marbling. In using marbling as a space-filling technique, the Omega artists never resorted to commercially marbled paper. Instead they created the effect themselves, by a gestural free rendering. Grant was influenced here by a study of painted abstract areas in Romanesque church decoration. In a sketchbook which recorded a visit to many French Romanesque buildings in the winter of 1912, several pages are taken up with a detailed analysis of the decorative marbling on the columns of St. Savin.

In Fry's work commercially marbled paper occurs in five, or even six, items. Three or possibly four come from the Alpine Club Exhibition – *Still Life with Coffee Pot*, *Queen Victoria*, *Bulldog* and, possibly, another *Still Life*. A pencil addition to the exhibition catalogue in the Tate archive adds 'mottled paper mushroom', and nothing in *Still Life with Coffee Pot* conforms to that description. Fry also uses commercially marbled paper in two other items, *Shabti Figure* and an unclassifiable work. The latter could either be a try-out for another *Essay in Abstract Design* or a design for a rug, since the paper shapes are quite carefully cut and their outlines remain clear.

It could be, if the date of 1914 is acceptable, that in works of fine art Grant again led the way in the use of such material. His *The Mantelpiece* (Tate Gallery) has a small piece of commercially marbled paper applied to the centre of the composition, and as the *Tate Gallery Report* states in the note to this painting, Grant applied the cut papers 'in front of the motif, being chosen by him to accord to the spaces as he perceived them'.[38] As with Fry's fine art use of papier collé, Grant used complicated pieces of cut paper, applying them liberally to the picture surface and then smudging their edges and their uniqueness with overpainting. Grant's *The Mantelpiece* is painted on board, a form of support used in most of Fry's experiments with papier collé. Fry's *Essay in Abstract Design* is on veneered board, and thick cardboard is used for *German General Staff*, *Still Life with Coffee Pot*, *Shabti Figure*, the possible rug design, and a try-out for another *Essay in Abstract Design*. Perhaps this choice of support derives from Grant's and Fry's working methods at the Omega, where they painted abstract designs on hard wooden surfaces including table-tops, chests of

drawers, trays and boxes. Maybe it was more difficult to paint or collage an abstract design on to a canvas than on to wood or board.

The sense of patriotism in *German General Staff*, *Bulldog* and *Queen Victoria* is reflected in an Omega Workshops entry for the Allies' Doll Show, which was held at the Grafton Galleries, London, in November and December. No catalogue has been traced, so the exact nature of the exhibition is unknown. *Colour Magazine* reported the Omega's entry[39] rather than any other, so their exhibits must have been worthy of some attention. The Omega sent a set of caricatures of the Kaiser, the Crown Prince, Lord Kitchener, General Joffre and the King of the Belgians. They were carved in wood, perhaps by Kristian, from designs by Fry. Fry was obviously interested in the design of toys – dolls, puppets, animals, etc. – since artist-designed toys were sold at the Omega. From 1910 onwards, having to entertain two young children would have given Fry an idea of what children liked, and he put this experience to good use. The caricatures for the Allies' Doll Show belonged to a slightly different category, being more than just playthings. One regrets that there seems to be no visual record of these five individuals, particularly since Fry awarded little regard to the art of caricature.

Although for Fry 1915 was a challenging and varied time, for the Omega it had been rather quiet. Dressmaking had become one of the main sources of stable income during this difficult year. It had begun tentatively only in the late spring, and, in fits and starts, it provided a small trickle of work throughout the summer. In September Ethel Sands visited the Omega and remarked on the 'ingenious' clothes for sale there – and in October there was still a demand, to which Fry responded: 'We are doing hats and dresses now as being things which people must have quand même tho' I confess I am surprised that people are still willing to spend money on things which one can't call necessaries, tho' I'm glad enough for the sake of those who depend on the Omega.'[40]

By 1915 those who depended on the Omega were few. But with the help of Roald Kristian, Fry was able to add publishing to the activities of the Omega. In struggling on with and diversifying his project, despite so many difficulties, Fry showed a tenacity that has to be admired.

6
THE ARTIST AS DECORATOR:
1916 and 1917

Fʀʏ began 1916 by settling himself in London rather than dividing his time between his studio in Fitzroy Street and his home in Guildford. He let his home, Durbins, to Lady Strachey from February for over a year, and told his mother at the end of January to contact him at the Omega rather than at Durbins: 'I must make some more permanent arrangement about how I'm going to live in town. That depends partly on what I'm to do with the Omega. It's a very difficult thing to settle.'[1] Again he implied that the Omega had a life of its own which was difficult to direct and predict.

However fluid or unsure personal arrangements were, a spirit of organisation and enterprise reigned at 33 Fitzroy Square. Vanessa Bell was granted her first ever one-man exhibition in a room at the Omega for the first two weeks of February. *The Times*, alone amongst newspapers, reviewed it:

Nothing in the exhibition seems to us as good as her Nativity – indeed, we feel that she is becoming more purely artistic than is natural to her, that she is painting pictures as she thinks they ought to be painted rather than as she would naturally paint them. Many of her works look like aesthetic exercises, whereas the Nativity raised no question about its method . . . But these pictures do raise questions about their method; and to most people, of course, the method will seem merely an absurd scribbling with paint. It is not that, as a second glance at some of the still lifes will show. But, in her own way, Mrs. Bell, after the manner of English artists, seems to be aiming too much at beauty, a beauty not of the objects represented, but of calligraphy in paint or of abstract design . . . But perhaps Mrs. Bell will pass through these aesthetic experiments to a more direct expression of herself.[2]

The Times and its art critic Clutton-Brock (although the article was anonymous) were usually strong supporters of the Omega and its artists. Here, though, they were not ready to uphold the latest developments in

Vanessa Bell's paintings, and preferred instead her two-year-old *Nativity*, exhibited at the second Grafton Group exhibition in January 1914.

The paintings in Bell's one-man show can probably be dated to between the second Grafton Group exhibition and February 1916, for she exhibited nothing during that time except five paintings at the Whitechapel Twentieth-Century Art Exhibition in May 1914, all of which had been shown before. Her paintings of the second half of 1914 and of 1915 fall neatly into the two categories of portraits and still lifes, the two genres mentioned in *The Times* review of her exhibition. From extant paintings and from photographs it appears that six still lifes and nine portraits were executed during this period, as well as four abstract works, two of which were oil paintings and two papier collé.[3] The portraits were of friends – three of Grant, two of Mary St. John Hutchinson, and one each of David Garnett, Iris Tree and Helen Dudley – as well as a self-portrait. Of the six still lifes, three were of flower arrangements and three were of domestic utensils. Any of these six would fit quite well *The Times'* description of scribbling with paint and an insistence on abstract design. This was particularly so in *Huntley and Palmers* and *Still Life – Wild Flowers*.

Bell wrote to Fry in January 1916 about her preparations for her Omega show: 'I have been making some artificial flowers. I thought I might show mine with my pictures.'[4] The willingness of Bell to show her applied art alongside her works of fine art is a good indication of the common ground she must have felt they shared. Possibly, too, the inclusion of strange coloured flowers made from bright scraps of material – a form of collage – would have helped explain obscurities in her paintings. Certainly, the imagery of the painted flowers in both Grant's and Bell's *The Mantelpiece* and *Still Life on Corner of a Mantelpiece* (Tate Gallery) would become much more explicit if compared with the Omega artificial flowers. It may be, though, that Bell merely wished to include arrangements of artificial flowers to alter the exhibition space.

It is not possible, without the evidence of a catalogue for her show, to know which still lifes and which portraits were exhibited at the Omega. *The Times* described their 'almost photographic look of likeness', and the scrubby, almost wayward use of paint would preclude any of the extant examples from being described by such a phrase. In all of them, an insistence on the patterning of the subject's clothes, on the coloured planes of the immediate surroundings, dominate the sitters and their distinctive features. However, Bell was able to suggest a good likeness by the turn of a head or the set of a chin, as her portraits without features can testify.[5]

Besides the still lifes and portraits, in 1914–15 Bell executed a handful of totally abstract works. None were likely to have been entries in her

Omega show. *The Times* commented on her emphasis on abstract design rather than on the objects represented, but made no comparison with paintings consisting of abstract design alone. Four of her abstract works are still extant, and a further abstract painting, which was in Fry's collection, has disappeared. By 1919 he was disenchanted with this painting, as he told her: 'The only picture of yours which has gone thin on my hands is that big abstract business which I have in my studio and which doesn't mean anything to me now.'[6] (The story that this painting, along with a couple of others, was destroyed by fire in Fry's outer study or shed at Durbins, is unfounded. He wrote about it from Dalmeny Avenue, where it was safely hanging after he had moved from Durbins.)

Probably this painting was a couple of feet in either direction, if not bigger. The chance to work on a large scale on decorative projects for the Omega, and on such extensive areas as screens six feet high, made Bell attempt a few very large paintings. They include her *Women and Baby* or *Nativity* of late 1913, now untraced (also in Fry's collection at Durbins, where it was photographed over a door in the main two-storeyed room), which was about six feet square; *The Tub* of 1917, which measures 71 × 66 in.; and another work of 1917 on the same scale, now only known from photographs, showing two diminutive figures walking by the side of a huge pond, with a large seated figure in the foreground.

The three either extant or visually recorded – *Women and Baby* or *Nativity*, *The Tub* and *Figures by a Pond* – show spare, empty compositions. The centre of each has a peculiar force, either being left bare or featuring one simple object. The same device is found in Bell's four abstract works. The two papiers collés have empty centres, the horizontal one showing traces of a large circle. Of the two abstract paintings, the smaller (Tate Gallery) has a vertical rectangle in the centre, and the larger a black square. A vital element of all four works is the narrow rectangle, placed vertically. This tendency had already been seen in Bell's work, bearing a resemblance to Kupka and his *Vertical Planes III*, though, as noted, she had regularly used such elements before a knowledge of the Kupka was available. In the two oil paintings, the narrow vertical rectangles are firmly tied to the edges of the canvases. In the two papiers collés, however, while some are placed along the edges of the paper, others float freely, thus creating a sense of depth by overlapping other areas of colour. From 1910, when Bell began to use narrow vertical painted strips, to 1913, the strips were always tied securely to the vertical edges of her canvases. But the first time they float freely, the change in composition is allied to a change of technique, with the use of papier collé.

Bell was also responsible for the decoration of the walls of the 'ideal

nursery', a room at the Omega which was unveiled in December 1913. In this she was assisted by Winifred Gill. Miss Gill remembered[7] how she had helped Bell to stick coloured paper to the ceiling of the room, and although she did not mention the same procedure for the walls, an examination of the photograph reveals that ceiling and walls were identical in treatment. Thus the whole room was a large papier collé. (No other would be seen until Matisse applied cut-outs to the walls of his studio and home from 1947 onwards.) Bell's vertical rectangular shapes are seen to be freely placed at intervals along the walls, not tied to the edges, because of course in the decoration they stand for tree trunks. Their subsequent appearance in two abstract papiers collés seems a direct result of her experience in decorating the nursery. This is particularly so in the vertical abstract, where two dark vertical rectangles in the upper right-hand corner are topped off by what could be an echo of an area of foliage, the appropriate piece of paper even being painted green. The two dark rectangles are set off by pieces of mid-blue paper. These too echo the end wall of the nursery, where a tree trunk stands in front of a pond.

As with Fry, Vanessa Bell's excursion into the field of abstraction in her fine art work was thus apparently a direct result of her work in applied art at the Omega. Unlike Fry, though, she was less timid in her fine art abstractions, daring to work on a larger scale. Of all her known works from 1914–15, apart from the dazzlingly bold portrait of Iris Tree, the largest is an abstract oil painting measuring 36×24 in. Even her two papiers collés are larger than Fry's *Essay in Abstract Design*, being $21\frac{3}{4} \times 17\frac{1}{4}$ in. and $19\frac{1}{4} \times 24\frac{1}{8}$ in. respectively. But there the comparison breaks down: Fry exhibited his abstract works, whereas Vanessa Bell never did.

Unfortunately, although Fry was responsible for the organisation of Vanessa Bell's first one-man exhibition, he has left no comment whatsoever on the exhibition or on the individual paintings: his first published article on her work had to wait until February 1926. Perhaps, as some sources indicate, he was overtaken by other concerns – the publication dates of *Simpson's Choice* and *Men of Europe*, and several urgent pottery orders. Virginia Woolf related how Fry was still embroiled with his publishing venture in February: 'Nessa has had a picture show, which the Times critic says errs on the side of beauty, "the national fault". I predict the complete rout of post-impressionism, chiefly because Roger, who has been staying with us, is now turning to literature, and says pictures only do "to look at about 4 times".'[8] Fry's recent Alpine Club Gallery exhibition may not have been a success, so putting him into this mood. However, the Omega pottery which he also showed at the Alpine Club Gallery was proving most successful.

After the publication, in autumn 1914, of the *Omega Workshops Descriptive Catalogue*, where the pottery offered was only single items, Fry decided to design full-scale dinner services. These included three different sizes of plate as well as various tureens. He used the facilities at Poole Pottery, where he threw the shapes he wanted, and these, he hoped, would be produced in quantity when ordered. In February 1916 Fry had to pay a visit to Poole to see about pressing orders, and he told his mother of his plans:

Strangely enough, the Omega's been looking up again lately and I'm going now down to Poole to do some more pottery that has been ordered. If I can get through it in time I mean to come round by Failand . . . just to see how you all are . . . if you'll forgive my not having evening dress. I had to bring some models for pottery and so they got crowded out.[9]

The letter indicates that Fry was continually designing new shapes, and that he could not with certainty rely on the workforce of the pottery to turn out pieces from moulds. He usually had to go down to Poole in person either to supervise or to do the work himself. In the autumn of 1916 he even spent a full week at Poole Pottery turning out pieces. He told his mother, as always, of his tiring schedule:

I've been really very busy. All last week I was down at Poole potting. I had several rather pressing orders and as I had to do everything myself (I mean they couldn't let me have one of their workmen to help) I could only get through by working all day from 6.30 A.M. so by the evening I was too tired to do anything but wash and eat and sleep.[10]

Besides bringing out new shapes, Fry was also experimenting with new glazes. Up until about 1915, Omega pottery had been available in white tin or turquoise glazes over the earthenware body. By the spring of 1916 Fry had introduced a jet-black glaze, and by the evidence of a letter to his daughter, a dull yellow-green and even a purple. Black and dull yellow green pieces still exist, but no purple ones, which Fry anyway felt were not a success.

Nineteen-sixteen was a successful year for the Omega pottery. Fry was now proficient in the craft, and the heaviness and great thickness of the earlier pieces were giving way to thinness and a greater sophistication of execution. An advertisement for Omega pottery was inserted in the *Burlington Magazine* for March, and then again in May and in August. Three pottery advertisements in one year were the most ever seen – they must have had some effect because Fry's pottery began to be known about in much wider circles. The *Sketch* paid two visits to the Omega Workshops

in 1916, and on one of these the journalist was impressed by the black dinner services on sale:

Imagine how perfectly gorgeous tomato soup would look in a black soup-tureen! Why, one would have tomato soup every day! And the plates are obviously waiting for salad – vivid green lettuce, shy radishes, and magenta beetroots! Fruit would be a Futurist feast in those black bowls, and macaroni most amusing; but in the subdued lights of these nights one would have to feel for the prunes in one's plates![11]

Presumably such a colourful description struck home. Fry's notebooks are peppered with names and addresses of people who purchased Omega pottery: 'Hon. Mrs. Hanbury Tracy, 4 Lowndes Square – 12 black plates dessert size, 4 fruit dishes, 4 little bowls' certainly reads like a direct response to the *Sketch* article. By July Fry was telling his mother that 'Norway and Sweden are at last beginning to ask for Omega things',[12] and in September: 'It would be too odd if after all the Omega were to survive the war. By the by they are actually clamouring for our pottery in California.'[13]

The connections made in Norway, Sweden and California in wartime cannot be traced, but indicate the breadth of Fry's contacts. In America, contact was also made between Fry and Mary Mowbray-Clarke, who ran The Sunwise Turn Inc., a 'modern book-shop' and gallery at 51 East 44th Street, New York. Mrs. Mowbray-Clarke was the wife of the American sculptor John Mowbray-Clarke, who had twelve works on exhibition in the 1913 Armory Show. From the letter on this subject which remains, dated February 1916, it would seem that she contacted Fry first. He responded with enthusiasm, feeling that America was 'bound to occupy . . . an entirely new place in the artistic development of Europe', in comparison with the situation of war-torn Europe. He suggested a scheme whereby Mrs. Mowbray-Clarke took only textiles or carpets on a sale-or-return basis, as he thought it unlikely that exporting furniture would be a sensible proposition. He added a cautionary postscript about the necessity to revise the prices in the *Omega Workshops Descriptive Catalogue* 'owing to the increased cost of materials'.[14] Sending pottery was not mentioned in this connection, so it is impossible to speculate on any link with California and the West Coast. It is also impossible to speculate on the extent of the transactions between Mrs. Mowbray-Clarke and the Omega.

As well as potting in Poole during February, Fry was planning a new interior decorative scheme, as the result of a new commission for the Omega. He told his daughter: 'Vanessa was in town so I got her to do a

design for a stained-glass window for the room at Berkeley Street.'[15] A letter to Philippa Strachey about the same subject implies less efficiency: 'I tried in the train to think of a scheme for decorating a room I've got to do and couldn't get anything out.'[16] The scheme, probably the result of a *Burlington Magazine* contact, came from Arthur Ruck, who, in his regular monthly advertisements in that magazine, described himself as an 'Agent for the private sale and purchase of important pictures and other works of art'. Up until the early months of 1916 Ruck had been functioning from 14 Clifford Street, London. But by April his advertisement indicated a change of address, to 4 Berkeley Street, London. Although he must have physically moved himself and his business in March, he was already in a position in February to ask Fry to plan the decoration of his new premises. On receipt of the commission, Fry delegated Vanessa Bell to design the stained-glass window. But probably nothing came of this, since from March to October 1916 Vanessa Bell and Duncan Grant removed themselves from the London art scene and went to Wisset Lodge, Halesworth, in Suffolk. This was in order that Grant could undertake agricultural work, necessitated by his stand as a conscientious objector. Vanessa Bell accompanied Grant in order to help him, by providing a domestic background.

Fry apparently offered her not only the design of a stained-glass window for the Ruck commission, but also the chance to paint a wall. She was no doubt sorry to lose this chance, by her departure from London before any mural painting at Berkeley Street could begin. She wrote to Fry from Suffolk to ask if the caretaker of the Omega, Mr. Upton, could 'take to pieces that enormous stretcher that Duncan left in the staircase at 22 Fitzroy Street and have it sent here. It seems rather absurd but I want to paint a vast picture – that design that I did for the wall of your room in Berkeley Street, the interior with figures.'[17] No large-scale work by Bell survives datable to 1916, and so there is no indication of the design of the interior with figures which she would have offered for the Berkeley Street commission.

With Vanessa Bell's departure – it is not known whether Grant was asked to design a mural too – Fry had to seek out other Omega artists for Ruck's commission. A new female painter who had appeared by this time was Dolores Courtney. Born in Russia, she studied art at a Paris academy and at Brangwyn's school in London. She may have met Fry through their mutual acquaintance, Ottoline Morrell. Fry's final choice for the Ruck commission obviously indicated the employees then available at the Workshops. They were Fry himself, Nina Hamnett, Roald Kristian and Dolores Courtney. With the exception of Fry, none were known to have

had experience of painting large-scale murals. Thus the Ruck commission could have been a slightly chancy operation. Nevertheless, contemporary visual and verbal evidence suggests quite a successful outcome. From written notices, it appears that more than one room was decorated, but illustrations only concentrate on one. The *Sketch* magazine reported a visit to 4 Berkeley Street, mentioning two decorated rooms, one of which had 'a ceiling that was like a rainbow chopped up in many pieces'.[18] Two coloured illustrations in *Colour Magazine* for June 1916 show two out of the four painted walls in one room, of which one wall is seen right up to the cornice. It would be hard to conceive, even in an Omega interior, of such murals lying beneath such a ceiling; probably the rainbow ceiling was in a room without murals. Maybe the room was without figurative murals like those reproduced in *Colour Magazine*, but with the walls given a decorative colour wash.

The two walls illustrated in *Colour Magazine* were entitled, with information from Fry, *Scenes of Contemporary London Life*. The choice of theme harks back to the scenes of *London on Holiday* selected for the Borough Polytechnic paintings of 1911. An article in *Colour Magazine*, 'On Painting and Decorative Painting', accompanied the two illustrations, and provided further information: 'It is obvious on studying the different walls that the four artists concerned in the work have, without suppressing their individual personality, worked in concert and aimed at modifying their designs in such a manner as to harmonise with the whole.'[19]

Besides working for Fry – as the only artists to hand when the commission arrived – Hamnett, Kristian and Courtney, who obviously knew each other's work well, decided on their own initiative to become part of a loose grouping who exhibited together in the spring of 1916 at the Alpine Club Gallery, under the umbrella title Independent Artists. The three joined together no doubt partly because they did not belong to any larger grouping, such as the London Group. Another motivation must have been a common aesthetic, and the fact that they were all working together at the Omega. So little of Kristian's and Courtney's work is known that it is hard to divine their central artistic aims, except to say that they shared with Hamnett at this time a concern for simple and bold realisations, often in strong jarring colours, of such subject-matter as portraits, still lifes and scenes from urban life. Indeed, as the article in *Colour Magazine* stated: 'The subjects chosen are scenes of contemporary London life such as may be found in proximity to a Tube station, a London Park, or in any street in the suburbs or West End.' Fry might have chosen this theme not only because of the success of a similar joint decorative

theme, but also because the directions taken by his artists already led that way. The illustrations in *Colour Magazine* showed a fireplace wall painted with a medley of four different scenes, divided from each other by three vertical lines, and a wall with a blocked-up doorway, which was cleverly incorporated into the single narrative sweep of the whole surface. Neither contribution was identified in the captions, which remained general, acknowledging the author merely as the Omega Workshops. However, the text of the article named one of the artists, in describing the wall with the blocked-up doorway: 'Note in Mr. Fry's fresco the characteristic label of the Underground, the railway bookstall, the current newspapers and magazines, the newsboy, the policeman!'

The only one of these artists still alive in the 1970s – Dolores Courtney – was able to provide a rough programme of the execution of these murals. She remembered that the four artists, each having one wall to paint, worked together in pairs. Kristian and Courtney were the first pair. Kristian's mural portrayed 'a part of London's industrial area, in dark brown and beige colours',[20] and her own, on the fireplace wall, showed scenes of a London park. As Courtney was finishing hers, Nina Hamnett began a scene 'in the same spirit' as Kristian's. Fry was the last to work in the room, producing the mural with the newspaper stall, which bore the inscription: 'This room was decorated by the Omega Workshops AD MCMXVI' plus an Omega symbol. It was unusual for Fry to be blatant, offering an inscription and a date for an Omega interior decoration, but perhaps, since this was the room of a well known art agent who would regularly have visiting clients, the chance of placing a free advertisement for the Workshops seemed too good to miss. (It seems a shame that, of all the newspapers and periodicals carefully painted on the stall, Fry could not find space for a *Burlington Magazine*!)

Fry was pleased with the room. He arranged for a party and a private viewing of the murals in May, with invitations to a far wider range of possibly interested parties than he had attempted to reach with any previous Omega interior decoration. The *British Architect*, a monthly periodical, published a black and white photograph of Fry's mural. The illustration was offered instead of a description of the room because the reviewer, invited to view the room, did not 'feel competent . . . to find the right words of description'. This appeared, for some reason, in the November issue,[21] although the murals must have been finished by the end of April or the beginning of May. On 29 April Fry wrote to Vanessa Bell in Suffolk about his scheme: 'I haven't quite finished the room yet – I've been so interrupted by other things. I think my panel's getting all right. I'm doing tables too for it, I did a design of a dog which turned out to be

another kind of dog when you turned it upside down; the tail becoming the head, both equally realistic.'[22] He also told her of a large circular rug which he was designing for Arthur Ruck. By the beginning of June, when that month's issue of *Colour Magazine* went to press, this rug had been woven and was on display in the Berkeley Street room with the painted walls. The article drew attention to the rug because of the way (probably uniquely amongst Omega rugs) the shapes in it harmonised with those on the walls: 'This carpet, which displays against its black background corresponding tones of dull yellow and red, repeats the general architecture in rectangular forms which distinguishes the designs of the frescoes.' Certainly, Dolores Courtney's wall fits this description. Fry's wall seems to have more of a horizontal bias, and is easier to read.

The division of Courtney's wall into four sections, cutting up many of the figurative shapes and so rendering them more abstract, was also a feature in three out of her four extant oil paintings, all of which are preserved in Fry's family's collection. Three are still lifes, and were probably shown in the exhibition 'The New Movement in Art' which Fry organised in Birmingham in July, and in London in October 1917.[23] The similarity suggests they may be representative of Courtney's style of *c.* 1916–17. (Her output during these years would not have been large, since she was occupied with starting a family.) They indicate a knowledge of synthetic cubism and the development of the use of papier collé, and they even suggest an acquaintance with the work of Juan Gris of about 1914, which would not be too surprising because Dolores Courtney was then living in Paris. Her four extant works, however, have no dimensions larger than $2\frac{1}{2}$ feet; so it is a little surprising to see her working successfully on an area about 7×15 feet. Obviously, an assessment of her painting career during the First World War can never be fully attempted.

The same is true of the other artists who worked on the Arthur Ruck commission – Nina Hamnett and Roald Kristian. Even their contribution to this work is unknown, although Dolores Courtney remembered Hamnett's mural as being a London street scene, in quite sombre colour harmonies. As well as the love of portraiture evidenced by Hamnett's works exhibited in 1916 and 1917, there appears an emergent interest in scenes of urban life. In April 1916 at a group show, 'The Independent Artists', at the Alpine Club Gallery, Hamnett exhibited a painting entitled *London Backyards*, which was praised as being 'most accomplished'. Again, when Fry showed her work in his 'The New Movement in Art' exhibition in 1917, three works fell within this urban group. They were *Fitzroy Square* (maybe even a portrait of the Omega Workshops), *The Landing Stage* and *London Backs*. Although none of these are extant, Nina

Hamnett related how she added to this category, in Paris, just after the war, when she painted a picture 'out of the hotel window. The window overlooked some roofs. As I had already done several roof scenes in London, I was interested to see some new roofs of a different colour.'[24] In November 1918 Virginia Woolf wrote the following wry comment to her sister: 'Nina Hamnett does roofs; why are you artists so repetitious; does the eye for months together see nothing but roofs?'[25]

Although Hamnett's mural for 4 Berkeley Street is not known, and the extant work of Dolores Courtney at this period is pitifully small, one painting stands as a document to the friendship Hamnett and Courtney must have experienced through their work at the Omega. This is *The Student*, a portrait of Courtney by Hamnett. It is typical of Hamnett's portraiture in that the material possessions of the sitter and fragments of the immediate environment contribute richly to the overall composition and the mood of the sitter. An article on her portraiture, by the same author who wrote on the Berkeley Street murals, commented: 'The sensitiveness that she brings to her composition leads her to accord to each detail just that balance of arrangement which makes of the whole a single well-proportioned study . . . Allied to fine draughtsmanship, well-defined modelling, and a skilful relation of spaces to masses, she achieves . . . a remarkable sense of "tactile values".'[26]

However commendable her portraits, still lifes, urban landscape paintings and her Berkeley Street mural, one is left wondering nonetheless at the calibre of Hamnett's contribution to the Omega Workshops. Her talents in applied art are unknown. As she herself said of her time at the Omega: 'We [she and her husband Kristian] worked at the Omega for . . . many hours a day . . . Vanessa Bell and Duncan Grant worked sometimes at the Omega Workshops . . . They painted batiks and boxes and turned out some fine work. I was never very good at decorative work.'[27] Fry made no comment on this apparent contrast between the fine work produced at the Omega by Bell and Grant and her own more meagre contribution. But he was obviously pleased by her paintings, with their reliance on tactile qualities. As buyer for the Contemporary Art Society in 1916 he purchased a painting of hers – *Still Life*; this, like most of the pre-1918 acquisitions, is now untraceable.

During the same year Fry bought a *Still Life* by Kristian for the Contemporary Art Society. This is also lost; and the same fate has befallen his Berkeley Street mural. But for a sentence from Mme. Courtney, we would not even know that the mural depicted a scene from an industrial area of London. Unlike Hamnett, who was painting urban scenes in 1916, Kristian is not known to have favoured such subjects, preferring still lifes,

portraits and animals. Equally, it is odd to think of him painting an area at least about 7 × 12 feet, when otherwise his largest work measures no more than 18 inches in any direction. The extant examples, reproduced in two contemporary magazines, *The Egoist* and *Form*, indicate his preferred subject-matter and style. Between September 1915 and February 1917 *The Egoist* carried a series of Kristian's woodcut portrait heads of literary and artistic figures. These included Albert Aurier, John Gould Fletcher, James Joyce and Henri Gaudier-Brzeska. *Form Magazine* illustrated woodcuts of animals – four in the April 1916 issue and three in April 1917. Unlike the portraits, the animal woodcuts bear no relationship to the text in which they are set, and may well have been originally executed by Kristian for his own pleasure.

When the Berkeley Street murals had been unveiled, Fry was able to take a short holiday in Paris. Although travel to France was difficult in wartime, Fry was assisted by his friendship with Lalla Vandervelde; he told his mother: 'I had an opportunity of making the journey comparatively easy as I'm going over with Mme. Vandervelde, the Belgian War Minister's wife who is on a mission.'[28] On 1 March 1916 Fry had given a lecture in French, of which both the original and an English précis survive,[29] to the Club Français of London University on the subject 'Quelques Peintres Français Modernes'. A few phrases from this lecture make it clear how important regular trips to Paris were for Fry: ' . . . for the Art of our European and American civilization there has been for a very long time one home, one centre, one capital – Paris. The art of all other countries is a provincial art . . . in default of that self-subsisting tradition of a central art the provincial artists are bound from time to time to renew this art by contact with the capital.'[30]

And thus this provincial artist went, in the company of a new friend, Mme. Vandervelde, to renew his acquaintance with the art of Matisse and Picasso. He wrote to Vanessa Bell of his visit: '. . . all conversations in Paris ended in discussing Seurat. I took over the reproduction in colour of the room at Berkeley Street and a photo of my General Staff and they were very much liked and they all thought they showed that we were going for just the same things.'[31] Although Fry was by his own definition a provincial artist, he did associate himself with that tradition whereby modern artists in Paris could rediscover their links with the classic art propounded by such painters as Giotto and Raphael. In his letter to Bell he does not name the artists referred to as 'they', but he does go on to mention Matisse and Picasso. In his lecture to the Club Français, he announced: 'It is even easy for us to guess that it is Matisse and Picasso who inherit

from Giotto and Raphael rather than authors of the pictures of the year whose names I would willingly cite if I had not unfortunately forgotten them.' This was written before he had seen their latest work; but he reassuringly found that it fitted his theories: 'The new Matisses are magnificent, more solid and more concentrated than ever.'[32]

Just before he went to Paris, Fry made preparations for a show of paintings by Alvaro Guevara, which was to be held at the Omega Workshops later in the summer. Guevara was a Chilean who had come to England in 1908. He had first studied art at Bradford College of Art, and attended the Slade School of Art from 1913 to 1916. While still a student, he had the honour of having a work bought by Fry for the Contemporary Art Society. It was a small oil painting, 13 × 18¼ in., entitled *Music Hall*, and was purchased between January and June 1915 (Fry was buyer for the first half of the year only). The work was bought even before Guevara first exhibited in public, and its purchase indicates how conscientious Fry was in seeking out fresh young talent for the Contemporary Art Society. Guevara was given his first ever exhibition, a one-man show, at 33 Fitzroy Square during August, where he showed twenty-eight oil paintings. Unfortunately no catalogue has been traced, although, as with the Vanessa Bell one-man exhibition at the Omega six months earlier, it is quite possible that no catalogue was produced. Thus we cannot know exactly what Guevara showed. Sickert wrote a small review for the *Burlington Magazine*, but concentrated on Guevara's style rather than naming any of the paintings.

Several of Guevara's paintings from this period have recently been rediscovered. From this evidence, together with contemporary sources, it is possible to categorise his work of c. 1915–17 into three groups: paintings of swimming-bath subjects; of music halls; and of single or grouped people at leisure in cafés or public houses.[33] Twenty-two swimming-bath titles, eighteen music hall titles, and six café or public house scenes are known. It is believed that Guevara's interest in swimming-baths and music halls was attributable to the influence of Sickert. Sir John Rothenstein, in his catalogue introduction to a Guevara exhibition at Colnaghi's in 1974–5, said:

Guevara learnt from many sources but from Sickert in particular . . . Sickert was a regular morning swimmer in the Marylebone baths and it was he who encouraged him [Guevara] to depict them, although he did so in a manner that echoed Matisse rather than Sickert . . . Fry admired and bought the sketchbook he made sitting at the water's edge.[34]

If Fry showed an admiration for such scenes, perhaps a large proportion

of Guevara's show at the Omega was taken up with his swimming-bath paintings. In the Colnaghi catalogue all these paintings are dated 1916–17, but to be awarded a show in August of 1916 Guevara must already have had quite a body of work, which may well have included these paintings; in this case they should be dated more correctly to 1916. Augustus John, a friend of Guevara's and an admirer of his paintings, visited his Omega show. Subsequently he recorded a change in his enthusiasm: 'Guevara has gone mad . . . he runs about the town arranging sales. I went again to his show and realised the hollow-ness of it all.'[35]

On the strength of the interest shown in his Omega exhibition, Guevara was offered a further one-man show – at the Chenil Galleries in February 1917. This received much wider press coverage – by contrast, the Sickert article in the *Burlington Magazine* is the only known review of the Omega show. A perceptive anonymous review of the Chenil exhibition appeared in *Vogue* for early March 1917, along with seven illustrations of Guevara's work. It emphasised just those aspects that would have appealed to Fry: 'In the presence of Guevara's pictures of the swimming-bath . . . the movements of his swimmers seem to express the joy of life,' and 'Throughout these paintings of Guevara's we find one of the most delightful traits. We find the feature in which truly modern art resem-bles primitive art: calligraphic execution. The hand – the sensitive human hand – does not attempt the exactitude that is the triumph of machinery . . . it would impart to line a nervous, personal quality.'[36] Perhaps Fry found in Guevara's rhythmic line, colour harmonies, subject-matter and sense of whimsy an echo of what he admired in the work of Grant.

It also appears that Fry entrusted Guevara with the decoration of a room in a private house, at about the same time as the commission for Arthur Ruck's flat at 4 Berkeley Street. Diana Holman-Hunt, in her biography of Guevara, states that Fry recommended him 'to design a room which was referred to by the critic of *Vanity Fair* [an American magazine] . . . as "a really fine post-impressionist sort of room, the only other gem of the kind lately seen in England being Wyndham Lewis' at the Eiffel Tower Restaurant"'. Apparently Fry provided Guevara with several assistants; being identified with one artist, this commission would have been against the principles of anonymity of the Omega. Unfortunately the article in *Vanity Fair* from which Diana Holman-Hunt quoted cannot be traced; thus there is no further information on Guevara's room. Miss Holman-Hunt's statement that Fry provided Guevara with several assistants has to be rejected as an exaggeration, since the Omega personnel

in the late spring of 1916 was diminished, and those available were working at 4 Berkeley Street. It is not known whether Guevara was actually an employee of the Omega Workshops or was just afforded exhibition space there.

By the early autumn of 1916, the personnel at the Omega was minimal indeed. Fry wrote to Vanessa Bell on 5 and 8 September, first telling her he was on his own, 'sitting in this deserted and lonely place', and then, brightening a little: 'Cheered up now. Been quite busy running the Omega all alone – Winnie's off for a holiday and there's been a lot to do one way and another.'[37] 'Winnie' (Winifred Gill) had reluctantly from the spring of 1916 become business manager at the Omega, since Mr. Robinson, a Quaker and conscientious objector, had joined the Friends' War Victims' effort, in Corsica. Fry also wrote to his father: 'I find myself very fully occupied in running the Omega all by myself just now. I thought at this season nothing would be done but there's been quite a rush of visitors, and some promise of considerable work to be done. The thing may pull through after all though I can hardly believe it will.'[38]

The 'promise of considerable work to be done' was the result of two arrangements, one public and the other private. The private commission was from Mme. Vandervelde, who wanted her flat to be decorated by the Omega. The public commission was a result of Fry's uncompromising behaviour. There was to be a large Arts and Crafts exhibition at the Royal Academy for most of October and November, but the organisers were obviously unsure whether the Omega Workshops fitted into this category. Fry reported to Vanessa Bell on the events surrounding this uncertainty:

I had a deputation of the Arts & Crafts yesterday at the Omega. Three sour and melancholy elderly hypocrites; full of sham modesty and noble sentiments. I was very firm with them and they've decided to offer me a corner of one of their galleries. I said I would only exhibit if I considered the space adequate. Of course poor men they couldn't help admitting how good most of the things were – while inwardly hating them and me all the time. They represent to perfection the hideous muddle-headed sentimentality of the English – wanting to mix in elevated moral feeling with everything![39]

To his mother he wrote:

I'm to have an exhibit of our things in the great art and crafts exhibition at the R.A. Isn't that amusing? But what was most amusing was the way in which the good people tried to leave me out and failed. I told them it was a matter of complete indifference to me whether we showed or not, but that if we didn't show I should publicly contest any claim that their exhibition was

representative of British applied art – whereupon they thought that the lesser evil was to give me a section to show in. I am now arranging it and hope to make some effect mainly by being so much soberer and more austere than my neighbour.[40]

A fortnight later, Vanessa Bell was apprised of the current state of affairs: 'I've arranged my things at the R.A. The brutes turned me out of the place they gave me and wanted to put me in a sort of dark cupboard. I got really angry and finally made the man give me a very fair though not conspicuous place and apologise profusely.'[41]

The eleventh Arts and Crafts exhibition opened at the Royal Academy on 9 October, and consisted of 647 exhibits. The Omega Workshops were afforded a space in the printing and lithography room. This was the first time that the Arts and Crafts exhibition had been held at the Royal Academy, and the organisers obviously wished to make good use of the spacious exhibition rooms. The largest room was designated the 'Hall of Heroes' and a grandiose scheme combining the work of the architect, painter and sculptor was planned. The room was divided into eight huge bays, in each of which a different artist was invited to paint a mural decoration in tempera. Although Fry and his Omega artists had good experience of such work on public and private sites, they were ignored. Instead the spaces were given to Joseph Southall, Charles Gere, Henry Payne, F. Ernest Jackson, Harold Speed, Gerald Moira, Sydney Lee and Walter Bayes.

In the catalogue of the exhibition, number 120 was 'Omega Workshops. Exhibit arranged by Roger E. Fry', but no individual items were detailed. With such a huge exhibition, only a tiny number of exhibits were singled out for comment in the press, and the Omega entry was almost completely overlooked. Fry had talked of making his entry sober and austere, and a small mention in the *Burlington Magazine* confirmed his avowed aim: 'A welcome note of courage is given by the Omega Workshops Ltd., here there is even danger of audacity to excess; still the products of this firm are original and virile, and an antidote to the sweetly pretty, which is so invidious and unfortunately so popular.'[42]

When Fry had organised his Omega stand, he was pleased to note that another stall in the exhibition was showing a range of strong and virile designs: the Design and Industries Association was exhibiting brightly coloured textiles, made in Lancashire for the West African market. The Lancashire mill also supplied these same fabrics for sale at the Omega Workshops. The Design and Industries Association had been founded in May 1915, in order to promote 'a more intelligent demand amongst the

public for what is best and soundest in design'. Logically, Fry would seem to have been an ideal committee member of this association – J. H. Mason, who advised Fry on his first Omega book, was a founder member – but he does not seem to have had any connection with it.

How great a choice Fry would have been able to make from current Omega stock is unknown; from his letters to Vanessa Bell and his mother, it looks as though he was not given a lot of time to plan his exhibit. It is not possible to estimate the stocks of furniture and smaller household items such as candlesticks and painted boxes, but one category would have been in good supply, and that was pottery. Fry devoted a good deal of his time to pottery during 1916; and a tiny review of the Omega's Royal Academy exhibit in *The British Architect* concentrated on its high quality: 'Whatever opinions one may hold as to Mr. Roger Fry's decorations, no one can deny him the gift of the most admirable pottery design of which our sketch gives some hint.'[43] Two pages then followed of rather poor pen and ink sketches of selected items from the exhibition. In their simplicity and strength two painted vases by Fry do stand out from other pieces – such as a bird bath in lead by Phoebe Stabler and a heavily decorated toy stand by Laurence A. Turner.

Connected with the Arts and Crafts exhibition was a series of talks on related subjects, each with a chairman and a selection of speakers. On 14 November the topic for discussion was 'New Aims for Commerce', and Fry was one of the speakers. *The British Architect* reported his speech:

Concerning the machine in art, Fry felt that this was the most important problem now before them, and it was by no means solved yet. They still did not know the least bit what the machine could do with advantage and what it could not do. He did not altogether agree in thinking that man could altogether control the machine. That was well illustrated in regard to the production of pottery.[44]

Fry was concerned that pottery should always reveal the joy in the making of it, for

. . . unless there was some joy in the making there would not be joy in the long run in the contemplation of any object, and it was very difficult to see how that joy was to be got in a machine-made object. If they were going finally to solve the question of the machine, they had got to find out how much good was done in being able to produce very rapidly, and in large quantities, or producing more slowly by processes which actually interested and occupied the mind of the person who was doing the work.

From the evidence of a later pronouncement by Fry, it appears he felt that problems resulted from the use of machinery in the mid-nineteenth

century; in his essay published by the Hogarth Press, *Art and Commerce*, we read: 'Then with the advent of the Prince Consort, and a new interest in the history of past art, there came the delightful dream that the finest optifacts (even the finest works of art) could be produced mechanically on so vast a scale that everyone might own a masterpiece.'[45] But he was unwilling to deny the usefulness of machinery. Rather he was concerned to point out the problems and how they could be faced: 'It is very hard to harness machinery to the production of works of art . . . Still, it would be untrue to say that machinery is fatal to the work of art. Its effect is to substitute an ideal exactitude for a felt approximation. Wherever the machine enters, the nervous tremor of the creator disappears.' Both *Art and Socialism* (1912) and *Art and Commerce* (1926) display a knowledge of Thorsten Veblen's book *The Theory of the Leisure Class*. This was originally published in America in 1899, reprinted four times and then revised by 1912. Veblen recognised that trait in humanity which he named 'conspicuous consumption'. He described it as expenditure on objects not necessary for comfort or use, but for advertisement or exaltation of personal status; and his analysis found a sympathetic audience in Fry.

But Fry would never have considered that the objects produced at the Omega would be purchased for such a reason. It would not have occurred to him, for example, that society ladies in London could vie with each other to own the brightest handpainted cushions. Maybe even the commission from Lalla Vandervelde, for the Omega to decorate her new flat, was motivated by such desires. She was, however, a good friend of Fry's and no doubt willing to put work his way. He wrote to his mother in October:

I'm doing all the furnishings of Mme. Vandervelde's flat. Everything has to be designed specially to fit into corners and nooks, for it's very badly planned, and it means a lot of detail and all has to be done in rather quick time. I don't know whether this will save the situation for the Omega, but she has determined to make it a great advertisement for us.[46]

When Fry said that he was doing all the furnishings, it is impossible to know whether to take him literally. Roald Kristian, Nina Hamnett, Dolores Courtney, Jock Turnbull (who was back for a brief spell at this time), and maybe even Alvaro Guevara, were probably available intermittently and may have helped. It seems probable that other artists were indeed working with Fry, because in the midst of preparations for Lalla Vandervelde's flat he was able to organise an exhibition at the Omega, held during the first two weeks of November. It consisted entirely of still life paintings, and the only known review mentioned works by Fry,

Grant and Hamnett. By November, Grant had moved from Suffolk to a farmhouse at Charleston in Sussex, to continue his work as a conscientious objector, and Vanessa Bell went with him. But although he had moved nearer to London, Grant took as little part in Omega activities as he had when he lived in Suffolk. His contribution to the Omega exhibition would have arrived by carrier, or would have been sought out by Fry from private collections in London.

In an article called 'The Artist as Decorator', printed in *Colour Magazine* in April 1917, Fry described the recent transformation of a private flat by Omega artists. But he only reported the artists as having painted the walls. He must have been referring to Lalla Vandervelde's flat, and thus it can be inferred, again, that he had help in that task. But the thirteen pieces of painted furniture still extant from Mme. Vandervelde's flat, a very motley assortment, could well be the work of Fry himself. They include standard painted Windsor armchairs, painted chests of drawers, and several cupboards decorated with leaves, stems and flowers. None of these are distinguished by their designs, but two other pieces do stand out: one is a commercial bed with painted wooden head- and foot-boards, which show a hardening and tautening of the shapes employed by Fry. The other piece of furniture is an inlaid desk decorated not with animals like the giraffe cupboard or the proposed tables with inlaid dogs for Arthur Ruck, but with a pair of mirrored meandering lines. Line and contour had always been important for Fry, but beginning in the winter of 1916 and continuing through 1917 and 1918 the quality of the drawn line began to assume a greater importance in his work and, consequently, in his scrutiny of the work of others. In February 1917 Fry confided to Vanessa Bell: 'I'm beginning to find out about drawing, for myself I mean. The way, that is, to unhitch the mind.'[47] This remark implies that he was attempting to draw in a very spontaneous, unlaboured way, rather after the manner of young children.

At the very time he wrote to Vanessa Bell, he was in the midst of preparing a show of children's drawings for the Omega Workshops. Maybe his growing interest in the free, gestural line was responsible for his attention to children's drawings. On the other hand, examination of the way his daughter drew might have led him to experiment in such a way for himself. He discovered the artistic talents of his daughter Pamela when she was only one year old, in 1903, and wrote to his mother about it. As Virginia Woolf recorded: 'Thenceforward, he was determined that his daughter's artistic inclinations should not be hampered by conventional instruction.'[48] Any attempt to teach art would, he believed, stifle an

individual's freedom and sensibility. He realised, in his own case, that his great knowledge of other art did tend to hamper and overwhelm his own talent.

From 19 February 1917 until the beginning of March, Fry held an exhibition of drawings and paintings by the children of artists in a room at the Omega Workshops. The work of the children of Augustus John, Eric Gill and Sydney Carline, as well as Fry's son and daughter, was included. He tried to persuade Vanessa Bell to send some of her children's work, but she replied to his inquiry with:

I'll see if I can find any drawings by the children but I thought you didn't think them generally interesting enough . . . It would be interesting if you could show things grown-ups had done as children. There was a lovely drawing by Duncan he had done when he was about 6. I think the children have 20 sketches from memory of a vase of flowers which was rather amusing.[49]

Since there is no catalogue or handlist, it is not known whether the exhibition included work by Vanessa Bell's children, or indeed, the work of Grant when a child. Fry's show at the Omega was a landmark in the exhibition of child art in Britain. It was, as Richard Carline said, 'the first attempt to stage a display of children's paintings as real works of art in their own right, entirely different in concept from the exhibitions of the Royal Drawing Society, which showed how near children could get to adult work'.[50] Fry was convinced of the futility of approaching schools, since any work they might lend would be unlikely to contain the aesthetic merits he admired. It was for this reason that he asked artist friends to lend the work of their children, believing that they would have been allowed to paint more freely than children who had simply learned art at school.

Augustus John came to look at the show. He appeared to miss the point Fry was trying to expound. Fry told Bell that John seemed 'to me almost entirely stupid – to have no reaction whatever to pictures'. Yet Richard Carline, who exhibited his work, recalled that a snake in a tree by David John aroused great admiration. Fry's ideas on child art may have been lost on Augustus John, but they profoundly influenced Marion Richardson, a young art teacher from Dudley in the West Midlands. Through her work teaching art in schools and prisons in the Midlands, she had made the acquaintance of Margery Fry, the penal reformer, who was then living in Birmingham. Marion arrived in London in February in order to show the educational authorities examples of her pupils' work in the hope of obtaining an inspectorate. She found her way to the Omega Workshops and the exhibition, and showed Fry some of this work. He immediately put

a selection of her pupils' paintings on show alongside the work by children of artists. Miss Richardson encouraged not mimetic skill, but imaginative skill; she would read a story to her pupils, who would then translate the words into drawings and paintings. This was a different approach from the way artists encouraged their children to experiment, but Fry found the results most praiseworthy. He was careful to distinguish between the two approaches, however; writing to his daughter about the work of the pupils of Dudley School, he said: 'They're quite different to the things the artists' children like you and the little Johns and Gills do, and I daresay they'd never come to being artists, but the imagination is astonishing.'[51] If, although the Dudley pupils had imagination and invention, Fry could not see them ever becoming artists, what did they lack? Was it a certain sensibility, or was it the presence of artistically educated parents?

Fry was excited by the qualities of the children's art, and by the beginning of March he had begun to write about it. This project was still active in May, when he wrote to his sister Margery: 'I'm trying to write a short book on children's drawings and the teaching of art . . . I'm trying to summarize a bit what I've learnt from the children's show, which was wonderful. It's real primitive art, not the greatest or purest kind of art, but real art, which is more than can be said of almost anything else we turn out nowadays.'[52] An article by Fry, entitled 'Children's Drawings', appeared in the *Burlington Magazine* in June 1917. His book, *Children's Pictures and the Teaching of Art*, was advertised in *Colour Magazine* in October and by Chatto and Windus in November, but it never reached publication. Fry's exhibition of child art as real art, rather than as the embryo production of an adult, had been preceded – perhaps to his knowledge – by two similar exhibitions, one in Europe and one in America. In May 1911 in Milan, the Futurist painters had included drawings and paintings by children and untrained workers alongside their own; and in 1912 Alfred Stieglitz held an exhibition of children's work at his Gallery 291 in New York. In the same year Kandinsky and Marc chose to reproduce children's drawings in their Blaue Reiter almanac.

'The Artist as Decorator' was Fry's first and only article for *Colour Magazine*. It was published in the April 1917 issue. To publish it in this magazine, with its emphasis on the practical aspects of modern art, must have been deliberate. Such a bias – away from pure theory – would probably not have been appropriate to the *Burlington Magazine*, his usual platform. Maybe Fry felt there was still a vestige amongst *Burlington Magazine* readers of the social distinction between fine and applied art; it was certainly something he had already brought to their attention, in 1910. In 'The Artist as Decorator' Fry urged people to let artists loose upon

the walls and ceilings of their homes; he described the genus of artist to his readers as 'charming but uncertain'. If he wished this article to advertise the Omega Workshops, perhaps this description of its employees was unlikely to inspire commissions. In the same month he placed an Omega Workshops advertisement in the *Burlington Magazine.* When article and advertisement were placed, no doubt both in March, the Omega may well have been in need of help. But at the beginning of April its fortunes looked quite hopeful. Fry wrote to Rose Vildrac in Paris: 'The Omega just keeps going – I am always astonished that it is not dead. Now a big London firm is taking an interest in our things and possibly I shall make some association.'[53] There is however no evidence of association with a large London firm at any period in the Omega's existence.

The *Colour Magazine* article included a reproduction of an oil sketch, probably by Fry, which gives an idea of the Omega Workshops' approach to wall painting during late 1916 and early 1917. The sketch showed an area of painted wall, divided up by pilasters, with smaller areas of colour in between. The painted decorations were abstract, composed only of very simple shapes. Except for the Cadena Café murals they were unlike any of the earlier Omega examples, which contained representational elements. The text described how the artist-decorator could work in an abstract, formal way, using a feeling for pure, decorative design and a sense of proportion and colour harmony to make a work of art out of an interior. Only in recent times, amongst more modern artists, had any interest emerged in the decorative possibilities of painting and architectural design. The interest in architectural design is exemplified by the murals in the oil sketch, which probably depicted the scheme used in Mme. Vandervelde's flat. And it could well have been fostered through experimentation with papier collé. But a concentration on single brush-strokes, on the effects of laying the paint on the wall, was something new in Omega interior decorations. Before the commission for the Vandervelde flat, in all Omega murals the paint had been applied as a means to an end. But with the Vandervelde murals, the application of the paint was the end in itself. Fry wrote of the separate brush-strokes giving the whole wall surface an agreeable vivacity and great richness – effects requiring crude and speedy execution. He had talked, too, of trying to draw in a more spontaneous manner; and perhaps through the fresh and unpolished methods of the Vandervelde murals he attempted a looser simplicity and an avoidance of finish that would also benefit his fine art work.

Grant and Bell, living outside London, were no longer involved in

large-scale interior schemes for the Omega. They were, however, involved in similar decorations on their own account. Although they were to live at Wisset Lodge in Suffolk only for about seven months, the temptation of areas of bare wall provoked them into producing large temporary decorations, which had to be painted over when they left. Their choice of decoration, reflecting a strictly personal taste, differed from that pursued at the Omega. One of the largest Wisset murals, executed by both Bell and Grant, was a copy in watercolour, scaled up to cover a bedroom wall, of a minute reproduction of Fra Angelico's *Visitation.* Copying an Old Master is likely to have been endorsed by Fry, who considered it a valuable mode of art instruction, even though it was not a form of decoration available to clients of the Omega. Indeed, while Grant and Bell were living in Suffolk, Fry was in the habit of sending photographs of works by Italian painters for them to copy. In June 1916 Bell wrote to Fry: 'I have been working hard at the copy of the Giotto. I am rather excited about it as I enjoy doing it so much. For some reason I feel nearly as free as if I were painting on my own account. I have quite changed the colour scheme.'[54] A short while later Fry sent two further Giotto photographs for Bell to work from, and this time she found the task difficult: 'I am rather appalled by the difficulty of copying either but I think I shall try the procession one. The other is astonishing – it seems to me rather like a Matisse – but I don't think it's as possible to copy.'[55]

It was in the early 1890s that Fry had adopted the habit of copying Old Masters in order to learn. Feeling this process was beneficial to his art, he began to urge other artists to do the same. And in the winter of 1916–17 he began to send photographs of works by Italian Old Masters for Grant and Bell to copy with a view to exhibiting. With Grant he was preaching to the converted: Simon Bussy had encouraged him to copy Old Masters, and Maxwell Armfield reported that when he first met Grant, in February 1906, Grant was copying a section of Piero della Francesca's *Nativity* in the National Gallery.[56] Armfield and Grant met again in Paris in 1907, when, as Armfield said, Grant was copying a Terborch in the Louvre. These examples were only part of a serious programme of copying that Grant pursued at the beginning of his artistic career. Most of his subjects were the work of early Italian artists, mostly fresco painters; the Terborch is a more unusual choice. In contrast, the copying of the Old Masters was not something Vanessa Bell was naturally drawn to.

Fry appears to have directed Bell – but not Grant, who chose his own models – to copy certain Italian Old Masters in order to exhibit a selection at the Omega Workshops. This 'Exhibition of Omega Copies

and Translations' was held in a room at the Omega for a couple of weeks from 11 May 1917. A catalogue exists, with a preface written by Fry, which further reveals his attitude towards the copying of Old Masters. The catalogue also reveals that, although he had tried to persuade a large circle of his artist friends to copy Old Masters for this show, Fry had to rely heavily upon work by himself, his daughter and his wife. Grant and Bell also contributed, even though they were permanently absent from London. Bell wrote from Suffolk after the show had been hung, asking who else had contributed: 'You don't tell me what you think of all the other pictures nor whether Sickert played up – I suppose not – nor Nina or Mme. Courtney. But according to Maynard Keynes there's no one but you and me and Duncan.'[57] Dolores Courtney did in fact respond and showed a copy of a Derain. But as Bell acknowledged, the idea of Sickert producing a copy of an Old Master for an Omega exhibition was quite unrealistic.

Vanessa Bell showed five works: two copies from Giotto, one each from Sassoferrato and Bronzino, and a copy of a thirteenth-century Persian miniature. Grant showed four: two copies from Piero della Francesca (one of them the detail from Piero's *Nativity* which he had been copying when discovered by Armfield), and one each from Antonio Pollaiuolo and Sassetta. It is believed that Fry also included his version of Grant's *The Ass*, which was appropriate, since it had originally been copied by Grant, or rather, enlarged, after a Persian miniature. Fry contributed the largest share of works, numbering eight: six copies from Italians – Raphael, Sassoferrato, Buffalmacco and Cimabue – a copy of a Ludger Tom Ring, and a copy of a Byzantine enamel. One is left wondering whether Fry positively sought out such recondite subjects, or whether his collection of Old Master photographs dictated the selection.

Besides three copies, all at least ten years old, by his wife Helen, and two recent ones by his fifteen-year-old daughter Pamela, the only additions to this close-knit circle were Dolores Courtney and Mark Gertler. Dolores Courtney's entry, which has survived in the collection of the Fry family, is mentioned in the catalogue as a copy of Derain's *Samedi*. The original was painted in 1913 and bought the same year from Kahnweiler's by Sergei Shchukin, the great Russian collector. Courtney may have known this painting at first hand, perhaps having seen it while she was in Paris in 1913. Wisely, she did not make a copy the same size as the original, which is $71\frac{1}{2} \times 89\frac{3}{4}$ in., but produced a version scaled down to $19\frac{3}{4} \times 25$ in. She also altered the colour scheme, choosing indian reds, yellow ochres and warm browns rather than Derain's sombre greys, ochres and blacks – perhaps as a result of working from a black and white illustration of the

painting. A handwritten addition to the 'Copies and Translations' catalogue belonging to Grant states: 'M. Gertler – Cézanne', implying that Gertler sent a copy of a Cézanne to the show after the catalogue had gone to press. No such painting by Gertler has been identified.

The versions of Derain and Cézanne, although instructive choices for the copyists, were not ideally suited to the exhibition as Fry had conceived it. He intended it as a lesson in rediscovering the art of the Old Masters through the eyes of contemporary artists. As he wrote in his catalogue preface:

> Each generation, almost each decade, has to remake its old Masters. If we did not go on continually revaluing and remaking them they would be not merely old, but dead. And such copies as those in the present exhibition may, perhaps, be of interest from this point of view, since they will show what are those elements in the work of various periods which have a special meaning for the modern conception of design.[58]

The exhibition would thus have been of value on two counts. First, it would have revealed aspects of modern art which could be linked to similar aspects in the art of the past which were already acceptable to the public. Second, it could have laid bare, by distorting or translating the original, an intention which the older master had had to obscure. Such was the reasoning behind the title 'Copies and Translations'. It was the copying rather than the translating of an Old Master which led Fry to write of Cimabue's *St. Francis at Assisi*: 'The whole composition is marvellous . . . but what's so wonderful – when one begins to study the forms in detail one finds just the kind of purposeful distortion and pulling of planes that you get in Greco and Cézanne and the same kind of sequence in the contours.'[59] For Fry, a work such as this did not need a translation – its intentions were not obscured.

With the exception of the Sassoferrato, the Ludger Tom Ring, the Pollaiuolo and one of the two Raphaels, all the works by the Italian school copied by Grant, Bell and Fry were either frescoes from large decorative schemes or tempera paintings on panel. Although all three artists were practised in the technique of tempera painting, they chose to copy these works in oil on canvas, unconcerned by the alteration in medium and support. Possibly the works were intended to be portable and thus saleable, although Fry must have recognised that the chance of selling any works from this Omega exhibition were very slim indeed. The motivation for the exhibition was didactic; sales would have been seen as a bonus. But even though Fry must have expected a poor response, he was still miserable: 'The show is an almost complete fiasco, not even our

clientele – not more than about ten people since opening and not one damned critic.'[60]

In fact, the only sales were two works by Grant – his copies of the Pollaiuolo and Piero's *Nativity* – and they were not bought for aesthetic, but for sentimental reasons. Maynard Keynes was the purchaser. As he explained in a letter to Grant, the Piero was bought because it was an old friend, and the Pollaiuolo as a possible wedding present for his brother Geoffrey. Fry would have written to Grant and Bell at Charleston, to tell them of the news of sales – even though they were still co-directors of the Omega, they were subject to the same rules on commission as other employees such as Henri Gaudier-Brzeska had been: 'By the by, did you and D. [Duncan] remember that we usually take a 20% commission on sales? I know it seems horrid but we have a lot of expenses – printing catalogues, postage etc.'[61]

In June Fry was having difficulty in his professional relationships with Grant and Bell as his co-directors. Because they were living permanently in Sussex, Fry was unable to put much Omega decorative work their way; and they had begun to accept commissions from friends without consultation with the Workshops. Grant and Bell had recently produced some painted furniture and decorated two rooms in Mary St. John Hutchinson's house at West Wittering in Sussex. Fry only learnt of this when Bell asked his advice on the headboard she had designed for Mrs. Hutchinson's bed. She also let slip that Mrs. Hutchinson was paying £12 for their decoration of the rooms. Fry reacted to this with annoyance: 'I hope the £12 is nett and she pays expenses otherwise it is fearfully underselling us – we should have probably asked £20 for 2 rooms.'[62] This is the only indication of the price the Omega charged for interior decoration.

At about the same time Vanessa Bell had received a bill for £48 for textiles from the Omega, which horrified her. Instead of her owing the Omega such a sum, she felt that the Omega still owed her some money. As she explained in a letter to Fry, this debt had probably arisen because she had been lax in her accounting: 'I don't know how people are paid now, whether by time or work, and it's difficult to know how to charge for things like designing dresses and hats etc.'[63] She then defended Grant's position, knowing he was unlikely to do so himself:

Duncan at any rate did bring it [the Omega] a great deal, and did work for it at a low rate – in fact he could only continue to work for it in that way if it could give him certain and pretty constant work. Otherwise he clearly couldn't afford to as he could make so much more by painting pictures. So that as he hasn't had any work from the Omega, or hardly any, for the last

two years, it does rather alter things and naturally when he is asked to do a room, it seems as if the sacrifice he would make by doing it through the Omega is hardly made up for by anything the Omega can do for him.

Bell then implied that such a discussion was likely to be rather academic in view of the Omega's weak financial state and paucity of artist-employees.

During the whole of 1917 the Omega received not a single large decorative commission. The only major activities were three exhibitions mounted by Fry – the drawings and paintings by children, the 'Copies and Translations', and a mixed show of paintings by young artists – and an evening club which met on Thursdays for informal discussions on questions of art and literature. Fry had founded the Omega Club in the late spring of 1917, with more success than in any other scheme of his that year. To his daughter away at boarding school, he wrote: 'We hope to get all the more interesting people in London to come.' And of course he did. Members included W. B. Yeats, Arnold Bennett and Lytton Strachey. They had to rough it, however. 'We hadn't enough chairs and didn't want to buy them so we made great pillows of sacking filled with straw and put them round the room against the wall.'[64] This club provided a welcome opportunity for intellectual stimulus in a constrained world.

Bell's letter to Fry ended with an offer of support from herself and Grant, but on different terms from their earlier relationship with the Omega:

But of course I want to help and not hinder the Omega, and so does Duncan, and we should both be quite ready to work through it – only I think that the whole position is different from what it was in the days when it could give artists a low wage because it was a constant one, that perhaps it ought to be reconsidered. I daresay this is all unnecessary though if the Omega is to come to an end.

In his reply, Fry entreated his two co-directors to remain as employees of the Omega:

If you and D. as directors and original members of the Omega were to say that you only did decorative work thro' the Omega it would be a great help, even if we didn't get a penny out of it. But in some cases where there was a lot of organization and business connected with it, we should of course arrange a certain commission. The main thing is that you would not be a rival firm. I believe in the long run this would be good for you.[65]

His major concern was apparently that, in the public eye, Bell and Grant should not seem to have seceded from the Omega and started up a rival venture. There was already a precedent, in the Rebel Art Centre. Fry no doubt felt that two secessions would weaken his position as organiser of the

major British decorative arts workshop, and further deprive him of talented artists.

A week later, Fry was asking Grant and Bell to lend him a good selection of their paintings of the past few years, for inclusion in a major mixed exhibition. As with all Fry's exhibition campaigns, this one was intended to 'disturb the profound self-complacency of the English'.[66] Unlike the others, however, it was to be in Birmingham rather than London, although a smaller version did show in London for a much shorter period. As with the second Post-Impressionist and the second Grafton Group exhibitions, the Birmingham show included both English and French paintings. Out of a total of seventy-eight works, Fry showed twelve of his own and lent twenty-three from his collection. His most personal taste was thus firmly in evidence. The only other lender, apart from the artists themselves, was Clive Bell, who sent four paintings. The exhibition was entitled 'The New Movement in Art', implying that the artists included shared a single direction. It also conveyed the idea, since Fry shunned the term Post-Impressionist, of a newer, more recent movement than this. The exhibition opened on 17 July and continued until the middle of September, at the Royal Birmingham Society of Arts in New Street. At the private view Fry gave a lecture on the new movement, and some of his ideas were reported in the Birmingham papers. They reinforce the implication that Fry was tired of the term Post-Impressionist – 'a term which he invented but which died out after a short vogue'.[67]

Out of twenty-four artists (fourteen of whom were foreign), nine had worked at the Omega for varying periods. Thus the show amply reflected the fine art works of the Workshops' employees; in fact fifty-two of the seventy-eight works were by these nine Omega employees. Unlike the second Grafton Group exhibition, no applied works were included. In his catalogue preface Fry isolated one tendency which ran through the work of these artists: '. . . the acceptance by all the more open-minded and progressive artists . . . of the work of Cézanne. Almost unknown during his lifetime, his work has since his death inspired a more complete revolution in the arts of painting and sculpture than any similar change recorded in the history of art.' In his opening address, reported the press, 'Fry somewhat startled his audience by admitting a great admiration for certain aspects of the Pre-Raphaelite "decorative poetical conception of art" as represented in Burne-Jones.'[68] This was probably an attempt on Fry's part to establish a rapport with a Birmingham audience: Burne-Jones was born in Birmingham and had been President of the Birmingham Society of Artists, and several of his works were in the City Art Gallery.

Fry's reference to Burne-Jones was a means of introduction, rather than part of his main thesis on the exhibition. Burne-Jones and Cézanne shared merely an approach to the construction of a picture; and Fry believed that the artists in his Birmingham exhibition followed Cézanne rather than any Pre-Raphaelite. In an article in 1926, Fry made the following distinction:

One may almost say that taste is always pendulous between Raphaelitism and Pre-Raphaelitism. Pre-Raphaelitism conceives of a content rich in ideas, interesting in the forms chosen for delineation – interesting both by their recherché nature and by their evocations of sentiment – and finally, rich in the decorative display of these forms. But Raphaelitism envisages no such interesting or curious content – is, in fact, satisfied with the most commonplace and banal content that comes to hand, and searches in the delineation of that content the utmost richness and intensity of plastic stimulus to the imagination; and in order to give this its full effect it eschews the disturbing influence which the rich decoration of the picture surface implies.[69]

Solomon Fishman, in his study of Fry's aesthetics, points out his fondness for dualist formulations such as vision and design, plastic and linear, form and content. This pleasure in antithesis was certainly given expression by Fry in the summer and autumn of 1917. On the one hand he could see, in the subject-matter of his little band of English artists, a tendency towards the commonplace. Examples are Vanessa Bell's *Bottles on a Table* or McKnight Kauffer's *Tree and Bridge*, which showed great attention to the formal qualities of the composition. But on the other hand, many subjects chosen were not universal and ordinary; instead they made great play with specific objects, sentiments, and even experiences peculiar to contemporary life, for example Fry's *German General Staff*, Grant's *The Ass*, or Bell's *Triple Alliance*. And in two of these, the Fry and the Bell, the picture surface had been enriched and the texture thickened by large aggressive areas of papier collé, which opposed the clarity of the formal structure.

The Omega period is thought of as Fry's most formalist decade. But although formalism was the aspect of art on which he laid most stress, he did not uphold it rigidly. He was always prepared to change his viewpoint; and during the Omega years he was very interested in the connection between art and literature. Fry's knowledge of Italian art would have included the Renaissance *Paragone*, the intellectual debate of the fifteenth and sixteenth centuries concerning the relative merits of different art forms. He himself tried to formulate theories of painting and poetry on the basis both of their figurative illusionistic qualities and on their more abstract and formal attributes. In his lecture at the opening of 'The New

Movement in Art', he told Vanessa Bell, he 'worked out a bit of my theory in poetry', and his admiration for Burne-Jones would have been stimulated by this. Also, Fry appreciated that Grant, in particular, had a 'natural inclination to fantastic and poetic invention',[70] which warred with an insistence 'upon the formal elements of design'.

In October 'The New Movement in Art' was shown in the Mansard Gallery at Heal's, London. It was now minus six paintings bought in Birmingham by Michael Sadler, and with Fry's entry reduced from twelve to seven paintings. It also included about thirty watercolours by McKnight Kauffer. When Fry's exhibition was on show at the Royal Birmingham Society of Artists, Kauffer was also exhibiting locally – in the foyer of the Birmingham Repertory Theatre. Fry wrote an essay for Kauffer's catalogue, and subsequently included the same work in his own show at Heal's. Thus, by the autumn of 1917 Kauffer had become the newest recruit to the Fry circle. Guevara, who had only a year before been awarded a one-man exhibition at the Omega, appears to have been dropped, since there was not a single painting by him in 'The New Movement in Art'. Although both men had been killed in the war, works by Gaudier-Brzeska and Doucet were included, from the stock at the Omega and Fry's own collection respectively. Roald Kristian had been arrested in April 1917 as an unregistered alien, and after three months' detention was deported; but three paintings by him were included, presumably lent by Hamnett or Fry.

Concurrently with organising 'The New Movement in Art' exhibition, Fry set about planning his third Omega book, part of Book III of *Lucretius on Death*, translated by his old friend Robert Trevelyan. With the removal from Britain of Kristian, Fry was no longer able to turn to him for woodcut illustrations. The Omega publishing venture was thus deprived of an illustrator with a good sense of what was required, and who had emerged as original. Fry and Trevelyan had already collaborated on two books, in 1901 and 1908, and on both occasions Fry had designed the frontispiece. *Lucretius on Death* was just following on in this tradition. Both Trevelyan's earlier books, containing his own poetry – *Polyphemus and other poems* and *Sisyphus* – reveal his concern as a poet with a reworking of ancient Greek myths and legends taken from the best of sources, the *Iliad* and the *Odyssey*. This reworking of great material was equivalent to what Fry had been doing earlier in the year, with his 'Copies and Translations' show. Trevelyan's text for the third Omega book fitted in very well, being a free translation of part of *De Rerum Natura* by Lucretius.

The only woodcuts in *Lucretius on Death* appear as the title page and the first initial letter of the text. The book was twenty pages in soft covers,

priced at 2s 6d and measuring $11\frac{3}{8} \times 8\frac{7}{8}$ in. There is no indication of its size of edition. Although the woodcuts were undoubtedly designed by Fry, it appears that he asked Dora Carrington to actually cut the blocks. Such a delegation, altering the individuality of the design, must have been unavoidable for a busy man. Fry was, however, tremendously pleased with the finished book. Uniquely, he took a whole-page advertisement in the *Burlington Magazine* to announce its publication.

From 1917, a year of exhibitions, only one tiny reference to an Omega commission has emerged. The work in question was hardly likely to ease a difficult financial situation. In November Fry wrote to his daughter: 'Lalla's moving into a new house which'll mean a deuce of a lot of little jobs for me I know and I fear no big one for the Omega which I shouldn't mind.'[71] Mme. Vandervelde appears to have moved home, always renting her accommodation, at regular and frequent intervals. The flat which the Omega had decorated for her in the autumn of 1916, and to which Fry referred in his article 'The Artist as Decorator', was being abandoned, and the same process would have to be undertaken again in a new set of rooms. From Fry's letter, the commission to decorate her new flat seems to have been given to him personally rather than to the Omega. This may have been on his advice, since the pool of artists on which he could call in 1917 was very small.

In the same month that Fry had a one-man exhibition of flower paintings at the Carfax Gallery, he also organised the first mixed-subject show of paintings by artists of his circle to be held at the Omega Workshops. It opened on 10 November, and included at least twenty oil paintings. No catalogue has been traced, and any idea of these works is only available from reviews. Unlike the work shown in 'The New Movement in Art', the paintings exhibited at 33 Fitzroy Square in November seem to have been done recently. *The Times* review called them 'advanced' pictures, no doubt choosing such a vague description because all others seemed unsuitable. Fry, after all, had shunned any group or movement title for his Birmingham and London exhibitions, using instead one that was bland and general.

Exhibits included a painting by Grant entitled *The Kitchen*, which *The Times*' critic praised: 'In most of his pictures he seems to give out memories of other works of art that he has absorbed into his subconsciousness. It is not imitation but a memory, transformed by the artist's own mind. Here he seems to have remembered some Sienese painting, but he has produced something quite original with its own curious beauty both of design and execution.'[72] A similar comparison with art and artists of an earlier period was provoked by a portrait of a lady by Fry, called *La Diligente*. The critic

described how the portrait 'rather unexpectedly reminds one of Raphael. It has, at the same time, such an abstract perfection of design and is so very lifelike.' The rewards of learning through copying Old Masters were now being reaped not only by the artists, but also by spectators.

7
DEBTS AND REGRETS:
1918 & 1919

WITH the beginning of 1918, sales and orders increased at the Omega, and its position improved. In January Fry and his Workshops received a commission to provide a set, furniture and costumes for Israel Zangwill's new play, *Too Much Money*. Zangwill wrote his play, a farcical comedy, during the war, and the instructions for the set of Acts I and III look as though they reflect a knowledge of an Omega Workshops decorative interior. 'The walls are frescoed with a flamboyant futurist pattern; a brilliant lamp hanging from the ceiling makes a colour harmony with a gaily cushioned divan . . . and a screen of strange hues and symbols.'[1] After only five years, the decorative projects of the Omega Workshops were beginning to find their way into fiction. The chapter on the Omega in Richard Shone's book, *Bloomsbury Portraits*, starts with a quotation from a novel called *The Pretty Lady* written by Arnold Bennett in 1918. In it the hero described a painted room 'that is unmistakably Omega'.[2]

The plot of Zangwill's *Too Much Money* concerned a Mrs. Broadley of Mayfair who suffered from the affliction named in the title. The Omega Workshops were to provide Mrs. Broadley's drawing-room and its furniture. In this way an Omega interior was presented on the London and Glasgow stage as an example of what could be done to the modern home only with a great deal of money. Theatregoers may have been convinced of the expense, but it was an illusion. Prices at the Omega were low in comparison with their equivalents. Heal's, for example, sold painted boxes and artificial flowers at twice the price. Standard Omega objects were used to decorate Mrs. Broadley's drawing-room – a sofa, painted and printed cushions, Vanessa Bell's *Bathers* screen, and handpainted pottery containing artificial flowers. Fry, in a letter to his daughter, talked of designing a dress for the actress Lillah McCarthy, who was to play the part of Mrs. Broadley and who, having seen his design, pronounced it splendid. The same letter also contained a 'design for a cushion for the

theatre – dark grey figures on yellow and green', together with a pen and ink drawing of two nude female figures facing each other. The design exemplified the symmetrical pattern of opposed forms of which Fry was so fond.

In February the play was dress-rehearsed in London, although it was actually to open in March in Glasgow. Fry was unwell with a liver attack, but still took pains to get the decorative effects right. He wrote to his mother: 'I had to go to the scene painters to put the finishing touches and paint the fireplace of which you saw the sketch.' He must have known she would recommend that he took some rest, but he pointed out the impossibility of this 'because the Omega is beginning to do more and better and I am almost the only person who can be called upon for designs'.[3] The sets and furniture were well received at the dress rehearsal, as Fry told his daughter. He also allowed himself a little praise – 'My mantelpiece looks stunning.'[4] Contemporary photographs of the set show no mantelpiece; but such a feature assumed great importance in Fry's interiors. It was after all the decoration of the mantelpiece for the sitting-room at the Ideal Home Exhibition that caused the row between Lewis and Fry. Again, like the Ideal Home Exhibition sitting-room, Mrs. Broadley's drawing-room was a very temporary affair. But for all its ephemeral nature, Fry was most willing to undertake commissions of this kind. After the dress rehearsal he wrote again to his mother, this time with cheerful news: 'Everyone seems to think it a huge success. The producer of the play says he thinks it will be the making of the piece so it may bring the Omega luck. On the whole things have been getting better and brisker there.'[5]

Fry had acquired a new business manager for the Omega, with whom he was very pleased. In wartime, with most young men either fighting or occupied with some profession linked to the war, Fry, in his usual businesslike way, had sought a manager from amongst a class of young men who were not occupied – the conscientious objectors. Mr. Robinson, the previous business manager, had also belonged to this group. Fry had discovered a suitable man – a Mr. Paice (again through the good offices of Winifred Gill, whose father had employed him before the war) – imprisoned as a conscientious objector, and he had persuaded the Home Office to release him for gainful employment by the Omega Workshops. Paice appeared to be doing a good job, as Fry reported to his mother: 'My C.O. is such a wonderful businessman and so prompt and energetic and so full of care and forethought. He saved me all the bother of the details about the play – arranging everything perfectly so that everything was ready to time and without a hitch.'[6] Perhaps the appointment of Paice as business manager had a bearing on the turn in fortunes of the Omega. Its personnel

was very depleted in the fourth year of the war, and any efficiency and reliability would have been most welcome to Fry.

When the decorative problems of *Too Much Money* had been settled, Fry went down to Poole for an energetic spell of potting. He was, in fact, so immersed in fulfilling pottery orders for the Omega that he was unable to see Sir Charles Holmes about possible purchases. These were to be made on behalf of the government from the Degas studio sale, to be held in Paris at the end of March. Fry had drawn the attention of Grant, and Holmes, to this imminent event. He had then withdrawn from the discussions and returned to his pottery, but only after he had written a note about the sale for the *Burlington Magazine*. In late March 1918 *Vogue* magazine carried a half-page photograph of a group of Omega products, along with a caption, 'The Keen Householder realizes that Spring is the moment in which to rejuvenate and improve her home.' The photograph showed two wooden armchairs, a square marquetry table, a 'lilypond' screen and a large white vase. These were all objects which had been available for the previous three or four years. Interestingly enough, although in the *Omega Workshops Descriptive Catalogue* marquetry tables were priced at £6 6s each, in the *Vogue* description the price for the same table was quoted as £5 10s. Perhaps Fry had to reduce his prices because of the hardships of wartime. Although the Omega was not mentioned by name in *Vogue*, the objects in the photograph were all described by the brief editorial in glowing terms.

The Omega was reported to be doing brisk business at the beginning of 1918. As in 1915 one of its most reliable sources of income seems to have been dressmaking. Indeed, by this time it was even profitable; and another female member of staff, Faith Henderson, had been called in to assist. In February Fry told Vanessa Bell of the benefits accruing: 'You see, the dressmaking is really a profit to the Omega now – we get nearly £2 a week out of it (which is really too much only it makes up for past deficiencies) so Paice is very keen to carry on.'[7] However, the spring and summer months are a complete blank in our record of the Omega's existence. Fry devoted this period to a concentrated discovery of his own artistic personality, drawing and painting by himself in various venues out of London. The luxury of such a programme must indicate a lack of business for the Workshops.

By the autumn, however, the Workshops were again central to Fry's life. On 26 October, an exhibition of modern painting opened at Fitzroy Square, with dresses by Mlle. Gabrielle and new Omega pottery. Joy Brown, who had helped make a series of dresses designed by Vanessa Bell

which were exhibited at the Omega in summer 1915, must have parted company with the Omega by this time, since the work of another dressmaker was included instead. Fry wrote to Rose Vildrac in October about this new seamstress: 'The Omega goes a little better. We have found a marvellous modiste – a real genius – a little French lady who was starving in Paris.'8 The name of the lady, not included in the letter, was Gabrielle Soëne. At the beginning of 1919 Fry, along with Edward Wolfe, painted her portrait. Fry's portrait, judging from the sitter's bare environment, was probably painted at the Omega, and Mlle Soëne could well be wearing one of the dresses shown in the exhibition.

Edward Wolfe, who painted her at the same time as Fry, was, in the autumn of 1918, the Omega's newest recruit. He was a student at the Slade School in 1917 and 1918, during which time he was introduced to Nina Hamnett. She in turn introduced him to Fry and the Omega. He first exhibited with the London Group at its eighth exhibition in the Mansard Gallery, Heal's, in the summer of 1918. As Fry and Hamnett were also exhibitors, it could be that an introduction followed from this event. At the time of Wolfe's arrival at the Omega handpainted candle-shades were in demand, and he was given the job of painting several with a similar design. He proved his worth by introducing variations on the set theme and, as Grant recalled, Fry was to say of him: 'Ah, yes, Wolfe, a perfect genius for candle-shades.'9 Wolfe's decorative talent was also given other uses. Fry's daughter Pamela recalls that while she was helping to paint some secondhand furniture at the Omega at the very beginning of 1919, Edward Wolfe was engaged on a commission to decorate a child's garden tent, which was set up inside 33 Fitzroy Square for him to paint.

In the exhibition of modern painting at the Omega in October 1918, Wolfe – with nine paintings – was the largest contributor. Most of the other artists were also Omega employees – Bell, Grant, Fry and Hamnett – with a few sympathetic friends: McKnight Kauffer and Gertler, who had shown before in Fry/Omega exhibitions, Benjamin Coria, a friend of Hamnett, and, rather surprisingly, Sickert. Sickert only showed one painting – *Chagford Cemetery* – and *The Times* critic was quick to pick up this anomaly: 'Sickert's Chagford Cemetery does not go well with the other pictures, but goes very well with itself.'10 Considering Sickert's friendly rivalry with Fry and his not too serious attitude to the Omega (for example, going in one day and attempting to commission a chamber-pot), it is a little surprising to see him exhibiting alongside paintings of which he would have been quite critical.

The exhibition was well prepared, and both a poster and a catalogue for it survive. The catalogue is only a list of exhibits without any text by Fry,

but it does sport a decorative woodcut on the front page. Fry probably commissioned Grant to produce the cover for the catalogue. He must have been prepared to overlook the rule concerning the anonymity of the designer, since Grant's initials in the top right-hand corner of the border are quite a prominent feature. As usual, Duncan Grant's painting – in this case, *Flowers* – won praise. Wolfe, too, with his nine paintings, drew comment from the critics, who found his work a little derivative but full of fluency. His drawing style – a free gestural line used expressively – was derived, like Hamnett's, from Modigliani and Gaudier-Brzeska; Fry bought several of Wolfe's drawings and reproduced one in his *Burlington Magazine* article 'Line as a Means of Expression in Modern Art' in December 1918.

Probably Wolfe's first oil painting as an Omega employee is a small *Still Life*. On the back of the canvas is the inscription: 'my first study painted 1918 Edward Wolfe in Nina Hamnett's studio Fitzroy St.' The subject is a group of Omega objects: an earthenware cat with a blue glaze, designed by Gaudier-Brzeska; a white earthenware jug (with a chip out of the rim already); and in the background part of the cover of the latest Omega Workshops book, hand printed by Fry. In its choice of subject and lengthy inscription, this small canvas is almost a celebration by Wolfe of his association with the Omega. As such, it assumes all the more importance in that no extant Omega object or design can be attributed to Wolfe. Thus we know nothing of his applied designs and decorations for 1918–19. A painted table and a painted tin tray survive, decorated by Wolfe in the mid-1920s, and these do give a hint of the abstract decorative work he might have produced at the Omega. Both his employment at the Omega, and other evidence, point to the high regard Fry had for him. In a letter to Vanessa Bell in December 1918, Fry wrote about the possible foundation of an artists' association, with a secretary and a dealer. The artist members of this association were to be recruited from Fry's circle, and he appended a list of the possible annual earnings of each. Grant, not surprisingly, came highest, with Wolfe second – in the position Etchells had held in relation to Grant in 1912–13.[11]

The poster designed by Fry for this mixed Omega exhibition of modern painting is the only extant Omega poster, though it was possibly one of several. Since it conformed to a standard size for posters, and gave travelling instructions on how to reach the Omega, maybe it was used on public sites such as the Underground. It listed three categories of works – paintings, dresses and new pottery. Under the heading of paintings, the names of Fry, Bell and Grant are listed along with Gertler, Hamnett and Wolfe, omitting Coria, Kauffer and Sickert. Since the reviews only

referred to the paintings, it is impossible to say what Gabrielle Soëne's dresses were like. New breakfast and dinner services were also advertised. It is not known in what way the dinner services had been redesigned – perhaps a different-coloured glaze was employed. In a letter written in September 1918 to Vanessa Bell, Fry sketched the design of a new coffee pot. It was tall, with two protruding ridges where the handle met the body; it had a lipped top and a flat-sided handle, and was produced with a white glaze.

While this exhibition was on, Fry was collecting woodcuts from his colleagues for his fourth Omega book. As early as July 1917, Virginia Woolf, as co-director of the newly formed Hogarth Press, had talked of acquiring a new press which would reproduce illustrations as well as text. She wrote of her plans to Fry: 'We are going to see a £100 press which we are told is the best made – particularly good for reproducing pictures. This opens up fresh plans . . . Wouldn't it be fun to have books of pictures only, reproductions of new pictures – but we must get you to tell us a little about how one does this.'[12] Fry's reply to this letter is not known. But a few days later, Virginia Woolf was writing to her sister with a similar idea: 'We should very much like you and Duncan to do a book of woodcuts – in fact we are getting a machine that is specially good for printing pictures, as we want to do pictures as much as writing. Of course they would take much less time to do.'[13]

From this it appears that Mrs. Woolf's motivation for a book of original woodcuts was twofold: first, an admiration for the illustrative capabilities of her sister Vanessa Bell, and of Grant; and secondly, a reduction of labour for the inexperienced duo of Leonard and Virginia Woolf at their Hogarth Press, with no type to be set and only one other person's efforts to be inked up and printed. Discussions about a Hogarth Press book of woodcuts lasted through August and September of 1917, with Vanessa Bell taking a major part in the planning. By September the idea of a book had been discarded: instead a portfolio of separate loose sheets was proposed. It would have one woodcut to a sheet and contain the work of other artists besides Bell and Grant (Bell tried to obtain some Kristian woodcuts from Fry for the project). But the idea finally came to grief late in September, when Bell realised that Leonard Woolf had reserved the right to have the final decision on the layout; this was something she could not accept. (In 1921, the Hogarth Press's plan for a book of woodcuts was revived, and they brought out *Twelve Original Woodcuts* by Roger Fry – with Fry no doubt having his say in the layout – which went into a third impression within two months.)

Fry had been producing woodcuts since 1911, when he became acquainted with Eric Gill. Grant's and Bell's excursions into this area of graphic activity were more recent – only really from 1917 – with the proposal of the Hogarth Press book of woodcuts. Both could have begun, though, to learn the craft of cutting patterns on woodblocks at the Omega, where from 1913 materials had been printed by hand using woodblocks. Recalling his brief period of woodcutting, Grant said: 'We learned to do it ourselves. I think Roger may have helped us at first. I found it very easy, but Nessa had difficulties at first. She kept gouging holes in herself.'[14] Before the Omega Workshops book *Original Woodcuts by Various Artists* was eventually published, both Bell and Grant had produced woodcuts for illustrative purposes: Grant designed and cut the cover for the Omega Workshops exhibition catalogue of October 1918, and Bell cut two woodcuts to accompany her sister's essay 'Kew Gardens', which was published by the Hogarth Press in May 1919.

As with the exhibition 'Copies and Translations of Old Masters', Fry had to negotiate with Grant and Bell at a distance to obtain what he wanted for his book of woodcuts. In November 1918, Bell responded to a call to action from Fry:

I have done another woodblock. Duncan has done 3 altogether. But we are both waiting for a fine tool with which to finish them. I hope Bunny [David Garnett] may bring me back one from London tomorrow and then we can soon get them done and send them to you. I daresay you won't want my second one or at any rate won't want the two cut, in that case will you choose which one you like best.[15]

The fine tool was acquired, and Vanessa Bell cut the two blocks of which she had written. Her lack of confidence in her woodcuts, especially in comparison with those of Grant, showed in the letter which accompanied them to London: 'I hope you won't think my second block too awful . . . I daresay it's too incoherent. I did another but I didn't much like it. However I now send you a print, very bad ones, of each block so that you can see for yourself. You may think the nude better but I don't think it is on the whole.'[16] Of the two she sent, one depicted some dahlias in a vase and the other a nude standing before a tub. Both were included by Fry in the book, and the nude, particularly, was admired. He wrote to her: 'Your woodcut of the nude is simply lovely. I don't think I've ever admired you enough . . . It's really a big thing. You are an artist.'[17] Her woodcut *Nude* was based on a large painting of the same subject but entitled *The Tub*, which she had executed in the summer of 1917.[18] The difference in size – the original painting measured 71 × 65$\frac{1}{2}$ in. and the woodcut 7$\frac{1}{2}$ × 4$\frac{1}{2}$ in. –

would not have caused any problems for Bell. Both she and Grant were able to work on a very large and a tiny scale; and their subjects could be scaled either up or down without much loss to the integrity of the composition – a facility presumably derived from practical experience at the Omega. The proportions of the woodcut are narrower and taller than those of the painting, and the resulting composition is tauter and more attractive, with the nude slightly more prominent, taking up almost half the space. Since an extant painting was the basis for one woodcut, it would not be surprising if a painting of a vase of flowers had been a model for the other – the dahlias. When embarking on a new venture – for example, producing designs for the Omega – it was Bell's practice at first to rely on existing paintings, and she kept to this method when she began to execute woodcuts.

The same tactics can be seen in the work of Grant. Of two woodcuts by him printed in the Omega book – *Hat Shop* and *The Tub* – *The Tub* is a copy of one of his paintings, done *c*. 1916–17.[19] Fry singled out *Hat Shop* for particular praise, and told Vanessa Bell:

I think his Hat Shop is wonderful and is typical of what's best and most characteristic in him . . . the element of the object with all its ordinary associations comes in. It's because those things are the ridiculous stands that support hats that the design at the bottom is so fascinating. There's a point not exactly of wit but of delicate and half-humorous fantasy about it. It's splendid as coherence of form . . . He ought always to watch for a subject . . . only some such subject, a thing with a definite point . . . only such a subject inspires him to the best of his purely formal sensibility.[20]

Again the existence of a large painting could conceivably lie behind the woodcut.

All the woodcuts included in this Omega book have a great freshness and vitality, which is due to the same hand both drawing and cutting the design. Also, the woodblock is seen only as a surface in which tones and textures can be manipulated for their own sakes rather than for reproducing an image for a wider audience. In contrast with other participants in the great English woodcut revival in the second decade of the twentieth century, the artists included in the Omega book all shy away from ostentation of whatever skill they possessed. All the woodcuts in the book are extremely personal, especially *Study* by Kauffer, and *Ballet* and *Group* by Edward Wolfe. Possibly all these woodcuts were first attempts, made with encouragement from Fry. The artists were not inhibited by lack of technique, regarding the woodcut as an art-form rather than a craft.

In late November Fry talked of all the woodcuts being harvested, 'and

we begin to print next week'. Richard Madley again was used as printer, and the woodcuts were published, in an edition of seventy-five copies, as a twenty-eight-page hardcover book measuring $10\frac{1}{4} \times 7\frac{3}{8}$ in. It bears the date of 1918 on the title page, but might not have been actually available until the beginning of 1919. The artists included were the Omega triumvirate of Fry, Bell and Grant; Kauffer and Wolfe too were persuaded to contribute; also Simon Bussy and Gertler; and two of Kristian's woodcuts were used, probably executed *c.* 1916 and retrieved from the collection of Fry or Hamnett. It was to be the last communal venture by members of the Omega Workshops.

With the end of the war in November 1918 there was the possibility that the public would be more willing to purchase new household objects. Fry was determined to be ready for this. There was an extreme shortage of new furniture to decorate, and he turned to buying up old pieces at salerooms. He admitted that the results were not always of the standard he would have liked. He told Vanessa Bell: 'As we can't get furniture made I've been buying old furniture and we are going to paint it at the Omega. You might let people know if they want to get chairs etc.'[21] When Fry said 'we' he can only have meant himself and Wolfe, since there was almost no one else at the Omega in the winter of 1918. With the signing of the Armistice and the release of young men from military duties, it became possible for former employees to find their way back to 33 Fitzroy Square, to pick up the threads and to earn a small amount of money. But most of those who had passed out through the portals of the Omega and were still alive – Etchells, Lewis, Wadsworth, Hamilton, Nash, Guevara, Roberts – had no intention of returning. They had various personal reasons, mostly connected with arguments with Fry. But one casual employee seems to have returned. Virginia Woolf wrote of a visit to see Roger Fry and the Omega at the end of October 1918, in the course of which she met Hubert Waley. Hubert was the younger brother of Arthur Waley. He had had a spell at the Slade School in 1912 and 1913, and a period sharing a studio on the north side of Caledonian Market, attempting to become an artist. In 1915, if not earlier, he had worked part-time at the Omega. He quit when he was called into the Artists' Rifles in 1916. Twenty-four painted lampshades and one painted bowl still record his time with the Workshops. The lampshades, all in the possession of the artist's family, are decorated with abstract designs painted in bodycolour on thin card. Other extant lampshades, designed for the Omega by Lewis and Kristian, bore human and animal subjects. Waley's, however, are totally abstract, relying for their composition on multicoloured interlocking zigzags.

In the notes left by Hubert Waley for an autobiography, he recalled his

artistic difficulties at this period his life. 'I lacked any single fixed ideal of style. Two incompatible styles chased each other round my bewildered brain – a calm topographical style, all straight lines, and a hysterical style, all wiggles.'[22] A pencil and ink drawing survives, from *c.* 1915, of a view of Regents Canal; in it both styles fight for supremacy. The upper part is made up of the calm topographical style. But where, in the lower half, the buildings are reflected in the canal and one would expect the same calm, straight lines to be continued, Waley has substituted his 'wiggly' style, composed of interlocking zigzags. Either the freedom of working at the Omega created this style or it was inherent, and Waley, having recognised it, used it with good results in the decoration of small household objects. In his autobiographical notes he had originally written of three incompatible styles. He crossed out the third, described as 'an oriental style, all flowing curves', possibly because when he wrote the notes in later life he could find no evidence of it.

Evidence of such a style might have escaped him until only a few months before his death. In 1968 Quentin Bell's *Bloomsbury* was published, with photographs of several items never before illustrated. One of these was an Omega bowl made by Fry, and decorated – so the caption related – with a scene of two boxers by Grant. Waley recognised the decoration of the bowl as his own work and informed Quentin Bell, so that later editions now give this authorship. The style Waley used for the figures of the boxers, with its simple profile shapes, spare use of line and dramatic contrast of tones, could well be termed 'oriental'. It was neither topographical nor hysterical; and it was one that Fry would have admired. The subject of boxing was a favourite of Waley's *c.* 1915. He regularly attended boxing matches at a ring at Blackfriars, and even produced a privately printed booklet on the subject, illustrated with scenes very similar to that painted on the bowl. By comparison the earlier attribution of this work to Grant was the more unlikely in that such pugilistic subject-matter hardly fitted Grant's pacific ideology.

In the summer of 1915 Fry and Hubert Waley had a correspondence on the subject of aesthetics. This may have been Waley's initial contact with a topic he was later to pursue in print – in *Burlington Magazine* articles and in a book, *The Revival of Aesthetics*, which was published in 1926, the same year as Fry's 'Some Questions in Aesthetics' appeared in his volume *Transformations.*

Waley may well have returned to work at the Omega in the winter of 1918; but Fry recorded, at the beginning of 1919, that he was still short of assistants. Matters were not helped by the great influenza epidemic of the winter of 1918–19 which killed tens of thousands. Fry and his family were

laid low; Mr. and Mrs. Upton, the caretakers of the Omega, were quite ill; and Wolfe and Gabrielle Soëne were dangerously so. In February Fry wrote of his activities to Vanessa Bell:

I'm simply tired out with all the cares of the Omega . . . Wolfe got ill . . . I had to do everything – all the furniture paintings. I have surpassed myself in ingenuity, inventing methods for treating this old rough furniture without the long processes of getting a good surface, and also in designing things which could be carried out on the old rough paint, using where possible the original design or what was left of it. On an average, I think I must have designed and painted one piece of furniture per day and some I would love to show you because I think they're the best things we've done in that direction. [23]

He did publicise his efforts, with a full page in the early April issue of *Vogue.* It showed six photographs of painted furniture under the heading 'The Newest Designs of Painted Furniture from the Omega Workshops'. One depicted the bed Fry painted in 1916 for Lalla Vandervelde, which could not really be classified as recent. But the other pieces, with the exception of a circular dining-table which was designed by Fry, revealed a family likeness to the 'rather common and amusing stuff' he had been buying from a dealer in the country, stock which had 'been for years in the bedrooms of farmhouses'. [24] Fry's daughter remembers him, accompanied by his friend Elspeth Champcommunal, the widow of a French painter, taking a horse and cart down to Horsham in Sussex to collect some of this furniture, which he had just bought in a sale.

Fry pronounced himself pleased with his efforts at transforming secondhand furniture into pieces suitable for modern homes. But he was irked at the way the Omega now took up every minute of his time and all his energy. He began to think of passing the problematic Workshops over to another management, telling Vanessa Bell:

I've been really tired out with all the worries and details of the Omega of late. I think I should chuck it now if it weren't that Mme. Champcommunal holds out hopes of taking it over later. She has a wonderfully clever friend, a great businesswoman who gave me a lecture on why I'd failed. It was fascinatingly interesting and entirely true. She's a real master of the technique of business . . . she says a good thing requires far more skill to 'put over' on the public than a bad and that I've given no attention and no skill to that side of the thing. [25]

Since Mme. Champcommunal had become editor of British *Vogue* magazine in 1916, she had exactly the right vehicle with which to promote the Omega Workshops in a much more businesslike manner. The increased demands of the Omega resulted from the revival in its clientele since the ending of the war. Fry told his mother of 'about fifty-odd orders' [26]

to be fulfilled. Such custom, in this difficult winter, indicated how much business the Omega must have enjoyed in favourable times.

In January 1919 the Omega was involved in projected decorations for another new play, with Lillah MacCarthy again as the leading lady; but these plans never materialised. Lillah MacCarthy was on the point of acting in a new Arnold Bennett play, *Judith*. Fry, reminded of Bennett as a good patron of the Omega, its club and its personnel, sought his advice. He wrote: 'I should like to talk to you about the Omega one day. It is at a critical point. There is a chance of getting it placed on better commercial footing or else of its failing ignominiously. In either case I shall retire from the chief position.'[27] Possibly Fry turned to Bennett where previously he had turned to Bernard Shaw, because Bennett had just given a demonstration of his generosity towards the Omega and its employees: he had been persuaded to commission a portrait of himself from Edward Wolfe and had bought a painting by Duncan Grant, negotiations in both cases being conducted by Fry.

While tiring himself painting furniture all day long, Fry decided on another exhibition for the Omega. This, a mixed show, was to be the last one held. Fry had been in contact with Diaghilev on the latter's visit to London in September 1918, and plans were aired for the Omega to design a ballet for the Russian impresario. With this project in mind, Fry went to the Russian ballet productions of *Soleil de Minuit* and *Contes Russes* in November and December, and was captivated by the stage designs of Michel Larionov. Larionov had been represented, by a single oil painting, in Fry's second Post-Impressionist exhibition of 1912. But his stage designs were seen in England for the very first time at the première of *Soleil de Minuit* on 21 November at the Coliseum in St. Martin's Lane. Fry went to the opening night of this and of *Contes Russes*, and declared that Larionov's stage settings and costumes for the latter constituted 'the most lovely spectacle that I've ever seen on the stage'.[28] (Just as a measure of the shift in Fry's allegiances in his Omega years – he had said exactly the same of Charles Ricketts' setting for *Salome* in June 1906.)

On 21 February Fry held a private view of this mixed exhibition at the Omega. There were eleven stage designs by Larionov, together with a retrospective exhibition of the work of pupils of Dudley High School, taught by Marion Richardson, plus some of the furniture Fry had been painting. He described the show to Bell:

. . . a retrospective exhibition of Dudley with a lot of wonderful things,
arranged all around the walls of the big room, pinned on to Holland curtains
– they produce a very good effect because they are so solid and definite in

colour and design. Then I have a lot of Larionov's wonderful designs for marionettes in the studio, and then the downstairs rooms emptied of all but furniture. They look much better than they've ever done before . . . But it was a horrible wet day yesterday and no one turned up to the private view.[29]

This lack of support was nothing new. Fry had experienced it at the opening of the Omega exhibition of 'Copies and Translations'. He made a characteristic choice in his use of bright patterned 'Holland' linen curtain material as background to the children's works of art. From the time of his Alpine Club Gallery exhibition in January 1912, he had always believed in a bright, bold environment for modern works of art. He had enlivened his galleries with commercially available patterned linens on the seating, and painted the frames of his canvases with strong chequered patterns. When he had the chance to enliven the walls of his exhibition spaces, he did so. His views on the hanging of exhibitions were equally vigorous. In 1920, writing of his long experience of hanging exhibitions, he gave the following advice: 'Naturally, to hang pictures you must consider them not as pictures but as objects to be composed on the wall like a mosaic.'[30] This view accorded well with the way he felt an artist sees objects: 'In such a creative vision the objects as such tend to disappear, to lose their separate unities, and to take their places as so many bits in the whole mosaic of vision.'[31] This standpoint could well have been fostered by an examination of, and admiration for, the later works of Cézanne.

The eleven Larionov designs which Fry showed at the Omega exhibition could have been obtained as a result of his meeting with Diaghilev, or, indeed, from the artist himself, who was in Paris at this time. Fry mentioned 'letters from . . . Larionov about his work for the Russian ballet' and that he was going to write about this for the *Burlington Magazine*. He was obviously intent on finding out more about Larionov's stage designs, and on sharing them with a wider audience. A catalogue, again using Grant's woodcut cover, accompanied the Omega Larionov/Dudley exhibition, but the text only concerned itself with the Dudley children's drawings. Fry wrote on Larionov for a wider audience, publishing his views on the designs in the March 1919 issue of the *Burlington Magazine*. This article argued that choreography precedes the set and the costumes; it was accompanied by seven illustrations of Larionov designs, four of which had just been on show at the Omega. Fokine's choreography was served by Bakst – not, in Fry's eyes, a front-rank creative designer. But with the new ballet of Massine, the pace of development and design was forced to change. Massine

. . . aimed at a conception of the dance which one might call 'heraldic' . . .

In Larionov and Goncharova the ballet has discovered two designers who are able to accept with eagerness the new conception of the heraldic dance, and whose natural inclination is to give to their designs an exactly corresponding transposition of the actual into a formal equivalent.[32]

Good theatre designers, then, like painters, were those who shunned realism and embraced formalism.

The children's art shown at the Omega with the Larionov designs was not in the same class, nor did it pretend to the same aims. But Fry believed that it was important and should be seen, because it 'has expression. It is not of course great art, it lacks the richness of experience and the logical control of great design, but it is a genuine higher art.'[33] Fry's catalogue text also asserted: 'The children themselves have been encouraged to criticise their own and their fellow pupils' work and so to build up a kind of common tradition somewhat analogous to the local traditions of art of the Italian towns in the Renaissance.' This analogy is reminiscent of Fry's general prejudices in favour of communal artistic expression; in describing the benefits of encouraging children to work in this way, he was harking back to other communal artistic experiments – the Borough Polytechnic murals and the Omega Workshops themselves – in which he could claim for himself a degree of success. His catalogue introduction does not, however, mention Paul Poiret's Ecole Martine, although its aims of free expression and communal endeavour would have endorsed his own belief.

By the time the Larionov/children's art show was taken down, the position of the Omega Workshops had become precarious. Fry was busy moving himself, his two children and his sister Margery into a new London house in Camden Town without previously having sold his house at Guildford. At the beginning of March he learnt of the sorry financial state of the Omega Workshops, which only echoed his personal accounts: 'Today I hear from the Accountant that the accounts are far from correct, that they can't be passed and that we're liable to God knows what penalties for not holding a shareholders' meeting last year which I was always reminding Paice about and he always said there was plenty of time and then forgot all about it.'[34] Mr. Paice's efficiency seemed to have failed him; even the new seamstress was a disappointment – 'Gabrielle has been more atrocious than I can tell you and has I fear ruined her clientele by sheer carelessness!'

The Omega had had several crises during the five and three-quarter years of its existence, but this time, by the spring of 1919, a decision to close down seemed the only course left. Fry had contemplated such action before, but the Omega had always managed to survive. He may well have

entertained moral objections to closing down a valuable form of artistic patronage during a time of war. But when peace was restored, these objections would fade. His attitude to the Workshops also appeared to have altered from one of tremendous enthusiasm to one of annoyance, resignation and regret:

This last show has been an utter fiasco. By being abject for most of an afternoon to Mrs. Matthias I have sold two chairs for £4, and that's all. It's too discouraging, and I see it's hopeless in this vile country. To think that no one but Lalla [Vandervelde] has given me so much as a room to do when I have endless devices for doing it cheaper than anyone else and could make it very swell. I've been very blue about it all.[35]

His mood of despair was obviously strong enough to block out memories of rooms at Lady Ian Hamilton's, the Cadena Café, and Arthur Ruck's. On top of all this gloom came the news that continued occupation of 33 Fitzroy Square had suddenly become doubtful: 'The Omega house is being sold and unless I buy it which I think may be rash or impossible I expect we shall be turned out.'[36] If he vacated the property and restored it to some sort of order Fry reckoned that at least £500 would be needed, and he had no such reserves. £500 certainly seems a large sum for the overpainting of two murals and the possible removal of shelves and cupboards; perhaps the interior of the house had been altered more than visual evidence suggests.

His two co-directors, Grant and Bell, made a late rally; but their support was decorative rather than financial. Bell wrote to Fry, offering suggestions, which as always tended towards the design of textiles or of clothes. She told him that she and Grant were prepared to paint some hats for sale at the Omega, since highly decorated hats were now said to be the latest fashion. But she knew it was a limited gesture: 'It's only a small experiment and I don't suppose it will come to much, but possibly people's snobbery will induce them to buy a hat painted by Duncan.'[37] Fry replied: 'I don't think I know how to set about it, but if you and D. could get and paint some I'd be delighted to put them in the Omega. I can't let Durbins or Omega or anything; in short, I shall soon be ruined.'[38]

A note in Fry's 1919 diary records a meeting at the Omega Workshops at 10 a.m. on 20 June, where there can be no doubt that plans were proposed for the closure of the Workshops. At the end of February there had been an examination of the shares held by the Omega shareholders. The original five – Fry, Vanessa Bell, Duncan Grant, Sir Alexander Kay Muir and Lady Ian Hamilton – had not been joined by any other supporters (with the exception of Margery Fry in January 1914 – as the result of family pressure, no doubt). Fry had turned to Bernard Shaw for financial help when setting

up the Omega, and in June 1919 he pressed Arnold Bennett for advice and money. But Bennett did not respond to this last attempt to keep afloat some form of patronage for the artists who had been employed there. Fry wrote to tell him of the Omega's certain closure:

I intend to [close] the moment I can let the premises. Of course it's irritating to lose 5 years of pretty continuous work and £2000 and nothing to show for it but it's the kind of chance one has to take . . . I think it's a pity because the commercialists will have it all their own way and there will be no attempt at really creative design. However people have the world the average man likes. I don't understand the animal and can't hope to manage him.[39]

In fact, it was less the commercialists than Fry's friends who benefited from the last event at the Omega. Fry decided to hold a clearance sale of his stock, at greatly reduced prices, from 23 June to 9 July. He advertised the clearance sale in the advertisement pages of the *Burlington Magazine*, and sent printed cards announcing the event to a wide circle of friends. As a result it was quite a success, with people daring to buy decorated household goods at reduced prices that they had ignored when offered at full price. Fry wrote of this to Vanessa Bell: 'Sir Michael Sadler came at 9.0AM one morning and with terrific energy bought up all sorts of odds and ends . . . I rather hope the sale will be a success and that we may clear off some of the vast sums that hang over me for repairs etc.', and again: 'A. M. Daniel came to the Omega sale and bought linens now they are $\frac{1}{2}$ the price of linens elsewhere. He's never done a thing for us before so it made me rather annoyed.'[40]

David Garnett and Francis Birrell were two others who benefited from the sale. They had just gone into partnership, setting up a bookshop in Taviton Street, but were devoid of furniture for the shop. As Garnett recalled: 'Roger was . . . able to help me furnish our shop with tables from the Omega for which he charged me only about a tenth of their value.'[41] It is not known how much stock was offered at the sale or how much was disposed of, but Fry's clearance sale announcement card made it clear that he still intended to offer certain articles from his new home in Camden Town: 'The Omega Pottery and Carpets can still be obtained by order, from Roger Fry, 7 Dalmeny Avenue, N.7, but the firm will no longer make articles for sale in their shops.' Perhaps the singling out of these two categories – pottery and carpets – indicates that they were Fry's favourites; or it could mean that he was left with more of these than anything else. The card also stated: 'The artists connected with the Omega Workshops will continue to carry on business as house decorators.' This must have been included as a panacea for Bell and Grant, so that clients who had

already approached them, both from inside and outside the Omega, would be informed that they were still available for interior decoration.

Relating how he bought Omega tables at the sale, Garnett also ventured the opinion: 'Roger Fry had just brought the Omega Workshops to an end at a time when a change in public taste, which would have ensured their success, was taking place.'[42] It may be unwise to speculate on how the Omega would have fared had it not been for the First World War, or had Fry not closed it when he did. What can be said is that the Omega Workshops exerted a powerful influence on most of the artists who worked there. Grant was to say in 1976: 'It was rather like a party, with all the gaps too. One was often on one's own. And then the crowds would come in on one. It was tremendously encouraging. I think it was the best period of my life.'[43]

Virginia Woolf was to say in her biography of Fry:

Who but Roger Fry could have undertaken such a task single-handed, or have carried it within an inch of success . . . ?
So the Omega workshops closed down. The shades of the Post-Impressionists have gone to join the other shades; no trace of them is now to be seen in Fitzroy Square. The giant ladies have been dismounted from the doorway and the rooms have other occupants. But some of the things he made still remain – a painted table; a witty chair; a dinner service; a bowl or two of that turquoise blue that the man from the British Museum so much admired. And if by chance one of those broad deep plates is broken, or an accident befalls a blue dish, all the shops in London may be searched in vain for its fellow.

THE PLATES

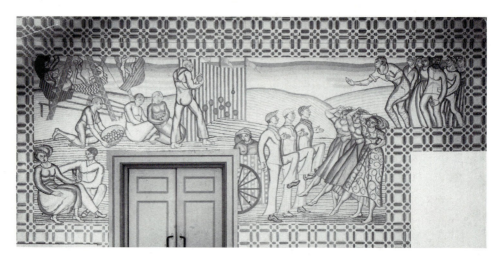

1 Frederick Etchells. Borough Polytechnic painting – *The Fair*

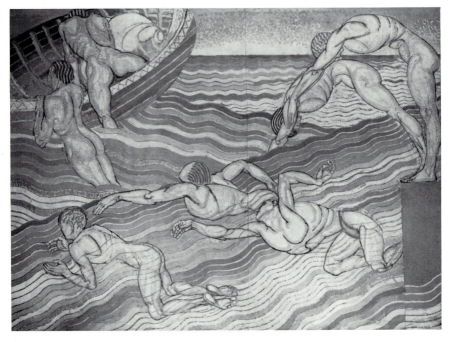

2 Duncan Grant. Borough Polytechnic painting – *Bathing*

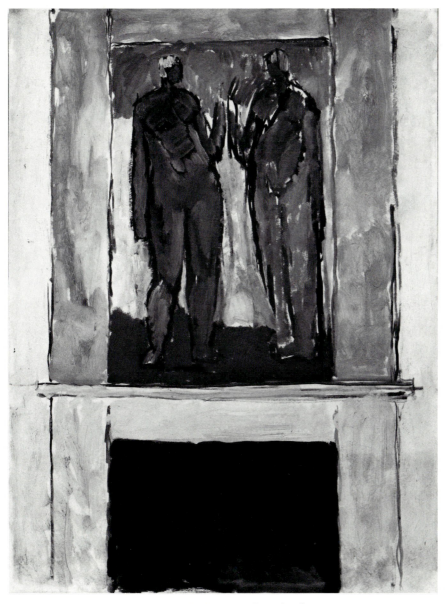

3 Vanessa Bell. Design for a fireplace

4 Duncan Grant. *The Queen of Sheba*

5 Duncan Grant. Design of swimmer for 38 Brunswick Square

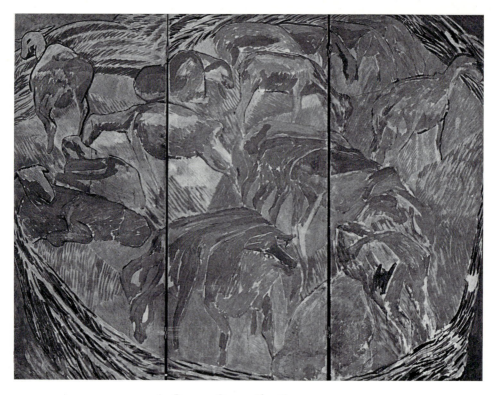

6 Duncan Grant. *Blue Sheep* screen

7 The *Sketch* magazine – photographs of Omega embroideries

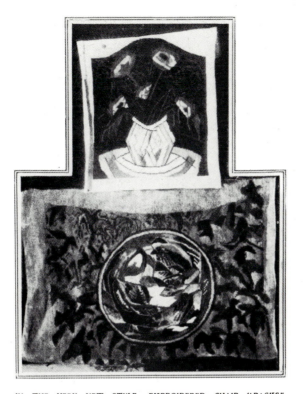

**IN THE VERY NEW STYLE: EMBROIDERED CHAIR "BACKS"
SHOWN BY MEMBERS OF THE GRAFTON GROUP.**

An exhibition of work—chiefly paintings in the very up-to-date Post-Im-
pressionistic manner—was opened at the Alpine Club Gallery the other day. The
exhibitors are members of the Society which calls itself the Grafton Group.

Photograph by Newspaper Illustrations.

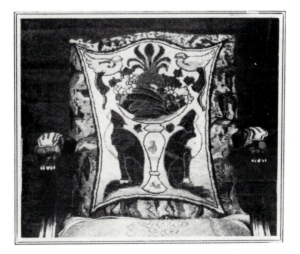

**SOMEWHAT IN THE OLD SAMPLER MANNER: A NEEDLEWORK
CHAIR "BACK" BY ONE OF THE GRAFTON GROUP.**

This particular chair "back" was designed by Mr. Roger Fry and carried out
by Miss Winifred Gill.

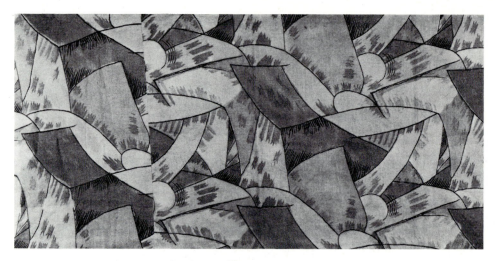

8 Omega fabric – 'Amenophis'

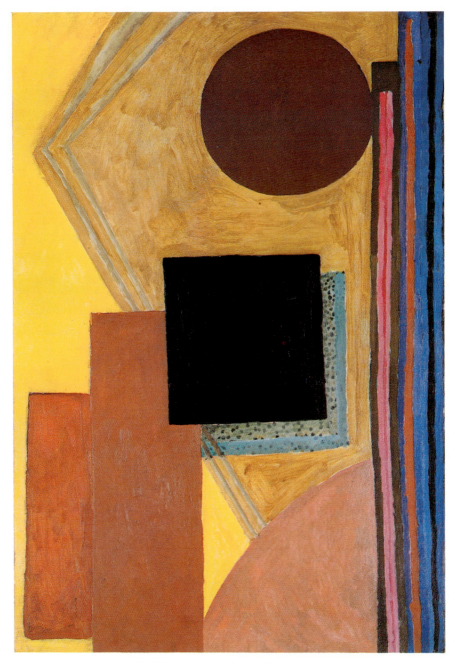

I Vanessa Bell. *Abstract Composition*

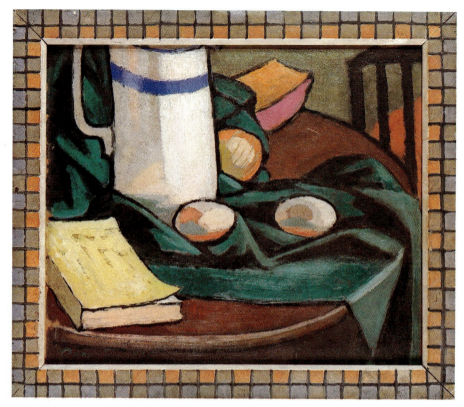

II Roger Fry. *Still Life – Jug and Eggs*

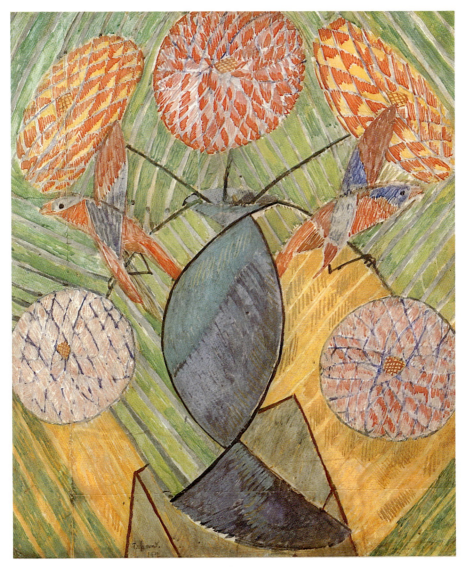

III Duncan Grant. Design for firescreen

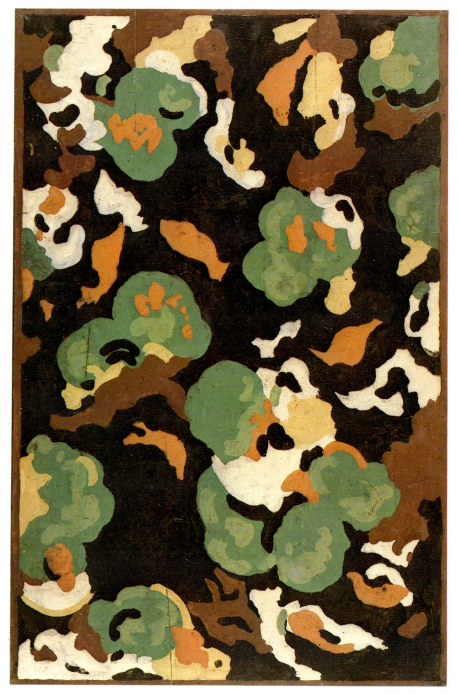

IV Duncan Grant. 'Lilypond' painted table

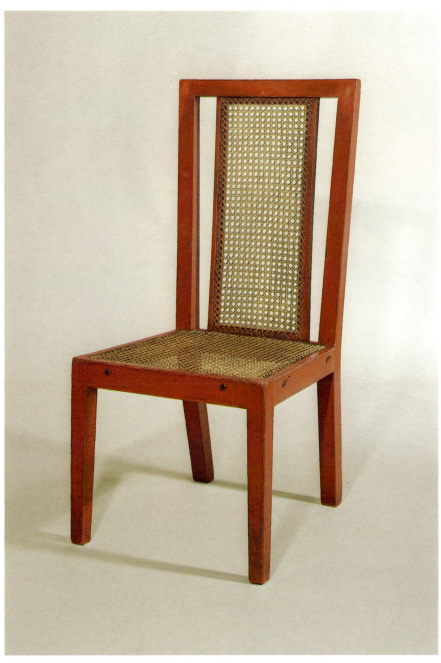

V Roger Fry. Omega Workshops dining chair

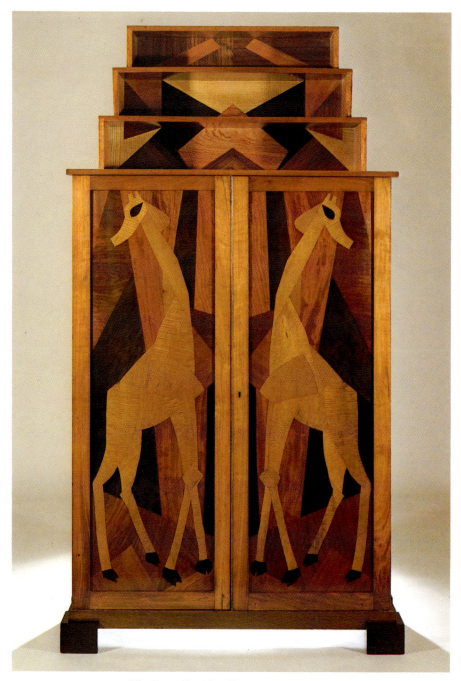

VI Roger Fry. 'Giraffe' marquetry cupboard

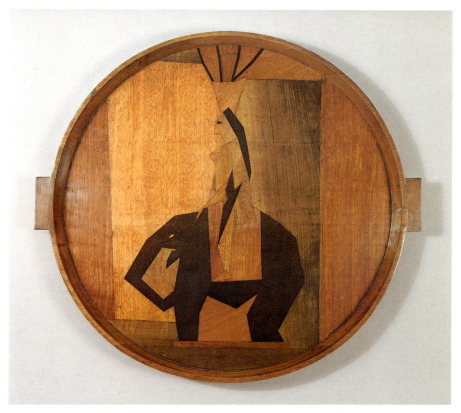

VII Duncan Grant. 'Elephant' marquetry tray

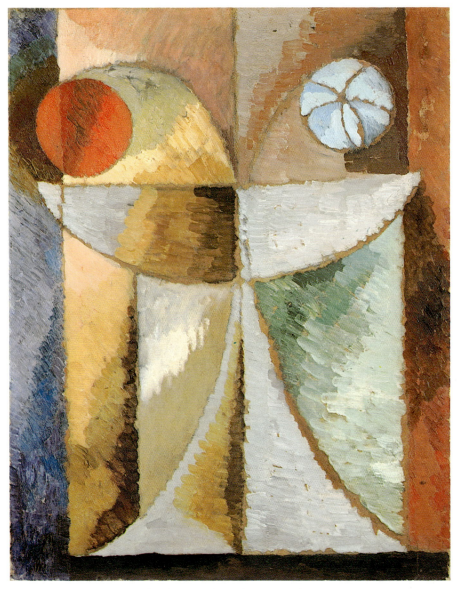

VIII Duncan Grant. Decorative design

MENU

Dîner du 12 Juin 1913
—
Potage Alpha
Saumon
Crème de Volaille aux
Petits Pois
Côtelettes d'Agneau
Haricots Verts

Galantine
Salade Russe

Glaces à l'Oméga
Dessert
—

9 Omega menu card

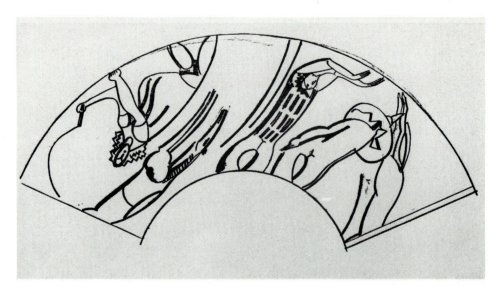

10 Wyndham Lewis. Design for a lampshade

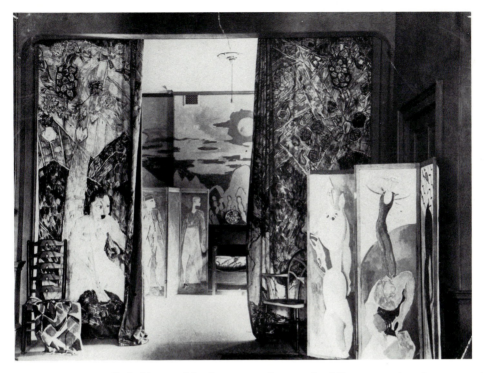

11 *Daily News and Leader* – press photograph of Omega opening day

12 Omega Workshops letter-head

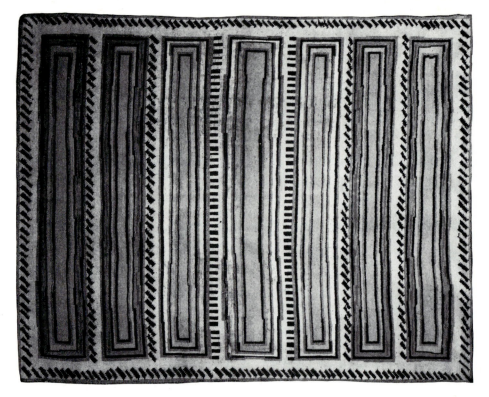

13 Duncan Grant. Rug designed for Ideal Home room

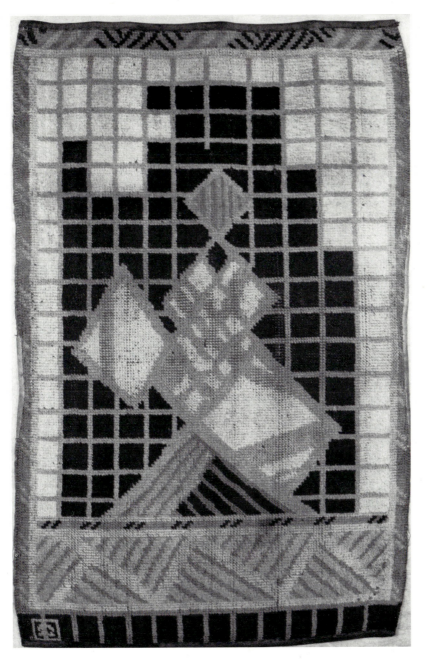

14 Frederick Etchells. Rug designed for Ideal Home room

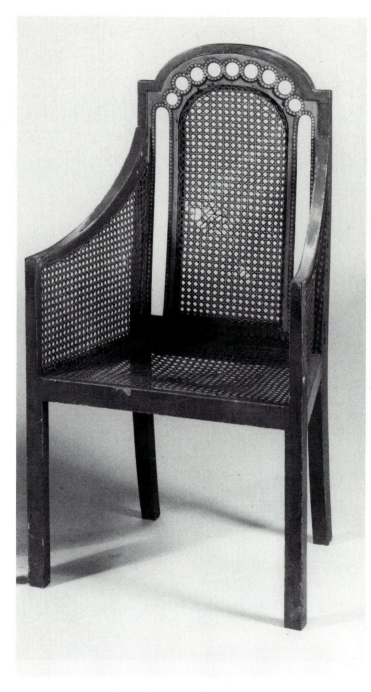

15 Roger Fry. Omega Workshops armchair

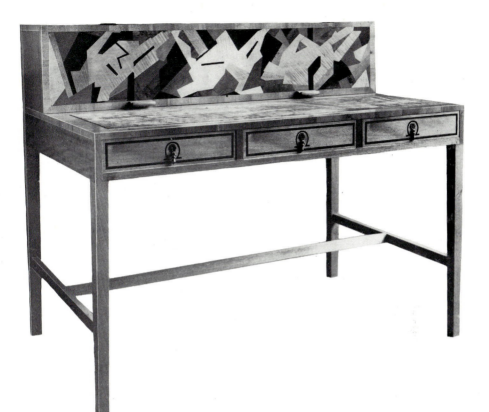

16 Omega Workshops marquetry desk

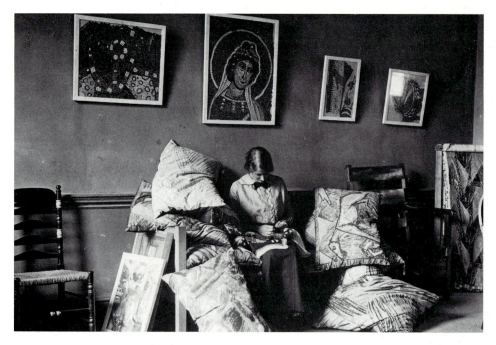

17 *Daily Mirror* – press photograph of Omega interior

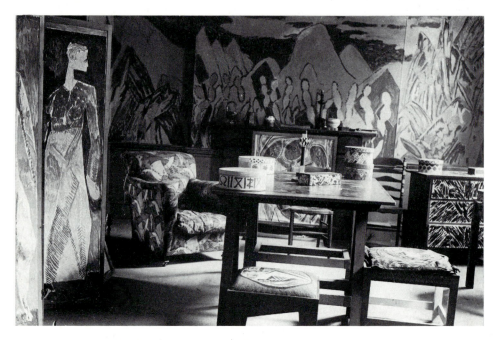

18 *Daily Mirror* – press photograph of Omega room

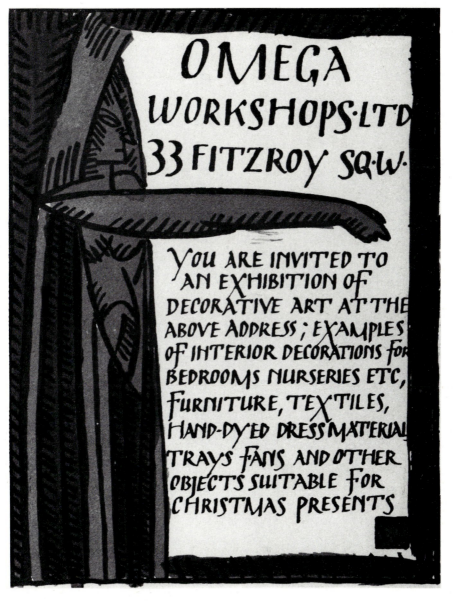

19 Duncan Grant. Invitation to Omega exhibition

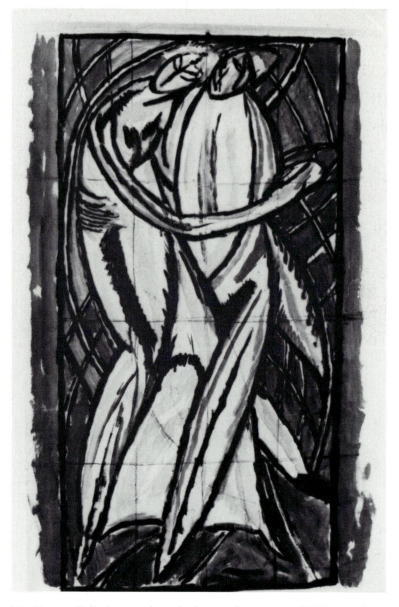

20 Vanessa Bell. Design of couple dancing for exterior of 33 Fitzroy Square

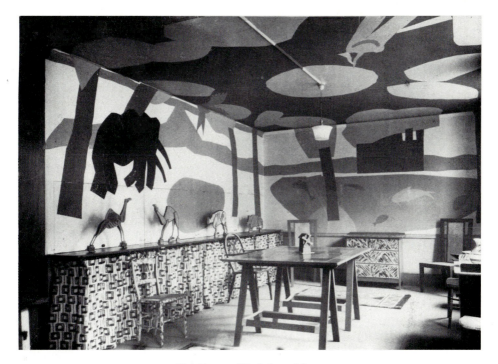

21 Omega Workshops Nursery

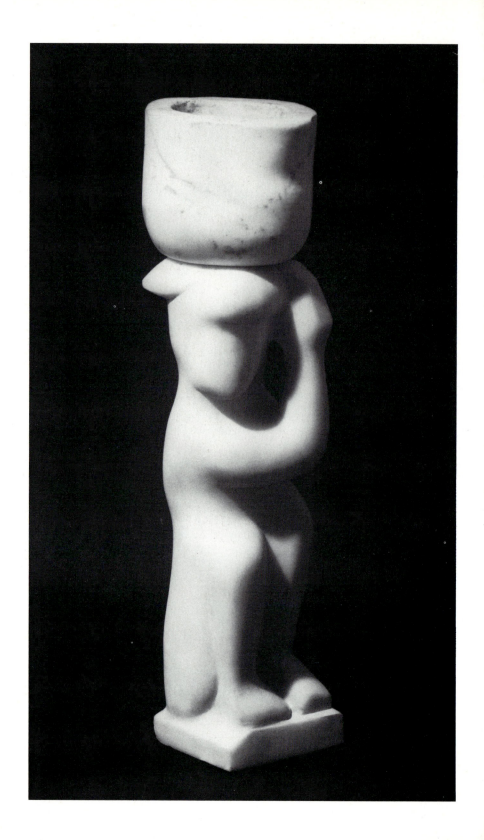

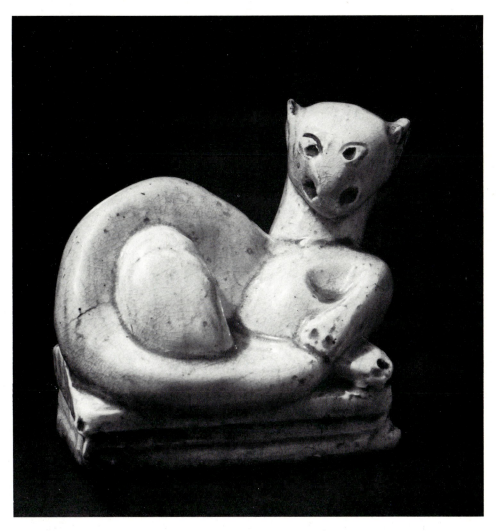

23 Henri Gaudier-Brzeska. Omega earthenware cat

22 Henri Gaudier-Brzeska. *Vase*

24 Henri Gaudier-Brzeska. Drawing for earthenware cat

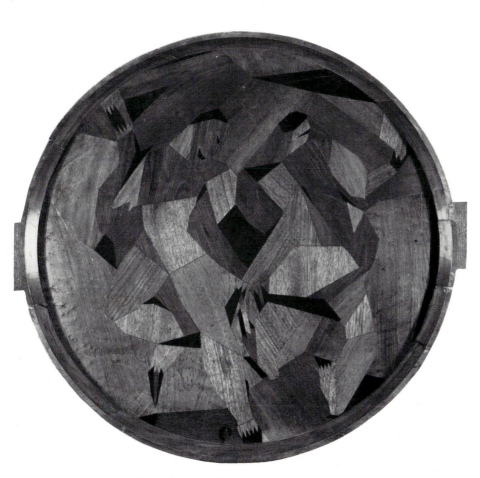

25 Henri Gaudier-Brzeska. Marquetry tray

26 Henri Gaudier-Brzeska. Drawing for marquetry tray

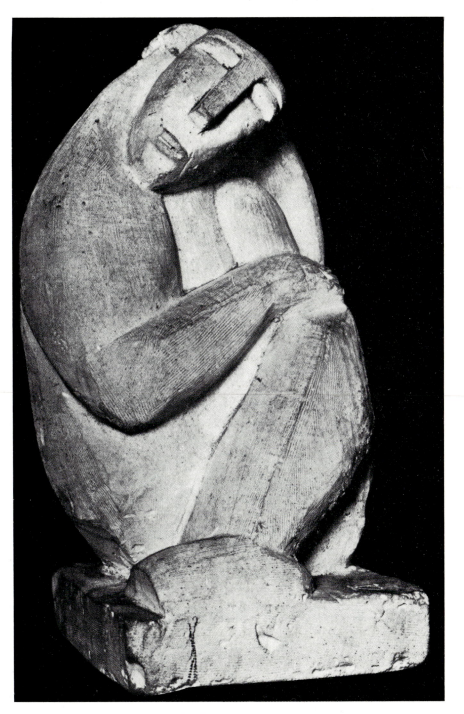

27 Henri Gaudier-Brzeska. Plaster newel for Omega

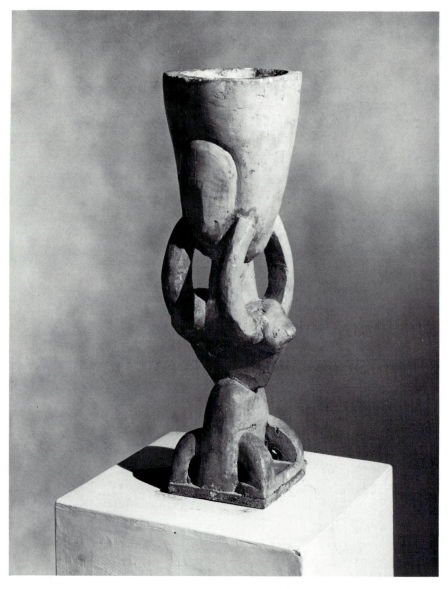

28 Henri Gaudier-Brzeska. Garden ornament for 1 Hyde Park Gardens

29 William Roberts. *Study for Theatre*

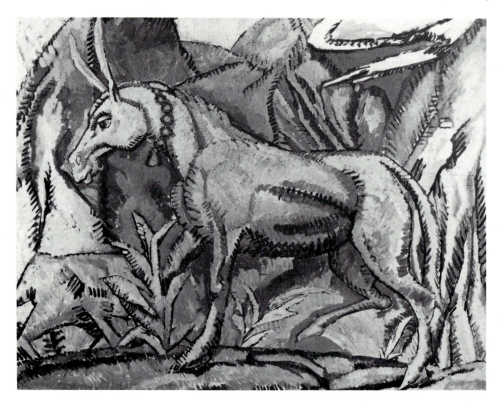

30　Duncan Grant. *The Ass*

31 Vanessa Bell. *Girl in front of tent*

32 Vanessa Bell. *Summer Camp*

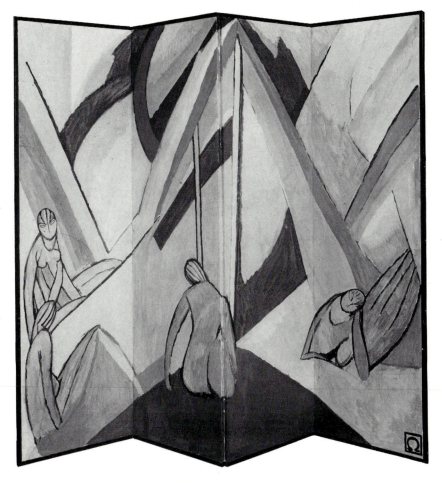

33 Vanessa Bell. *Bathers in a Landscape* screen

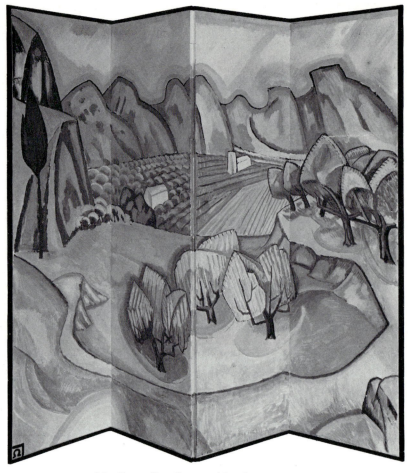

34 Roger Fry. *Provençal Landscape* screen

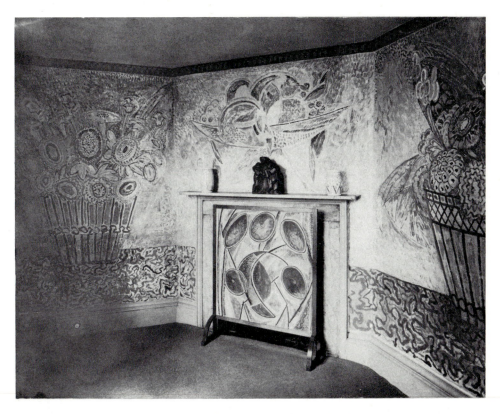

35 Omega wall decorations in antechamber

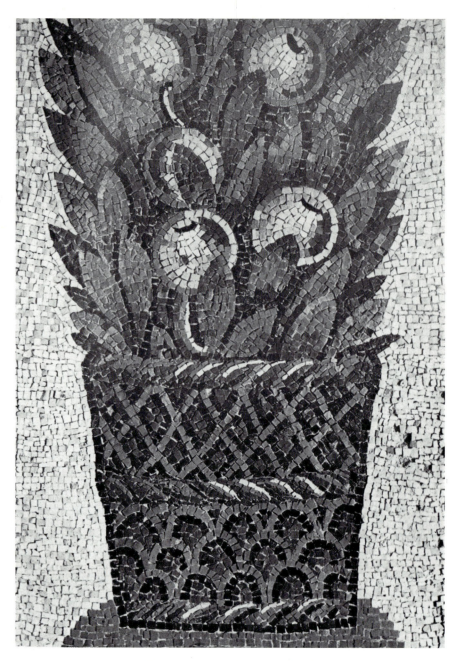

36 Detail of mosaic from Galla Placidia, Ravenna

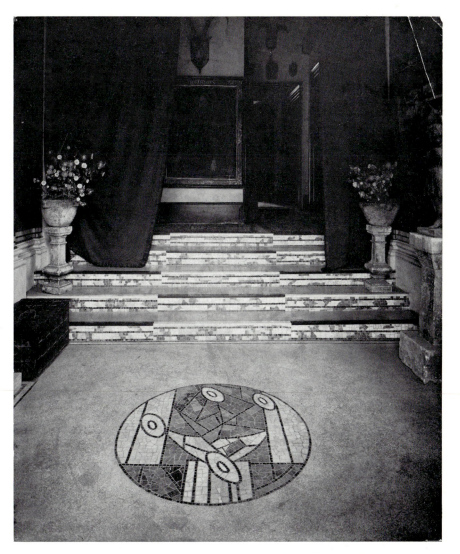

37 Omega mosaics – entrance hall of 1 Hyde Park Gardens

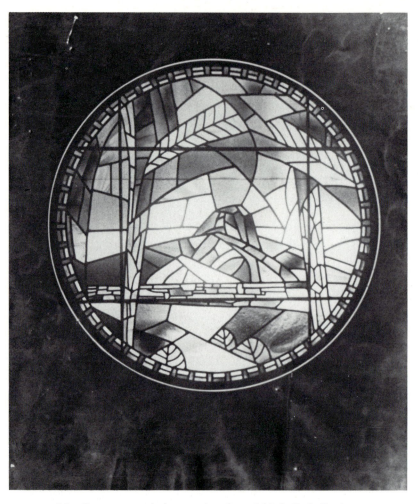

38 Omega stained-glass window from 1 Hyde Park Gardens

39 Roger Fry. Marquetry desk for 1 Hyde Park Gardens

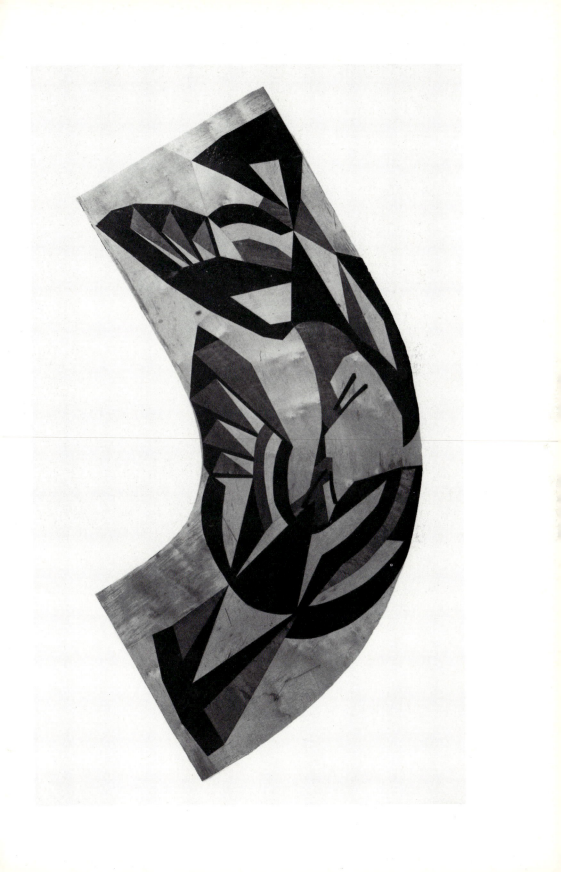

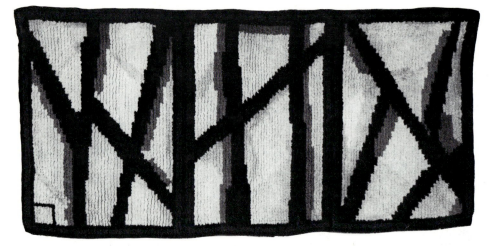

40 Vanessa Bell. Rug designed for Lady Hamilton

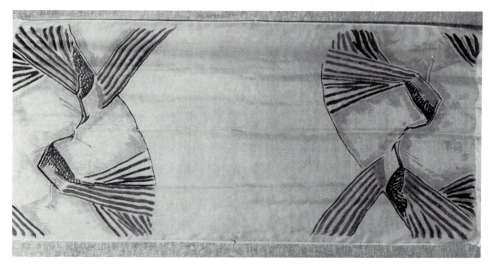

41 Roger Fry. Painted silk stole with fighting peacocks design

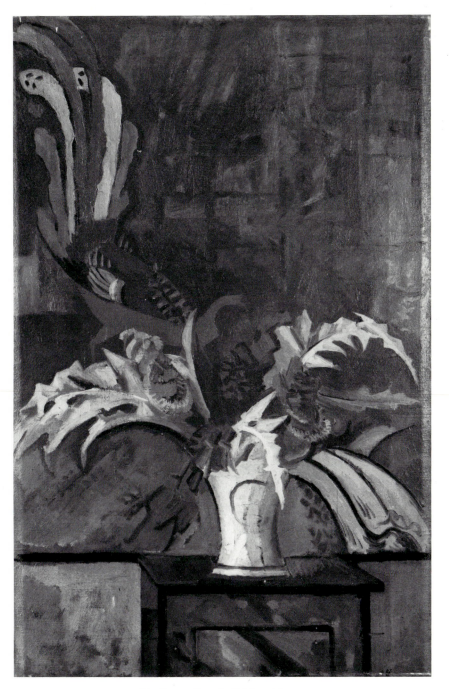

42 Roger Fry. Still life – *Flowers*

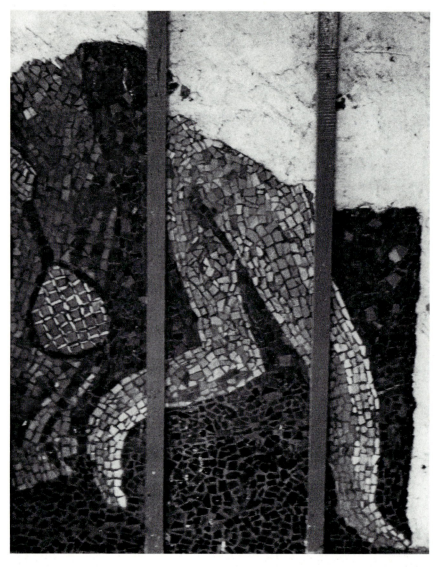

43 Mosaic at Durbins by Fry, Bell and Grant

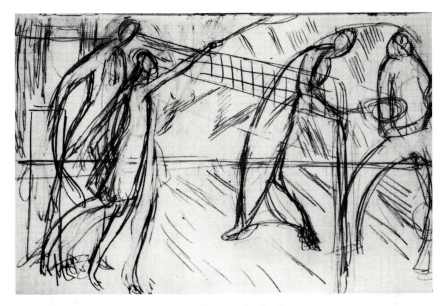

44 Roger Fry. Cartoon for Durbins mosaic

45 Omega Workshops banner

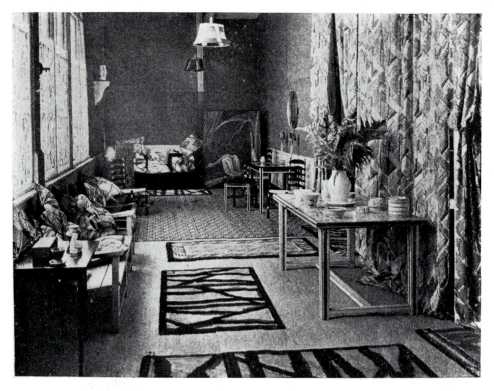

46 Omega lounge at AAA exhibition

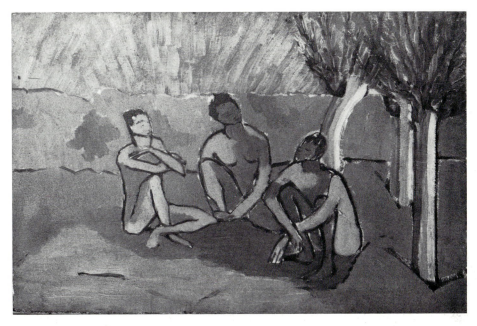

47 Jessie Etchells. *Seated figures*

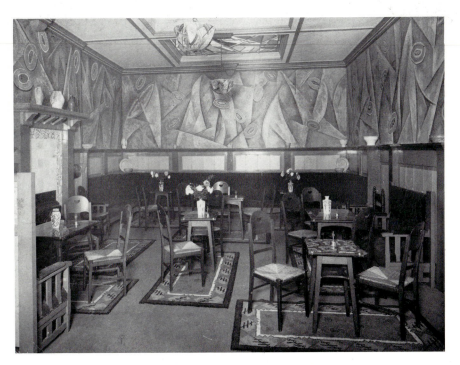

48 Omega Workshops – Cadena Café, Westbourne Grove

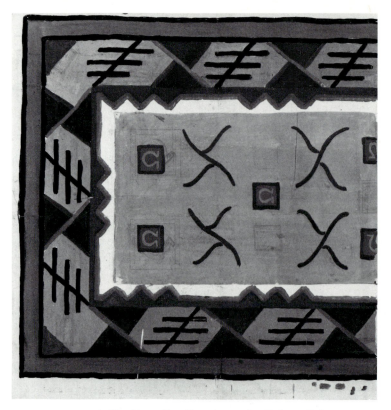

49 Roger Fry. Rug design for Cadena Café

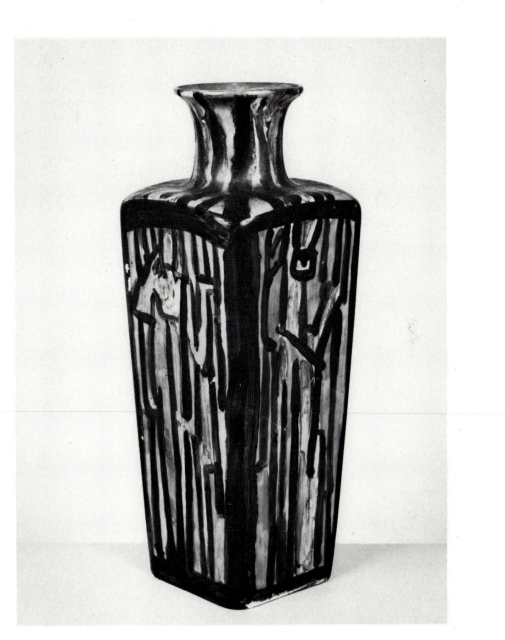

50 Omega Workshops decorated vase

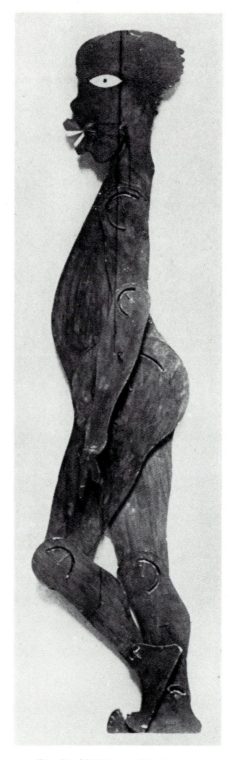

51 Roald Kristian. Marionette

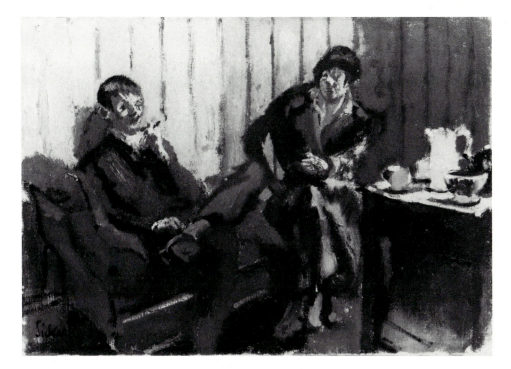

52 Walter Sickert. *The little tea party*

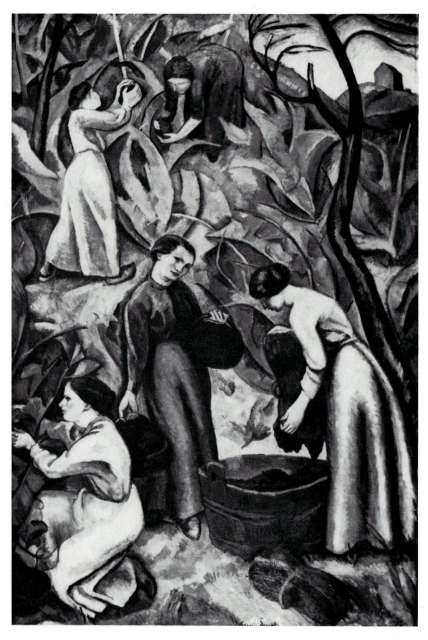

53 Henri Doucet. *Les Vendangeuses*

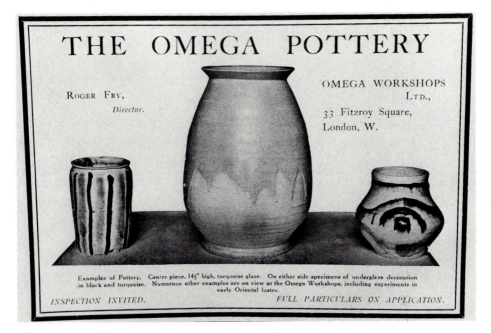

54 Omega Workshops pottery advert from *Burlington Magazine*

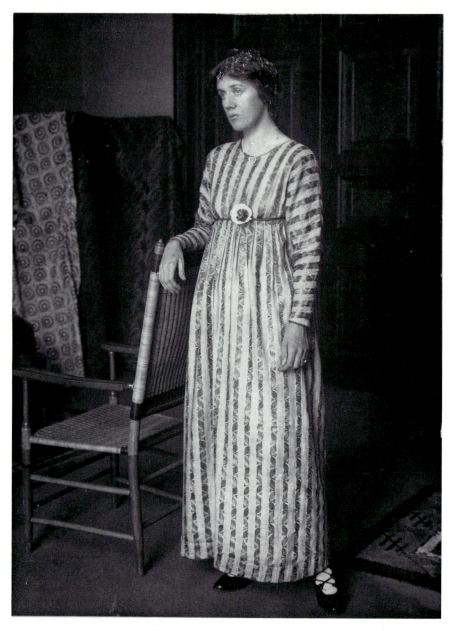

55 Vanessa Bell wearing an Omega dress of her own design

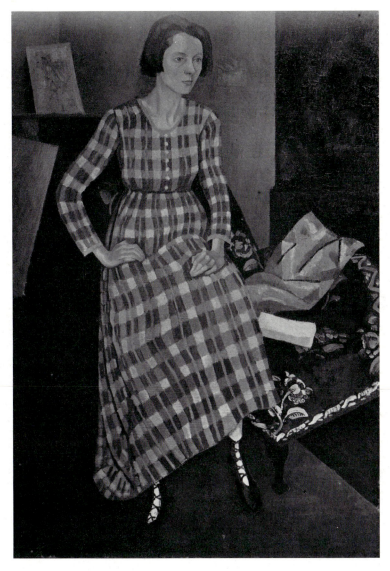

56 Roger Fry. Portrait of Nina Hamnett in an Omega dress

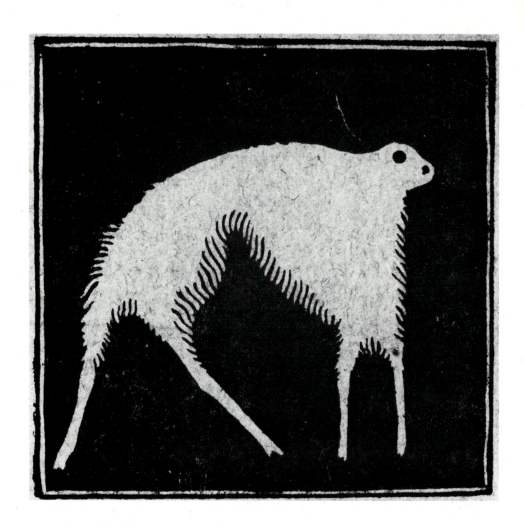

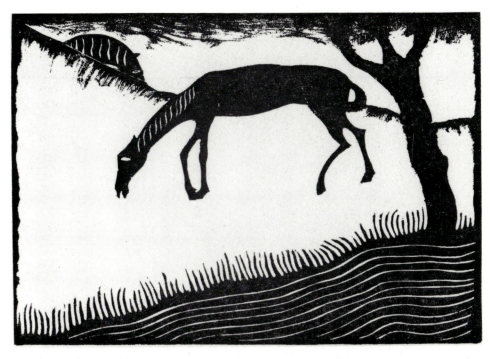

57 (*Left and above*) Roald Kristian. Two woodcuts reproduced in *Form* magazine

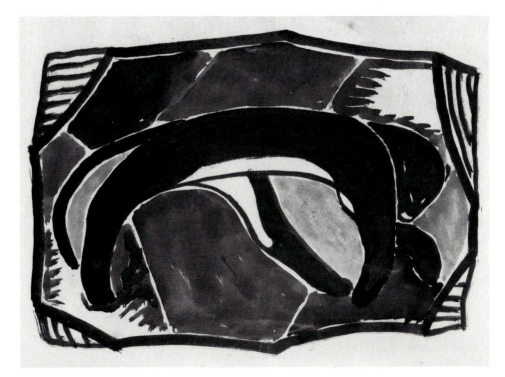

58 Roald Kristian. Design for rug

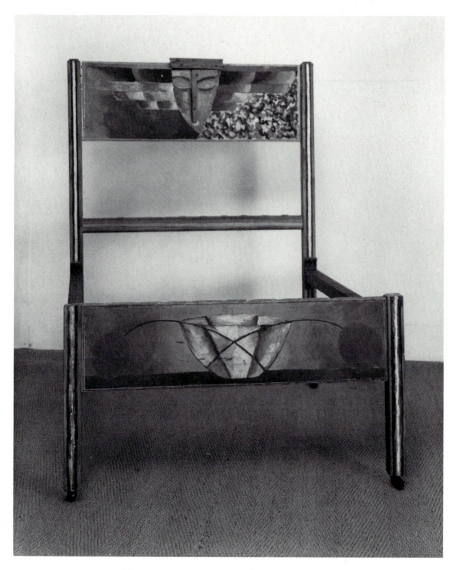

59 Duncan Grant. *Morpheus*, painted bed

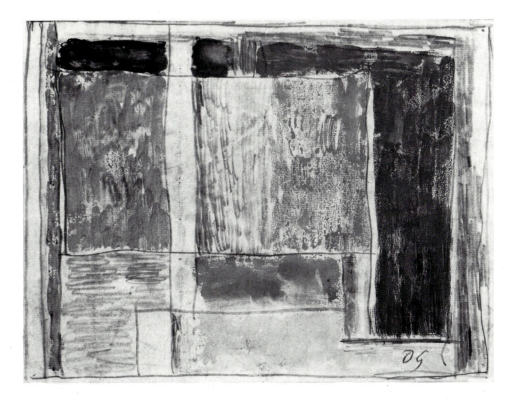

60 Duncan Grant. Design for rug

61 Roald Kristian. Cover design for *Simpson's Choice*

62 Roald Kristian. Woodcut illustration for *Simpson's Choice*

"NOW IN THIS TIME."

OW in this time, the War endures
Now in this time, wounds freely flow,
Pain, and evil deeds freely flow forth,
Now in this time, Death is so powerful in face
of the great sun
That the earth cannot contain her spoils.

The War is at its height,
Panting, and like the tide, without force,
Arrested yet continuing in the most bestial will,
Over the most measureless extent of States,
In the bitterest depths of mankind.

It is gorged with dead and with ruins,
But of dead and of ruins, more widespread, more unknown,
Abundance is prepared for it.

Issue of the greatest War—is my book.

———————

63 Roald Kristian. Woodcut illustration for *Men of Europe*

64 Roger Fry. *Essay in Abstract Design*

65 Picasso. *Head of a Man*

66 Roger Fry. Design for marquetry cupboard

67 Roger Fry. Design of rug for Arthur Ruck

68 Roger Fry. *Still Life with Coffee Cup*

69 Roger Fry. *German General Staff*

70　Roger Fry. *Essay in Abstract Design*

TOYS.

Animals in jointed wood, hand-painted in the workshops, made from designs by our artists. The patent supports of the feet enable these animals to take innumerable dramatic poses.

The designs are made with a view to seizing the character of the animal rather than to literal imitation.

Omega moveable animals strongly made in three-ply wood:—

Camels	- Large Size	**7/6**	...	Small Size	**1/6**	
Rhinoceros	,, ,,	**7/6**	...	,, ,,	**1/6**	
Elephants	,, ,,	**10/6**				
Tigers	,, ,,	**10/6**				

Windmills **3/-**

Omega Doll's-Houses and Puppet Stages.

71 Omega Workshops Descriptive Catalogue – page of toys

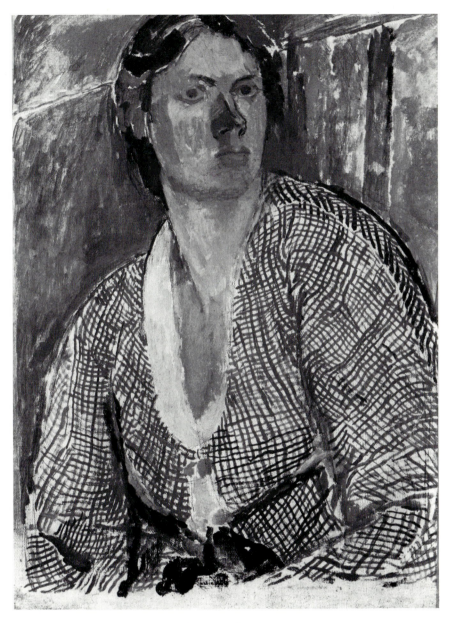

72 Vanessa Bell. *Self-portrait*

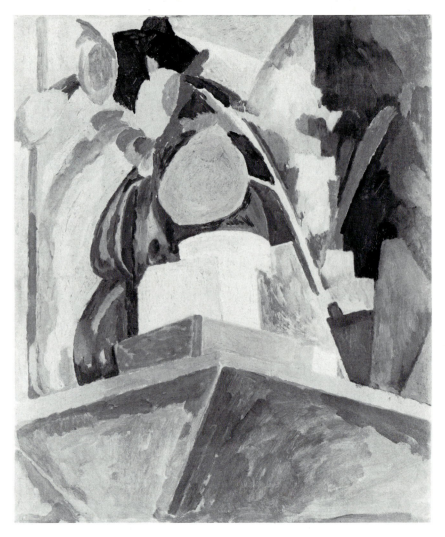

73 Vanessa Bell. *Still life on a Corner of a Mantelpiece*

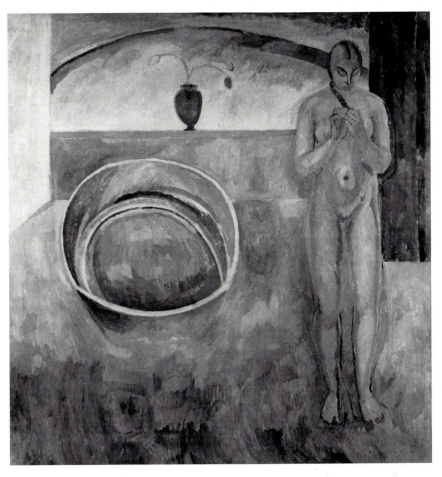

74 Vanessa Bell. *The Tub*

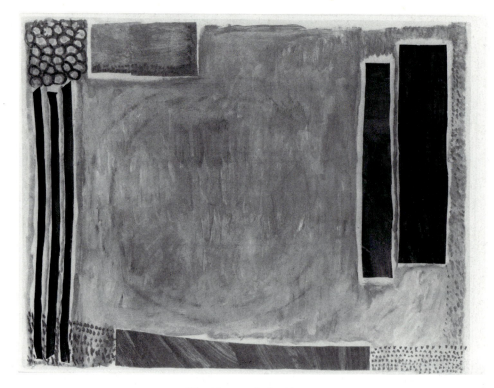

75 Vanessa Bell. *Abstract*

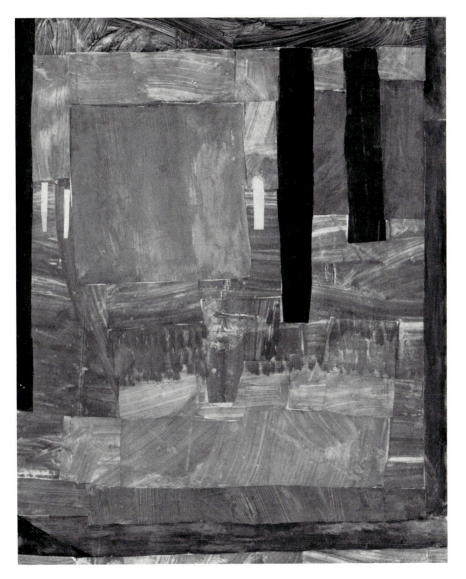

76 Vanessa Bell. *Abstract*

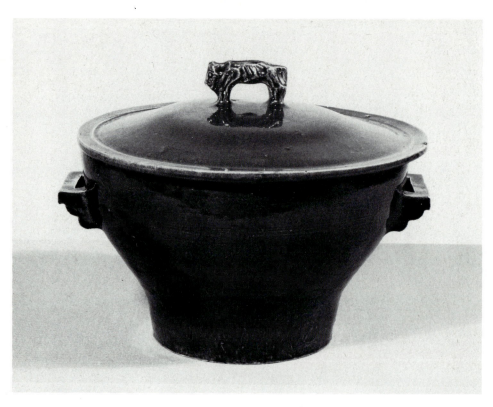

77 Roger Fry. Omega Workshops tureen

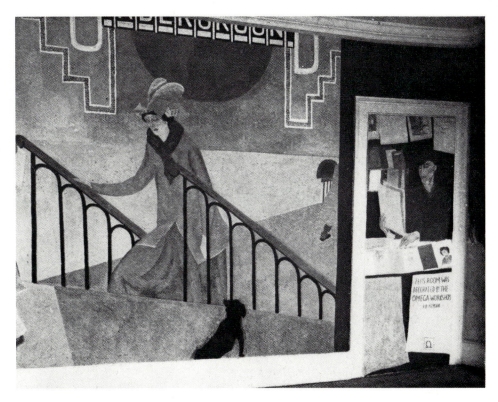

78 9 Omega Workshops decorations of room for Arthur Ruck

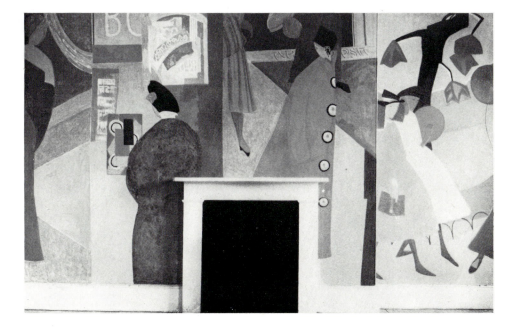

80 Dolores Courtney. *Still Life*

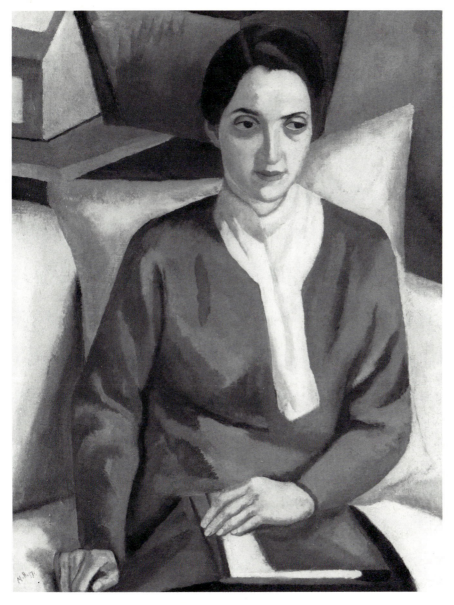

81 Nina Hamnett. *The Student* – portrait of Dolores Courtney

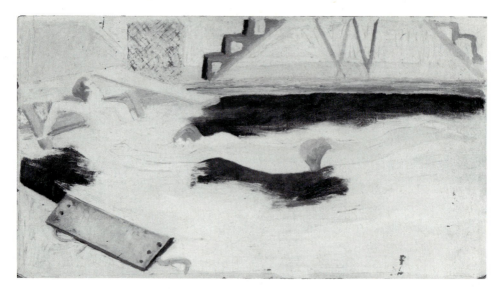

82 Alvaro Guevara. *The Swimming Pool*

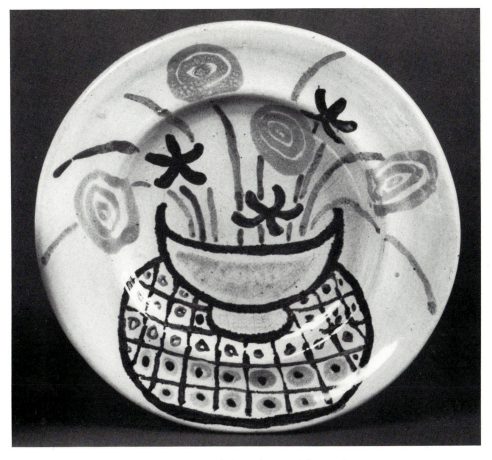

83 Roger Fry. Omega Workshops decorated dinner plate

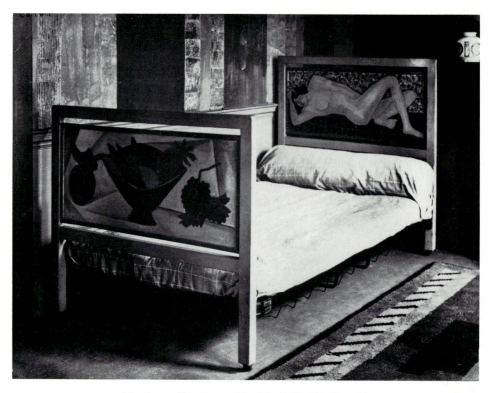

84 Roger Fry. Painted bed for Lalla Vandervelde

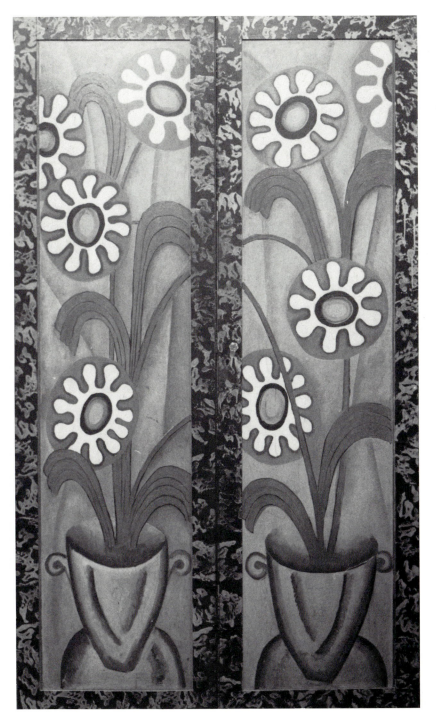

85 Roger Fry. Painted cupboard for Lalla Vandervelde

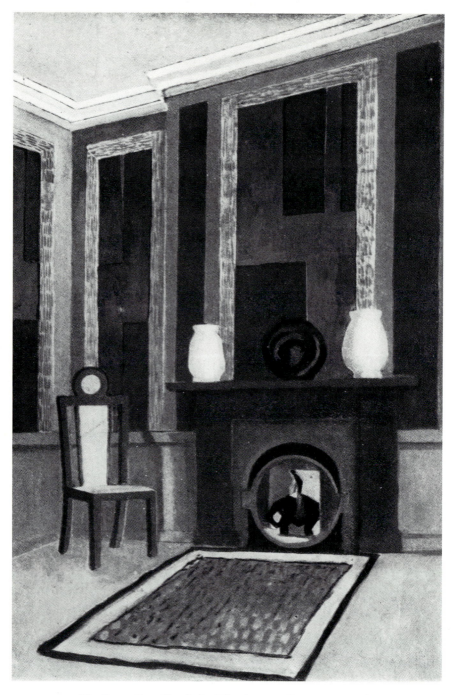

86 Roger Fry. Sketch for 'The Artist as Decorator' article

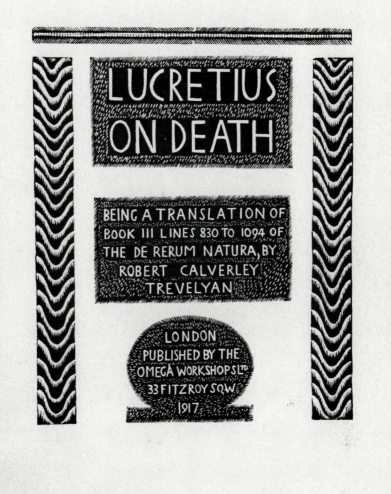

87 Roger Fry. Title page of *Lucretius on Death*

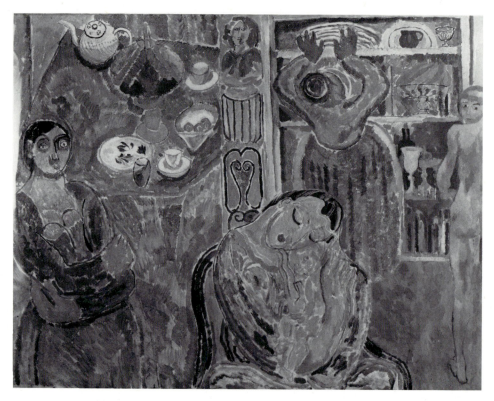

88 Duncan Grant. *The Kitchen*

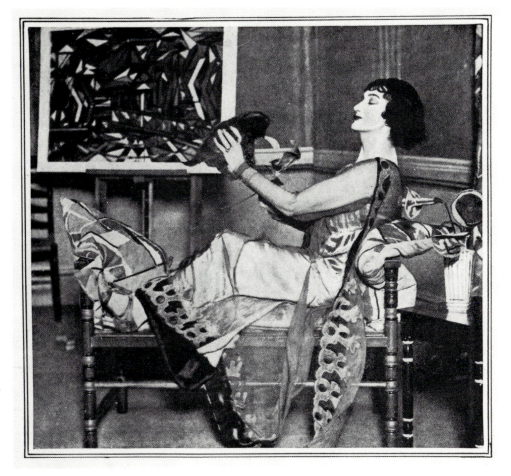

89 Press photograph from the *Sketch* – 'Mrs. Broadley' in *Too Much Money*

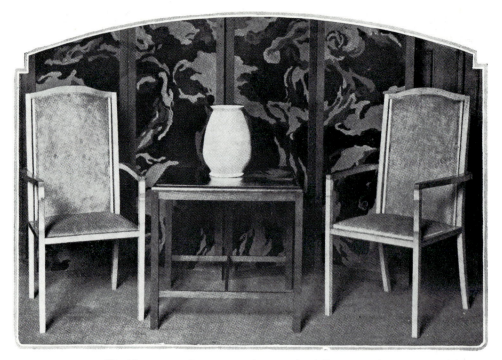

90　*Vogue* magazine – press photograph of Omega products

EXHIBITION OF SKETCHES
BY M. LARIONOW,
AND DRAWINGS BY THE
GIRLS OF THE
DUDLEY HIGH SCHOOL.

OMEGA WORKSHOPS Ltd.,
33, FITZROY SQUARE,
W.1.

FEB., 1919.

91 Duncan Grant. Woodcut cover for Omega Workshops catalogue

92 Edward Wolfe. *Still Life*

93 Vanessa Bell. Woodcut – *Nude*

94 Duncan Grant. Woodcut – *Hat Shop*

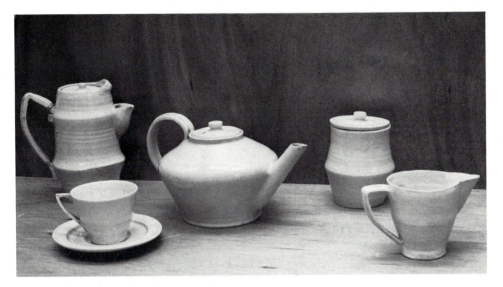

95 Roger Fry. Omega tea and coffee set

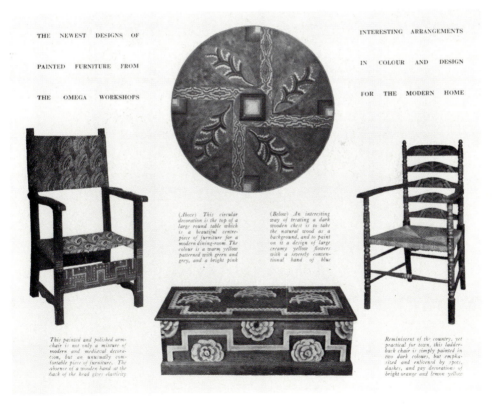

96 Vogue magazine – press photograph of Omega products

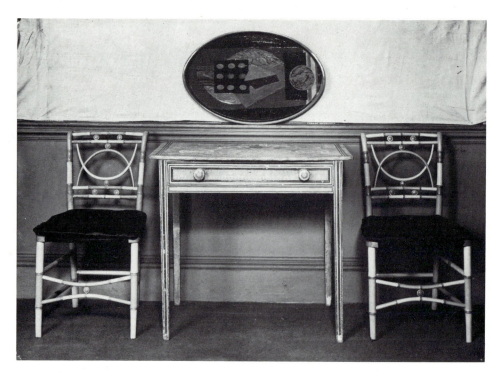

97 Painted second-hand furniture from the Omega Workshops

Clearance Sale of
Omega Stock

AT GREATLY REDUCED PRICES
From June 23rd to July 9th

It is found to be impossible any longer to maintain the shop at No. 33, Fitzroy Square. The artists connected with the Omega Workshops will continue to carry on business as house decorators and the Omega Pottery and Carpets can still be obtained by order, from Roger Fry, 7, Dalmeny Avenue, N.7, but the firm will no longer make articles for sale in their shops. In view of this decision a sale will be held at No. 33, Fitzroy Square, at which the present stock will be disposed of at very greatly reduced prices.

OMEGA WORKSHOPS LTD
33 Fitzroy Square, W.1.
Near Warren Street and Portland Road Stations.

98 Omega Workshops Clearance Sale notice

ACKNOWLEDGEMENTS

This book has only been made possible through the help, generosity and friendship of Roger Fry's daughter, Pamela Diamand, who has supported and encouraged me every step of the way. I am especially indebted, too, to the following colleagues: Dr. David Brown, Richard Morphet, Richard Shone, Dr. Frances Spalding and Simon Watney; and I would also like to acknowledge my gratitude to others who have helped me: Mr. Richard Adeney, Mrs. Helena Aldiss, Dr. and Mrs. Igor Anrep, Miss Isabelle Anscombe, Miss Elizabeth Aslin, Mrs. Barbara Bagenal, Mr. Keith Baker, Dr. Wendy Baron, Miss Jane Beckett, Professor and Mrs. Quentin Bell, Mr. John Booth, Mr. Alan Bowness, Miss Dorothy Bosomworth, Mrs. Penelope Bulloch, Mrs. Katherine Cobbett, Mrs. Annabel Cole, Mr. Roger Cole, Mr. Richard Cork, the late Mrs. Dolores Courtney, Mrs. Elizabeth Elwyn, Miss Mary-Ellen Evans, Mrs. Angelica Garnett, the late Miss Winifred Gill, the late Mr. Duncan Grant, Dr. Christopher Green, Miss Janet Green, Mrs. Jennifer Hedley-Dent, Mr. Patrick Heron, Mr. Eliot Hodgkin, Mr. Richard Humphries, Lord Jeremy Hutchinson, Miss Sheelah Hynes, Miss Susan Kemp, Lord and Lady Kennet, the late Mrs. Janet Leeper, Mr. and Mrs. Lukas, Mr. and Mrs. Nicholas Mavrogordato, Mrs. Valerie Mendes, Professor Hamish Miles, the late Mr. Raymond Mortimer, the late Dr. A. N. L. Munby, Mrs. Elizabeth Noble, Miss Lucy Norton, Mrs. Frances Partridge, Sir Peter Pears, Professor and Mrs. Giles Robertson, Mr. Kenneth Rowntree, Mrs. George Shields, Miss Susan Slade, Miss Marion Stewart, Miss Rosamund Strode, Mrs. Betty Taber, Dr. David Thistlewood, Mr. Philip Troutman, Mrs. Julian Vinogradoff, Dr. and Mrs. Daniel Waley, Mr. Peter Waugh, Miss Joy Weber and the late Mr. Edward Wolfe.

Considerable assistance has been given to me by many institutions throughout Britain, but I wish to single out the staff of the Bethnal Green Museum; the Courtauld Institute Galleries and Library; Kings College Library, Cambridge; the British Library Newspaper section at Colindale; the Victoria and Albert Museum and its National Art Library, most notably Mr. Carol Hogben who gave me access to his own files for his 1963–4 Omega Workshops exhibition; and all those in the Tate Gallery Library and Archive, where the efforts of Miss Sarah Fox-Pitt and Miss Clare Colvin have been invaluable.

I am most grateful to the following for giving me permission to quote from copyright sources: Miss Felicity Ashbee for C. R. Ashbee's unpublished Memoirs; Professor Quentin Bell for an unpublished memoir of Roger Fry by Vanessa Bell, also Professor Bell and Chatto and Windus Ltd for Clive Bell's Art; Dr. David Brown for an unpublished thesis on the work of Duncan Grant; Cambridge University Press for Roger Fry's Last Lectures; Constable and Co. Ltd, for Nina Hamnett's Laughing Torso; Mrs. Pamela Diamand for her unpublished memoir of the Omega Workshops and the transcript of a taped conversation with Winifred Gill, and for Roger Fry's unpublished lecture notes and letters; Mrs. Pamela

Diamand and Chatto and Windus Ltd for Roger Fry's *Vision and Design*, and the *Letters of Roger Fry, edited by Denys Sutton*; Mrs. Angelica Garnett for letters by Clive and Vanessa Bell, and Duncan Grant's scrapbook; the Hogarth Press Ltd for Roger Fry's *Art and Commerce*; the Author's Literary Estate and the Hogarth Press for Virginia Woolf's *Roger Fry. A Biography*, and *The Letters of Virginia Woolf, Volume 1 1888–1912* and *Volume 2 1912–1922*; Dr. and Mrs. Daniel Waley for unpublished autobiographical memoirs by Hubert Waley; Mr. Simon Watney for an unpublished thesis on Bloomsbury Abstraction, and transcripts of conversations with Duncan Grant.

Finally, I would like to thank Dr. Stanley Olson who helped me to begin, Gill Coleridge who encouraged me on my way, Anthony d'Offay and Caroline Cuthbert of the Anthony d'Offay Gallery, London, for giving me the opportunity to see so many relevant works, and Tom Rosenthal, Peter Grose and Sue Moore at Secker and Warburg for helping me to realise what you now hold in your hand.

SELECT BIBLIOGRAPHY

Allied Artists' Association, London, exhibition catalogues 1908–19

'Allied Artists' Association at Holland Park Hall', *Athenaeum* 4521 (20 June 1914) pp. 859–6

'Art and Craft Furnishing at Olympia', *Journal of the Royal Society of Arts*, Vol. 61 (17 October 1913) p. 1042

Art and Industry Report, London: HMSO 1932

'Art and Reality', *The Times* (8 May 1914) p. 4

Artistes Indépendants, Paris, exhibition catalogue 1912

Artistes Indépendants, Paris, retrospective exhibition catalogue 1884–1914, 1926

Arts and Crafts Exhibition, London, Royal Academy exhibition catalogue 1916

ASLIN, Elizabeth, *The Aesthetic Movement*, London: Elek Books 1969

BARON, Wendy, *Sickert*, London: Phaidon Press 1973
– Camden Town Recalled, London, Fine Art Society exhibition catalogue 1976
– *Miss Ethel Sands and her Circle*, London: Peter Owen 1977
– *The Camden Town Group*, London: Scolar Press 1979

BELL, Clive, 'The English Group', Intro. to Second Post-Impressionist Exhibition catalogue, London, Grafton Galleries 1912
– 'Post-Impressionism and Aesthetics', *Burlington Magazine*, January 1913, pp. 226–30
– *Art*, London: Chatto and Windus 1914
– 'Contemporary Art in England', *Burlington Magazine*, July 1917, pp. 30–7
– *Pot-Boilers*, London: Chatto and Windus 1918
– 'How England met Modern Art', *Art News*, XLIX, October 1950, pp. 24–7, 61
– *Old Friends. Personal Recollections*, London: Chatto and Windus 1956
 'Mrs. Clive Bell's pictures', *The Times* (11 February 1916) p. 9

BELL, Quentin, 'Roger Fry – An Inaugural Lecture', University of Leeds 1964
– 'Bloomsbury and the Arts in the Early Twentieth Century', *Leeds Art Calendar*, no. 55, 1964, pp. 18–28
– 'The Omega Revisited', *The Listener* (30 January 1964) pp. 201–4
– *Bloomsbury*, London: Weidenfeld and Nicolson 1968

BELL, Quentin, and Stephen CHAPLIN, 'The Ideal Home Rumpus', *Apollo*, October 1964, pp. 284–91

– 'Reply with Rejoinder', *Apollo*, January 1966, p. 75

BELL, Vanessa, Exhibition of Paintings by Vanessa Bell, London, Adams Gallery exhibition catalogue 1961

Vanessa Bell, A Memorial Exhibition of Paintings, London, Arts Council exhibition catalogue 1961

Vanessa Bell, A Memorial Exhibition of Paintings, London, Arts Council exhibition catalogue 1964

Vanessa Bell, Drawings and Designs, London, Folio Fine Art exhibition catalogue 1967

BENNETT, Arnold, *The Journals*, selected and ed. Frank Swinnerton, London: Penguin 1954

BERTRAM, Anthony, *Paul Nash: The Portrait of an Artist*, London: Faber and Faber 1955

BINYON, Lawrence, *The Flight of the Dragon*, London: John Murray 1911

BISSON, R. F., *The Sandon Studios Society and the Arts*, Liverpool: Parry Books 1965

Blast no. 1, ed. Wyndham Lewis, London: John Lane 1914

Blast no. 2, ed. Wyndham Lewis, London: John Lane 1915

The Bloomsbury Group: The Word and the Image VII, London – National Book League exhibition catalogue 1976

Bloomsbury Painters and Their Circle, Fredericton, Canada, Beaverbrook Art Gallery and tour exhibition catalogue 1977

BOTTOMLEY, Gordon, *Poet and Painter: Being the Correspondence between Gordon Bottomley and Paul Nash 1910–46*, ed. Claude C. Abbot and Anthony Bertram, London 1955

BRODZKY, Horace, *Henri Gaudier-Brzeska 1891–1915*, London: Faber and Faber 1933

Horace Brodzky Memorial Exhibition, London, Fieldbourne Galleries exhibition catalogue 1973

The Café Royalists, London, Parkin Gallery and elsewhere exhibition catalogue 1972

CARLINE, Richard, *Draw They Must*, London: Edward Arnold 1968

CARRINGTON, Noel (ed.), *Mark Gertler: Selected Letters*, London: Rupert Hart-Davis 1965

CAUSEY, Andrew, *Paul Nash*, Oxford: Clarendon Press 1980

'Centre for Revolutionary Art', *Daily Mirror* (30 March 1914) p. 7

'Cézanne and the Post-Impressionists', *The Times* (8 January 1913), p. 10

Exhibition of Pictures by Paul Cézanne and Paul Gauguin, London, Stafford Gallery exhibition catalogue 1911

CHAMOT, Mary, Dennis FARR and Martin BUTLIN, *The Tate Gallery: The Modern British Paintings, Drawings and Sculpture*, Vol. I A–L, London: Oldbourne Press 1964

– Vol. II M–Z, London: Oldbourne Press 1965

CLUTTON-BROCK, Alan, Introduction to the exhibition catalogue, 'Duncan Grant', London, Tate Gallery, May–June 1959

CLUTTON-BROCK, Arthur, *Simpson's Choice*, London: Omega Workshops Ltd. 1915

COBURN, Alvin Langdon, *Men of Mark*, London: Duckworth and Co. 1913

– *Alvin Langdon Coburn, Photographer: An Autobiography* London: Faber and Faber 1966

COLE, Roger, *Burning to Speak: Henri Gaudier-Brzeska*, London: Phaidon Press 1979

COLLINS, Judith, and Richard SHONE, Duncan Grant Designer, Liverpool, Bluecoat Gallery, and Brighton, exhibition catalogue 1980

CONSTABLE, W. G., 'Duncan Grant', London: *British Artists of Today*, no. VI, 1927

'Contemporary Art. An Artist's View of the Leicester Exhibition', *Leicester Mail* (11 January 1919) p. 7

'The Contemporary Art Society', *Pall Mall Gazette* (3 April 1913) n.p.

The Contemporary Art Society, loan exhibition of works, Manchester, City Art Gallery exhibition catalogue 1911–12

– first public exhibition in London, Goupil Gallery exhibition catalogue 1913

– exhibition of pictures, Liverpool, Sandon Studios exhibition catalogue 1914

– *Report for the years 1914–1919*, London 1919

– loan exhibition of Modern Foreign Paintings, London, Colnaghi's exhibition catalogue 1924

COOPER, Douglas, *The Courtauld Collection: A Catalogue and Introduction*, London: Athlone Press 1954

CORK, Richard, 'Vorticism and Its Allies', London, Arts Council exhibition catalogue 1974

– *Vorticism and Abstract Art in the First Machine Age*, Vol. I: *Origins and Development*, London: Gordon Fraser 1975

'Countess and Futurist', *Sketch* (4 March 1914) p. 26

DARROCH, Sandra J., *Ottoline: A life of Lady Ottoline Morrell*, London: Chatto and Windus 1976

DAVIES, Randall, 'The Grafton Group', *New Statesman* (10 January 1914) pp. 436–7

– 'The Omega Workshops', *New Statesman* (24 January 1914) pp. 501–2

– 'The Allied Artist's Association', *New Statesman* (27 June 1914) p. 372

'Decoration at the Ideal Home Show', *Journal of the Royal Society of Arts* (24 October 1913) p. 1062

DUNLOP, Ian, *The Shock of the New*, London: Weidenfeld and Nicolson 1972

EDE, H. S., *A Life of Gaudier-Brzeska*, London: Heinemann 1930

– *Savage Messiah*, London: Heinemann 1931

ELLWOOD, G. M., 'Futurism in Design', *Drawing*, September 1915, p. 109

EMMONS, Robert, *The Life and Opinions of Walter Richard Sickert*, London: Faber and Faber 1941

English Chintz: Two Centuries of Changing Taste, London, V. and A. exhibition catalogue 1955

English Post-Impressionists, Cubists and Others, Brighton Public Art Galleries exhibition catalogue Dec. 1913–Jan. 1914

'Eradication of Sentimentality from the Modern Home', *Vogue*, late May 1917, p. 40

ETCHELLS, Frederick, 'The Ubiquity of Lettering', *Artwork*, Vol. 2, Oct. 1924, p. 111

FARR, Dennis, 'Wyndham Lewis and the Vorticists', *Burlington Magazine*, August 1956, pp. 279–80

FERRABY, H. C., 'Artists as House Painters', *Daily Express* (28 March 1913) p. 5

FISHMAN, Solomon, *The Interpretation of Art*: University of California Press 1963

'The Friday Club and its Ideals', *Pall Mall Gazette* (30 January 1913) p. 5

Exhibition of Pictures by Members of the Friday Club, exhibition catalogues 1911–16

FRY, Roger, 'Tempera Painting', *Burlington Magazine*, June 1905, pp. 175–6

– 'A Note on Water-colour Technique', *Burlington Magazine*, June 1907, pp. 161–2

– 'A Modern Jeweller', *Burlington Magazine*, June 1910, pp. 169–74

– 'The Grafton Gallery', *The Nation* (19 November 1910) pp. 331–2

– 'The Post-Impressionists', *The Nation* (3 December 1910) p. 402–3

– 'A Postscript on Post-Impressionism', *The Nation* (24 December 1910) pp. 536–7

– 'Artlessness', *The Nation* (20 May 1911) pp. 287–8

– 'The Autumn Salon', *The Nation* (11 November 1911) pp. 236–7

– 'The Futurists', *The Nation* (9 March 1912) pp. 945–6

– 'The Allied Artists at the Albert Hall', *The Nation* (20 July 1912) pp. 583–4

– 'The Exhibition of Modern Art at Cologne', *The Nation* (31 August 1912) pp. 798–9

– 'The Grafton Gallery: An Apologia', *The Nation* (9 November 1912) pp. 249–51

– 'The French Post-Impressionists', Second Post-Impressionist Exhibition catalogue, London, Ballantyne and Co., 1912

– 'The Case of the Late Sir Lawrence Alma Tadema, O.M.', *The Nation* (18 January 1913) pp. 666–7

– 'Crepitation', *The Nation* (22 February 1913) pp. 851–2

– 'The Allied Artists', *The Nation* (2 August 1913) pp. 676–7

– Intro. to 'Works by Boris von Anrep', London, Chenil Gallery exhibition catalogue October 1913

– 'Blake and British Art', *The Nation* (22 November 1913) p. 359

– 'Blake and British Art', *The Nation* (22 November 1913) p. 359

– 'Blake and British Art', *The Nation* (7 February 1914) pp. 791–2

– 'The Art of Pottery in England', *Burlington Magazine*, March 1914, pp. 330–5

– 'A New Theory of Art', *The Nation* (7 March 1914) pp. 937–9

– 'Two Views of the London Group – Part 1', *The Nation* (14 March 1914) pp. 998–9
– 'Rossetti's Watercolours of 1857', *Burlington Magazine*, June 1916, pp. 100–9
– 'Gaudier Brzeska', *Burlington Magazine*, August 1916, pp. 209–10
– 'The Artist as Decorator', *Colour Magazine*, April 1917, pp. 92–3
– 'Children's Drawings', *Burlington Magazine*, June 1917, pp. 225–31
– Preface to 'The New Movement in Art: An Exhibition of Representative Works Selected and Arranged by Roger Fry', Birmingham, Royal Birmingham Society of Artists exhibition catalogue 1917
– 'On a composition by Gauguin', *Burlington Magazine*, March 1918, p. 95
– 'A Possible Domestic Architecture', *Vogue*, late March 1918, pp. 40–1, 66, 68
– 'Line as a Means of Expression in Modern Art', *Burlington Magazine*, December 1918, pp. 201–8 and February 1919, pp. 62–9
– 'Copying Old Masters', *Drawing and Design*, January 1919, p. 7
– 'Mr. Larionow and the Russian Ballet', *Burlington Magazine*, March 1919, pp. 112–18
– *Architectural Heresies of a Painter*, London: Hogarth Press 1921
– 'Modern Mosaic and Mr. Boris Anrep', *Burlington Magazine*, June 1923, pp. 272–8
– *Duncan Grant*, London: Hogarth Press 1923
– *Transformations*, London: Chatto and Windus 1926
– 'Vanessa Bell', *Vogue*, early February 1926, pp. 33–5, 78
– 'Hand-Printed Stuffs by Phyllis Barron and Dorothy Larcher', *Vogue*, late April 1926, pp. 68, 96
– *Cézanne. A Study of his Development*, London: Hogarth Press 1927
– *Henri Matisse*, London: Zwemmer 1930
– *Reflections on British Painting*, London: Faber and Faber 1934
– *Last Lectures*, Oxford: Oxford University Press 1939
'Mr. Roger Fry on Principles of Design', *Art Chronicle* (28 February 1913) p. 160
'Mr. Roger Fry on Principles of Design', *The Connoisseur*, May 1913, p. 1
'Mr. Roger Fry's Art, Composition in Three Dimensions', *The Times* (11 November 1915) p. 11
Paintings and Drawings by Roger Fry, London, Alpine Club Gallery exhibition catalogue 1912
Paintings by Roger Fry, London, Alpine Club Gallery exhibition catalogue 1915
Flowerpieces by Roger Fry, London, Carfax Gallery exhibition catalogue 1917
'Vision and Design: The Life, Work and Influence of Roger Fry 1866–1934', London, Arts Council exhibition catalogue 1966
The Futurist Painter, Severini, Exhibits his Latest Works, London, Marlborough Gallery exhibition catalogue 1913

GARNETT, David, *The Golden Echo*, London: Chatto and Windus 1953
– *The Flowers of the Forest*, London: Chatto and Windus 1955
– *The Familiar Faces*, London: Chatto and Windus 1962
– and Francis BIRRELL, *Some Contemporary English Artists*, London: Garnett and Birrell 1921

GATHORNE-HARDY, Robert (ed.), *The Early Memories of Lady Ottoline Morrell*, London: Faber and Faber 1963
– (ed.), *Ottoline at Garsington*, London: Faber and Faber 1974
GAUDIER-BRZESKA, Henri, 'The Allied Artists' Association', *The Egoist* (15 June 1914) pp. 227–8
GORDON, Donald E., *Modern Art Exhibitions 1910–16*, Munich: Prestel-Verlag 1974
GORDON-STABLES, Mrs. Louise, 'On Painting and Decorative Painting', *Colour Magazine* VI June 1916, pp. 187–8
– 'Nina Hamnett's Psychological Portraiture', *Artwork* Vol. 1 No. 2, October 1924, p. 112
The Grafton Group, First Exhibition, London, Alpine Club Gallery exhibition catalogue 1913
'The Grafton Group', *Athenaeum* 4456 (22 March 1913) p. 339
'The Grafton Group', *Pall Mall Gazette* (27 March 1913) p. 4
'Embroidered Chairbacks shown by members of the Grafton Group', *Sketch* (2 April 1913) p. 406
The Grafton Group, Second Exhibition, London, Alpine Club Gallery exhibition catalogue 1914
'The Grafton Group', *The Times* (3 January 1914), p. 11
'The Grafton Group at the Alpine Gallery', *Pall Mall Gazette* (8 January 1914) p. 5
'The Grafton Group at the Alpine Gallery', *Athenaeum* 4498 (10 January 1914) p. 70
Paintings by Duncan Grant from 1910 to 1929, London, Paul Guillaume Gallery exhibition catalogue 1929
Duncan Grant. A Retrospective Exhibition, London, Tate Gallery exhibition catalogue 1959
Duncan Grant and his World, London: Wildenstein & Co. Ltd. exhibition catalogue 1964
Duncan Grant Watercolours and Drawings, London, d'Offray Couper Gallery exhibition catalogue 1972
Duncan Grant. A Display to Celebrate his Ninetieth Birthday, London, Tate Gallery exhibition catalogue 1975
Duncan Grant. A Ninetieth Birthday Exhibition of Paintings, Edinburgh, Scottish National Gallery of Modern Art and elsewhere exhibition catalogue 1975
Duncan Grant and Bloomsbury, Edinburgh, Fine Art Society exhibition catalogue 1975
'Alvaro Guevara – A Spanish Painter in England', *Vogue*, early March 1917, pp. 46–7
Alvaro Guevara exhibition catalogue, London, Colnaghi & Co. Ltd. 1974–5

'In the Great World – Lady Hamilton', *Sketch* (21 April 1915) p. 52
Nina Hamnett Paintings and Drawings, London, Eldar Gallery exhibition catalogues 1918, 1919

HAMNETT, Nina, *Laughing Torso: Reminiscences*, London: Constable 1932

Hampshire House Social Club, exhibition catalogues 1906–13

HANNAY, Howard, *Roger Fry and other Essays*, London: Allen and Unwin 1937

'A Harmony of the Furnishings of Two Centuries at River House, Upper Mall', *Vogue*, early February 1919, pp. 40–1

HARRISON, Charles, 'Roger Fry in Retrospect', *Studio International*, May 1966, pp. 220–1

HASLAM, Malcolm, 'Some Vorticist Pottery', *The Connoisseur*, October 1975, pp. 98–101

HOLMAN-HUNT, Diana, *Latin among Lions: Alvaro Guevara*, London: Michael Joseph 1974

HOLROYD, Michael, *Lytton Strachey: The Years of Achievement 1910–1932*, London: Heinemann 1968

HULME, T. E., 'Modern Art I – The Grafton Group', *The New Age* (15 January 1914) pp. 341–2

HUWS JONES, E., *Margery Fry. The Essential Amateur*, London: Oxford University Press 1966

JOHN, Augustus, *Chiaroscuro: Fragments of an Autobiography*, London: Jonathan Cape 1952

'John, John! How he's got on', *Sketch* (28 March 1917), Supplement 4,5

JOHNSTONE, J. K., *The Bloomsbury Group*, London: Secker and Warburg 1954

JOUVE, Pierre Jean, *Men of Europe*, trans. Roger Fry, London: Omega Workshops 1915

KANDINSKY, Wassily, *The Art of Spiritual Harmony*, London: Constable 1914

KEYNES, Milo (ed.), *Essays of John Maynard Keynes*, Cambridge: Cambridge University Press 1975

KONODY, P. G., 'Dissensions', *Observer* (26 October 1913) p. 10

– 'Post-Impressionism in the Home', *Observer* (14 December 1913) p. 8

– 'The Grafton Group', *Observer* (11 January 1914) p. 7

– 'Mr. Roger Fry's Exhibition', *Observer* (14 November 1915) p. 9

KRISTIAN, Roald, 'Albert Aurier', *The Egoist* (1 December 1915) pp. 191–2

LEWIS HIND, Charles, *The Post-Impressionists*, London: Methuen 1911

– 'New Art and Newer Literature' *Daily Chronicle* (24 March 1913) p. 4

– 'Three London Art Houses', *Daily Chronicle* (18 December 1913) p. 6

LEWIS, Percy Wyndham, *The Caliph's Design*, London: The Egoist Ltd. 1919

– *Rude Assignment*, London: Hutchinson 1951

– *Blasting and Bombardiering*: University of California Press 1967

Wyndham Lewis and Vorticism, London, Tate Gallery exhibition catalogue 1956

The Letters of W. Lewis, ed. W. K. Rose, London: Methuen 1963

LIPKE, William, *David Bomberg: A Critical Study of his Life and Work*, London: Evelyn Adams and Mackay 1967

– 'Futurism and the Development of Vorticism', *Studio*, April 1967, pp. 173–8

The London Group, London, Goupil Gallery exhibition catalogues 1914–20

London Group Retrospective Exhibition: 1914–1928, London, New Burlington Galleries exhibition catalogue 1928

'Look Here' [Omega closing], *Sketch* (9 July 1919) p. 39

MacCARTHY, Desmond, 'Kant and Post-Impressionism', *Eye Witness* (10 October 1912) pp. 533–4

– 'Post-Impressionist Frescoes', *Eye Witness* (9 November 1911) pp. 661–2

'Manet and the Post-Impressionists', London, Grafton Galleries exhibition catalogue 1910–11

MARRIOTT, Charles, 'A Folk Art Revival' [First Grafton Group], *Evening Standard* (25 March 1913) n.p.

– 'Notes on Art Exhibitions' [Second Grafton Group], *Evening Standard* (7 January 1914) n.p.

– 'The New Movement in Art', *Land and Water* (18 October 1917) pp. 19–20

– *Modern Movements in Painting*, London: Chapman and Hall 1920

MICHEL, Walter, 'Vorticism and The Early Wyndham Lewis', *Apollo*, January 1963, pp. 5–9

– *Wyndham Lewis: Paintings and Drawings*, London: Thames and Hudson 1971

'Modern Embroidery', *Vogue*, late October 1923, pp. 66–7

'Modern Furniture', *House and Garden*, January 1921, pp. 19–23, 66

'A Monthly Chronicle – Omega Workshops', *Burlington Magazine*, November 1915, p. 80

– 'The Arts and Crafts Exhibition', *Burlington Magazine*, November 1916, p. 340; December 1916, p. 388

– 'Exhibition of Modern Paintings and Drawings at the Omega Workshops', *Burlington Magazine*, December 1918, p. 233

MORPHET, Richard, 'The Art of Vanessa Bell', essay in 'Vanessa Bell: Paintings and Drawings', London, Anthony d'Offay Gallery exhibition catalogue 1973

MORTIMER, Raymond, *Duncan Grant*, London: Penguin Modern Painters 1948

'Mural Decoration: Exhibition at Crosby Hall', *The Times* (4 June 1912) p. 12

NADELMAN, Elie, Exhibition of Sculpture by, London, Paterson Gallery exhibition catalogue April 1911

NASH, Paul, 'Modern English Textiles', *Art Work*, Vol. 2 No. 6, January–March 1926, p. 80

– *Room and Book*, London: Soncino Press 1932

– *Outline: An Autobiography and Other Writings*, London: Faber and Faber 1949

NAYLOR, Gillian, *The Arts and Crafts Movement*, London: Studio Vista 1971

NEVINSON, C. R. W., *Paint and Prejudice*, London: Methuen 1937

New English Art Club Summer and Winter Exhibitions, London, Royal Society of British Artists Galleries, exhibition catalogues 1913–16

The New Movement in Art, Birmingham, New Street Gallery exhibition catalogue 1917

'The New Movement in Art', *Burlington Magazine*, November 1917, p. 202

NICOLSON, Benedict, 'Post-Impressionism and Roger Fry', *Burlington Magazine*, January 1951, pp. 11–15

– 'Roger Fry and the Burlington Magazine', *Burlington Magazine*, October 1966, p. 493

Omega Workshops Limited, *Prospectus*, London 1913
'A New Venture in Art – Exhibition at the Omega Workshops', *The Times* (9 July 1913) p. 4
'The Omega Workshops', *Illustrated London News* (13 September 1913) p. 408
'The Omega Workshops', *The Times* (10 December 1913) p. 13
'The Omega Workshops', *Illustrated London News* (27 December 1913) p. 1100
Omega Workshops Limited, *Descriptive Catalogue*, London 1914
'A Visit to the Omega Workshops – Mr. Roger Fry on Modern Design and Applied Art', *Drawing and Design*, August 1917, pp. 76–7
Omega Workshops Catalogue of Furniture, Textiles and Pottery, Millers of Lewes and the Arts Council exhibition catalogue 1946
Original Woodcuts by Various Artists, London, Omega Workshops 1918
'Original Woodcuts by Various Artists', *Burlington Magazine*, October 1919, p. 175

PEVSNER, Nikolaus, 'Omega', *Architectural Review*, XC, August 1941, pp. 45–8
PHILLIPS, Claude, 'Roger Fry Exhibition', *Daily Telegraph* (16 November 1915) p. 3
'Phrynette's Letter to Lonely Soldiers by Marthe Troly-Curtin', *Sketch* (4 October 1916) p. 4
'Phrynette's Letter from London', *Sketch* (15 December 1917) p. 230
– *Sketch* (13 November 1918) p. 210
– *Sketch* (19 March 1919) p. 368
'The Second Post-Impressionist Exhibition', *Hearth and Home* (30 January 1913) p. 575
'Post-Impressionism Again', *The Nation* (29 March 1913) p. 1060
'Post-Impressionism in the Home', *Pall Mall Gazette* (11 April 1913) p. 3
'Post-Impressionism', Sandon Studios Society Bulletin, June 1913, p. 7
'Post-Impressionism Furniture', *Daily News and Leader* (7 August 1913) p. 10
'Inspired by Post-Impressionism', *Illustrated London News* (25 October 1913) p. iv, Ladies' Supplement

REID, B. L., *The Man from New York. John Quinn and his Friends*, New York: Oxford University Press 1968
REILLY, C. H., 'Contemporary Art exhibited at Sandon Studios', *Liverpool Daily Post and Mercury* (2 February 1914) p. 10
RICHARDSON, Marion, *Art and the Child*, London: University of London Press 1948
ROBERTS, William P., *Abstract and Cubist Paintings and Drawings*, London: Canale Press 1957
– *The Vortex Pamphlets 1956–58*, London: Favil Press 1958
– *Paintings 1917–1958*, London: Favil Press 1960

William Roberts A.R.A., Retrospective Exhibition, London, Arts Council exhibition catalogue 1965

ROSENBAUM, S. P. (ed.), *The Bloomsbury Group: A Collection of Memories*, London: Croom Helm 1975

ROSS, Margery (ed.), *Robert Ross: Friend of Friends*, London: Jonathan Cape 1952

ROTHENSTEIN, John, *Modern English Painters*, Vol. 1, London: Eyre and Spottiswoode 1952

– *Modern English Painters*, Vol. 2, London: Eyre and Spottiswoode 1956

RUTTER, Frank, *Revolution in Art*, London: Art News Press 1910

– 'The Mural Paintings at the Borough Polytechnic', *Art News* (15 November 1911) p. 9

– 'Allied Artists at the Grafton Galleries', *Sunday Times* (5 March 1916) p. 5

– *Evolution in Modern Art: A Study in Modern Painting 1870–1925*, London: Harrap 1926

– *Art in my Time*, London: Rich and Cowan 1933

SADLEIR, M., *Michael Ernest Sadler, A Memoir by His Son*, London: Constable 1949

SHAW, G. B., 'Mr. Roger Fry's Criticism', *The Nation* (1 March 1913) p. 888

SHONE, Richard, 'The Friday Club', *Burlington Magazine*, May 1975, pp. 279–84

– *Bloomsbury Portraits*, London: Phaidon Press 1976

SICKERT, Walter, 'A Monthly Chronicle: Roger Fry', *Burlington Magazine*, December 1915, pp. 117–18

– 'Alvaro Guevara', *Burlington Magazine*, August 1916, p. 220

'Simpson's Choice – The Tediousness of Hell', *Observer* (6 February 1916) p. 4

SITWELL, Osbert, *A Free House or The Artist as Craftsman (Being the Writings of Walter Richard Sickert)*, London: Macmillan 1947

SPALDING, Frances, Portraits by Roger Fry, London, Courtauld Institute Galleries exhibition catalogue 1976

– 'Vanessa Bell 1879–1961', Sheffield, Mappin Art Gallery and elsewhere exhibition catalogue 1979

– *Roger Fry: Art and Life*, London: Paul Elek/Granada 1980

SUTTON, Denys, 'Omega Revived', *Financial Times* (26 November 1963) p. 4

– 'Jacques Copeau and Duncan Grant', *Apollo*, August 1967, pp. 138–41

– 'A Silver Age in British Art', intro. to British Art 1890–1928, Columbus, Ohio, Columbus Gallery of Fine Arts exhibition catalogue 1971

– (ed.) *Letters of Roger Fry*, 2 vols, London: Chatto and Windus 1972

THORNTON, Alfred, *Fifty Years of the NEAC 1886–1935*, London: Cowen Press 1935

– *Diary of an Art Student of the Nineties*, London: Pitman and Sons 1938

TODD, Dorothy, and Raymond MORTIMER, *The New Interior Decoration*, London: Batsford 1929

'As the leading lady in Too Much Money: Miss Lillah McCarthy', *Sketch* (17 April 1918) p. 50

TREVELYAN, R. C., *Polyphemus and other poems,* London: Brimley Johnson 1901

– (trans.) *Lucretius on Death,* London: Omega Workshops 1917

Twentieth-Century Art, A Review of Modern Movements, London, Whitechapel Gallery exhibition catalogue 1914

VANDERVELDE, Lalla, *Monarchs and Millionaires,* London: Butterworth 1925

Vorticist Exhibition, London, Doré Galleries exhibition catalogue 1915

'The Vorticists', *Glasgow Herald* (11 June 1915) p. 8

Edward Wadsworth, Paintings, Drawings and Prints exhibition catalogue, London, P. & D. Colnaghi 1974

WATNEY, Simon, *English Post-Impressionism,* London: Studio Vista Eastview Editions Inc. 1980

WEBB, Michael, 'A Last Flourish of Aestheticism', *Country Life* (2 January 1964) pp. 16–17

Max Weber, The Years 1906–1916, New York, Bernard Danenberg Galleries Inc. exhibition catalogue 1970

WEES, William C., *Vorticism and The English Avant-Garde*: Toronto University Press 1972

Edward Wolfe, ARA: A Retrospective Exhibition of Paintings and Drawings, London, Arts Council Gallery and elsewhere exhibition catalogue 1967

WOODESON, John, *Mark Gertler. Biography of a Painter 1891–1939,* London: Sidgwick and Jackson 1972

WOOLF, Virginia, *Roger Fry: A Biography,* London: Hogarth Press 1940

ZANGWILL, Israel, *Too Much Money,* London: William Heinemann 1924

ZILCER, Judith, The Noble Buyer: John Quinn Patron of the Avant-Garde, Washington DC, Hirschorn Museum exhibition catalogue 1978

NOTES

Abbreviations

CAS Contemporary Art Society
KCC King's College, Cambridge
TGA Tate Gallery Archive

Initials have been used to classify correspondence, those of the writer being followed by those of the recipient, e.g., VBRF signifies a letter from Vanessa Bell to Roger Fry; other correspondents are CB – Clive Bell – and DG – Duncan Grant. This method was used by the cataloguers of the Charleston Papers when they were stored at Kings College, Cambridge, and I have retained this system for this book. The Charleston Papers have now been purchased by the TGA and have been recently recatalogued and renumbered by myself; thus a new numbering system will come into force, listed side by side with the older one.

Chapter 1

1 Sutton, *Letters of Roger Fry*, (Chatto & Windus), 1972, Vol. 1, p. 359.
2 Virginia Woolf, *Roger Fry: A Biography* (Hogarth Press, 1940), pp. 156–7.
3 Letter to *The Nation*, 8 February 1913, p. 782.
4 Roger Fry, 'The Post-Impressionists – II', *The Nation*, 3 December 1910, p. 402.
5 Roger Fry,' A Postscript on Post-Impressionism', *The Nation*, 24 December 1910, p. 536.
6 Roger Fry, 'The Grafton Gallery – I', *The Nation*, 19 November 1910, p. 31.
7 Unpublished lecture by Roger Fry, 'The Present Outlook in Painting and Applied Art', Dunfermline, Scotland, December 1924. MS in Fry Papers, KCC.
8 Roger Fry, 'A Modern Jeweller', *Burlington Magazine*, April 1910, p. 170.
9 C. R. Ashbee, *Should We Stop Teaching Art?* (B. T. Batsford, 1911), p. 26.
10 'A Visit to the Omega Workshops. Mr. Roger Fry on Modern Design and Applied Art', *Drawing and Design*, August 1917, p. 76.

11 Ibid.
12 The ten founder members of this Society were Lady Ottoline Morrell, Philip Morrell, D. S. MacColl, C. J. Holmes, Edward Marsh, Charles Aitken, Arthur Clutton-Brock, J. Bowyer Nichols, Robert Ross and Roger Fry.
13 VB/Ms. VI – 'Memories of Roger Fry', pp. 1–2. MS in the collection of Quentin Bell.
14 Virginia Woolf, 'Mr. Bennett and Mrs. Brown', paper read to the Heretics, Cambridge, 18 May 1924; subsequently published in *Collected Essays*, Vol. 1 (Hogarth Press, 1966), p. 320.
15 VB/Ms. VI – 'Memories of Roger Fry', p. 7.
16 C. Lewis Hind, *The Post-Impressionists* (Methuen, 1911), p. 28.
17 *The Flight of the Mind, The Letters of Virginia Woolf 1888–1912* (Hogarth Press, 1975), p. 456.
18 Sutton, *Letters of Roger Fry*, Vol. 1, p. 344.
19 Ibid., pp. 344–5.
20 Roger Fry, 'The Artist in the Great State', in *The Great State*, ed. H. G. Wells (Harper, 1914), p. 254. This essay was reprinted as 'Art and Socialism' in *Vision and Design* (Chatto and Windus, 1920).
21 D. Grant to Lytton Strachey, 15 April 1910. Letter in Strachey Collection, British Library.
22 Sutton, *Letters of Roger Fry*, Vol. 1, p. 347.
23 Ibid., p. 338.
24 David Talbot Rice, *Byzantine Art* (Penguin Books, 1962), p. 81.
25 Roger Fry, translation of Maurice Denis, 'Cézanne', *Burlington Magazine*, January 1910, p. 207.
26 Grant's contemporary oil painting, *Lemon Gatherers*, in the Tate Gallery, also exploits this formula. Grant stated that this painting was inspired by the Sicilian Players who appeared at the Shaftesbury Theatre in February–March 1908; why, then, did this inspiration take at least two years to reach its visual expression? Could a strong influence, and catalyst for the posed figures with their backs to the spectator, be Matisse's six-foot 1909 clay version of *The Back*, which Grant saw on a visit to Matisse's studio in the summer of 1909? Grant's predilection for painting backs was virtually exhausted by the time Fry exhibited Matisse's *The Back* (in plaster) in his second Post-Impressionist exhibition.
27 Letter from Bernard Adeney to Mary Chamot, 31 December 1953, Tate Gallery.
28 Letter from Bernard Adeney to Nikolaus Pevsner, 29 April 1941; copy, Victoria and Albert Museum.
29 Crane was reported thus in *The Times*, 15 February 1912, p. 4.
30 Anonymous review in the *Athenaeum*, 23 September 1911, p. 366.
31 Anonymous review in *The Times*, 19 September 1911, p. 9.
32 This information was drawn to my attention by Frances Spalding; see her article, 'The Borough Polytechnic Murals', a copy of which is in the Tate Gallery Archive.
33 For an illustration of this fresco, see *The Studio*, 'The New Magpie and Stump – A Successful Experiment in Domestic Architecture', Vol. V, 1895, p. 68.
34 Graded concentric squares can be seen painted on several table-tops, notably the small circular table, Misc. 2(4)–1934, V. and A. collection.
35 Robert Ross, *Morning Post*, 19 September 1911, p. 5.
36 Sutton, *Letters of Roger Fry*, Vol. 1, p. 353.
37 Ibid., p. 354.
38 'Post-Impressionism in the Home', *Pall Mall Gazette*, 11 April 1913, p. 3.
39 Catalogue entry by Richard Morphet in the pamphlet, 'Duncan Grant: A display to celebrate his ninetieth birthday', published by the Tate Gallery, February 1975.

40 VBRF17, 16 August 1911, TGA.
41 VBRF34, 2 September [1911], TGA; RFDG, undated [September 1911], Fry Papers, KCC.
42 Sutton, *Letters of Roger Fry*, Vol. 1, p. 352.
43 VBRF38, 14 September [1911], TGA.

Chapter 2

1 *Art News*, 15 January 1912, p. 27.
2 An example of a regular patterned frame by Fry is that around his *Still Life with Eggs* (collection of his daughter); regular patterned frames by Etchells are seen with his *The Dead Mole* (Keynes estate), and *Entry into Jerusalem* (estate of Duncan Grant); Grant's random blob frames can be seen around his portrait of Katherine Cox, *in situ* when photographed for the second Post-Impressionist catalogue but now missing from the painting, which is in the collection of the Courtauld Institute Galleries, and around a portrait of Gerald Shove (Keynes estate); a Vanessa Bell random blob frame surrounds her painting entitled *Conversation* (collection of the Courtauld Institute Galleries).
3 Robert Ross, *Morning Post*, 4 January 1912, p. 4.
4 Ibid.
5 Roger Fry, 'The Present Outlook in Painting and Applied Art', Dunfermline lecture.
6 'Designs for Mural Painting. A Competitive Exhibition', *The Times*. 5 February 1912, p. 11.
7 At the second exhibition of the Camden Town Group at the Carfax Gallery in December 1911, Lewis showed (35) *Port de Mer*, (36) *Au Marché* and (37) *Virgin and Child*.
8 Sutton, *Letters of Roger Fry*, Vol. 1, p. 355.
9 Grant painted *The Ass* on the back of *The Red Sea* in April 1914. This was a second attempt at this subject; he also painted another version in late 1913.
10 Examples in the work of Robert Delaunay are *La Tour* of 1910–11, *Les Tours de Laon* and *La Ville de Paris*, both of 1912; in the work of Marcel Duchamp, his two versions of *Nu Descendant un Escalier*, one of December 1911, the other of January 1912.
11 Postcard from Fry to Grant, dated 18 March 1912 by postmark, Fry Papers, KCC.
12 VBCB28, 6 April [1912], TGA.
13 Sutton, *Letters of Roger Fry*, Vol. 1, p. 356.
14 Grant's six works were: *The Queen of Sheba, Dancers, Mme. B., Preparation for Whippets, Still Life* and *View of Corfe*. *The Queen of Sheba* and *Dancers* are in the Tate Gallery; *View of Corfe* is in Leeds City Art Gallery, where it is known under the title *The Red House on the Hill; Preparations for the Whippet-race* (also known as *Man with Greyhound*) is in a private collection.
15 Etchells' seven works were: *L'Entrée en Jérusalem, Le Fauteuil, Sur la Bascule, La Désenchantée, La Taupe Morte, Etude* and *Esquisse*. Richard Cork, in his *Vorticism and Abstract Art in the First Machine Age*, Vol. 1, p. 51, writes of 'Etchells' readiness to play around with a pot-pourri of disparate conventions'. The subject-matter of *The Dead Mole* (*La Taupe Morte*) stemmed from a real-life game of charades which took place in the garden of his home, whereas the subject material of *The Entry into Jerusalem*, or to give it its alternative title, *Palm Sunday*, has to stem either from Etchells' imagination or be based on an earlier source. In fact the composition is closely modelled on an Ottonian manuscript of *c*. 1000 on Christ's entry into Jerusalem from the Gospel Book of Otto III, which had been reproduced in facsimile a few years before Etchells'

painting. It is quite rare to see an early-twentieth-century avant-garde English artist turning to such a medieval source as this.

16 Letter from V. Bell to W. Lewis, dated June, W. Lewis archive, Cornell University Library. William Lipke, in his Ph.D. thesis, 'A History and Analysis of Vorticism', University of Wisconsin, 1966, p. 239, note 41, dates the letter to June 1913, but it is obvious that the event which it describes took place in June 1912.

17 VBRF7, 5 June [1912], TGA.

18 Walter Sickert, from 'The Teaching of Art and Development of the Artist', which first appeared in the *English Review* of July 1912 and was reprinted in *Walter Richard Sickert – A Free House or The Artist as Craftsman*, ed. Osbert Sitwell (Macmillan, 1947), p. 307.

19 *Robert Ross: Friend of Friends*, ed. Margery Ross (Jonathan Cape, 1952), p. 226.

20 VBRF7, 5 June [1912], TGA.

21 Examples are *The Big Girl* (Tate Gallery); *On the Grass* (Ashmolean Museum, Oxford); and *Woman with Bird* (private collection).

22 Richard Shone, *Bloomsbury Portraits* (Phaidon, 1976), p. 72.

23 VBRF24, Sunday [August 1912], TGA.

24 Ibid.

25 C. R. Ashbee, 'Memoirs', Vol. 3, 'Back to the Land April 1908–August 1914,' p. 264. Ms. in V. and A. Library collection.

26 Roger Fry, letter to Editor of the *Burlington Magazine*, March 1908, p. 375.

27 Roger Fry, 'The Present Outlook in Painting and Applied Art', Dunfermline lecture, 1924.

28 Roger Fry, *Reflections on British Painting* (Faber and Faber, 1934), p. 34.

29 Roger Fry, 'The Grafton Gallery: An Apologia', *The Nation*, 9 November 1912, p. 249.

30 Roger Fry, *Art and Commerce* (Hogarth Press, 1926), p. 9.

31 Roger Fry, 'The Artist as Decorator', *Colour Magazine*, April 1917, p. 92.

32 Sutton, *Letters of Roger Fry*, Vol. 1, p. 361.

33 Virginia Woolf, *Roger Fry: A Biography*, p. 179.

34 Logan Pearsall Smith to Roger Fry, 21 December 1912, Fry Papers, KCC.

35 C. R. Ashbee, 'Memoirs', Vol. 3, p. 312.

36 Winifred Gill, tape interview with Stephen Chaplin in *c.* 1962.

37 Roger Fry to Bernard Shaw, circular letter, 11 December 1912, Add. MS 50534, MSS Dept., British Library.

38 Virginia Woolf, *Roger Fry: A Biography*, p. 180.

Chapter 3

1 *The Question of Things Happening. The Letters of Virginia Woolf 1912–1922*, ed. Nigel Nicolson (Hogarth Press, 1976), p. 16.

2 D. Grant's 1913 diary (private collection, London). This entry for 8 January is only one of a handful for the whole of the year – what could have been a document packed with fascinating information has been left neglected by Grant.

3 R. Fry to G. B. Shaw, 11 December 1912, Add. MS 50534, MSS Dept., British Library, Shaw wrote across the top of this letter: 'Sent £250'. VBCB47, 26 December [1912], TGA. George Davison, a friend of Grant, was an early member of the CAS, and a well-known landscape photographer.

4 VBRF86, 16 January [1913], TGA.

5 R. Fry to G. B. Shaw, 11 December 1912, Add. MS 50534.

6 VBRF91, 24 January [1913], TGA.

7 VBCB101, 21 August [1913], TGA.

8 Clive Bell, 'Post-Impressionism and Aesthetics', *Burlington Magazine*, January 1913, CXVIII, pp. 226–7.

9 Sutton, *Letters of Roger Fry*, Vol. 1, p. 362–3. The name of the architect who placed an order is not known, and no collaboration initiated by a big firm of cotton printers is believed to have occurred.

10 Sutton is wrong in believing that the Leicester Palette Club organised this show. A catalogue for the show, preserved at Leicester Art Gallery, gives the organisers as the CAS.

11 The Liverpool exhibition took place at the Sandon Studios, Liberty Buildings, from 15 February to 8 March 1913, and included fifty-two works.

12 Lewis's ten entries in the second Post-Impressionist exhibition were (112) *Mother and Child*, (128) *Creation*, (194–8) *Timon of Athens* designs, (199) *Amazons*, (200) *Creation* and (201) *Timon*.

13 Undated letter from W. Lewis to R. Fry, *The Letters of Wyndham Lewis*, ed. W. K. Rose (Methuen, 1963), pp. 46–7. Rose dates this letter August-September 1913, as does Richard Cork, *Vorticism and Abstract Art in the First Machine Age*, Vol. 1, p. 92. But the mention in the letter of the Grafton works being sent on to Liverpool can only indicate a date of February-March. Rose and Cork possibly overlooked the clue of the Liverpool show, because they both wanted to use this letter as an incident immediately preceding the Ideal Home rumpus, which occurred in October 1913. The fact that it actually dates to February–March gives Lewis's association with the Omega Workshops a more ironic flavour.

14 Leonard Woolf, *Beginning Again. An Autobiography of the Years 1911–1918* (Hogarth Press, 1964), pp. 95–6.

15 G. B. Shaw to *The Nation*, letter dated 26 February 1913, published in issue of 1 March 1913, pp. 888–9. Sir William Blake Richmond (1842–1921) and Sir Philip Burne-Jones (1861–1926), both Royal Academicians and sons of successful Royal Academicians, were violently opposed to Post-Impressionism.

16 R. Fry to G. B. Shaw, 11 December 1912, Add. MS 50534.

17 Sutton, *Letters of Roger Fry*, Vol. 1, p. 365.

18 VBRF95, n.d. [6 March 1913], TGA.

19 *Daily Chronicle*, 24 March 1913, p. 4.

20 Grafton Group exhibition catalogue, Alpine Club Gallery, 15–31 March 1913. The twelve invited artists were Bernard Adeney, Mrs. Adeney, Jessie Etchells, Winifred Gill, Spencer Gore, C. F. Hamilton, C. R. W. Nevinson, Helen Saunders, Alfred Thornton, Edward Wadsworth, W. Kandinsky and Max Weber. Kandinsky's and Weber's paintings were identified in the catalogue.

21 Clive Bell, *Art* (Chatto and Windus, 1914), p. 79.

22 (3) *Room with Figure*; (10) *portrait of a woman?*; (42) *portrait of a woman?*; (44) *portrait?*; (23) screen: *Daffodils*.

23 *Westminster Gazette*, 25 March 1913, p. 3; *Daily News and Leader*, 27 March 1913, p. 5. The recorded existence of Bell's screen ends with the close of this exhibition. It is never mentioned or exhibited again. Such a total disappearance is puzzling, unless it was painted over with another composition.

24 (11) *The Chinese Student*; (19) *Composition*; (43) *Joseph and Potiphar's Wife*. Like Bell's screen, Etchells' three Grafton Group works were never heard of again.

25 *Daily Citizen*, 26 March 1913, p. 5.

26 Hamilton showed (24) *The Guitar Player* and some faceted drawings of heads.

27 These remarks come from the *Daily Telegraph*, 22 March 1913, p. 6, and the *Westminster Gazette*, 25 March 1913, p. 3. In his 1917 list of works (to be found in Walter Michel, *Wyndham Lewis: Paintings and Drawings* (Thames and Hudson, 1971),

p. 447) Wyndham Lewis writes of 'a large paper roll, cartoon, The Laughing Woman' and 'Laughing Woman, painting in possession of the Contemporary Art Society'. It would seem quite logical to link the paper cartoon with the painting, and to judge the paper cartoon to be a preliminary study. But where does that leave Lewis's *Three Women* from the Grafton Group exhibition, described as caught in the act of laughing? Perhaps *Three Women* was a secondary stage between the first paper cartoon and the oil painting. The oil painting was finished by the end of March 1913, since it was included in the first CAS public exhibition in London, held at the Goupil Gallery, 1–12 April 1913. All three works – the paper cartoon, the Grafton Group *Three Women* and the oil painting – are now lost.

28 Grant showed (8) *Matting*; (31) screen: *Sheep*; and (50) *Construction*. The painted screen is now in the collection of the V. and A. and was reviewed in *The Times*, 20 March 1913, p. 4, the *Daily Telegraph*, 22 March 1913, p. 6, and the *Westminster Gazette*, 25 March 1913, p. 3. Duncan Grant showed *Construction* again in the Twentieth-Century Art Exhibition at the Whitechapel Art Gallery, London, 8 May–20 June 1914 (35). It must have been slightly reworked – see VBCB107, n.d. [April 1914], TGA.

29 *The Times*, 20 March 1913, p. 4.

30 Charles Marriott, *Evening Standard*, 25 March 1913, n.p.

31 *Daily Citizen*, 26 March 1913, p. 5; *Daily Telegraph*, 22 March 1913, p. 6.

32 *Sketch*, 2 April 1913, p. 406.

33 *Daily Express*, 18 March 1913, p. 2; *Pall Mall Gazette*, 27 March 1913, n.p. Richard Shone, *Bloomsbury Portraits*, p. 99, says there was a painted table by Etchells included in the Grafton Group exhibition, but I have found no evidence to support this statement.

34 *Pall Mall Gazette*, 11 April 1913, p. 3; *Daily News and Leader*, 7 August 1913, p. 10.

35 Michael Sadler owned several pictures and drawings by Kandinsky, collecting his work after an initial conversion to it at the Allied Artists' Association exhibition at the Royal Albert Hall in July 1911. For further information see Michael Sadler, *Michael Ernest Sadler, A Memoir by His Son* (Constable, 1949), pp. 237–40. (The son called himself Michael Sadleir to distinguish himself from his father.)

36 A. L. Coburn to Max Weber, 29 January 1913, letter in the possession of Miss Joy Weber.

37 A. L. Coburn to Max Weber, 13 March 1913, letter in the possession of Miss Joy Weber.

38 A. L. Coburn to Max Weber, 16 March 1913, letter in the possession of Miss Joy Weber.

39 VBRF55, 23 November [1911], TGA.

40 VBCB46, 25 December [1912], TGA.

41 VBRF87, 13 January [1913], TGA. There is an Omega painted box, in a private collection in London, which when seen in a raking light reveals the existence of an earlier simple geometric pattern beneath the present decoration.

42 Reported in VBRF59, 26 December [1912], TGA.

43 VBCB95, 2 April [1913], TGA.

44 Sutton, *Letters of Roger Fry*, Vol. 2, p. 369.

45 Omega Workshops Ltd., Artist Decorators, *Descriptive Illustrated Catalogue*, n.d. [published October 1914], p. 8.

46 Not in fact a quote from one of Miss Gill's letters, but taken from the transcript of a taped conversation between Stephen Chaplin, Winifred Gill and Pamela Diamand, *c.* 1962. Copy of transcript in collection of Pamela Diamand.

47 Miss Gill, in the tape conversation and the letters, speaks only of a French firm;

Nikolaus Pevsner, who had the assistance of the Omega manager Charles Robinson when writing his 1941 article on the Omega, also only offered France. Peter Floud, late Keeper of Textiles at the V. and A., was the first to suggest the firm of Besselevrier et Cie, of Maromme, France as the printer of the Omega linens. His evidence for doing so has not been recovered. From 1910 to 1914 the Maromme Print Works Company had a London office at 6 Snow Hill, and it may be that Fry made contact with this firm in the City of London rather than on one of his peripatetic French tours. An unknown firm 'further South' took over the printing of the linens when Maromme suffered damage in the war. The process of printing the linens has never been satisfactorily settled. The Maromme Print Works probably used wooden blocks covered with felt; then the firm further south had to evolve another method due to the loss of the original blocks. W. Gill recalled: 'They evolved a scheme of making lino-type metal blocks to print with and in order to give a slight play of light and colour in the surface as well as not too rigid an outline the metal was washed over with glue and sprinkled with flock.' Yet, in an interview published in the periodical *Drawing and Design*, August 1917, pp. 76–7, Fry said, no doubt referring to the firm further south: 'It would not be fair to divulge these methods, but it is sufficient to say that the roller-printing of the machine is utilised.'

48 Amenophis is the name of three Egyptian kings of the New Kingdom. It is not known why Fry chose it for an Omega linen; perhaps the book painted in the *Still Life, Jug and Eggs* had something to do with Egyptian art history.

49 Vanessa Bell's painting *Milk Jug and Eggs* is in oil on board, 12¼ × 16 in. (collection of Anthony d'Offay Gallery). The same milk jug is seen also in her painting *Nursery Tea*, and must have been quite a favourite studio prop. A summary list of the shared motifs by Fry, Vanessa Bell and Grant is as follows:

1911 Brusa pines VB RF
1911 Portrait of Pamela by the lily pond RF DG
1912 Byzantine princess VB DG
1912 Italian landscape VB RF
1912 Portrait of Henri Doucet VB DG
1913 Portrait of Lytton Strachey RF VB DG
1913 Portrait of a model with coiled plaits RF VB
1914 Still life on mantelpiece VB DG
1914–15 Triple Alliance still life VB DG
1915 Portrait of David Garnett VB DG
1915 Portrait of Iris Tree VB DG
1915 Portrait of Mary Hutchinson VB DG

50 *Pall Mall Gazette*, 11 April 1913, p. 3.

51 Three paintings which underwent this process are *Summer Camp* by Vanessa Bell, which became a screen decoration; *Lilypond* by Duncan Grant, which became a pattern applied to table-tops and screens; and *The Ass* by Duncan Grant, which became a cushion cover design.

52 *Pall Mall Gazette*, 11 April 1913, p. 3.

53 Ibid.

54 Sutton, *Letters of Roger Fry*, Vol. 2, p. 367.

55 *Sketch*, 23 April 1913, p. 72; *Art Chronicle*, 25 April 1913, p. 204. The *Art Chronicle* article is mostly lifted straight from the *Pall Mall Gazette* article of 11 April.

56 Although Fry's, Grant's, Clive and Vanessa Bell's signatures are on the document, dated 13 May by Withers, they cannot have signed it on that day since they were all still out of the country – possibly in France, making their way back from Italy. They must have signed it before their departure for Italy.

57 The only restaurant in Great Portland Street was no. 48 – M. & G. Pagani's.

58 VBRF93, 6 February [1913], TGA.

59 Winifred Gill, letter 5, 29 August 1966, copy in TGA.

60 *Art Chronicle*, 22 August 1913, p. 62.

61 Tate Gallery Library copy, with annotations possibly by John Doman Turner, one of the members of the Camden Town Group.

62 Walter Michel, *Wyndham Lewis: Paintings and Drawings*, Catalogue of works, numbers 61, 121 and 160.

63 *The Times*, 9 July 1913, p. 4.

64 *Daily News and Leader*, 7 August 1913, p. 10.

65 Winifred Gill, letter 2, June 1966, copy in TGA. Doucet's *Le Repas*, lent to the second Post-Impressionist exhibition by Paul Gallimard, was reproduced in the illustrated catalogue. The five sheets of designs for pottery vessels are part of item HHF263, which was given to the Courtauld Institute by the Trustees of Fry's Bequest.

66 Sutton, *Letters of Roger Fry*, Vol. 2, p. 371.

67 During 1912–13, the iconography of Adam and Eve and the Creation suddenly became popular amongst certain artists belonging to Fry's circle: Lewis painted two versions of *The Creation* in 1912; Vanessa Bell produced an Omega design of *Adam and Eve* in 1913; Grant painted a *Head of Eve* and a huge canvas, *Adam and Eve*, in the winter of 1913; and Wadsworth, by the autumn of 1913, had painted an *Adam and Eve*.

68 Distorted poses are to be found in Grant's *Adam and Eve*, *Man with a Whippet* and *The Queen of Sheba*; Eve's facial characteristics are found again in the painting *Head of Eve* and in an Omega painted fan; the small internal facets are seen again in the body of the woman on the painted screen standing behind these painted curtains. Frances Spalding attributes the curtains to Henri Doucet; see her *Roger Fry: Art and Life* (Elek/Granada, 1980), p. 178. But the hand of Grant in the figures of Adam and Eve is unmistakable.

69 The mural painted on the back wall of the Omega Workshops ground-floor showroom was christened *Blue Lagoons* by a *Sketch* journalist. It was executed in the summer of 1913, quite possibly by Vanessa Bell with additional help from Grant and Doucet, and remained on the wall until the Omega closed in the autumn of 1919. G. Spencer Watson exhibited a painting – *The Three Kings* – at the Royal Academy Summer Exhibition of 1920, which can be regarded as a sort of homage to the Omega, since the cloak of one king reproduces a section of the *Blue Lagoons* mural and that of another is made from the Omega Workshops woven textile known as 'Cracow'. Spencer Watson's *The Three Kings* is now in the collection of Rochdale Art Gallery.

70 Wendy Baron, *Miss Ethel Sands and her Circle* (Peter Owen, 1977), p. 109.

71 The head of the female on the left of Lewis's *Study for a Screen: Three Figures* (Courtauld Institute Galleries, Fry collection), which is illustrated on p. 87 of R. Cork, *Vorticism*, Vol. 1, is strikingly similar to the head on the extreme right of the letterhead. The way several of the figures in the letterhead bend their forearms and wrists in front of their bodies is seen in several of Lewis's candle/lampshades. Also, the decorative feature of enlivening the material draped over the figures with short parallel lines filling a triangular shape is used in both the shades and the letterhead.

72 Omega Workshops prospectus, Tate Gallery Library collection; VBRF100, 15 September [1913], TGA.

73 The term 'Ideal Home Rumpus' first appeared in print as the title of an article written by Quentin Bell and Stephen Chaplin in 1964 which objectively offered all the original documentation surrounding this affair.

74 Augustus John, *Chiaroscuro. Fragments of an Autobiography* (Jonathan Cape, 1952), p. 50.

75 The five Omega employees who left were Lewis, Hamilton, Wadsworth, Frederick Etchells and Jessie Etchells. Frederick's sister Jessie, six years his junior, had showed

herself gifted artistically, and he had presumably been responsible for her subsequent introduction to the Omega Workshops. When he left her continued employment there must accordingly have become untenable.

76 Circular letter written by Lewis, Etchells, Hamilton and Wadsworth; copy amongst Fry Papers, KCC.

77 *Daily Mail* Ideal Home Exhibition catalogue, Omega Workshops entry – Stall 104, Gallery, n.p.

78 VBCB99, 18 August [1913], TGA. The colour photograph of the Omega sitting-room was reproduced in the *Illustrated London News*, 25 October 1913, p. 666.

79 The impact of Diaghilev's Ballets Russes, which first astonished London audiences in 1911 and again in their 1912 and 1913 seasons, could likewise be considered an inspiration. In June 1913 the Ballets Russes gave the London premiere of Stravinsky's 'Le Sacre du Printemps', which would have been a powerful stimulus to any of these artists who saw it.

80 Sutton, *Letters of Roger Fry*, Vol. 2, p. 372.

81 W. Gill, letter to Carol Hogben, 24 October 1963, V. and A. Collection.

82 William Roberts, *A Reply to my Biographer Sir John Rothenstein* (Favil Press, 1957), p. 9.

83 Design for rug – pencil and bodycolour on white paper, $39\frac{3}{4} \times 55\frac{3}{4}$ in., E723–1955, Prints and Drawings Dept., V. and A. given by Margery Fry.

84 *Roger Fry: Last Lectures*, intro. Kenneth Clark (Cambridge University Press, 1939), p. 36.

85 Pierre Daix and Joan Rosselet, *Picasso, The Cubist Years 1907–1916* (Thames and Hudson, 1979), p. 208, cat. no. 95.

86 The entry for Grant's *The Tub* – T723 – in *The Tate Gallery Report 1964–65* (HMSO, 1966), p. 37, states that the painting is inscribed 'D. Grant 1912' bottom left, which it undoubtedly is. But when *The Tub* was illustrated in colour as Plate 5 in Raymond Mortimer's *Duncan Grant* (Penguin Modern Painters, 1948), it does not bear any inscription and is dated 1913 in the caption. It therefore looks as though Grant added the date of 1912 between the years 1948 and 1965, which he was in the habit of doing to his works when they left his possession.

87 This still life is illustrated in black and white in Roger Fry, *Duncan Grant* (Hogarth Press, 1923), plate 9.

88 *The Head of Eve* is illustrated in Fry, *Duncan Grant*, plate 8; *Tents* is plate 7 and *The Ass* plate 6.

89 Besides the Ideal Home rug, this can be found in another rug design – E726–1955, Prints and Drawings Dept., V. and A.; in a design of a reclining nude – E721–1955, also Prints and Drawings Dept., V. and A.; and on an Omega Workshops invitation to a Christmas Exhibition, 1913, copies of which are in various collections.

90 Etchells' love of geometric forms can be seen in the painted frame he executed for his 1912 painting *The Entry into Jerusalem* (estate of Duncan Grant); in the painted frame and the clothes of the two protagonists in *The Dead Mole* of 1912 (Keynes estate); in the patterned cloth in the still life of 1912–13 (collection Tate Gallery, 5403); in the patterned clothes of the figures in his *Group of Figures* of 1912–13 (collection Towner Art Gallery, Eastbourne).

91 Omega Workshops Ltd., *Descriptive Illustrated Catalogue*, p. 7.

92 B. J. Fletcher and C. Crampton carried out some experiments in pulp-cane furniture at Leicester Art School in 1906, and as a result they founded the Dryad Works at Leicester in 1907. Fry was one of their earliest customers.

93 It was illustrated in black and white in *House and Garden*, January 1921, p. 22, in an article on modern furniture. The caption to the photograph gave the owner as Lady Tredegar. I am grateful to Carol Hogben, who drew my attention to this article.

 94 W. Gill, letter 3, 4 July 1966, copy in TGA.
 95 Virginia Woolf, *Roger Fry: A Biography*, p. 197.
 96 Examples are *Bathing*, Borough Polytechnic canvas (Tate Gallery, 4567); *Swimmer with goldfish*, design for a painted cupboard, 1912 (private collection); two designs for murals at 38 Brunswick Square, 1912 (HHF263, Fry collection, Courtauld Institute Galleries); painted Omega box, 1913 (collection V. and A., Circ. 42 and 42a–1965); painted Omega vase, 1913 (private collection, Edinburgh); painted linen chest, 1916 (estate of Duncan Grant).
 97 The first example is thought to be a papier collé poster for the Grafton Group exhibition which opened on 15 March 1913. The poster was seen at Charleston in the summer of 1973, but its present whereabouts is unknown.
 98 Two such paintings are *Abstract*, oil on canvas (collection Anthony d'Offay Gallery) and *Asheham Group*, oil on board (collection Anthony d'Offay Gallery). The *Abstract Kinetic Collage Painting with Sound* is in the Tate Gallery, T1744.
 99 Circular letter, copy in Fry Papers, KCC.
100 Mr. Pecksniff is a character in Dickens' *Martin Chuzzlewit*.
101 *Blast*, edited by Wyndham Lewis, no. 1, 20 June 1914 (John Lane, 1914), p. 134.
102 Foreword by Frank Rutter to the catalogue of the Post-Impressionist and Futurist exhibition held at the Doré Galleries, London, from 12 October 1913 to 16 January 1914.
103 R. Fry to G. B. Shaw, 11 November 1913, Add. MS 50534.
104 Letter from D. Grant to R. Fry, 20 October 1913, copy in TGA; Sutton, *Letters of Roger Fry*, Vol. 2, p. 373.
105 Daix and Rosselet, *Picasso, The Cubist Years 1907–1916*, p. 307, cat. no. 615.
106 Roger Fry, 'The Grafton Gallery: An Apologia', *The Nation*, 9 November 1912, p. 251.
107 R. Fry to Rose Vildrac, 4 November 1913, original in French in Fry papers, KCC; English translation in Sutton, *Letters of Roger Fry*, Vol. 2, p. 375.
108 C. H. Reilly, review of a Contemporary Art Society loan exhibition at the Sandon Studios, *Liverpool Daily Post and Mercury*, 2 February 1914, p. 10.
109 *Blast*, no. 1, *Group* by Cuthbert Hamilton, illustration xviii (black and white), between pages 128 and 129.
110 The two other paintings by Jessie Etchells are *Seated Figures*, illustrated on p. 49 of Simon Watney's *English Post-Impressionism* (Studio Vista, 1980), and *Theatre Balcony* – both in the collection of the estate of Duncan Grant. *Seated Figures* bears an affinity to Derain's *Three Figures in a Meadow* of 1906 (collection Musée du Petit Palais, Paris).
111 Late in 1913 Grant painted his first version of *The Ass* (oil on paper laid on to canvas) which was shown in the second Grafton Group exhibition in January 1914. This was bought by Fry, who reproduced it as Plate 6 in his book *Duncan Grant*, published by the Hogarth Press in 1923. It remained in Fry's collection until his death, when it passed to the Anrep family. For a reason as yet undiscovered, Grant painted a second version of *The Ass* (oil on canvas, on the back of *The Red Sea*) in April 1914. A letter VBRF127 TGA gives the evidence for this dating. Both paintings of *The Ass* have the same measurements – 4 × 5 feet – but Fry's version shows much use of hatching. Since the cushion cover also displays hatching, it is likely to have been copied from Fry's picture. The second version of *The Ass* is a gentler work, with a softer treatment of body and background. It is not easy to guess why Grant chose to produce two large oil paintings of the same subject within a short space of time. The second version of *The Ass* was illustrated in *Vogue*, early February 1919, p. 40, where the painting was shown hanging in the drawing room of Mr. St. John Hutchinson. Hutchinson was the buyer for the Contemporary Art Society from July 1918 to January 1919, and it could be that

the painting was bought during that period. It passed into the stock of the Contemporary Art Society at an unknown date prior to 1963, when it was presented by the Society to the Ferens Art Gallery, Kingston upon Hull.

112 P. G. Konody, *Observer*, 14 December 1913, p. 8.

113 Sutton, *Letters of Roger Fry*, Vol. 2, p. 371. Sutton only gives a blanket date of 1913 for this letter, but in fact it is a postcard with a clear postmark of 28 November 1913 – original in Fry Papers, KCC.

114 Ibid.

115 Konody, *Observer*, 14 December 1913.

116 The design is bodycolour and oil on paper, squared up for enlargement. Its size is 30 × 15 in., just under half the size of the actual panel; collection E734–1955, Prints and Drawings Department, V & A.

117 Vanessa Bell letters to Fry are VBRF147, 17 September 1913, and VBRF100, 18 September [1913], both in TGA.

118 Konody, *Observer*, 14 December 1913.

119 Paintings such as *46 Gordon Square* of 1909–10, *Studland Bay* of 1912, *Italian Landscape* of 1912, *Interior, Gordon Square*, of 1912, *Self-portrait* of 1912–13, *Portrait of a Model with coiled plaits* and *Street Corner Conversation*, both of 1913, all show these characteristics.

120 VBRF131, n.d. [July 1913], TGA.

Chapter 4

1 Roger Fry to Henri Gaudier-Brzeska, undated letter on Omega Workshops notepaper (collection of Roger Cole).

2 Typed circular dated 13 November 1913 (Wyndham Lewis collection, Cornell University Library).

3 Winifred Gill to Duncan Grant, letter 9, 29 December 1966, copy in TGA.

4 B. L. Reid, *The Man from New York. John Quinn and his Friends* (OUP New York, 1968), pp. 204, 251.

5 Mervyn Levy, *Gaudier-Brzeska Drawings and Sculpture* (Cory, Adams and Mackay, 1965), illustration on p. 65.

6 Henri Gaudier-Brzeska, 'Allied Artists' Association, Holland Park Hall', *The Egoist*, 15 June 1914, p. 227.

7 Ibid.

8 H. S. Ede, *Savage Messiah* (Heinemann, 1931), p. 151.

9 Nina Hamnett, *Laughing Torso* (Constable, 1932), p. 43.

10 Both plaster maquettes are in the collection of the Tate Gallery, T365 and T839.

11 Horace Brodzky, *Henri Gaudier-Brzeska 1891–1915* (Faber and Faber, 1933), pp. 134–5.

12 Both these drawings are in the collection of the Tate Gallery; the view of the interior, with the inscription 'Showing large stone. One of a pair to be carved as flower pots for garden for Omega Workshops (Fry)', is T1786. It has never been satisfactorily decided whether Gaudier-Brzeska was commissioned by Lady Hamilton through the Omega to provide her with stone vases for her garden or for her entrance hall.

13 A variety of sources record Gaudier-Brzeska's earlier excursions into areas of design: in 1911 he drew designs for a firm of calico printers; he produced large posters and advertising designs, and a design, 'Parrots', for wallpaper (design in the V. and A.); and he decorated Lovat Fraser's rooms.

14 Lytton Strachey to Duncan Grant, letter 123,6 February 1914, Strachey Papers, MSS Dept., British Library.

15 Nina Hamnett, *Laughing Torso*, pp. 42–3.

16 Winifred Gill to Duncan Grant, letter 5, 29 August 1966, copy in TGA.

17 William Roberts, *The Vortex Pamphlets 1956–58*, pamphlet 3, p. 8.

18 Sutton, *Letters of Roger Fry*, Vol. 2, p. 378, 379.

19 VBRF113, 26 December [1913], TGA.

20 John Currie to Edward Marsh, quoted in John Woodeson, *Mark Gertler. Biography of a Painter 1891–1939* (Sidgwick and Jackson, 1972), footnote 122.

21 Sutton, *Letters of Roger Fry*, Vol. 2, p. 377.

22 Anonymous review of Fry's lecture, 'Post-Impressionism Explained', unidentified newspaper, 31 January 1914.

23 Roger Fry, 'The Present Outlook in Painting and Applied Art', Dunfermline lecture, 1924.

24 Roger Fry, 'Vanessa Bell', *Vogue*, early February 1926, p. 34. *Women and Baby* is illustrated in this article.

25 'The Grafton Group', *The Times*, 3 January 1914, p. 11.

26 'The Grafton Group', *New Statesman*, 10 January 1914, p. 436.

27 T. E. Hulme, 'Modern Art. – 1. The Grafton Group', *The New Age*, 15 January 1914, p. 342.

28 Sutton, *Letters of Roger Fry*, Vol. 2, p. 377.

29 Anthony Bertram, *Paul Nash: The Portrait of an Artist* (Faber and Faber, 1955), p. 73.

30 Ibid., p. 74.

31 Andrew Causey, *Paul Nash* (Clarendon Press, 1980), p. 49, footnote d.

32 Ibid.

33 Sutton, *Letters of Roger Fry*, Vol. 2, p. 379.

34 Letter from Janet Leeper to the author, 14 March 1973.

35 Turnbull's capacity as a designer cannot be assessed since there is no firm evidence about him and his work – even his christian name is unknown, 'Jock' being only a nickname. There are three candidates for this identity, though none of them properly fit the facts. A Scottish artist called Andrew Watson Turnbull who listed stained glass amongst his activities in *Who's Who in Art* is discounted because he was born in 1874 and was thus thirty-nine in 1913, and not 'about twenty-five'. Another Scottish artist was John A. Turnbull, who was probably in his early twenties in 1913. He studied painting at Edinburgh College of Art, and after graduating was granted postgraduate studio space there. Since he was recorded as being in an Edinburgh College of Art studio in February 1914, he was unlikely to have been working at Fitzroy Square at the same time. Another John Turnbull certainly worked within London circles of advanced art, although this was after the war; but it is not recorded if he was a Scot. He showed paintings of aircraft in the Group X Exhibition organised by Wyndham Lewis and held at the Mansard Gallery, Heal's, from March to April 1920. Since Miss Gill recalled that 'Jock' Turnbull joined the Territorials – the Yeomanry – at the outbreak of war, this does not match with the RAF experience of this John Turnbull.

36 Such a comparison can be found in Richard Cork, *Vorticism and Abstract Art in the First Machine Age*, Vol. 1, p. 134, and in the introduction by Jane Beckett and Chris Mullen to the exhibition catalogue, 'A Terrific Thing: British Art 1910–16', Norwich Castle Museum, October–November 1976, p. 15.

37 Roger Fry, 'The Ottoman and the Whatnot', *Athenaeum*, 27 June 1919, p. 529.

38 Roger Fry, 'A Possible Domestic Architecture', *Vogue*, late March 1918, p. 66, where there is an illustration of this screen.

39 Vanessa Bell showed *Women and Baby* (12), *Landscape with figures* (304), *Design for*

screen (305), *The Girlhood of Thisbe* (313: this painting is now known as *The Spanish Model*), *Still Life* (317); Roger Fry showed *The Road* (306), *The Bridge* (307), *Avignon* (308), *The Road to the Quarry* (311), *The Farm* (312); Duncan Grant showed *Slops* (13), *Construction* (35), *Still Life* (309), *Dancers* (310), *Lemon Gatherers* (329), *The Queen of Sheba* (364), *Tulips* (365).

40 Henri Gaudier-Brzeska, 'Allied Artists' Association, Holland Park Hall', *The Egoist*, 15 June 1914, p. 228.

41 T. E. Hulme, 'Modern Art. – 1. The Grafton Group', *The New Age*, 15 January 1914, p. 341.

42 Henri Gaudier-Brzeska, notebook in the possession of Roger Cole.

43 'London Salon', *The Times*, 16 June 1914, p. 11.

44 *New Statesman*, 27 June 1914, p. 372; *Journal of the Royal Society of Arts*, 3 July 1914, p. 726.

45 *New Statesman*, 27 June 1914, p. 372. Askelon or Ashkelon, a city mentioned several times in the Old Testament, was one of the five chief cities of Philistia. Perhaps this reference was an oblique accusation of philistinism from the *New Statesman* critic.

46 Winifred Gill to Duncan Grant, letter 7, 10 October 1966, copy in TGA.

47 Roger Fry to Bernard Shaw, 22 March 1914, Add. MS 50534, MSS Dept., British Library; Virginia Woolf, *Roger Fry: A Biography*, p. 199.

48 Sutton, *Letters of Roger Fry*, Vol. 2, p. 380.

49 Ibid., p. 381.

50 Jessie Etchells' 1914 diary, in the possession of her daughter, Mrs. Elizabeth Elwyn.

51 Wyndham Lewis, foreword to the catalogue of the 'Exhibition of English Post-Impressionists, Cubists and Others' held in Brighton from November 1913 to January 1914.

52 VBRF138, 25 August [1914], TGA.

53 Sutton, *Letters of Roger Fry*, Vol. 2, pp. 381, 382, 383.

54 Virginia Woolf, *Roger Fry: A Biography*, p. 197.

55 George Schenck died in 1919 at the grand age of eighty-seven. Such a fact seems hard to reconcile with Winifred Gill's reminiscences to the effect that the potter at Mitcham 'when the war broke out . . . was called to the colours'.

56 Winifred Gill to Duncan Grant, letter 3, 4 July 1966, copy in TGA.

57 VBRF120, Sunday [late 1913], TGA.

Chapter 5

1 David Garnett, *The Flowers of the Forest* (Chatto and Windus, 1955), p. 25; Walter Sickert to Ethel Sands, quoted in Wendy Baron, *Miss Ethels Sands and her circle*, p. 137.

2 Nina Hamnett, *Laughing Torso*, p. 80.

3 *Colour Magazine*, February 1915, p. 2.

4 Nina Hamnett, *Laughing Torso*, pp. 81–2.

5 Roald Kristian, 'Albert Aurier', *The Egoist*, 1 December 1915, pp. 191–2. This obituary note was accompanied by a woodcut portrait of Aurier by Kristian.

6 Nina Hamnett, *Laughing Torso*, p. 81.

7 Sutton, *Letters of Roger Fry*, Vol. 2, p. 384.

8 Roger Fry, 'The Art of Pottery in England', *Burlington Magazine*, March 1914, p. 330.

9 Virginia Woolf, 'Old Bloomsbury', in *Moments of Being* (Chatto and Windus, 1976), p. 173.

10 VBRF161, Friday [March–April 1915], TGA.

11 This information is gleaned from Winifred Gill to Duncan Grant, letter 6, 12 September 1966, copy in TGA.

12 VBRF171, 12 June [1915], TGA.

13 VBRF178, Tuesday [c. July 1915], TGA.

14 Klaus Lankheit, *Franz Marc, Katalogue der Werke*, Cologne 1970, no. 833: Tiger, woodcut 1912, 200 × 240 mm, p. 269.

15 VBRF135, n.d. [May 1915], TGA.

16 *Glasgow Herald*, 11 June 1915, p. 8.

17 P. G. Konody, *Observer*, 4 July 1915, p. 9.

18 *Athenaeum*, 10 January 1914, p. 70.

19 VBCB87, Friday [c. June 1915], TGA.

20 Duncan Grant in conversation with David Brown in the autumn of 1972. Quoted in Brown's MA thesis, 'Duncan Grant to 1920', University of East Anglia, 1973.

21 The same process can be seen in his delayed response to Picasso's *Nude with Drapery* of 1907. When asked by David Brown in 1972 whether he had seen any paintings of Kupka in Paris or elsewhere before the First World War, Grant replied no, but this answer came after the passage of nearly sixty years and cannot necessarily be relied upon.

22 Sutton, *Letters of Roger Fry*, Vol. 2, p. 388.

23 Examples of books with woodcuts designed and cut by Ricketts and Shannon are their *Daphnis and Chloe* of 1893 and *Hero and Leander* of 1894. William Nicholson published several volumes of woodcuts, for example *Twelve Portraits* and *London Types*, between 1898 and 1902.

24 Eric Gill, *Autobiography* (Jonathan Cape, 1940), p. 135.

25 Duncan Grant in conversation with Simon Watney, 26 July 1976.

26 Leslie T. Owens, *J. H. Mason 1875–1961, Scholar-Printer* (Frederick Muller, 1976), pp. 23–4.

27 Arthur Waley, *One Hundred and Seventy Chinese Poems* (Constable, 1962), p. 5.

28 Sutton, *Letters of Roger Fry*, Vol. 2, p. 425.

29 Roger Fry, 'Book Illustration and a Modern Example', essay in his *Transformations* (Chatto and Windus, 1926), p. 157.

30 'A Monthly Chronicle', *Burlington Magazine*, November 1915, p. 80.

31 'Books of the Day', *Observer*, 6 February 1916, p. 4.

32 Information from the biographical note on Charles Vildrac in Sutton, *Letters of Roger Fry*, Vol. 2, p. 756.

33 Sutton, *Letters of Roger Fry*, Vol. 2, p. 393; letter from Gordon Bottomley to Roger Fry, 12 February 1916, Fry Papers, KCC.

34 Walter Sickert (although the article is anonymous), 'A Monthly Chronicle', *Burlington Magazine*, December 1915, p. 118.

35 The five works known to have had some papier collé applied to them were (2) *Queen Victoria*, (6) *Bulldog*, (12) *Still Life*, (15) *Three Men in Long Military Cloaks* (also known as *German General Staff*) and (45) *Essay in Abstract Design*. This information is from pencil annotations on the Alpine Club Gallery exhibition catalogue in the Tate Gallery Archive. Perhaps numbers 19 or 44 in the exhibition, both of which were entitled *Essay in Abstract Design*, contained some papier collé, although the anonymous annotator of the catalogue made no mention of this.

36 It seems – if one accepts the memory of Margaret Nash, the widow of Paul Nash – that Fry made an attempt at the time of the First World War to be considered as a war artist. He showed *Three Men in Long Military Cloaks* (or *German General Staff*) in the 1928 Retrospective Exhibition of the London Group, and Margaret Nash was one of those who helped to gather the paintings for that exhibition. In her 'Memoir of Paul Nash

1913–1946' (written *c.* 1950, now in MS form in the V. and A. Library), she wrote on p. 23: 'I discovered a picture [by Fry] and a very bad one at that, entitled "The Three Generals", which represented the Kaiser and his two well-known Generals, standing on a globe, with melodramatic sky behind, and on the back of it the label "Returned by the Ministry of Information".'

37 A waterlily pond inhabited by goldfish is a motif that appears in much of Grant's work for the Omega in 1913. It was first used in the background of a portrait by Grant of Fry's daughter, Pamela, painted in the garden of Fry's house, Durbins, in the summer of 1911. The confining of the motif to just lilypond with fish appears in a sketchy oil painting of circa 1912. The pond was a central feature of Fry's garden, carefully planned by him with Gertrude Jekyll, and Grant was known to have been very fond of it. When Grant came to decorate table-tops and screens at the Omega, he used the composition of his 1912 painting as source material. He did not copy it directly however; Fry's daughter Pamela relates how Grant, when working with size colours in the workshop at the Omega, was urged by Fry to pour them straight onto the table-top, so that lilies, leaves, fish and water all became random pools of colour. These appe r to have been the most successful of all Omega designs, being regularly repeated by demand.

38 Duncan Grant, *The Mantelpiece*, 1914, *Tate Gallery Report 1970–72*, 1972, p. 110.

39 'Palette and Chisel', *Colour Magazine*, November 1915, p. x.

40 Roger Fry to Lady Fry, 11 October 1915, Fry Papers, KCC.

Chapter 6

1 Sutton, *Letters of Roger Fry*, Vol. 2, p. 392.

2 'Mrs. Clive Bell's Pictures', *The Times*, 11 February 1916, p. 9.

3 One of the abstract oil paintings, entitled *Abstract Painting*, dated *c.* 1914, gouache on canvas, $17\frac{3}{8} \times 15\frac{1}{4}$ in., is in the collection of the Tate Gallery; the other oil painting, untitled and undated, oil on canvas, 24×36 in., is in the collection of the Anthony d'Offay Gallery. Both of the papier collés are entitled *Abstract*; one measures 22×17 in. and is in the collection of the Museum of Modern Art, New York, the Joan and Lester Avnet collection; the other measures $19\frac{1}{4} \times 24$ in. and is in the collection of the Anthony d'Offay Gallery.

4 VBRF189, 4 January [1916], TGA.

5 Examples of such portraits are: *The Studio: Duncan Grant and Henri Doucet painting at Asheham*, 1912 (private collection); *Portrait of Virginia Woolf in a Deckchair*, 1912 (private collection); *Frederick and Jessie Etchells painting*, 1912 (collection of the Tate gallery); *Self-portrait painting*, 1912–13 (collection of Pamela Diamand).

6 Sutton, *Letters of Roger Fry*, Vol. 2, p. 449.

7 Winifred Gill to Duncan Grant, letter 5, 29 August 1966, copy in TGA.

8 *The Question of Things Happening. The Letters of Virginia Woolf 1912–1922*, ed. Nigel Nicolson (Hogarth Press, 1976), pp. 77–8.

9 Roger Fry to Lady Fry, 16 February 1916, Fry Papers, KCC.

10 Roger Fry to Lady Fry, 25 October 1916, Fry Papers, KCC.

11 'Phrynette's Letters to Lonely Soldiers by Marthe Troly-Curtin', *Sketch*, 4 October 1916, p. 4.

12 Sutton, *Letters of Roger Fry*, Vol. 2, p. 400.

13 Roger Fry to Lady Fry, 22 September 1916, Fry Papers, KCC.

14 Roger Fry to Mary Mowbray-Clarke, 14 February 1916, John and Mary Mowbray-Clarke Papers 1901–25, Archives of American Art.

15 Sutton, *Letters of Roger Fry*, Vol. 2, p. 395.

16 Ibid., p. 395.
17 VBRF199, Saturday [c. April 1916], TGA.
18 'Phrynette's Letters', *Sketch*, 4 October 1916, p. 4.
19 Mrs. L. Gordon-Stables, 'On Painting and Decorative Painting', *Colour Magazine*, June 1916, p. 188.
20 Dolores Courtney in a letter to the author, 6 November 1973.
21 'Notes', *British Architect*, November 1916, p. 141.
22 RFVB30, 29 April 1916, TGA.
23 In 'The New Movement in Art' exhibition held at the Royal Birmingham Society of Artists in New Street, Birmingham, Dolores Courtney showed (19) *Still Life*, £10, (20) *Still Life*, £10, (21) *Still Life*, £8. When the exhibition was shown in London at the Mansard Gallery in Heal's in October, Courtney showed (15) *Still Life*, £10 10s, (16) *Still Life*, £10 10s. Because of the identical titles of her painting none can be positively identified with those shown in these two exhibitions.
24 Nina Hamnett, *Laughing Torso*, p. 127.
25 *The Question of Things Happening. The Letters of Virginia Woolf 1912–1922*, ed. Nigel Nicolson, p. 300.
26 Mrs. L. Gordon-Stables, 'Nina Hamnett's Psychological Portraiture', *Artwork*, October 1924, p. 115.
27 Nina Hamnett, *Laughing Torso*, p. 81.
28 Roger Fry to Lady Fry, 21 June 1916, Fry Papers, KCC.
29 TS of 'Quelques Peintres Français Modernes', Fry Papers, KCC; this lecture, which was delivered in French, was subsequently published in French in three instalments in *Le Français – Journal de la Société des Professeurs de Français en Angleterre*, in October 1918, January and April 1919. Autograph translation and précis in English by Roger Fry, Fry Papers, KCC.
30 Autograph translation and précis in English, p. 1.
31 Sutton, *Letters of Roger Fry*, Vol. 2, pp. 399–400.
32 Ibid., p. 400.
33 The exhibition of the work of Alvaro Guevara, organised by Mark Glazebrook at Colnaghi's, London, from December 1974 to January 1975, revealed to the public many paintings previously untraced and unexhibited for many decades. In the exhibition catalogue Glazebrook acknowledges how Diana Holman-Hunt's research for her book on Guevara made the exhibition possible.
34 Sir John Rothenstein, introduction to the catalogue 'Alvaro Guevara 1894–1951', P. D. Colnaghi & Co., London, 1974–5, n.p.
35 Quoted in Diana Holman-Hunt, *Latin among Lions: Alvaro Guevara* (Michael Joseph, 1974), p. 99.
36 'Alvaro Guevara – A Spanish Painter in England', *Vogue*, early March 1917, p. 47.
37 RFVB47, 5 September 1916, TGA; RFVB48, 8 September 1916, TGA.
38 Roger Fry to Sir Edward Fry, 7 September 1916, Fry Papers, KCC.
39 RFVB51, 20 September 1916, TGA.
40 Sutton, *Letters of Roger Fry*, Vol. 2, p. 402–3.
41 RFVB52, 6 October [1916], TGA.
42 'A Monthly Chronicle', *Burlington Magazine*, December 1916, p. 388.
43 'Notes', *British Architect*, November 1916, p. 144.
44 'New Aims for Commerce', *British Architect*, December 1916, p. 166.
45 Roger Fry, *Art and Commerce* (Hogarth Press, 1926), pp. 16–17.
46 Sutton, *Letters of Roger Fry*, Vol. 2, p. 403.
47 Ibid., p. 403.
48 Virginia Woolf, *Roger Fry: A Biography*, p. 126.

49 VBRF220, Wednesday [February 1917], TGA.
50 Richard Carline, *Draw They Must* (Edward Arnold, 1968), p. 167.
51 Sutton, *Letters of Roger Fry*, Vol. 2, p. 406.
52 Ibid., pp. 409–10.
53 Ibid., p. 408.
54 VBRF202, Wednesday [June 1916], TGA.
55 VBRF205, Wednesday [c. June–July 1916], TGA.
56 Armfield's first meeting with Grant – quoted in Richard Shone, *Bloomsbury Portraits*, p. 49; the second meeting is recorded in Maxwell Armfield, 'My Approach to Art', n.p., in the exhibition catalogue by Armfield, Southampton Art Gallery, June 1978.
57 VBRF221, Wednesday [May 1917], TGA.
58 Roger Fry, preface to the catalogue of 'Omega Copies and Translations', copy in a private collection.
59 Sutton, *Letters of Roger Fry*, Vol. 2, p. 408.
60 RFVB89, 18 May 1917, TGA.
61 RFVB88, 17 May 1917, TGA.
62 RFVB90, n.d. [c. June 1917], TGA.
63 VBRF226, Saturday [June 1917], TGA.
64 Sutton, *Letters of Roger Fry*, Vol. 2, p. 404.
65 Ibid., p. 411.
66 Ibid., p. 413.
67 'Artists in Revolt', *Birmingham Gazette*, 18 July 1917, p. 2.
68 Ibid.
69 Roger Fry, 'Sandro Botticelli', *Burlington Magazine*, April 1926, pp. 199–200.
70 Roger Fry, *Duncan Grant* (Hogarth Press, 1923), p. vii.
71 Roger Fry to Pamela Fry, 23 November 1917, Fry Papers, KCC.
72 'Advanced Pictures', *The Times*, 20 November 1917, p. 11.

Chapter 7

1 Israel Zangwill, *Too Much Money. A Farcical Comedy in Three Acts* (William Heinemann, 1925), p. 1.
2 Richard Shone, *Bloomsbury Portraits*, p. 97.
3 Roger Fry to Lady Fry, 10 February 1918, Fry Papers, KCC.
4 Sutton, *Letters of Roger Fry*, Vol. 2, p. 425.
5 Roger Fry to Lady Fry, 16 February 1918, Fry Papers, KCC.
6 Ibid.
7 RFVB130, 21 February 1918, TGA.
8 Sutton, *Letters of Roger Fry*, Vol. 2, p. 437.
9 Richard Shone, *Bloomsbury Portraits*, p. 168.
10 'Modern Pictures', *The Times*, 2 November 1918, p. 3.
11 Sutton, *Letters of Roger Fry*, Vol. 2, p. 441. The idea of founding an artists' association, although originally the brainchild of the dealer Percy Moore Turner and the unemployed David Garnett, would have been a very sympathetic one to Fry, believing as he must have done that the Omega could not continue for much longer. In fact, he helped to bring such an organisation into being when, in 1926, the London Artists' Association was founded, with support from four wealthy sponsors – Samuel Courtauld, Maynard Keynes, L. H. Myers and Frank Hindley Smith. Fry was responsible for choosing the artist members of the London Artists' Association, and they included Fry

himself, Grant, Vanessa Bell, Bernard Adeney, Keith Baynes, Frederick Porter, Edward Wolfe, Douglas Davidson and Raymond Coxon.

12 *The Question of Things Happening. The Letters of Virginia Woolf 1912–1922*, ed. Nigel Nicolson, p. 166.

13 Ibid., p. 168.

14 Duncan Grant in conversation with Simon Watney, 26 July 1976.

15 VBRF271, 11 November [1918], TGA.

16 VBRF273, 21 November [1918], TGA.

17 Sutton, *Letters of Roger Fry*, Vol. 2, p. 439.

18 *The Tub* is in the collection of the Tate Gallery, T. 2010.

19 Grant's original painting of *The Tub* was lost, and he painted a second version c. 1940; this version is reproduced as colour plate 12 in Simon Watney, *English Post-Impressionism* (Studio Vista/Eastview Editions Inc., 1980). It was believed that the original was destroyed in a fire at Roger Fry's home, Durbins, but this is disproved by the fact that Fry lent the 1916–17 version of *The Tub* to the Retrospective Exhibition of the London Group held at the New Burlington Galleries, London, in May 1928. *The Tub* was entitled *Woman in Bath* in the catalogue.

20 Sutton, *Letters of Roger Fry*, Vol. 2, p. 438.

21 Ibid., p. 442.

22 Hubert Waley, 'Fragments of an Autobiography', p. 7. TS in the collection of his son, Daniel Waley.

23 Sutton, *Letters of Roger Fry*, Vol. 2, p. 447.

24 Ibid., p. 445.

25 RFVB167, 22 February 1919, TGA.

26 Sutton, *Letters of Roger Fry*, Vol. 2, p. 443.

27 Roger Fry to Arnold Bennett, 3 March 1919, University College Library, London University.

28 Sutton, *Letters of Roger Fry*, Vol. 2, p. 442.

29 Ibid., p. 447.

30 Ibid., p. 498.

31 Roger Fry, 'The Artist's Vision', *Athenaeum*, 11 July 1919, p. 595. This article was reprinted in *Vision and Design*.

32 Roger Fry, 'Mr. Larionov and the Russian Ballet', *Burlington Magazine*, March 1919, pp. 112, 117.

33 Roger Fry, preface to the catalogue of the 'Exhibition of Sketches by Mr. Larionow, and Drawings by the Girls of Dudley High School', p. iii.

34 RFVB195, incomplete, n. d. [early March 1919], TGA.

35 Sutton, *Letters of Roger Fry*, Vol. 2, p. 448.

36 RFVB164, 20 January 1919, TGA.

37 VBRF290, Wednesday [c. May 1919], TGA.

38 Sutton, *Letters of Roger Fry*, Vol. 2, p. 452.

39 Roger Fry to Arnold Bennett, 2 June 1919, University College Library, London University.

40 RFVB177, 22 June 1919, and RFVB178, 26 June 1919, both in TGA.

41 David Garnett, *The Flowers of the Forest*, p. 204.

42 Ibid.

43 Duncan Grant in conversation with Simon Watney, 26 July 1976.

LIST OF PLATES

20 Vanessa Bell, design of couple dancing, September 1913, pencil, gouache and oil, 30 × 18¾ in. (76.2 × 47.6 cm), Victoria and Albert Museum

21 Omega Workshops nursery, Omega publicity photograph, December 1913

22 Henri Gaudier-Brzeska, vase, 1913, Seravezza marble, height 16 in. (40.6 cm), Anthony d'Offay Gallery

23 Henri Gaudier-Brzeska, Cat, spring 1914, glazed earthenware, 4⅝ × 4⅝ in. (12.4 × 12.4 cm), private collection

24 Henri Gaudier-Brzeska, drawing for earthenware cat, spring 1914, ink, 8½ × 11¼ in. (21.6 × 28.6 cm), Kettle's Yard

25 Henri Gaudier-Brzeska, Marquetry tray, late 1913/early 1914, various woods, diameter 25 in. (63.5 cm), Victoria and Albert Museum

26 Henri Gaudier-Brzeska, drawings for marquetry tray, late 1913/early 1914, pencil and ink, 14½ × 9½ in. (36.8 × 24.2 cm), Anthony d'Offay Gallery

27 Henri Gaudier-Brzeska, plaster design for woodwork newel, spring 1914, plaster, size unknown, present whereabouts unknown

28 Henri Gaudier-Brzeska, garden ornament, spring 1914, plaster on wooden base, height 25 in. (63.5 cm), Tate Gallery

29 William Roberts, study for 'Theatre', 1914, pencil, 8¾ × 6¼ in. (22.2 × 15.9 cm) sold Sotheby's 11 December 1968

30 Duncan Grant, The Ass, late 1913, oil on paper laid on canvas, 48 × 60 in. (122 × 152.4 cm), Dr and Mrs Anrep

31 Vanessa Bell, Girl in front of tent, August 1913, oil on board, 21 × 14½ in. (53.3 × 36.8 cm), Anthony d'Offay Gallery

32 Vanessa Bell, Summer Camp, August 1913, oil on canvas, 24½ × 29½ in. (62.2 × 75 cm), Anthony d'Offay Gallery

33 Vanessa Bell, Bathers in a Landscape screen, late 1913, gouache on paper, 70¼ × 82 in. (178.5 × 208.3 cm), Victoria and Albert Museum

34 Roger Fry, Provençal Landscape screen, late 1913, gouache on paper, 70½ × 83 in. (179.1 × 210.8 cm), private collection

35 Roger Fry, Vanessa Bell and Duncan Grant, wall decorations in antechamber, late 1913/early 1914, tempera on plaster?, whereabouts unknown.

36 Mausoleum of Galla Placidia, Ravenna, mid fifth century, detail of mosaic decoration

37 Vanessa Bell, mosaic floor in entrance hall of 1 Hyde Park Gardens, spring 1914, still in situ

38 Roger Fry, stained-glass window for 1 Hyde Park Gardens, summer 1914, coloured glass in leaded lights, diameter 51 in. (129.5 cm), Victoria and Albert Museum

39 Roger Fry, marquetry desk, spring 1914, various woods, height 30½ in. (77.5 cm), destroyed by fire 1978

40 Vanessa Bell, rug for Lady Hamilton, 1 Hyde Park Gardens, spring 1914, hand-knotted wool on canvas, 75 × 35¾ in. (190.5 × 90.8 cm), Victoria and Albert Museum

41 Roger Fry, silk stole with fighting peacocks design, summer 1913, silk chiffon hand-painted with dyes, 39 × 85 in. (99 × 215.9 cm), Victoria and Albert Museum

42 Roger Fry, still life: Flowers, 1913, oil on canvas, 38 × 24 in. (96.5 × 91 cm), Tate Gallery

43 Roger Fry, Vanessa Bell and Duncan Grant, mosaic of badminton players, spring 1914, glass and ceramic tesserae, height 57 in. (144.8 cm), Durbins, Guildford

44 Roger Fry, cartoon for Durbins mosaic, spring 1914, pencil, 7½ × 11½ in. (19 × 29.2 cm), private collection

45 Roger Fry and Vanessa Bell, Omega Workshops banner, May 1914, cloth collaged

and hand-painted, 24 feet 1 in. × 51 in. (734.5 × 129.5 cm), Victoria and Albert Museum

46 Omega Workshops lounge at the Allied Artists' Association Exhibition, June-July 1914, Omega publicity photograph

47 Jessie Etchells, *Seated figures*, 1913, oil on canvas, 12 × 18 in. (30.5 × 45.8 cm), private collection

48 Cadena Café, 59 Westbourne Grove, July–September 1914, Omega publicity photograph

49 Roger Fry, rug design for Cadena Café, summer 1914, pencil and gouache, 36 × 36½ in. (91.4 × 92.2 cm), Victoria and Albert Museum

50 Omega Workshops painted vase, late 1913/early 1914, commercial porcelain vase hand-painted, height 9¼ in. (23.5 cm), Fitzwilliam Museum, Cambridge

51 Roald Kristian, marionette for *Boîte à Joujoux*, January 1915, cardboard, size and present whereabouts unknown

52 Walter Sickert, *The little tea party*: Nina Hamnett and Roald Kristian, 1915–16, oil on canvas, 10 × 14 in. (22.5 × 35.5 cm), Tate Gallery

53 Henri Doucet, *Les Vendangeuses*, 1913, oil on canvas, 44⅞ × 59½ in. (114 × 151 cm), Musée de la Ville de Poitiers

54 Omega Workshops advertisement for pottery, *Burlington Magazine*, March 1915

55 Vanessa Bell wearing an Omega dress of her own design, summer 1915, Omega publicity photograph

56 Roger Fry, portrait of Nina Hamnett in an Omega dress, *c.* 1917, oil on canvas, 53½ × 35½ in. (136 × 90.1 cm), Weetwood Hall, University of Leeds

57 Roald Kristian, woodcut of a sheep, *Form*, April 1916, 4 × 4 in. (10.2 × 10.2 cm); and woodcut of a horse, *Form*, April 1916, 4¼ × 6 in. (10.8 × 15.2 cm)

58 Roald Kristian design for a rug, 1915–16, coloured inks, 10¼ × 13 in. (26 × 33 cm), Victoria and Albert Museum

59 Duncan Grant, 'Morpheus' painted bed, 1915, oil on wood with wood collage, headboard, 11½ × 32 in. (29.2 × 81.3 cm), estate of Duncan Grant

60 Duncan Grant, design for a rug, *c.* 1915, pencil, gouache and oil, 18⅞ × 24 in. (48 × 61 cm), Anthony d'Offay Gallery

61 Roald Kristian, cover design for 'Simpson's Choice', summer 1915, printed woodcut, 11¼ × 8 in. (28.6 × 20.3 cm), private collection

62 Roald Kristian, woodcut illustration for 'Simpson's Choice', summer 1915, printed woodcut, 7 × 6 in. (17.8 × 15.2 cm), private collection

63 Roald Kristian, woodcut illustration for 'Men of Europe', autumn 1915, printed woodcut, 11 × 8¾ in. (28 × 22.2 cm), private collection

64 Roger Fry, *Essay in Abstract Design*, 1914 or 1915, oil, oil on paper and bus tickets on board, 14¼ × 10½ in. (36.2 × 26.8 cm), Tate Gallery

65 Pablo Picasso, *Head of a Man*, spring-summer 1913, oil, charcoal, ink and crayon on sized paper, 24⅜ × 18¼ in. (62 × 46.5 cm), Richard S. Zeisler

66 Roger Fry, design for marquetry cupboard, *c.* 1915, pencil, chalk, gouache and papier collé on tracing paper, 14¼ × 8½ in. (36.2 × 21.6 cm), Victoria and Albert Museum

67 Roger Fry, design of a rug for Arthur Ruck, dated 7 April 1916, ink, gouache and papier collé, 17 ×23⅞ in. (43.2 × 60.6 cm), Victoria and Albert Museum

68 Roger Fry, *Still Life with Coffee Cup*, 1914 or 1915, oil, gouache and papier collé on board, 19⅝ × 14½ in. (50 × 37 cm), Courtauld Institute Galleries

69 Roger Fry, *German General Staff*, 1915, oil and papier collé, *c.* 6 × 5 feet (182.9 × 152.4 cm), present whereabouts unknown

70 Roger Fry, *Essay in Abstract Design*, *c.* 1915, pencil and oil, 14 × 10 in. (35.6 × 25.4 cm), Courtauld Institute Galleries, Fry Bequest

71 Omega Workshops descriptive catalogue – Page 13 – Toys, October 1914, $8\frac{1}{2} \times 5\frac{1}{2}$ in. (21.5 × 14 cm), private collection

72 Vanessa Bell, *Self-portrait*, *c.* 1915, oil on canvas laid on panel, 25 × 18 in. (63.5 × 45.7 cm), Anthony d'Offay Gallery

73 Vanessa Bell, *Still Life on a Corner of a Mantlepiece*, 1914, oil on canvas, 22 × 18 in. (56 × 45.5 cm), Tate Gallery

74 Vanessa Bell, *The Tub*, May 1917, oil and gouache on canvas, $71 \times 65\frac{1}{2}$ in. (167 × 108.3 cm), Tate Gallery

75 Vanessa Bell, *Abstract*, *c.* 1914, oil, gouache and papier collé, $19\frac{1}{4} \times 24\frac{1}{8}$ in. (48.9 × 61.3), Anthony d'Offay Gallery

76 Vanessa Bell, *Abstract*, *c.* 1914, oil, gouache and papier collé, $21\frac{3}{4} \times 17\frac{1}{4}$ in. (55.3 × 43.8 cm), Museum of Modern Art, New York, The Joan and Lester Avnet Collection

77 Roger Fry, Omega Workshops tureen with dark-blue glaze, 1915–16, earthenware with dark-blue glaze, height $6\frac{1}{2}$ in. (16.5 cm), Courtauld Institute Galleries, Fry Bequest

78 Omega Workshops murals for Arthur Ruck, 4 Berkeley Street, April–May 1916, tempera on plaster, size unknown, wall by Roger Fry

79 Omega Workshops murals for Arthur Ruck, 4 Berkeley Street, April–May 1916, tempera on plaster, size unknown, wall by Dolores Courtney

80 Dolores Courtney, *Still Life*, *c.* 1916, oil on canvas, $26\frac{3}{4} \times 20$ in. (68 × 50.8 cm), private collection

81 Nina Hamnett, *The Student*: portrait of Dolores Courtney, 1917, oil on canvas, 32 × 24 in. (81.3 × 61 cm), Ferens Art Gallery, Kingston upon Hull

82 Alvaro Guevara, *The Swimming Pool*, 1916, oil on canvas, $17\frac{1}{2} \times 22\frac{1}{2}$ in. (44.5 × 57.2 cm), sold Sotheby's 22 June 1977

83 Roger Fry, Omega Workshops decorated dinner plate, *c.* 1914, earthenware with white tin glaze decoration in four colours, diameter 9¾ in. (24.8 cm), private collection. Photograph courtesy Anthony d'Offay Gallery

84 Roger Fry, painted bed for Lalla Vandervelde, autumn 1916, commercially available bed with hand-painted head- and foot-boards, panels 18 × 36 in. (45.7 × 76.2 cm), Victoria and Albert Museum

85 Roger Fry and assistants?, painted cupboard for Lalla Vandervelde, autumn 1916, commercial wardrobe, gessoed and hand-painted, $75\frac{1}{2} \times 63\frac{3}{8}$ in. (192 × 161 cm), Victoria and Albert Museum

86 Roger Fry, sketch for 'The Artist as Decorator' article, early 1917, oil on board, $18\frac{1}{2} \times 12\frac{1}{8}$ in. (47 × 30.8 cm), Courtauld Institute Galleries, Fry Bequest

87 Roger Fry, title page of *Lucretius on Death*, summer 1917, printed woodcut, $11\frac{3}{8} \times 8\frac{7}{8}$ in. (28.9 × 22.5 cm), private collection

88 Duncan Grant, *The Kitchen*, 1914, oil on canvas, $42 \times 53\frac{1}{2}$ in. (106.7 × 135.9 cm) private collection

89 Lillah MacCarthy as Mrs Broadley in *Too Much Money*, *Sketch*, 17 April 1918

90 Group of Omega Workshops products, *Vogue*, late March 1918

91 Duncan Grant, woodcut cover design for Omega Workshops catalogue, first used September 1918, printed woodcut, $9\frac{3}{4} \times 7\frac{1}{4}$ in. (24.8 × 18.4 cm), Victoria and Albert Museum

92 Edward Wolfe, *Still Life*, 1918, oil on canvas, 12 × 10 in. (30.5 × 25.4 cm), private collection

93 Vanessa Bell, *Nude*, November 1918, woodcut, $7\frac{1}{4} \times 4\frac{3}{8}$ in. (18.5 × 11 cm), printed in *Original Woodcuts by Various Artists*

94 Duncan Grant, *Hat Shop*, November 1918, woodcut, $7\frac{1}{2} \times 4\frac{3}{8}$ in. (19 × 11 cm), printed in *Original Woodcuts by Various Artists*

95 Roger Fry, Omega Workshops coffee and tea pottery, 1916–18, earthenware with white tin glaze, height of teapot 5⅜ in. (13.5 cm), Victoria and Albert Museum

96 'The Newest Designs of Painted Furniture from the Omega Workshops', *Vogue*, early April 1919

97 Painted second-hand furniture from the Omega Workshops, spring 1919. Omega publicity photograph

98 Omega Workshops Clearance Sale notice, June 1919, printed card, 7¾ × 5⅛ in. (19.7 × 13 cm), Tate Gallery Archive

 I Vanessa Bell, *Abstract Composition*, c. 1914, oil on canvas, 36½ x 24½ in. (92.8 x 62.2 cm), Anthony d'Offay Gallery, London

 II Roger Fry, Still Life – *Jug and Eggs*, 1912, oil on board, with frame painted by the artist, 14⅛ x 16⅛ in. (39.5 x 41 cm), private collection

 III Duncan Grant, design for firescreen, c. 1913, gouache on paper, 29 x 23¾ in. (73.7 x 60.3 cm), Anthony d'Offay Gallery, London

 IV Duncan Grant, 'Lilypond' painted table, late 1913/early 1914, oil on wood, table top, 49 x 31½ in. (124.5 x 80 cm), Anthony d'Offay Gallery, London

 V Roger Fry, Omega Workshops dining chair, autumn 1913, painted wood with cane seat and back, height 43½ in. (110.2 cm), Anthony d'Offay Gallery, London

 VI Roger Fry, 'Giraffe' marquetry cupboard, c. 1915, various woods, 64 x 42 x 14 in. (162.6 x 106.7 x 35.5 cm), Anthony d'Offay Gallery, London

 VII Duncan Grant, 'Elephant marquetry' tray, late 1913, various woods, diameter 25¾ in. (65.4 cm), Anthony d'Offay Gallery, London

VIII Duncan Grant, decorative design, 1913, oil on paper laid on board, 24⅝ x 19 in. (62.6 x 48.3 cm), Anthony d'Offay Gallery, London

The colour plates have been kindly provided by the Anthony d'Offay Gallery, London, for whose generosity I am most grateful.

INDEX

Items in *italics* indicate illustrations.